RALPH LAUREN

—

IN HIS OWN FASHION

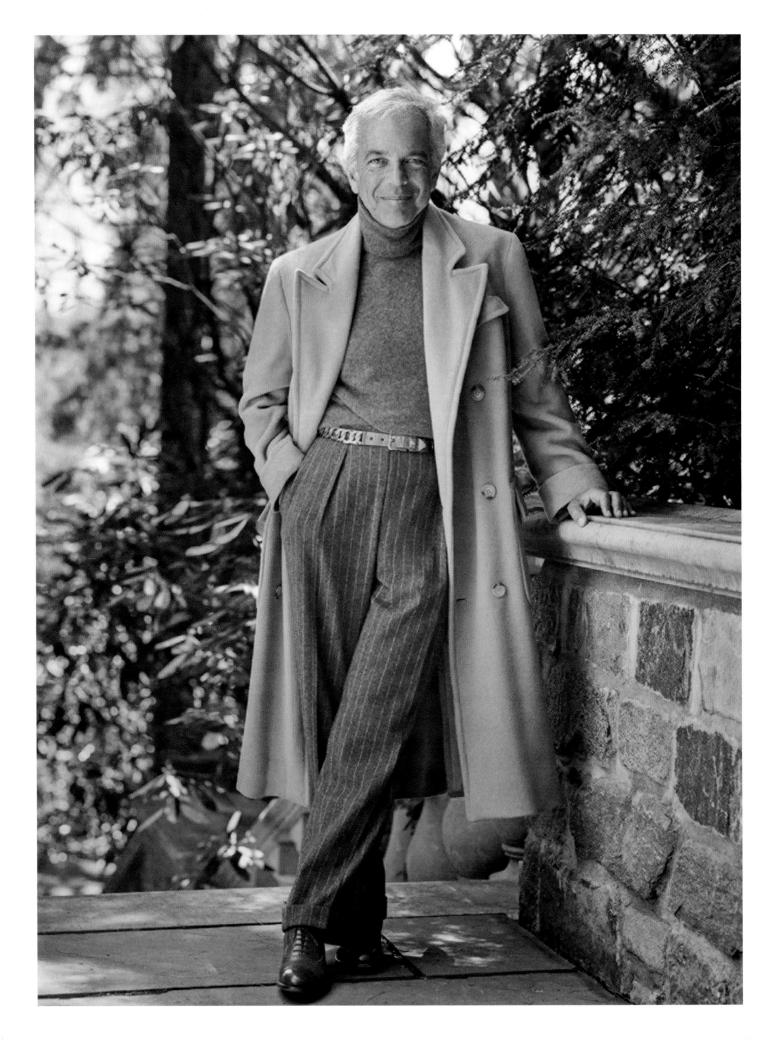

RALPH LAUREN

IN HIS OWN FASHION

ALAN FLUSSER

ABRAMS, NEW YORK

In dedication to my mentor and Buddhist teacher
Daisaku Ikeda, President of the Soka Gakkai International

*"A great human revolution in just a single individual will help achieve a
change in the destiny of a nation, and, further, will enable a change in the
destiny of all humankind." —Daisaku Ikeda*

CONTENTS

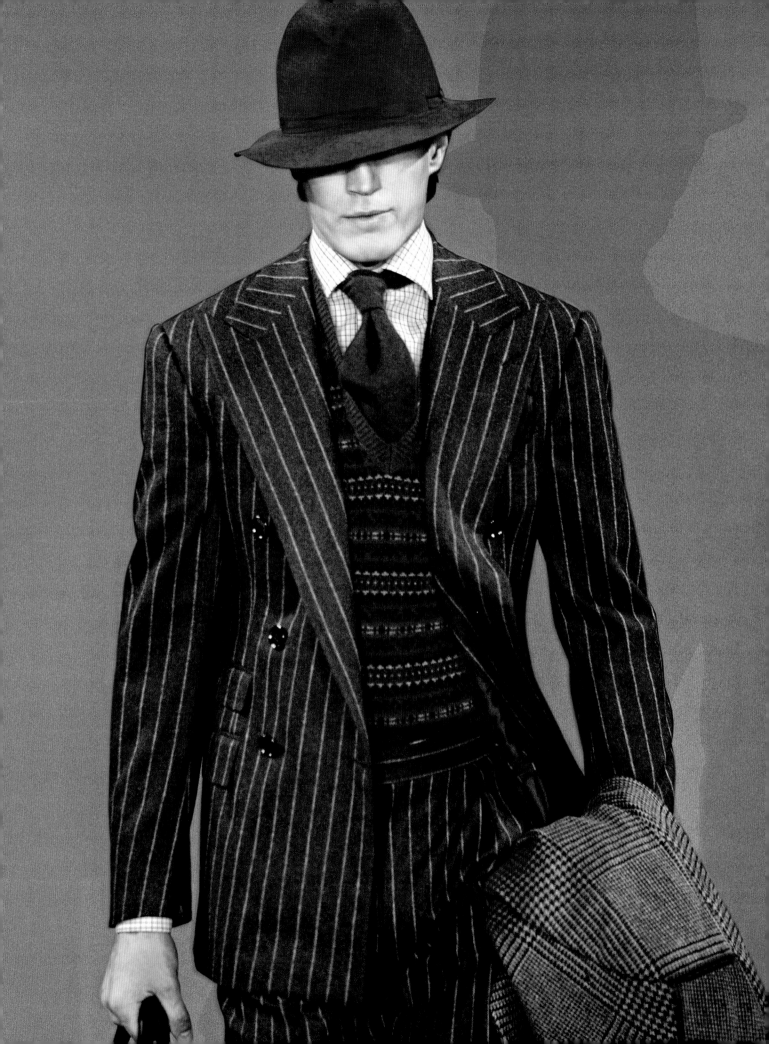

WOMENSWEAR

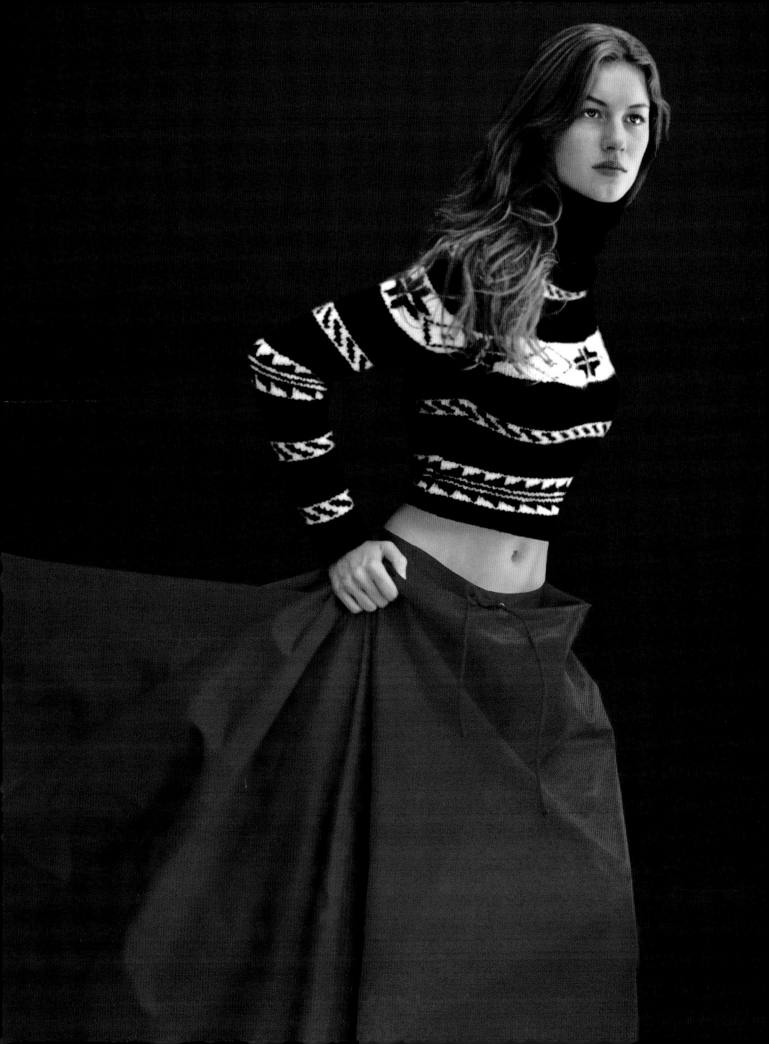

RESIDENCES, HOME, PUBLIC PORTALS & VROOMS

INTRODUCTION

The first time I met Ralph Lauren was in the fall of 1977 at his 40 West Fifty-Fifth Street offices in New York City. At the time, I was designing a sportswear collection for Pierre Cardin named Relax that was beginning to attract some attention. Ralph, through his then-partner, Peter Strom, reached out to inquire whether I might be interested in working for them. As it happened, I was in the early stages of forming a joint venture with another Cardin executive and a Japanese trading company that had offered to finance my business start-up. Imagine Ralph, with his taste and experience, helping this newcomer to birth and develop his own brand!

For complicated reasons, a deal was never made, and I proceeded on my own. My first collection debuted in the fall of 1979. Ensconced in my chintz and antique-strewn atelier, the clothes had an old-world 1930s English-American feel to them. Between the setting and the fashion sensibility, it was not long before people began comparing me to Ralph. For someone just starting off, it was flattering even to be considered in the same breath.

Over the years, we'd manage to meet maybe once or twice a year. I'd come up to his offices and we'd gab. Sometimes it would be about an article I was writing or a more formal interview for one of my books. On occasion we'd flirt with the idea of working together, but for one reason or another that never materialized.

Twelve years ago, leaving one of his women's shows, I was feeling particularly braced by the collection's prodigious glamour and connoisseurship. Over the years I'd evolved my own fashion-show grading system, which was more *Where's Waldo* than haute fashionista. Although prepared to consider the runway designer as that moment's fashion oracle, I was more interested in spotting any stand-alone, future collectibles within the procession. In this case, Ralph had managed to pepper his show with an abundance of these timeless classics. His triumph was not just in their number but also in his ability to balance them so skillfully on the creative-commercial tightrope. Like pitching a perfect game, he tossed off a collection of visually arresting clothes with strong signature statements that were as capable of scoring with the Rockefellers as well as with the real housewives.

A few days later, having digested the local reporter's accounting of Ralph's alleged lack of whoop-de-do fashion, I bumped into Lee Traub, wife of Bloomingdale's former chairman Marvin Traub. Having seen them at many of Ralph's shows over the years, I asked her what they had thought of it. Lee responded that after thirty-odd years of traipsing all over the globe accompanying her husband to one fashion extravaganza after another, they felt that the show had been one of Ralph's best and could have stood proudly alongside any they had ever attended.

This exchange further sparked my curiosity. Bothered by not being able to square my sense of Ralph's place in the designer firmament with that of fashion's penmen, I began to consider the subject more seriously. Although Ralph's runway shows did not always provide the rush of edgy spectacle lusted after by Gotham's self-proclaimed fashion illuminati, for anyone interested in how history's most legendary dressers—the Hepburn girls, the Duke of Windsor, Babe Paley, Fred Astaire, Coco Chanel—liked wearing their fashion, Ralph was the hottest ticket in town.

The next time we met, I asked Ralph about it, and he shrugged as if this was familiar terrain and, not surprisingly, a sore subject. He replied that for too long many in the American fashion media just didn't get him while the international press seemed to appreciate him more. John Fairchild, former owner of *Women's Wear Daily* and the late éminence grise of the fashion industry, told him he knew he was doing well because all his European women friends were wearing Ralph Lauren.

Clearly, the consumer appeal of Ralph's clothes tells a different story from that of the fashion commentariat. His message of consistency and promise of forever-fashion resonates with the ultimate jury, the paying customer. After all, here's a man who'd forged one of the largest high-quality fashion empires in the history of the world while proclaiming to be anti-fashion. Perhaps Ralph's emphasis on timeless-ness over trendiness prompted anxiety or even resentment from fashion's Fourth Estate while his growing fan base simply leapfrogged over the local scribes, rattling their sense of place and self-importance along the way.

My previous books have referenced Ralph's contributions to the world of men's fashions; here I propose Ralph as not only our generation's preeminent tastemaker but also the leading guardian and ultimately the savior of high-class taste and style. As his roots deepened and his influence widened through the globalization of the Polo brand, Ralph forged a bulwark against the culture's deteriorating taste level by championing time-honored style over fashion's more provisional solutions. Reinvigorating the public's interest in well-bred taste and quality, he ended up democratizing it more profoundly than any of his peers—and maybe more than anyone in modern history.

Although one of my primary missions is to establish an artistic knighting of Mr. Lauren, of equal importance is to illuminate his many courageous marketing and business decisions along with their life lessons for future generations to be inspired by. Watching Ralph become who he is has long been a source of inspiration and wonder for those of us who share his Aristotelian vision, "not with things as they are, but with things as they might be and ought to be."

Charles Gwathmey, the well-known architect and close friend of Ralph, stated, "Ralph basically revolutionized America's visual aspirations." To that I would add, Ralph not only revolutionized them, he smartened them up as well.

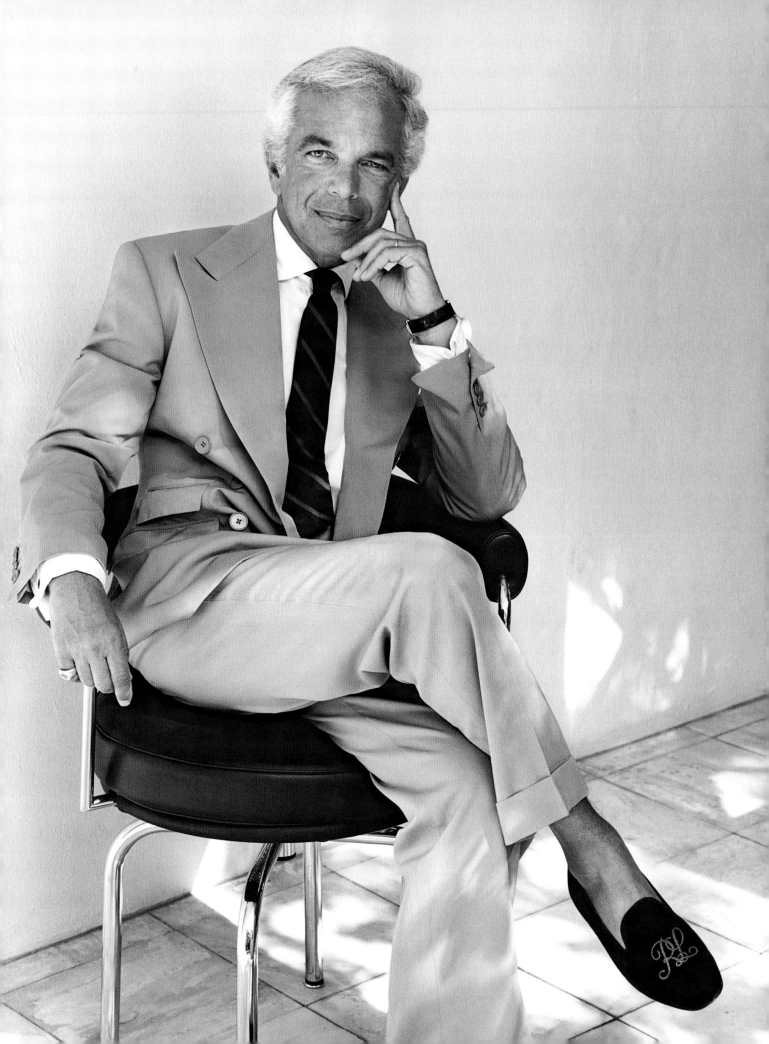

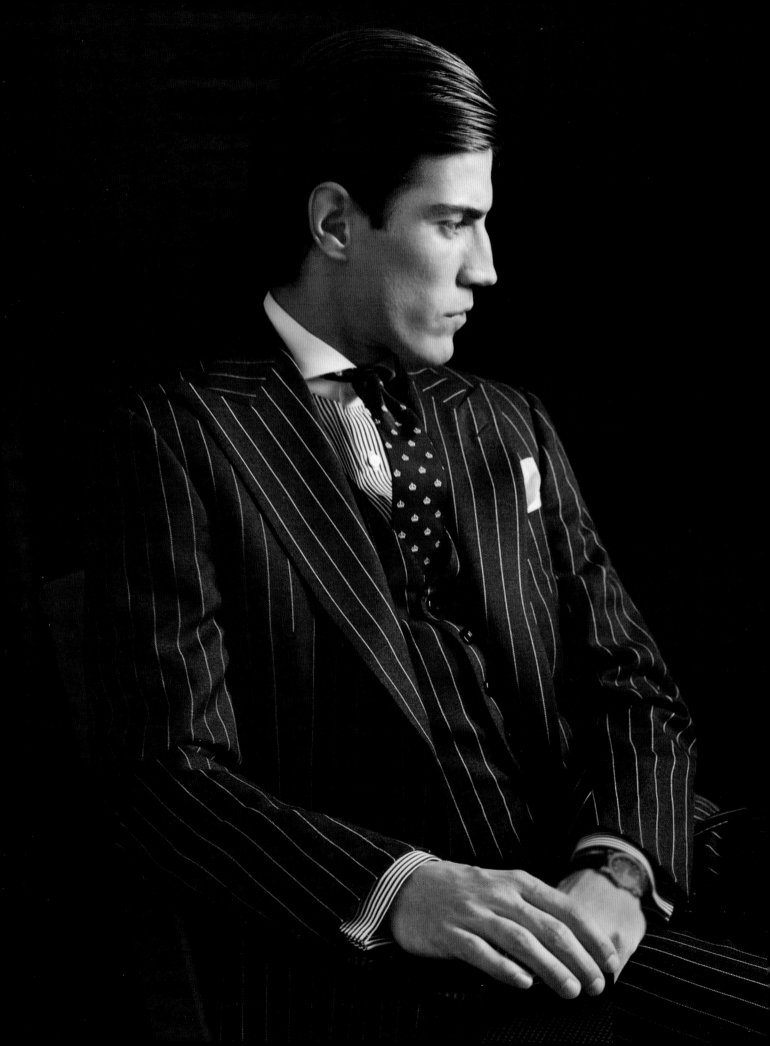

MENSWEAR

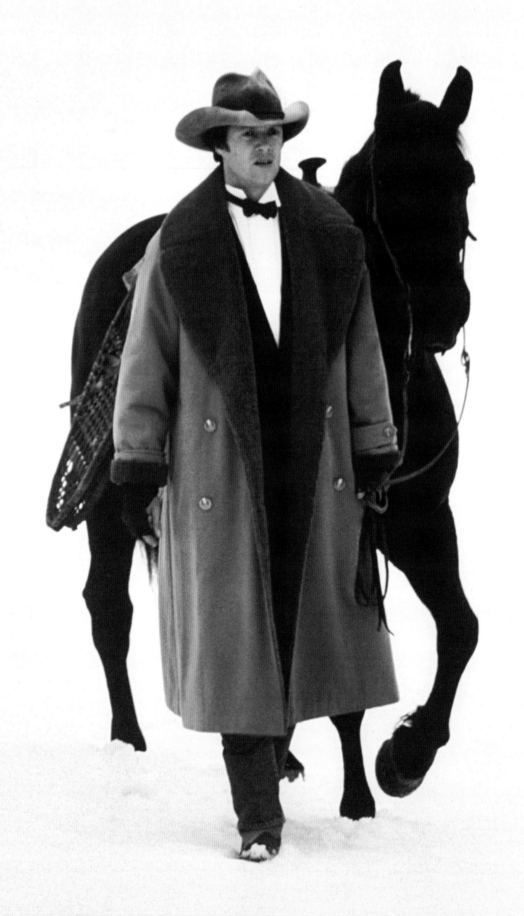

"I DON'T DO SHOULDERS, I DO WORLDS"

I t's difficult to think of a name that evokes more visual identity than that of Ralph Lauren. Describe something as "very Ralph Lauren" whether referring to a manner of décor, dressing, design, or even a dog, and the name triggers a set of pictures clearer and more concrete than the mention of any other designer. Calvin Klein, Giorgio Armani, and Karl Lagerfeld are world-famous fashion designers; however, none conjure up a way of life with the same familiarity or cinematic sweep as Ralph Lauren. Although Coco Chanel, Yves Saint Laurent, and Christian Dior were fashion-transforming originators , employing their names today as adjectives would leave most modern fashion minds dazed rather than dazzled.

The appeal of Ralph Lauren's mallet-swinging polo player stretches from Harlem to the Champs-Élysées. Recognized around the world as a symbol of quality and continuity, the polo-player logo cuts across countries, continents, and cultures to speak to both street kids and socialites.

Polo by Ralph Lauren is the American brand worn most frequently by Britain's royals and Europe's aristocracy.

With his landmark stores gracing the capitals of Europe and Asia, his rainbow of polo shirts dotting the beaches from Brazil to Bora Bora, and his restaurants serving classic American fare in capitals around the world, Ralph Lauren may be the foremost ambassador of the American Dream. His style leadership has certainly spilled over to the rest of the world, becoming both a conscious and subliminal part of so many people's lives. Like Rolls-Royce, which elevated itself far above the state of the merely elegant to become an article of faith and a way of life, Ralph Lauren, the man and the mark, share a similar investiture.

Ralph's feel for and connection to his customer has no modern equivalent. Unlike most designers who began designing clothes for an abstract following, Ralph built his design aesthetic upon the terra firma of his own taste based on a "self as consumer" approach to fashion. Starting in menswear, he was able to audition his creations personally rather than outsourcing them to the opposite sex, thus accelerating his trial-and-error learning curve.

17

Ralph Lauren, master storyteller. A 1977 photograph of a man leading a horse in the snow wearing an old-fashioned western hat, evening clothes, and a long fawn-colored wool coat with teddy bear collar reads "Style not Fashion." The image is not about the availability of the clothes or even the clothes themselves, but of a world that resonates beyond mere clothes, a place whose character is implied by the swagger and prerogative of the man's gesture—America.

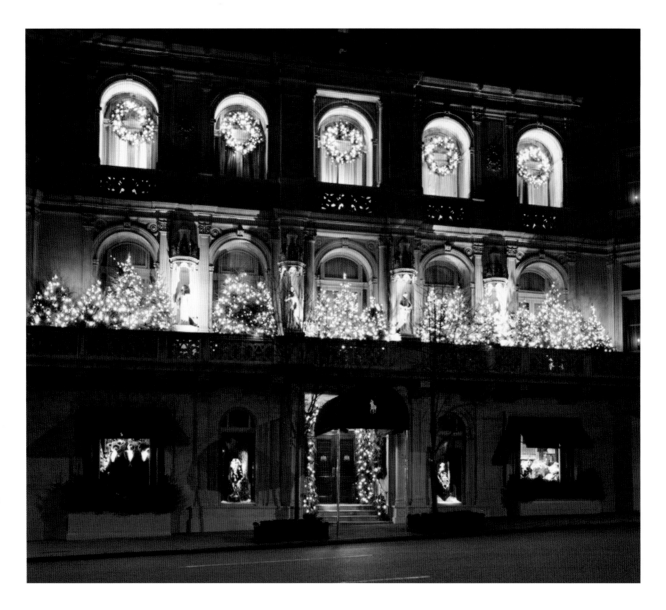

Above: No tour of the world's high sanctuaries of male adornment would be complete without a visit to the Rhinelander, a five-story, neoclassical French limestone mansion originally commissioned by Gertrude Rhinelander Waldo back in 1897. After undergoing a massive overhaul to restore it to its turn-of-the-century glory days, it reopened in 1986 as the crown jewel of the Ralph Lauren Empire and the physical embodiment of everything the designer believed in. There has never been a modern retail stage setting like it, not on Fifth Avenue, not in Europe, not in Hollywood.

Opposite: England's Prince Charles, who wears only British-made clothes for most public events, is a Ralph Lauren customer.

Ralph has long been his own ultimate customer. Fueled by a drive to create his own fashion look and aesthetic, he initially set his sights on clothes that resonated with him either because they filled a void in his own wardrobe or because they were not available elsewhere. Like Chanel, whose personal style was inextricable from her own fashion, Ralph's personal attire became the driving force for his evolving vision. Chanel may have been the first European designer to co-opt her own dressing style for her fashion engine—Ralph elevated it to an art form.

Although relying heavily on his own taste and instinct, Ralph didn't hesitate to use others—such as his family—as sounding boards. There's nothing more grounding or illuminating than a wife and three children's growing needs and maturing fashion awareness. Ralph would watch and react to what his extended family—his wife, his kids, their friends, his work colleagues—might be shopping for themselves. Observing them helped reinforce his own consumer-centric approach to fashion, keeping him focused on designing not just for looks but for living.

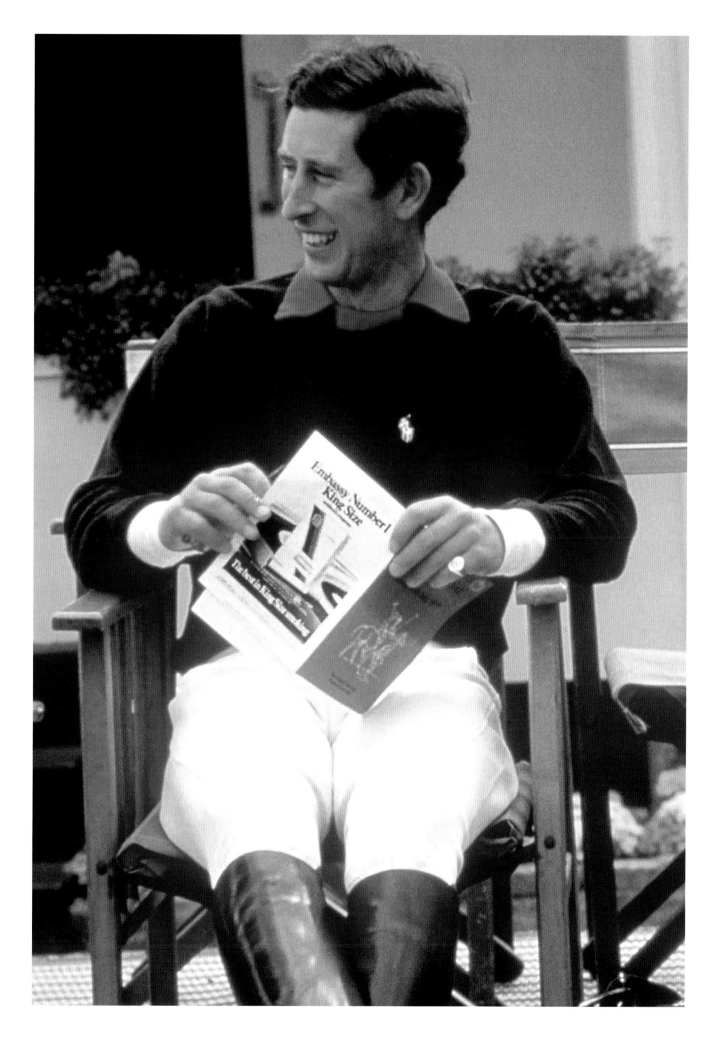

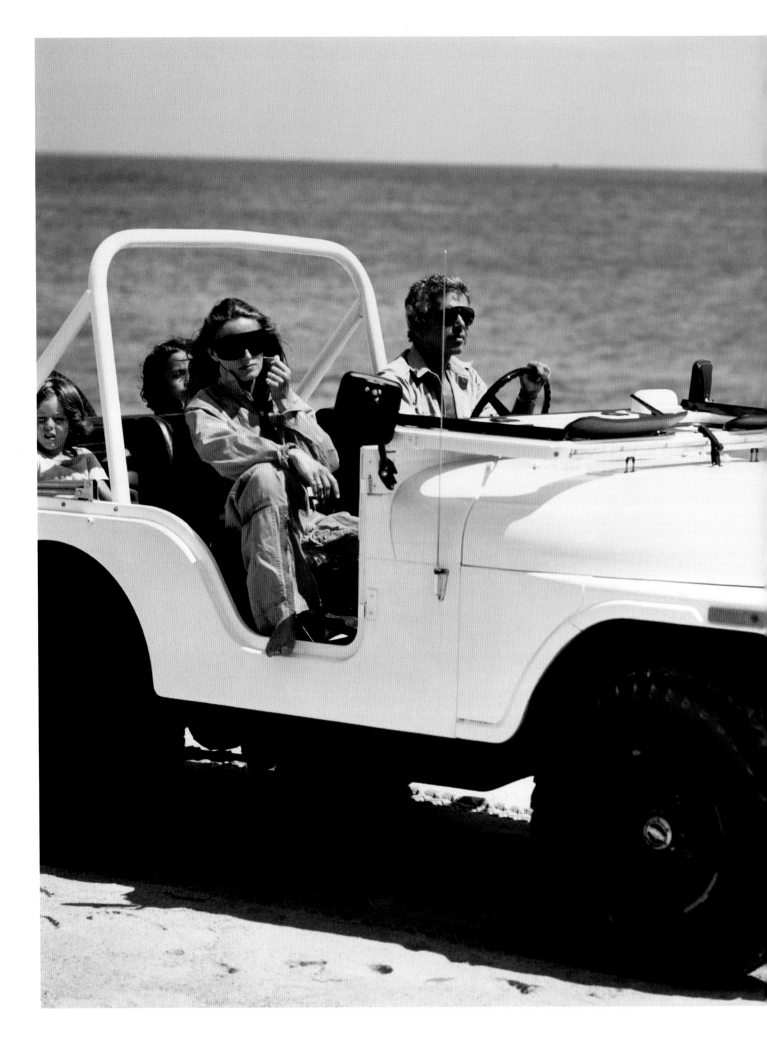

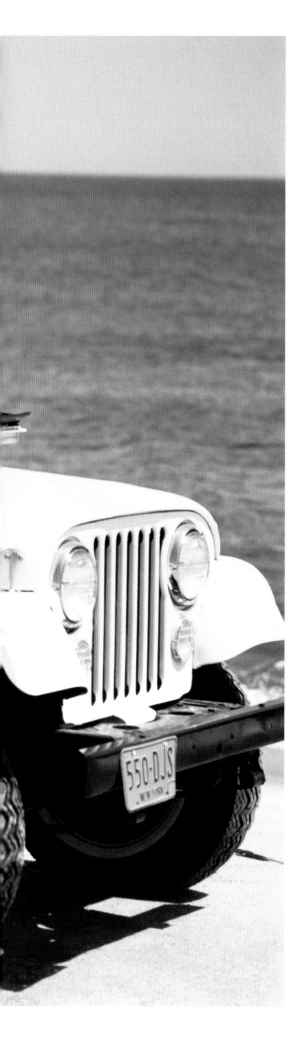

Early on, Ralph set in motion a lifelong pattern of reaching out to others for their opinions. The company's early years are flush with stories of him working late with his design staff and then popping out to ask anyone from a random employee to the cleaning lady for their reaction to some color or swatch. Even today the designer remains the final arbiter on all such matters, but his interest in others' ideas has never diminished, playing a primary role in his self-tuning, internal dialogue of a creative process.

Perhaps the most exceptional component in Ralph's unique connection to his customer is his feeling for what it's like to yearn for something beyond one's economic or social reach. As a young man with little money who could only dream about the clothes he wanted, Ralph learned up close and personal the power of seduction and the primordial urge for a better life. Out of his nose-pressed-to-the-window fascination with the trappings of the upper class, Ralph identified with the longings of those who did not grow up going to private schools or ivied colleges or Brooks Brothers yet wanted to be part of that world. Given his ambition to frequent greener pastures, it's no surprise he chose to tether his artistic vision to his idealized tastes of the American and British upper classes.

Ironically, having become the seduced early in life, Ralph grew to become the consummate seducer—attracting the best people to work for him, convincing retailers to try it his way, encouraging his staff to follow his lead, and ingratiating himself with the press. For Ralph, clothing was simply a road map to something larger—a total feeling, a lifestyle. As he opined, "I don't do shoulders, I do worlds." His was an image-conscious, hope-filled utopia where buying a polo shirt entitled you to a time-share in the whole shooting match. It was easy to get pulled into this pretend world, because it was so completely packaged. You didn't have to finish the sentence, it had already been done for you. Although an average high school student, Ralph does recall getting a C in math but an A in psychology.

21

Ralph and Ricky Lauren's 1976 Jeep CJ-5 is a member of the Lauren family. "A car is more than a way of getting from place to place. It's about time spent with family and about creating special experiences and memories," said Ralph in the Spring/Summer 2016 Polo Ralph Lauren magalog. Ralph's success has come, in part, because he's stayed connected to what his customers want while staying true to himself.

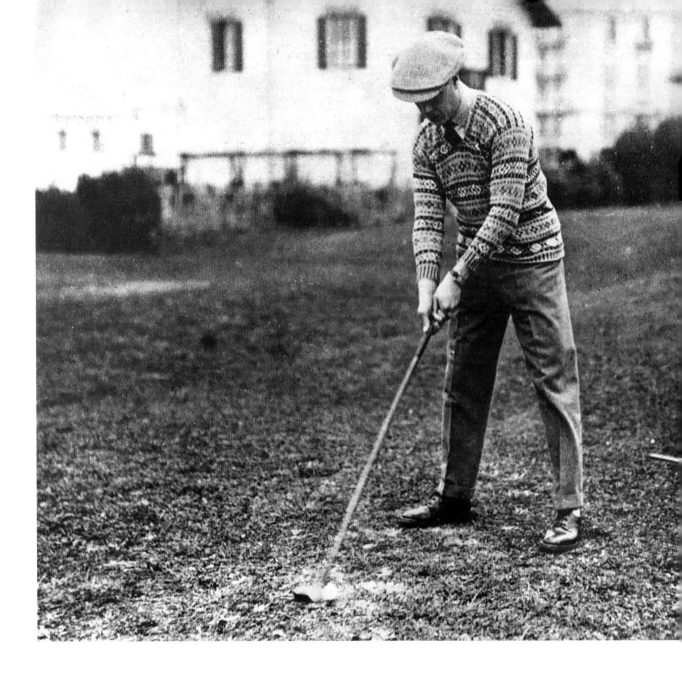

The Prince of Wales playing a round of golf at Biarritz, France, sporting one of the kingdom's home-crafted products, the Fair Isle pullover, which his royal imprimatur would make forever popular and iconic.

In current psychological parlance, the ability to feel and understand emotions in ourselves and others that can lead to personal growth and achievement is termed "emotional intelligence." In Ralph's case the term could be amended to "emotional fashion intelligence," which he seems to possess in an ever-ready abundance. Those who've worked with him over the years readily acknowledge that he has a very special kind of antenna that instantly registers whether something feels right for him. It would certainly explain, in part, his talent for being able to give people what they really want even before they know it themselves.

Ralph's holistic vision presaged the now prevailing worldview of the interconnectedness of mankind, that people are not isolated from each other but instead effect each other's lives in ways seen and unseen. Ralph was confident that he knew how to reach out and touch people because what he created was always something that

RALPH BUILT ONE OF
THE LARGEST HIGH-FASHION
BUSINESSES IN HISTORY
BASED ON A VERY PUBLICLY
ARTICULATED ANTI-FASHION
PHILOSOPHY.

convincing the public that improving on another's design equates to fashion creativity. Arguing that he took established status symbols and turned them into commodity products, they claim he's not a real designer but a stylist with a great taste level who knew how to build a brand.

Actually, those troubled by the notion of Ralph as a "real" fashion designer might be surprised to find him in partial agreement with them. He'd certainly be the first to acknowledge that creating "fashion" or "being in fashion" was never his grand scheme. In one of modern fashion's reigning ironies, Ralph built one of the largest high-fashion businesses in history based on a very publicly articulated anti-fashion philosophy. From the very beginning, his overriding interest was in clothes that have staying power and are thus timeless. As for his design skills, those would likewise be considered suspect, as he never studied at or graduated from a fashion school.

Back in the late sixties when bowler hats were still Bond Street staples, there were those who felt Ralph had gone to London to copy a British perennial, the Fair Isle sweater, to sell back in the States. As myth often bucks up against reality, the story is not only woefully off the point but historically inaccurate as well. Yes, Ralph did have the creative wisdom to recognize that the original Scottish Fair Isle men's vest was a wearable of unimpeachable stylishness. Unfortunately, courtesy of the ascending youth culture and Mother England's Peacock Revolution, it had fallen out of popular favor and practically disappeared. Other than unearthing an old one from a vintage clothing store or a random flea market, what was available at that time were ill-fitting, poor imitations of the artisan-colored and handcrafted originals. So Ralph set out to re-create them, giving them just enough "design juice" to bring back the essence of what excited him about them in the first place. Much as the legendary Duke of Windsor did fifty years earlier by donning this very same article of apparel for golf, thereby resuscitating the dying Scottish knitting industry, Ralph took this clearly forgotten prewar British country classic and breathed new life into it, saving it from certain fashion extinction.

23

touched him first. He understood the world of unspoken assumptions and subliminal aspirations that link people and allow them to dream collectively. Like his customers, he was still the guy looking at the movies or old magazines and saying, "Wow, that's where I'd like to be."

So Ralph was not only the Pied Piper for his own dreams but also for the millions who shared his vision of the good life. As both the protagonist and the passenger, Ralph forged a new kind of fashion covenant, a bridge over which his customers could blunt the disconnect between what they saw in the fashion magazines and in their own lives. Ralph may have been the first to cross the finish line, but in his wake millions were to follow.

Naturally, with success came critics. Despite almost universal acclaim for his far-reaching contributions to stylish living, detractors persist who dismiss him as nothing more than an exceptional marketer whose talent lies in

His critic's refrain of whether one can be regarded an artist-designer if your work does not involve making new things but simply remaking old things better is really a glass-half-full dialectic, with the answer not necessarily being a simple black or white. In response to criticism about his relationship to Picasso and cubism, the artist David Hockney stated, "he always knew how great the artist was by how great the artist he copied." Frank Sinatra once confided to Tony Bennett that if he saw something great, he'd steal it. The forward-looking French designer Pierre Cardin defined true design genius as the talent to create or cast any product with an intrinsic or identifiable design personality, from a dress to a spoon.

Yes, Ralph Lauren is responsible for bringing some products to the marketplace that boast a former bloodline or provenance. Nevertheless, in mining items from the past as inspiration, his designs are no chintzy knockoffs. Like the alleged Fair Isle–sweater caper, "Ralph resurrects classics that come to feel not like imitations of the past but collectibles unto themselves, benchmarks against which other things, including the originals that inspired them, are measured," said Paul Goldberger in a 2007 *Vanity Fair* article.

Ralph's design credentials will never fit into any conventional template. They also fall principally outside the realm of a fashion school's syllabus or, for that matter, vision. Learning how to tell good taste from bad, high-brow style from low, wannabe chic from the real thing, stretching a fashion archetype by breathing new life into it or designing clothes with a natural elegance rather than a designed look constitute a totally different educational paradigm than the classroom-taught, technical-based skill set typically associated with the modern fashion-design curriculum.

In the beginning, what Ralph set out to learn was not to be found in a classroom but through dialogue with those menswear insiders, master tailors, and carriage-trade retailers whom he befriended in his quest to learn the substance and subtleties of classic men's design and style. As both practitioners and self-appointed mentors in the fine art of male habiliment, they took him under their communal wing to share their insights and those sartorial explorations that informed them.

Ralph would filter his evolving visual intelligence through an expanding storehouse of upper-class taste and style signifiers. His unconscious need to ground his talent in something timeless and with heritage helped him cultivate an eagle's eye for a vintage item's crucial design details and intrinsic pedigree. However, it's one thing to become so visually astute that you can appreciate an article's inherent stylishness and quite another to know what to do about it. Repurposing a blanket into a toggle coat or reinvigorating a tired classic into a contemporary one requires a skill set capable of fashioning something into more than just the sum of its parts. Not many people can take a single garment or concept and extend it beyond all expectation better than Ralph.

So which is the more authentic measure of a fashion designer's talent—technical fluency or visual intelligence? While Ralph's talents clearly fall into the latter category, it should be noted that those possessing technical prowess are available for hire. Notwithstanding, if, as Pierre Cardin suggests, true design genius is defined by the ability to invest every aesthetic endeavor with a distinguishing stamp or signature, Ralph would graduate with flying colors.

To raise the collective bar for viewing matters of taste and style requires a force of nature not visited upon this planet very often. Whereas much has been made of pushing or reconfiguring the design envelope, true art can often mean discarding it altogether. The degree to which this designer has transformed the fashion envelope may still be open to debate; that the universe is likely to play host to another Ralph Lauren anytime soon is not.

> "RALPH RESURRECTS CLASSICS THAT COME TO FEEL NOT LIKE IMITATIONS OF THE PAST BUT COLLECTIBLES UNTO THEMSELVES, BENCHMARKS AGAINST WHICH OTHER THINGS, INCLUDING THE ORIGINALS THAT INSPIRED THEM, ARE MEASURED."
> — PAUL GOLDBERGER

More than any other designer of our era, Ralph Lauren has anticipated our collective longings with such split-second timing that he managed to create what we wanted next before we realized it ourselves. In that sense, you could argue that he has long been at fashion's very vanguard.

24

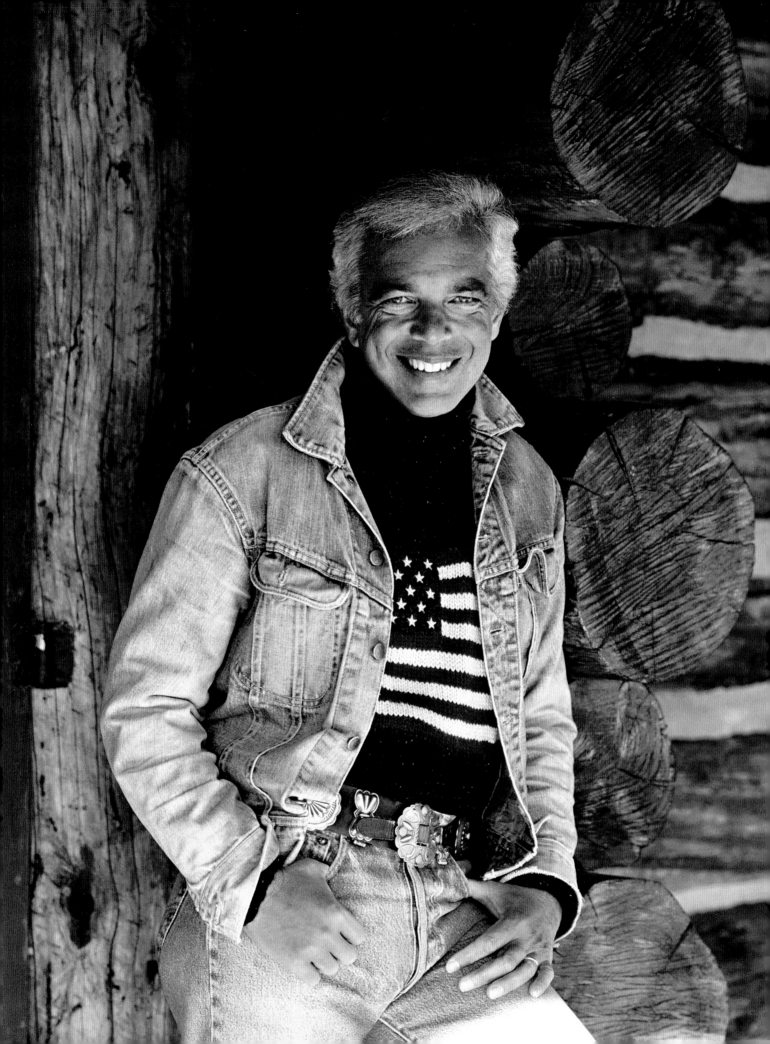

A LITTLE
TRAVELING
MUSIC

Ralph Lauren may not have been born into a world of privilege, but he was privileged to have grown up in the world he was born into. The youngest of four children, Ralph was born on October 14, 1939. At the time of his birth the United States had not yet been drawn into World War II. His parents were hopeful, and New York City's Bronx had proved a good place for them to put down roots. Surviving the tough years between the Depression and the war, they felt confident that they were bringing up their children in a safe corner of the world. For Ralph's parents, family, religion, and the values of their shared neighborhood were how they planned to bring up their children, of which Ralph was the last of four—his sister Thelma having presented herself in 1929, his brothers Leonard in 1932 and Jerome in 1934.

Ralph was approaching six when the atom bomb put an end to the war overseas. Wartime production had helped pull America's economy out of the Depression, and from the late forties forward jobs were plentiful, wages were higher, and after dealing with a lack of goods during the war, Americans were eager to spend. Aspirations of consumers, stimulated by advertising, became a driving force.

By far the most popular product at that time was the television set. In 1946 only seven thousand Americans owned black-and-white TV sets; by 1960 more than fifty million sets were in households across the country. Television became a national obsession, with shows reflecting the new optimism and sense of opportunity.

America's low-key, plainspoken president Dwight Eisenhower personified the electorate's optimism that it was just a matter of time before the country's most difficult problems would be solved.

It was an exhilarating period in America, particularly for those first- and second-generation immigrants like Ralph's parents who had settled in the Mosholu section of the Bronx. It was named after the Mosholu Parkway, a wide boulevard with landscaped meridians that connected the Bronx Zoo and the New York Botanical Garden to the south with Van Cortlandt Park and the Grand Concourse to the north. Built in 1888 by the famous urban architect Frederick Law Olmsted, the parkway ranked among the country's most beautiful roadways.

Mosholu's first- and second-generation Italian, Irish, and Jewish immigrants felt lucky to reside in the proximity of such a tree-lined, leafy greenway. The ten-square-block neighborhood was like a small town where everyone knew everyone else. Parents would line their chairs up and down the blocks while the kids played in the streets. Mothers cautioned their kids to be "home before dark." Ralph remembers that from the age of five, "I'd go down one flight of stairs, out my building lobby, turn right, and roller-skate next door through the schoolyard with always something to do."

Ralph Lauren grew up at 3220 Steuben Avenue, a six-floor redbrick building. Situated on a hill directly across from Mosholu Parkway, the building sat adjacent to two-story P.S. 80 with its six white columns and sprawling paved schoolyard. Rented mostly to Jewish families, the Lauren home was a walk-up with a black-and-white checkerboard-tiled lobby where on rainy days kids would take shelter and play. In those days family finances had to be in "high cotton" to live in a building with an elevator.

A totally cute and carefree young Ralph.

The apartment was a small two-bedroom with one bathroom and a sliver of a kitchen. Ralph and his two older brothers shared one bedroom that looked out on the schoolyard, while his parents occupied the other bedroom. Thelma slept on a pullout sofa in the living room. Fortunately for Ralph, she and Lenny were so much older that by the time Ralph was a teenager, they had moved out. Then, much like in other families, Ralph shared a room with only one sibling, his older brother Jerry. As Ralph recalls, "I couldn't wait for one of them to move out so I could have half the drawers."

Ralph's parents, Frank and Frieda Lifshitz, were first introduced to each other in their late teens at a local club organized to promote Russian culture. Both Jewish immigrants and Orthodox who spoke Yiddish spliced with Russian phrases, they had quite different temperaments. Frank, Ralph's father, was an artist who shouldered dreams of becoming an important figure in the art world. But faced with the challenges of the Depression and raising a family, he was forced to earn a living as a house painter. A dreamer, Frank thought of himself more in the manner of an artist than a tradesman. He carried himself like a French artist or boulevardier—sporting neckties and tweed jackets, tipping his hat to women, and walking with a certain jaunty, almost dancer-like gait.

Frank was the go-to painter for anyone moving into or out of the neighborhood. From time to time he was called upon to craft special paint treatments such as faux wood grain or marble finishes as well as the occasional mural, several of which graced Manhattan building lobbies in the thirties and forties. Especially proud of his father, Ralph would often take friends into Manhattan to show them the textured walls and signed murals that his dad had created.

Mother Frieda was the no-nonsense, Jewish-minded side of the Lifshitz clan. A strong, forceful figure who carried herself with a certain nobility, she set the tone of the family. Where Frank wanted to reach for the heavens, Frieda, her feet planted firmly on the ground, wanted her children to get a good Jewish education first and afterwards move toward professional careers. Keeping the Jewish flame alive, she nurtured everyone who came into her orbit. Food was terribly important to her. A great cook, she always seemed to be preparing or brewing up something. Steve Bell, Ralph's best friend and next-door neighbor, remembers the house on Steuben Avenue as small but comfortable, always warm with an aroma of food.

The family apartment exuded Ralph's father's passion for painting and art. Table surfaces were frescoed with florals or fruit, pastoral settings from medieval Europe, and aristocratic images painted from museums or art books decorated the walls. Jerry recalls, "that we were all artistic. Always sketching. Thelma was very good, I wasn't bad. My mother would pay me ten dollars to do a sketch of someone in the family. Ralph didn't sketch so much but he took it all in." Reflecting the push and pull of his parents' differing temperaments, Ralph grew up in a home both conservative and decorous, religious yet artistic.

Considering his future as the culture's preeminent shaper of popular fashion and taste, Ralph's childhood did not hold to any clichéd image of a young designer-in-training poring over his mother's old issues of *Vogue*. To the contrary, he was a regular New York City kid, out playing sports with the boys, no more interested in fashion than any of his family. Like most boys his age growing up in postwar America, Ralph was strongly influenced by the hero-worshipping world of professional athletes and sports. Throughout boyhood and adolescence, Ralph lived and fantasized about sports, playing as much stickball and basketball as he could. Hoping to one day become a professional-level athlete, he dreamed of shooting a basketball like Elgin Baylor, passing like Bob Cousy, or dominating the courts like "Sweetwater" Clifton, the legendary forward who played for the New York Knicks.

Baseball was another of Ralph's passions. He worshipped the Yankees and especially the great Mickey Mantle. When he played stickball, he "became" Mickey Mantle or Joe DiMaggio, acting out what he thought they might be thinking. Ralph pursued his dream of professional sports so single-mindedly that as an undersized freshman in high school, he made the basketball team at the boys' Talmudical Academy, an affiliate of Yeshiva University. Unfortunately, transferring the following year to the much larger DeWitt Clinton High School, Ralph's competitiveness wasn't enough to overcome his shorter frame, as they had four thousand kids to choose from. Undeterred, Ralph tried out for the team every year. He did manage to make an impression on members of the varsity squad when he ended up playing against them in the summer intramural leagues.

As the Lifshitz boys got older, clothes started becoming important to them. Ralph often points to his brothers as a major reason for his early interest in matters sartorial. His father was a tasteful guy but he was not a dandy. For the most part, Ralph came to clothes much like his two older brothers, more out of self-expression and what they could do for you in and around your social group rather than as some larger fashion statement. But when you have older brothers to look up to and learn from, you end up becoming more advanced than kids of your own age.

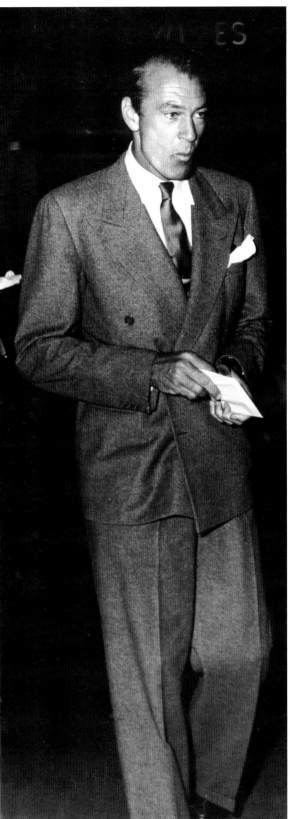

Along with sports and his developing interest in clothes, Ralph's other love was movies. For an overwhelming majority of Americans in the 1940s, "going to the movies" meant watching those films that came out of the Hollywood studios and played at the local theaters. They thought of the movies as pure entertainment like fishing or baseball and went to them without much thought or planning. The movie theater was a place of moral comfort and reassurance, as the studios produced infinite variations on formulaic stories for moviegoers who valued continuity and high style. It was definitely a time that bred classicists and connoisseurs in the audience.

As with most of the parkway kids, Ralph accompanied his friends to the double features at the neighborhood art deco movie palace, aptly named the Tuxedo Theatre, which quickly turned into a local shrine for him. Growing older, they would travel farther to take in films at the deluxe Paradise Theater on the Grand Concourse, widely considered the grand dame of the Bronx's movie theaters. One of the five famed "Wonder Theaters" developed by Loews, this single-screen picture palace had over thirty-eight hundred seats, making it one of the largest in the city. The auditorium was designed to depict a sixteenth-century Italian baroque garden, bathed in Mediterranean moonlight, with stars twinkling in the ceiling as clouds passed by. Uniformed attendants in the men's rooms dispensed towels and a sense of privilege to many for the first time.

Inhaling the elegant bearings of Hollywood's iconic black-and-white era, Ralph would scrutinize the manners and dress of its leading men and women: the stylish

29

Two of Ralph's earliest and most revered style icons, Hollywood leading men Douglas Fairbanks (*left*), comme il faut haberdasher, and the ever-long-and-lean Gary Cooper (*right*) draped in satin and flannel.

frolicking of Fred Astaire and Ginger Rogers in *Top Hat* or *The Gay Divorcee*; Katharine Hepburn's "pants-and-pearls look" in *The Philadelphia Story*; the lean, cowboy heroism of John Wayne and Randolph Scott in John Ford's panoramic sagas of the American West. Back when the big studios ran the show, their brightest stars were expected to set examples of social and sartorial stylishness on and off the big screen. With the golden age of Hollywood coinciding with the golden age of American menswear, nowhere was this beau ideal more captivatingly displayed than on the backs of Hollywood's leading men. Film stars were more likely to be found donning their own duds in front of the cameras than at any other time in motion picture history.

Burrowed in the Bronx yet buoyed by a fertile imagination, Ralph would lose himself in one of his mythical roles, playing any one of his fantasy characters, whether it took him to the English countryside, the Rocky Mountains, or the South of France. Wiling away hours at the movies, Ralph remembers, "I'd go to the movies and fall in love with the girl, Audrey Hepburn in *Roman Holiday* or Grace Kelly in *To Catch a Thief*." As for westerns, he was captivated by the image of "the good guy." But instead of the clean-shaven, fringe-trimmed, banjo-playing hero astride the white horse, Ralph wanted to be Randolph Scott, the tough, trail-worn cowboy. Later on, his favorite movie character became Howard Roark as played by Gary Cooper in Ayn Rand's *The Fountainhead*, an architect who refuses to compromise his dreams.

In contrast to the realities of everyday life, the world of make-believe opened gentler, more graceful vistas. The difference was, Ralph didn't want to return to real life. Going to the movies with his friends and brothers would influence everything that he would become. Later on Ralph would create advertising campaigns that raised escapism and aspirational high living to an art form. But for now, movies let him dream as if the world those stars inhabited was real. And clothes offered one way into those screen-inspired fantasies.

With images of sports heroes and movie stars dancing in his head, Ralph began feeling around for a place for himself. Although he was not yet able to connect the dots of his seemingly random visual odyssey, it's not hard to see how those archetypal roles and heroes that Ralph fell in love with inspired him to want to relive them on one level or another.

Back in the day, Ralph remembers growing up near a short stretch of a low cast-iron fence, which locals called "the Rail." Situated across from P.S. 80, the grassy patch separated the sidewalk from the divide between Mosholu Parkway's two directions of traffic. During lunch, after school, at nights, or on weekends, guys would gather and, hanging around the Rail, talk about sports, tell jokes, one-upping each other. Those wearing tight black-leather jackets were known as the "rocks," those donning crewneck sweaters and penny loafers were the "preps." It was a huge conglomeration of kids ranging in age from twelve to well into their twenties, with few drugs and even less teenage sex but always with something happening. Clusters of boys and girls would crowd the Rail, protecting their established turf, their local gang names emblazoned on the back of their jackets. Although there were different cliques, it was very inclusive, with every group having its own piece of turf.

"What you did was work the Rail, that was your social life," recalled Garry Marshall, the television producer who based much of his hit series *Happy Days* on his childhood in the same neighborhood. "Our neighborhood was unique in that elsewhere what mattered was how well you played ball and how tough you were. Here, you could be funny or dress up and nobody would call you a sissy. We respected humor as well as looking cool and going out with girls."

Mention the Rail to former habitués like comedian Robert Klein, designer Calvin Klein, or Calvin Klein's future business partner Barry Schwartz, and their eyes glaze over recollecting those innocent yet formative days. Some say they met their best friends during that period; others formed business relationships that outlasted their marriages.

Under pressure from his mother who harbored hopes of her sons maintaining their Orthodox roots, Ralph followed his brother Jerry into the Yeshiva pre–high school. But by the end of tenth grade, Ralph had had enough, finally prevailing in the battle with his mother, and enrolled in DeWitt Clinton High School, the all-boys public school across the parkway from his apartment.

Sitting on twenty-one acres with a large student body, DeWitt was one of the largest public schools in the Bronx. It had its own swimming pool, football field, and a big avenue in front of it adorned with trees and plants. Founded some fifty years earlier, it became one of the major incubators of the culture's future success stories: basketball greats like Nate Archibald and Dolph Schayes; music composer Richard Rodgers; actors Judd Hirsch and Burt Lancaster; writers Lionel Trilling, James Baldwin, and Avery Corman; playwrights Paddy Chayefsky and Neil Simon; comedian Robert Klein; plus a host of congressmen, TV newscasters, and even a Nobel laureate.

31

The always-dreaming and ever-stylish Ralph Lauren to be.

There Ralph flourished, now a strong B student and on the Dean's Office Squad, an exclusive club that one had to be recommended for, which meant it carried a degree of status. The squad roamed the halls for a few hours a week with a list of students who'd arrived late or skipped class. They'd round them up and escort them to the dean, who would then dress them down. Although there wasn't much to do, it gave them a lot of freedom. It was a heady assignment, but then again Ralph was up to the occasion, always dressed up and making a good impression.

In the summer of 1956 at age seventeen, like his two older brothers before him, Ralph went off to Camp Roosevelt in the Catskill Mountains to work as a waiter. One of a multitude of coeducational sleepaway camps attended mostly by Jewish children, the camp spread over three hundred-and-fifty acres bordering on Monticello's Sackett Lake. Four hundred campers ranged in age from five to seventeen with one hundred twenty-five counselors. Ralph's three summers there were a very important experience for him, a kind of confidence-building, social rite of passage. It was the first time he was exposed to people who had grown up outside the Bronx and beyond the insular world of his immigrant parents. It was difficult for Ralph to move around the Bronx without his brothers' reputations upstaging him. But in the Catskills of upstate New York, socializing would become a bit more fluid.

Although most of the campers were middle class, some of the children were enrolled in private schools, many the offspring of the new managerial class. This upscale world enamored Ralph, helping to feed his curiosity about the lifestyles and dress of people from advantaged backgrounds. An outsider, it was his first exposure to an entitled group of older camp counselors, some of whom were attending colleges like Hamilton or Cornell, which added to the preppy atmosphere.

By his second year Ralph had climbed up the next rung on the camp pecking order from waiter to counselor, which meant he was in charge of teaching kids athletics and how to live together. By the third year Ralph and his best friend

Steve Bell were named lieutenants in the camp's "Color War." Coming toward the middle of August, the three-day-long rite was the highlight of the camping season, and only those counselors most in favor with management got to be Color War lieutenants and generals and lead the troops in competition. Winning such a key role in only three years was both unprecedented and empowering; it was a big honor and Ralph took the assignment seriously.

Color War meant dividing the camp into two competing teams, dressed in the camp colors of either blue or gray so that each side could be recognized. They competed in sports, sang, put on plays, and were awarded points. Ralph was to lead the troops and inspire them, so they could come out on top. By his last summer Ralph's preppy flair was in full bloom and beginning to be recognized as something more than simply an offshoot of his brothers. "His embryonic management style was also in evidence, dressing his lieutenants in obligatory uniforms of blue oxford shirts, white Bermudas, and black-and-white saddle shoes, with no deviations allowed." Ian Schrager, the Studio 54 cofounder-turned-hotelier and one of Ralph's campers, remembers his leader's take-no-prisoners competitive drive. "Ralph lost his voice running all over the place rooting for everyone."

> "HIS EMBRYONIC MANAGEMENT STYLE WAS ALSO IN EVIDENCE, DRESSING HIS LIEUTENANTS IN OBLIGATORY UNIFORMS OF BLUE OXFORD SHIRTS, WHITE BERMUDAS, AND BLACK-AND-WHITE SADDLE SHOES, WITH NO DEVIATIONS ALLOWED."
> — MICHAEL GROSS

It was his first real marker of a success for which he alone was responsible. As Ralph recalled, "It was a big thing in my life. I'd started at the bottom, not knowing anyone, and worked my way up to the top. It sounds like nothing now, but at the time, it was very important to me." Prior to his camp experiences, much of Ralph's persona revolved around a kind of teenage swagger; however, after his Camp Roosevelt years his deepening self-awareness became the springboard for imagining what he might be capable of.

Around this time, Jerry returned from Lackland Air Force Base in Texas having completed his annual two weeks training in the Air National Guard. Enduring the same taunts about his last name at mail and roll calls as his older brother Lenny did during his stint in the service, Jerry finally decided to deal with the family surname. Lifshitz had "shit" in it, making the boys the long-standing butt of jokes and snide remarks beginning in childhood and

Discharged from the Army Reserve with a leg injury, Ralph continued to be preoccupied by matters of style and taste.

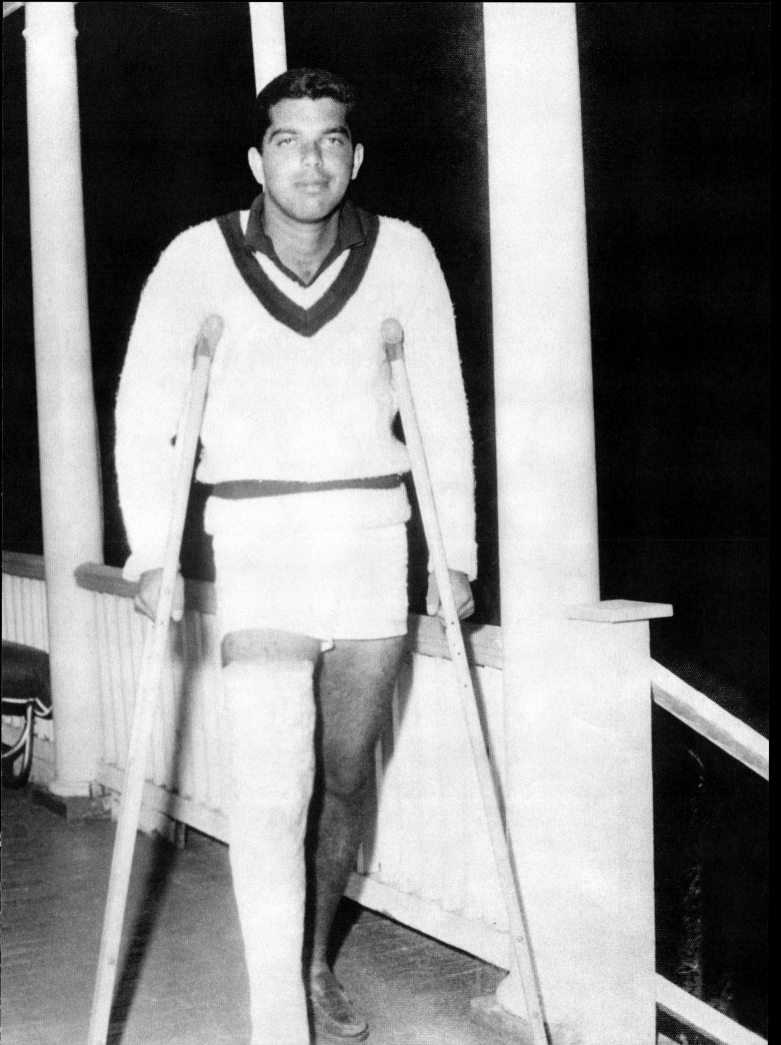

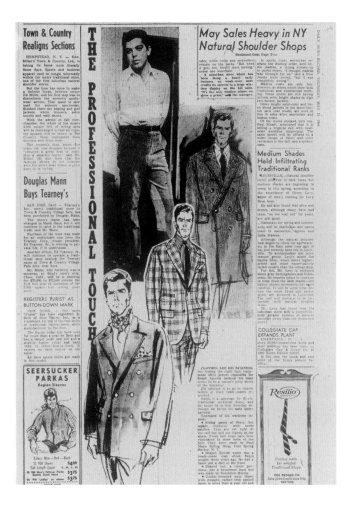

The first article ever written about Ralph detailed how he dressed differently from others, how he went to shops and custom tailors to have things made that he couldn't find in the marketplace, and that his taste was a season's jump ahead of the market.

In 1957, Ralph's last year in high school, DeWitt graduates had to specify a career ambition for their entry in the yearbook, The Clintonian. By graduation time Ralph felt confident enough to thwart convention and simply write *Millionaire*. After high school, like his older brother Jerry, Ralph decided to enroll in the City College of New York (CCNY) to study business management. Situated at Twenty-Third Street and Lexington Avenue in Manhattan, CCNY was an hour's subway ride from the Bronx. A public institution that traditionally educated immigrants of modest means, CCNY graduated many brilliant scholars, but it was also a stopgap for those students who had little other option. If you were prepared to work hard, you could get a solid education; however, for those students like Ralph who fantasized about quads filled with classmates cavorting about in pursuit of campus romances, CCNY was not exactly the realization of his dreams. For a while he went to day school, later switching to nights, so he could get a job at Allied Stores, a department store buying office, one of several in New York.

Although Ralph had never attended a prep school, he started to dress as if he did. By high school Ralph had discovered ground zero of the "Eastern school look," Brooks Brothers of 346 Madison Avenue. Surrounded by other like emporiums of patrician patronage—J. Press, Chipp, Paul Stuart, Abercrombie & Fitch—Brooks symbolized a state of mind, the ultimate redoubt of American male tradition and classicism. Not only did Brooks Brothers and its retail confreres sell clothes, they knew how to romanticize them, promoting a world of gentleman's service and to-the-manor-born repartee.

Compared to that atmosphere, CCNY seemed tired, oppressive, even irrelevant. Ralph's grades reflected his turmoil, and after two years he decided he'd had enough. Why was he commuting two hours a day to school when everything he was learning and wanted to learn was at work? Naturally he felt guilty as all his friends had either finished college or were in the process. He also felt as if he were letting down his parents.

Twenty years old and out of work, Ralph couldn't find a job because the military draft was still in place. Fortunately, Jerry stepped in, calling on a college friend, Neal Fox, who was working as a salesman at Brooks Brothers. Fox referred him to the personnel department, and Ralph was hired as the store's youngest assistant salesman. For Ralph it was as if he had awakened and found himself in heaven. Excited to go to work and learn how to sell and minister to those men who dressed in the Eastern school look, Ralph stayed almost six months. Brooks Brothers was to have a huge influence on Ralph.

continuing into adolescence. "I got tired of being on the defensive with somebody fooling around with the sound of my name, after all it wasn't some family dynasty," said Jerry. Ralph had also just returned from summer camp where he suffered the same mockery from the youngsters there, who at age ten could be especially cruel.

Anglicizing or abbreviating one's last name had long been the practice of Eastern European immigrants eager to blend in. Jerry and nineteen-year-old Ralph officially changed their family name to one that had the same initials and sounded as if they were just another American family. Initially reluctant, Lenny would eventually choose to follow suit. As to the new name, no one seems to recall how it came to be chosen, but it was Lauren, easy to pronounce and remember, classless, and totally American in resonance.

Leaving to fulfill his military obligation, soon afterwards Ralph was serving six months in the Army Reserve marching around New Jersey's Fort Dix. Discharged due to a leg injury, he moved back home with his parents. Ralph couldn't stop thinking about clothes; men's style and fashion preoccupied his total being. Somehow, he knew his destiny was connected to a career in gentlemen's clothes, but how to begin? An employment agency clerk took one look at how he was dressed and sent him for an interview at a glove company.

Determined to secure a foothold in the menswear business, Ralph took a job as a shipping clerk at Meyers Make Inc., a middle-level manufacturer of men's and women's gloves that was really on the downside of its commercial fortunes. Starting virtually at the bottom in the packing room, Ralph learned how to post orders, stamp and mail packages, and to work with the salesmen's order books to record sales and arrange shipments. Bored from the start, Ralph persevered. He asked to join the sales force and be given a chance to sell women's gloves that buttoned up to the elbow, hardly the kind of product one would associate with the launching of a menswear career.

The job required stamina and a sense of mission. A salesman arrived at the office early, figured out which buyers were in town and where, and then pounded the pavement running around town to make sales. It was hard to get customers to agree to meet with someone they didn't know and even harder to get them to commit to a serious-sized order. But Ralph was not to be deterred, spending hours waiting to see a potential customer and then retreating gracefully in the wake of being rejected. His strength was his personality, which was enthusiastic and engaging. Frank Arnold, who worked with him at Meyers, said of Ralph at the time, "he may have been making forty or fifty dollars a week, but he dressed like a million bucks. He was an easygoing, warm guy but you could see his thoughts were elsewhere. He was really interested in menswear, in fashion."

In a chance encounter with Ed Brandau, a friend from Brooks Brothers who was managing the New York showroom of a glove company, Ralph left to go to work for him, adding a perfume line to supplement his income. Although he was living at home and saving on rent, he needed to make more money, if for no other reason than to support his ever-expanding wardrobe. Brandau helped by calling another friend, Abe Rivetz, owner of Rivetz & Co., a Boston tie maker. Rivetz had been thinking about adding a salesman to handle the company's New York City accounts as well as those in the surrounding suburbs, so Brandau recommended Ralph.

"RALPH WAS DIFFERENT . . . IF EVERYBODY WAS CLEAN SHAVEN, RALPH WORE A BEARD. WHEN THE INDUSTRY WAS SELLING SKINNY TIES, RALPH HAD TO WEAR A WIDE ONE. I'D CONSTANTLY BE TELLING HIM TO GET A HAIRCUT AND CLEAN HIS RAINCOAT. . . . HE DIDN'T HAVE ENOUGH MONEY TO BE SO MAGNIFICENT . . . HOW HE MANAGED IT, I DON'T KNOW."
— MEL CREEDMAN

By this time Ralph was dressing like no other salesman. Even though he was now working for a conservative firm selling conservative ties, Ralph was also showcasing himself. Ralph's look had made an immediate impression on his new boss. Sixty-year-old Rivetz was taken by his new young charge, becoming Ralph's mentor. He even declared to the others that Ralph was going to become somebody important. Unfortunately, or maybe fortunately, nobody at the company ever came to regard Ralph in such august terms.

Ralph was twenty years younger than anybody there and dressed like no one else—spread collar dress shirts, flare-bodied side-vented suits, two-, not three-, button jackets. Whatever his manner of attire was, it definitely was not buttoned-up, or -down, Bostonian. Whereas the Rivetz folks wanted nothing more than to fit into the company's carefully molded New England persona, here was this impassioned young city guy who wanted to not only stand out, but apart. It wasn't long before people outside the company began to notice Ralph and his clothes. On May 21, 1964, the *Daily News Record*, the men's industry trade newspaper, ran a full-page article about Ralph's wardrobe headlined "The Professional Touch." It featured drawings and descriptions of the customized clothes Ralph was said to wear on his sales rounds—clothes the paper deemed to be "a season's jump ahead of the market."

The crew at Rivetz was dazed. Since when did Ralph Lauren give interviews and, more to the point, who cared what Ralph Lauren thought about clothes? "Ralph was

35

different," said Creedman, Rivetz's son-in-law. "If everybody was clean shaven, Ralph wore a beard. When the industry was selling skinny ties, Ralph had to wear a wide one. I'd constantly be telling him to get a haircut and clean his raincoat. . . . He didn't have enough money to be so magnificent," stated Creedman. "How he managed it, I don't know."

Bob Stock, a salesman at Alvin-Murray, one of Rivetz's accounts, tells of first encountering Ralph, who pulled up in an open Morgan sports car attired in a WWII leather aviator jacket and goggles. Inquiring as to who that might be, the answer was, "a tie salesman." Stock thought he looked like someone from another planet.

About this time Ralph needed to see an eye doctor. On the appointed afternoon he arrived to be greeted by the woman he was destined to marry. Nineteen-year-old Ricky Anne Loew-Beer was a Hunter College student of Austrian heritage working part-time to earn a little extra money. Majoring in English with a slight Continental accent, she was unlike any girl Ralph had ever seen.

From the time he set eyes on her, Ralph was entranced. He would insist it was love at first sight. On one of their early dates, Ralph remembers calling for Ricky outfitted in one of his dressy striped suits in his two-seater Morgan with its red-leather seats and hood strap. He was taking her dancing to one of the city's newest pleasure domes, L'Interdit, a discotheque in the Gotham Hotel. As it happened, another of Ricky's part-time jobs was teaching dance at the Fred Astaire Dance Studio. Although reserved and quietly academic, Ricky surprised Ralph because she could really dance. Ralph said he fell in love all over again after the first dance.

Although their courtship lasted only eight months before they married, each has a defining story about passing the other's so-called taste test. Ricky recounts the time in their early courtship when being out on a date and having such a good time, they lost track of time and came

home later than they should. Her mother was so upset that Ralph just said goodnight at the door and left. The following night Ricky was dreading coming home, knowing her parents would probably still be upset. When she finally returned from work and opened the door, to her surprise her parents were not angry. Her mother told her that Ralph came over to apologize and had sat with them for breakfast. He explained the circumstances and expressed the hope that it would not prevent him from continuing to date their daughter. Ricky was impressed. "Nobody I knew had the character, no less the courage to do something like that. We'd only been going out for a short time, but it made me think he was really someone special."

Ricky also recounts being out for a casual stroll and window-shopping with Ralph when they came upon a store with jean jackets displayed in the window. Stopping, Ralph asked her which one she liked. As Ricky remembers, there were several—a Lee, Wrangler, and Levi's. She pointed out the one she preferred and enumerated the reasons: the collar, the stitching, the grommets, and so on. Ralph looked at her in mock disbelief; he couldn't believe his fortune to be with someone this beautiful and smart who also appreciated good design. Looking back, Ricky muses, "What if I had chosen the wrong jacket?"

Not long after that Ralph asked her to marry him. Soon they were looking for an apartment to move into after they were married. Ralph wanted to live in Manhattan and eventually found a tiny studio he thought he could afford. Signing the lease, he put down two months' rent and a security deposit, almost everything he had except the two hundred dollars he'd saved for their honeymoon. The landlord reneged and Ralph took him to court, losing on a technicality. Ralph and Ricky were married on December 20, 1964. Ricky was finishing her last year of college before becoming an elementary school teacher and Ralph was selling ties. Instead of moving into

FROM THE TIME HE SET EYES ON HER, RALPH WAS ENTRANCED. HE WOULD INSIST IT WAS LOVE AT FIRST SIGHT. ON ONE OF THEIR EARLY DATES, RALPH REMEMBERS CALLING FOR RICKY OUTFITTED IN ONE OF HIS DRESSY STRIPED SUITS IN HIS TWO-SEATER MORGAN WITH ITS RED-LEATHER SEATS AND HOOD STRAP.

Ralph says that from the moment he met Ricky, he fell in love with her. Ricky Lauren says, "He was terrific with my parents, very much the gentleman. They were very impressed by him. We met in April, he proposed in June, we were engaged in September, and married in December."

Manhattan they took a rear two-room apartment in the Bronx, several blocks from Ralph's parents. It was hot, noisy, the kitchen was a tiny niche in the living room, and the landlord was not sure he wanted Ralph for a tenant. "Frankly, I was worried that he couldn't pay the rent," said Isidor Schacter, who owned the building. "He was a tie salesman. But I'll say this, he never missed a payment."

Abe Rivetz died on Ralph and Ricky's wedding day. For Ralph it was a big loss, as Abe was to be his mentor. Ralph hoped Mel Creedman, Abe's son-in-law who took over the business, would give him the same opportunities that Abe had promised him. A bit later on, Ralph asked Creedman if he could design the line. Creedman told him that there was no such thing as a tie designer in their industry. And on that score, he was right. Back in the early 1960s, neckwear's shapes and widths were pretty much pre-ordained by tradition as well as the fabric supply houses who prepared the silk collections for the manufacturers to choose from.

The closest thing to designing was coloring the line: deciding whether a silk tie should have a navy background with a burgundy stripe or the reverse, or if the polka dots were going to be the size of a dime or a penny, or the season's motifs small and contrasting or large and muted.

Creedman thought Ralph was pretty much a neophyte who didn't understand the commercial side of the business and just wanted to add another talking point to his résumé. But what really irritated him was how much time Ralph spent talking about clothes to retailers as opposed to selling them. And it was true, Ralph would sit and chat at length with those taste-making tailors like Roland Meledandri and Morty Sills spending hours dissecting such tailoring subtleties as a peak lapel's desired belly's shape or the ideal angle of a jacket's breast pocket. Clearly Creedman, defender of all neckwear orthodoxy,

and Ralph Lauren, neckwear's enfant provocateur, saw the necktie's destiny quite differently and thus were on an eventual collision course.

Ralph was nothing if not persistent. Finally, before going off to Europe on a two-week buying trip, Creedman agreed to let Ralph color a tie range as long as his selections were approved by head salesman Phineas Connell. Ten days later, Ralph set up a meeting to show his work to Connell and the owner, Jeff Greenhut. After reviewing Ralph's colorings, Connell told him straight out that he found them unacceptable, too different for the customer, and that he would not sign off on them. Concerned that Ralph might overreact, Connell asked Greenhut his opinion. He basically agreed with Connell. Ralph was told he had to start all over and redo them.

In 1966, his third year with Rivetz, Ralph decided to make himself indispensable, hopefully justifying a bonus on top of his thirteen-thousand-dollar salary. He did double duty in the showroom, putting in more hours and opening new accounts along with coloring the line. At the same time, he was increasingly preoccupied with the new three-and-a-half-inch and wider neckties first associated with London's mod fashions. Begging Creedman to let him present the new "bib fashions" to Bloomingdale's, Creedman finally agreed, just to pacify his young lion.

For Ralph, the writing was on the wall; he needed more creative freedom. At the same time as he was looking around for a new job, he booked a major order with Abraham & Straus, a division of Federated Department Stores. Ralph colored the new ties, delivered them to the store himself, and then quit. About a week later Creedman got a call from the A&S buyer who demanded Creedman remove the overly bright ties from his shelves or Rivetz would never sell them again. As the story has come to be told many times over, according to Creedman, "the world just was not ready for Ralph Lauren."

39

Ralph started out making the kind of simple, unfussy, well-cut tailored clothes that his wife Ricky liked. "My wife, Ricky, is my muse. Her personal style and natural beauty have always been my inspiration."

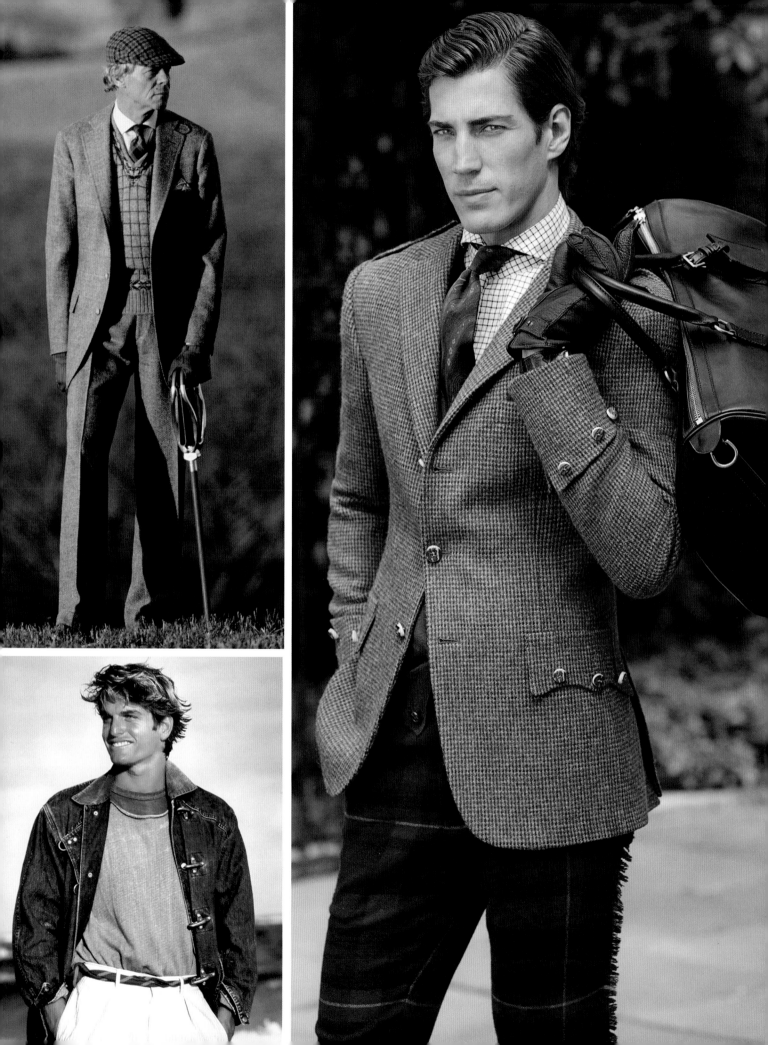

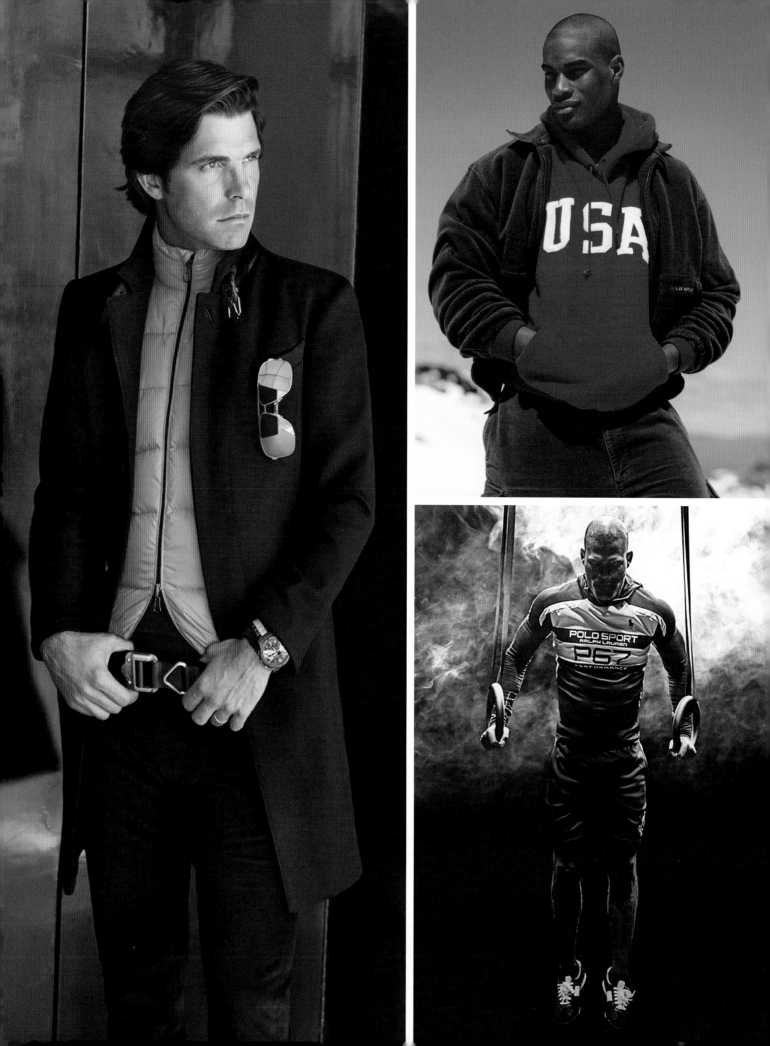

Fashion Undercurrent—The Under Thirties

Produced and written by John Leitzes.
Photographs by Steve Kapovitch and James Barnes.

The business of men's fashion is rapidly changing, and is in a volcanic stage at present.
Many people are involved in this revolution of men's wear, ranging from the highly publicized to the not so.
The four individuals presented here are playing a substancial part in creating
that image which eventually reaches you. These young men are merchandising on four different levels—from the mass
produced design to the individual custom tailored level.

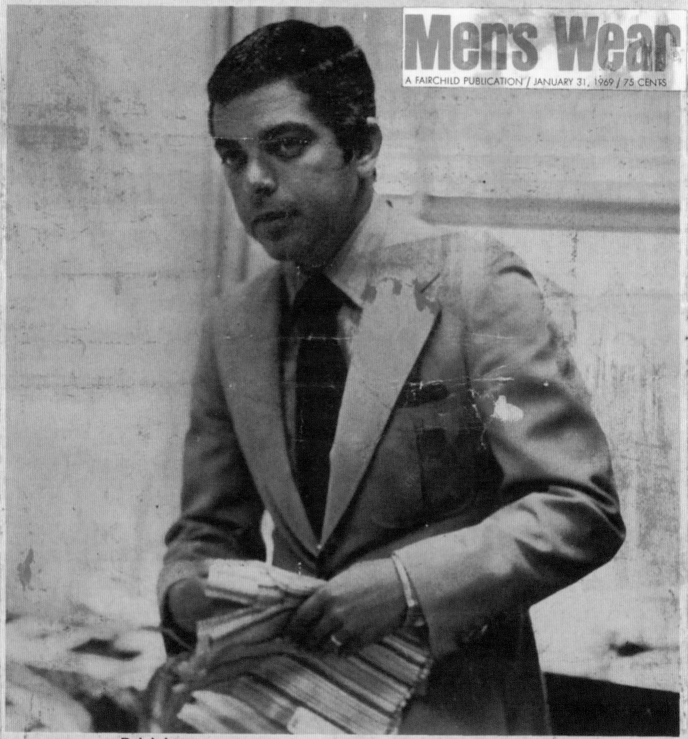

Men's Wear

A FAIRCHILD PUBLICATION / JANUARY 31, 1969 / 75 CENTS

Ralph Lauren, twenty-eight, is a designer of neckties. And "designer" is meant
in every sense of the word, for he creates everything from the color to the weave and shape of the fabric. If it were
possible to view the full collection of Mr. Lauren's designs, you would realize that not only a unique
necktie exists, but also a complete concept. This is what Ralph Lauren has set out to do and, by all means, has achieved.
He aims his merchandise for the quality-minded and the more expensive tastes. Prices start at

STARTING WITH A TIE

The One-Man Brand

From the very start, Ralph pretty much envisioned how he saw his business unfolding in the future. He was going to outflank Brooks Brothers, raising the proverbial sartorial bar with better quality, taste, and style. Beginning with what he knew, neckwear, he'd build a foundation and then branch out from there. Ralph now committed himself to getting the financing he needed to create his own line.

Prior to leaving Rivetz, Ralph had begun searching for potential investors. Acting on the advice of a successful garment manufacturer who lived upstairs, Ralph contacted an old friend's father about how to secure a credit line to launch his tie collection. He also approached Murray Burton and Alvin Cohen, owners of his local men's store to ask if they were game; however, they had decided to renovate their own store, so they turned him down. In the meantime Ralph asked George Bruder, one of the city's finest quality tie manufacturers, to make him some samples.

The materials that Ralph chose had never been used in necktie production before and the factory struggled to make them. They were heavy, lush fabrics found mostly in the upholstery and interior decorating trades. The ties were quite wide and pricey, feeling more like lavish dinner napkins than slips of silk intended to decorate a gentleman's front. With Ralph's penchant for perfectionism, the relationship required a lot of hand-holding. But unlike the attitude of Ralph's former employer, such fussiness didn't make Ralph a showoff, just meticulous. According to Bruder, Ralph's favorite euphemism was "it's not quite right."

Difficult to discourage, Ralph was on a mission, and like many such impassioned pioneers, he was not prepared to deviate from his vision just because others did not share it. On this and related subjects, Ralph was inclined to speak his mind, regardless of whether the audience was sympathetic or not. Dick Jacobson, a piece goods converter, was an early supporter of Ralph's and like him shared an appreciation for old-world taste and vintage menswear magazines. He set up an appointment for him with Gant, a successful New Haven manufacturer of Ivy League sport shirts. Gant was a national brand that was well respected by the country's top retailers and its owners, brothers Marty and Elliot Gant, were considering selling neckties with their shirts.

"I never went to fashion school. I didn't know what a designer was. I knew I had something, but I didn't know what it was. And it could just have easily been nothing." —Ralph Lauren

Ralph warmed up by outlining the opportunities out there that Gant was missing, even raising the specter that their look might be getting stale and that they were on the verge of losing their edge. He recommended becoming more creative, using better fabrics with bolder styling instead of updates of the same looks they had been relying on for so many years. He was convinced they could raise prices and their customers would respond positively to the more compelling presentation.

Suffice it to say the brothers were less than enthused. When Ralph phoned Jacobsen the next day to tell him how well the meeting had gone, Jacobsen told him that the Gants were unimpressed; in fact, they felt he was an arrogant and brazen young upstart. As it happened, Ralph was the one with the fashion binoculars as a new world of menswear was coming down the tracks.

Years later Ralph would find their attitude hard to understand. "Let me tell you. If a kid came into my office and said that to me, I'd hire him in a second," says Ralph. "I was never disrespectful, what I had was enthusiasm. I believed in what I was saying. I told them what I felt. They didn't want to hear it."

Potential deals came and went, nobody seemed prepared to take the leap. Finally, the stars moved into alignment and Ralph met someone who was interested enough to seriously listen. Ned Brower was the president of Beau Brummell, a successful neckwear company based in Cincinnati that produced the kind of default neckwear for those men who didn't want to waste too much time choosing a necktie in the morning. Brower had been keeping abreast of the fashion reporting and saw that it was just a matter of time before the industry was going to play host to "name" designer neckwear. Menswear's *Daily News Record* was abuzz with stories about European designers while America's Bill Blass became the latest womenswear designer to sign a license to design menswear.

As a mass-market tie company selling shiny, Broadway-esque neckwear, Beau Brummell's look was the polar opposite of Ralph's. Brower reasoned that if Ralph was prescient and men were ready to bedeck themselves in pricey napkin-like designer silks, he would not compete with his existing customers. From *Ralph Lauren: The Man Behind the Mystique:* "'We'll start a new division, and you'll run it,' Brower finally decided. 'You'll do the selling and if our sales force has time to help, fine. Otherwise you are on your own.' Maybe the world was ready for Ralph Lauren after all."

In April 1967 Ralph moved into a windowless, vest pocket–size room in Beau Brummell's offices in the Empire State Building where he stored his neckwear collection in a desk drawer. After six months he needed more space, so they moved him into the back half of a larger room whose front half was occupied by an amusing character who sold bowties. Ralph now occupied a chest of drawers and a desk. Not much better than a prison cell, but it was *his* prison cell.

Finally able to launch his own brand, he needed a name. Whether in tandem with brother Jerry, who by then was designing for Jones New York, or in collaboration with his new boss, Ned Brower, the name Polo was hatched. The choice of the Polo name would prove to be a stroke of genius. A rich man's game, polo as a moniker had cachet, it suggested affluence, style, and exclusivity—the same qualities Ralph wanted his ties to convey. Polo was sports mixed with an international quality, a European playboy lifestyle. It was perfect.

Now all Ralph had to do was learn the production side of the business and start getting his ties around customers' necks. Tough sledding at first, his attempt to introduce something new into the tradition-bound world of men's neckties was met with considerable resistance from retailers. Necktie widths at the time were two or so inches. Prices generally topped out at five dollars. Ralph's ties started at three to three-and-a-half inches in width and opened at the unheard of price of seven dollars and fifty cents, ascending to the rarefied climes of fifteen dollars. But the ties' size and price were not the only obstacles.

Ralph used fabrics not associated with neckwear. Scouring the remnant shops on Manhattan's Lower East Side that specialized in upholstery and home decorating materials, Ralph's ties were made of more exotic, luxurious fabrics: silk tapestries, hand-blocked prints, textured Indian silks, hefty diagonal windowpanes. They were also more labor intensive, constructed individually by hand, and finished expensively using a special slip-stitch that allowed the tie to stretch but then pull back into its original shape. The silhouette of his tie was also different. The new two-button coat's lower V front opening afforded more space to accommodate a bigger tie. Ralph's ties sprang full-bodied from the knot, making them as wide in the throat as they were in the apron. The necktie's sheer bulk attracted attention all on its own.

"I'm promoting a level of taste, a total feeling," Ralph told the *Daily News Record* that year. "It's important to show the customer how to wear these ties, the idea behind the look." For Ralph, he was not just selling a tie, but also making a larger statement. As he put it, "I don't care how wide the lapels or the neckties are. All I want is the old money look, I want to stand for the same kind of thing Abercrombie & Fitch and Brooks Brothers used to and should have gone on to."

In the first six months, Ralph opened only a handful of accounts, although they were the right ones. Prestigious retailers Paul Stuart and Roland Meledandri were the first to come on board. Needing them for legitimacy, Ralph agreed to sell both stores his ties without the Polo label on them. The stores' reputations lent his product a credibility he could leverage with other retailers. Cliff Grodd, the late owner of Paul Stuart, initially felt the ties bordered on the outlandish; however, he soon came around, confessing that they really attracted attention and that Ralph's timing was nothing short of providential.

Soon to follow were other small specialty stores at the top of their city's respective sartorial ladders—Louis Boston, Eric Ross in Beverly Hills, Alvin-Murray in the Bronx as well as Polo's first national account, Neiman Marcus. Neal Fox, who had helped Ralph get his job at Brooks Brothers, was now vice president of men's and boy's clothing for Neiman's.

"Fox was Ralph's kind of guy. He liked clothes with shape while most men still favored straight hanging lines with high, three-buttoned fronts. 'I wanted to move to two-button suits with a waist,' Fox said, 'like the ones Lauren was already wearing. It was happening but not at the commercial level. The buttons were coming down, lapels were widening, and here comes a guy with a wide tie that's got texture and feel and exotic fabrics. His timing couldn't have been better.'" Fox invited Ralph to come to Dallas. Ralph flew round-trip to Dallas in one day to save the cost of a hotel room, returning with an impressive order of twelve hundred ties.

Nevertheless, to become recognized as a national brand, Polo still needed that New York City flagship store. Neiman's was impressive but they didn't have a Manhattan anchor. Ralph tried to interest Saks Fifth Avenue, but its buyer wasn't receptive. The story goes that after finally agreeing to see the collection, the men's buyer proposed to start by cherry-picking Ralph's best looks to see how they sold. Although desperate to land the account, Ralph painstakingly explained that if they didn't present his wider, more expensive ties as a total collection, the customer might not understand the overall look, and therefore he politely but firmly turned down the order. Upon hearing this, Saks's senior merchant stood up and cavalierly intoned, "Nobody tells Saks Fifth Avenue how to buy merchandise," concluding with, "You'll never sell Saks Fifth Avenue." The merchant remained gainfully employed at Saks long enough for the story to gather legend and become his personal bête noire, although he eventually became a great supporter of Ralph's tailored clothing and his Polo look later on.

Wallach's, a specialty store chain with its own marquee store on Fifth Avenue and other stores sprouting up on the East Coast, came in to buy the ties but Ralph turned them down as well. Although Wallach's volume would have done wonders for his struggling division as well as for his business credibility with Ned Brower, Ralph felt they did not project the right image. Building for the future and always thinking about the big picture, he reasoned that Wallach's middle-of-the-road merchandise would cheapen the hard-won elitist status of his more expensive product.

Finally, Ralph's high-minded thinking was about to pay dividends; he was to become important to an important store. Bloomingdale's was just winning its reputation as the alternative to the dowager department stores on Fifth Avenue. According to Marvin Traub, president of Bloomingdale's, "Ralph understood what we were doing. He knew his customer. He was a man who knew what was happening in New York, who was watching what was going on in Europe, and who shopped at Bloomingdale's. Ralph saw it before many others did—even those who worked at the store."

Bloomingdale's no longer occupies the stature it once did back in the 1960s when its hip young "Saturday's

47

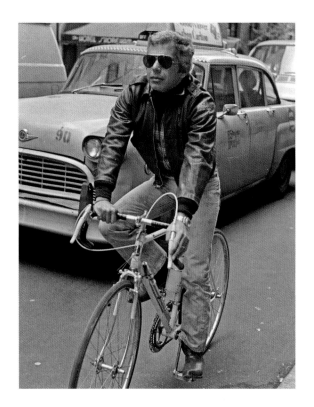

Dressed in leather bomber jacket and jeans,
Ralph would pedal over weekly to Bloomingdale's
to check on his neckwear stock and presentation.

48

them. Acceptance by Bloomingdale's would have automatically elevated Polo's standing with the other major retailers in the national Federated Store group at a time when Polo badly needed the visibility and sales volume.

But taking a page out of Ayn Rand's famous book *The Fountainhead*, like one of his favorite literary heroes, Howard Roark, Ralph refused to budge. Narrowing his ties and putting a Bloomingdale's label on them would all but destroy their identity and specialness. Ralph was not prepared to compromise, not on their uniqueness, nor in his belief in their timeliness.

Brower was incredulous, suggesting Ralph was more interested in cachet than cash. He was wrong. Ralph wanted to make money; he just felt there was more than one way and that his approach required gestation so its roots had enough time to deepen and strengthen for the longer haul—what Ralph called "his longer-term point of view."

Bloomies did come around and relatively quickly. Shafer bought one rack of ties that sold well enough for him to then conspire to take some of them to Italy and "knock them off," or copy them. When Ralph complained to Schultz, who by now had taken to wearing Polo ties, he countermanded Shafer to stop, resulting in Shafer's refusal to buy any more Polo neckwear. Fortuitously, Shafer's assistant tie buyer had gotten a promotion to men's manager in Bloomingdale's Fresh Meadows store in Queens. He'd sidestepped Shafer to buy some Polo ties and they were selling like hotcakes, arousing the attention of upper management. Schultz brought the situation to Frank Simon, who ordered Shafer to start carrying the Polo neckwear in their Manhattan flagship, and the rest, as they say, is history.

That next Father's Day, Bloomingdale's New York flagship store put Ralph's ties in a four-foot display case and on a small standing rack. Ralph made sure everything was perfect, even coming to the store to polish the brass case. Stated Simon, "Those ties were wide and unconventional and they looked wonderful to me because they represented a new direction."

"Ralph was ecstatic," recalls Marvin Traub, president of Bloomingdale's. "I think the day we agreed to carry his ties at Fifty-Ninth Street was one of the happiest in his life." Unprepared to leave anything to chance with his newest and most important outpost, Ralph would deliver his ties to Bloomingdale's personally, calling in at least twice a week. On Saturday mornings he would arrive early to restock his showcase, pulling up in his sports car attired in his worn jeans and a vintage bomber jacket. He'd show the sales force exactly how his ties were to be tied, with a little dimple below the knot. "Even then, Ralph was steadfast in how his designs should be displayed."

Generation" descended on its Fifty-Ninth Street and Lexington Avenue flagship every weekend to shop and be seen. As its slogan proclaimed, "Unlike any store in the world." Not only was Bloomingdale's on the forefront of the emerging designer fashion scene, it was to become the cornerstone of the budding Polo business.

Ralph had found someone to champion his cause to the store in the person of Joe Aezen, a brash but respected neckwear salesman for Rooster ties. Having crossed paths at various industry functions, Aezen had grown completely enamored of the new kid's dressing style, equating it to a walking tutorial in natural-shoulder sophistication. Since Ralph's ties didn't compete in price or look with his more traditional neckties, Joe would make his store rounds each week handing out Polo ties to the Bloomingdale's men's team. Touting the ties' appeal, he would chat up Franklin Simon, the men's merchandiser, Jack Schultz, the divisional men's buyer, and Gary Shafer, the tie buyer and stylist for Sutton East, the store's private label. Resistant at first, but as a favor to Aezen, Shafer finally agreed to buy a batch of the Polo neckties if Ralph would compromise and agree to narrow them and put the Bloomingdale's label on

In those days Bloomingdale's men's department was still cut very much in the Brooks Brothers' mold, staid and traditional. According to Marvin Traub in *Like No Other Store*, "I was wearing traditional suits then but quickly became perfectly comfortable wearing a wide tie. That tie was the beginning of an explosion in America. Until then, menswear had little in the way of a fashion business. There had not been a major fashion change in a decade. Once you had a wide tie, however, all your ties were dated. And you needed a new shirt and a new suit to go along with it. Ralph's ties, we realized, were the beginning of a change in American menswear."

From his earliest days at Rivetz, Ralph would make time to talk with the fashion press who would report that he was someone to watch, recommending that retailers go see for themselves. Somehow Ralph had the maturity of mind to understand how important such relationships could be, garnering a surprising amount of coverage at a time when he couldn't afford to advertise. One of his earliest supporters was a wavy- and silver-haired, impeccably dressed former radio talk show host from Washington, D.C., Robert L. Green. Having moved to New York City in the late 1950s, he became the men's fashion editor at *Playboy* magazine and a recognized arbiter of male fashion and style.

Taking an immediate liking to young Ralph, Robert was the first editor of a national magazine to put Ralph's ties in the same fashion spreads with the more established menswear designers like Pierre Cardin, Bill Blass, and John Weitz. In no time Ralph's star began to rise, slowly building a following among a small but growing group of style-savvy customers. Whether on a plane, in Europe, or dining at a stylish restaurant, spotting a man similarly arrayed was like sharing a sartorial epiphany. One of Ralph's contemporaries, the designer Bill Blass, was quoted at the time, "I think Ralph has extraordinary taste, it's especially curious in one so young, this understanding of the taste of the great gentlemen of the thirties. He's the first young designer I've seen who I feel as sure about as I feel about myself."

By the end of the first year, the Polo division at Beau Brummell was making fashion headlines. Ralph's ties were beginning to sell briskly, and all of a sudden the Polo label was hot. At this point Ralph wanted to do it all, to create his own line and expand into shirts and tailored clothing. While Ralph wanted to quickly move into other product categories, Ned Brower was only interested in building a neckwear business. Finally Ralph decided that he wanted his own business. Six months later he told Brower that he was going to leave and set up his own

company. In 1968 he formed his own menswear company, Polo Fashions Inc., in partnership with the clothing manufacturer Norman Hilton, a third-generation, high-quality suit manufacturer with a factory in Linden, New Jersey, and offices at 1290 Sixth Avenue, at the time the wholesale epicenter of better American menswear in New York City. In exchange for fifty percent of the business, Hilton extended the new company a fifty-thousand-dollar line of credit along with the assurances to manufacture the new Polo tailored clothing.

From *Ralph Lauren: The Man Behind the Mystique:* "What did Ned Brower think of Norman Hilton stepping in? He thought it was great, however, on one condition. If Ralph wanted to keep the Polo trademark, he'd have to buy his remaining inventory of neckwear piece goods. 'I let Ralph take the name for two reasons,' said Brower. 'First, it was his idea. Second, I didn't think we could move forward without him. A lot of people later asked how we could let him go. Obviously today, I wouldn't. But who knew what was going to happen back in 1968?'"

Ralph felt very indebted and appreciative to Ned Brower, thanking him by sending him a solid-gold fountain pen from Tiffany & Co. Years later, whenever Brower admired a Polo item, it would arrive in the mail with a label on the sleeve reading "made expressly for Ned Brower." When Brower died, Ralph sent his wife Shirley Brower a letter that she still treasures. "Everything I am today, I can thank Ned Brower for," wrote Ralph.

Norman Hilton assumed that Ralph would move into his same office building at 1290 Sixth Avenue. Situating the new business there seemed like a logical decision to everyone except the designer. In fact, it was exactly what he didn't want. Entering its cavernous and heavily trafficked lobby, the visitor moved toward a gigantic name directory listing all the manufacturers from A to Z. Wanting to set himself apart and give a very different first impression of Polo's specialness, Ralph felt the setting was much too commercial and impersonal. He hoped to find something more residential and charming.

The designer John Weitz had a showroom nearby in a narrow ten-story rent-controlled residential building at 40 West Fifty-Fifth Street. The owners were happy to lease to commercial tenants who would not be affected by the rent control laws. Ralph took a similar two-bedroom apartment on the sixth floor deciding to make one bedroom the showroom and the other his design studio. His father came down and painted the fireplace for him. Over the next two decades, the burgeoning Polo organization would come to occupy almost the entire building.

AN AUDIENCE OF ONE

Suiting Himself

50

Having never attended an Ivy League college or fashion school and with no distinguishable connection to the upper classes, Ralph Lauren absorbed an inbred dressing construct that, through trial and error, led him to first try and "get it right" for himself and then for future generations. The question is: How has he been able to "get it right" for so many years, turning out more future classics each season than any designer in fashion history?

He's done it, in part, by assembling an unprecedented storehouse of high-bred taste touchstones to anchor his creative vision. Fascinated with a blue-blooded culture few were born into, Ralph began early on to observe and file away those prototypes of well-born dressing and style. That he was able to single out these references and trust in their integrity speaks to the sustainability of his self-charted philosophy. But more than that, it was his ability to cross-pollinate the new with these heritaged style eye-cues that invested Polo Ralph Lauren with its thrust and staying power.

Ralph's coming of age was a most fortuitous confluence of timing and circumstance. He got his start at a time when both the menswear industry and society at large were entering a one-way tunnel of prolonged upheaval and social change. Determined to soak up as

much knowledge and insight as he could, Ralph was the beneficiary of arguably the most unique and priceless of fashion educations. Not only was he mentored by the last generation of authentic menswear experts, tastemakers, and top-drawer custom tailors, he was to rub shoulders with two of the postwar's most important retail giants while still at the top of their game—Brooks Brothers and Roland Meledandri.

By the time he was to attract the financial backing that allowed him to turn his attention to designing more than men's neckties, Ralph had developed a broad feel for a landscape of old-world dressing habits that had largely been obfuscated by time and fashion. How he came to connect with these chiefly unwritten and unspoken style cues is really the story of a man whose roots began to seek such soil at such a young age that he was to forge a level of visual intelligence far in advance of his years.

Looking back on his formative years as the youngest of four children surrounded by the aspirations of an artistic father, one can see how certain influences began to engage his imagination, shaping and sharpening his inner style antenna. Early on, clothes and their possibilities took on more and more importance to him. Like many adolescent teens, dressing up became a rite of passage, a measure of standing within one's own peer group. Nevertheless, for Ralph, experimenting with clothes and creating new outfits quickly became a launching pad for personal expression. Increasingly image conscious, he began to view clothes as a means of gaining attention as well as separating himself from the crowd.

It's a good thing the designer-to-be loved clothes and the idea that they could be used to reshuffle
his daily identity deck. Here as a young teenager, Ralph is already creating outfits with his own personal
stamp—vintage sweater, button-fly jeans, and a hand-me-down oversized school jacket.

A couple of Ralph's personal favorites, two of the modern world's most paragon dressers of all time.

Opposite: Dubbed the original "California Girl" for her golden looks and athletic ability, Slim Keith was a New York socialite and American fashion icon during the 1950s and 1960s. Here she is photographed in an outfit of her own design.

Right: Right up there with the Duke of Windsor, Fred Astaire was in a league of his own, trotting out his gray flannels and tweeds. "The way Astaire walked was already like dancing," said actress-dancer Leslie Caron.

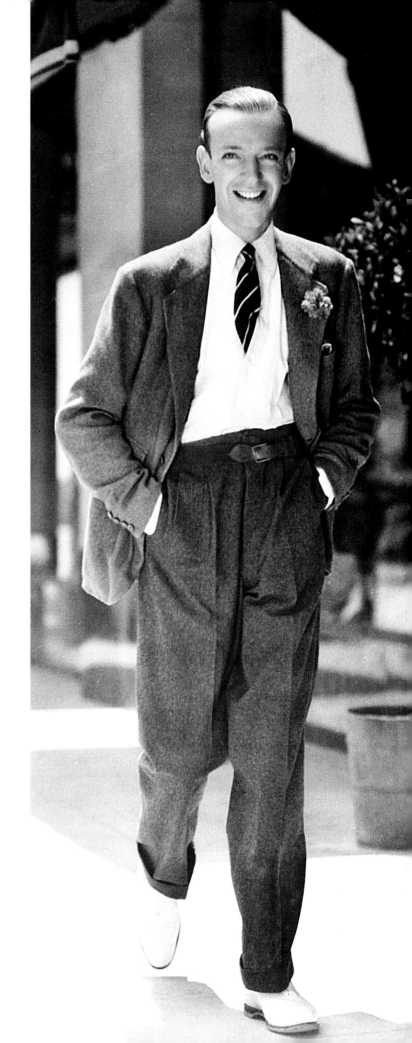

As the youngest brother, Ralph became the beneficiary of many of his two older brother's castoffs. Ralph couldn't wait to get his hands on his brothers' old varsity sweaters or discarded army clothes. That they were pre-owned made little difference, as he would figure out how to mate them with something of his own, injecting his increasingly stylish sleight-of-hand into the enterprise. According to his buddies, Ralph would routinely show up in an offbeat outfit such as an oversized army poncho worn over Ivy League duds. Calvin Klein, who grew up in the same neighborhood, remembers Ralph mixing olive drab army clothes with tweeds.

While not your typical form of teenage recreation, second-hand clothing provided Ralph with an affordable means of expanding not only his wardrobe, but his education as well. Along with brother Jerry, his closest teenage friend, Ralph would scour thrift shops and vintage clothing stores in search of sartorial treasure; the perfectly weathered bomber jacket or just-so faded fatigue pants. Combing through pre-owned clothes helped him to distinguish a great leather jacket from a poor reproduction or a genuine archetype from some impostor. As training grounds, these mini-museums of bygone taste and out-of-date fashions helped expand the boys' visual frames of reference, providing them with first-hand primers on the design, modeling, and detailing of all kinds of clothes. Among the teaching props were garments made with special pocket treatments or shoulder expressions, along with all quality levels of craftsmanship from the hand-sewn-in-America to mass-produced-in-Hong Kong (China). Unlike the classroom curriculum of the typical fashion school, this was a living, hands-on syllabus that, should the force be with you, might help one leave with reward-in-hand and a heightened incentive to double back sometime soon.

Learning how to breathe new life into someone's prematurely discarded classic or build an ensemble around a vintage cowboy shirt or a beat-up safari jacket was to become one of Ralph's most valued skill sets. It also helped shape and broaden the designer-in-training's feel for a more personal, eclectic approach to dressing and style.

It's not hard to see how such an early coding of apparel figured so prominently in Ralph's evolving realization that fashion could be short-lived, while timeworn or vintage apparel had the potential for continuity and longevity. Fast-forward to his first year in business—when describing his look to the press, Ralph stated, "You must understand oldness to be a real fashion dresser. This is traditionalism. There is real beauty in an old seersucker suit that bags."

By the late 1950s, Manhattan menswear could be distilled into three basic dressing genres. Centered around the Garment Center, the Seventh Avenue or Broadway Look became America's frothy reworking of the decade's earlier Continental Look as first imported from Italy. Ensconced on the other side of the tracks was the anything-but-shiny Ivy League Look of the soft-shouldered, sack-suited White Anglo-Saxon Protestant as epitomized by Madison Avenue's Brooks Brothers and J. Press. Separated by no more than several city blocks, these two menswear mentalities were polar opposites. And literally situated between them, lining either side of Fifth Avenue, was the Mid-American Look as purveyed by established department stores like Saks Fifth Avenue, De Pinna, and Weber & Heilbroner. There, devoid of immigrant pretension or old boys' club airs, Midwestern manufacturers like Chicago's Oxxford and Hart Schaffner Marx knocked out boardroom conservative, middlebrow mantles for America's upwardly mobile executive class.

Having seen enough Broadway and mid-American taste in and around the Bronx, Ralph decided that on the way to living out his upper-class dreams, he should start to dress like them. Frequenting Brooks Brothers, Ralph would soak it all up, spending whatever money he earned on the Ivy League's staples. In 1959, if you were to pick one place in the world to study Brahmin taste and the underpinnings of American traditional fashion, Brooks Brothers was it. The store's merchandise and taste level still reflected the purity of the vestmental tradition that birthed it. Within its hallowed halls, fashion meant naturalness, understatement. Here consistency was considered a virtue. To many outsiders Brooks was a stronghold of conservatism and dry style. But to a wide-eyed teenager who loved clothes, Brooks was sartorial theater come to life, where the admission was free and all you had to do was keep your eyes open and pay attention, which is exactly what young Ralph did.

Showcased throughout the store and within its cavernous street windows were the brethren's weekly symposiums on the correct way to hold your sartorial knife and fork. Where better to digest tutorials on pattern-on-pattern dressing or the prerogatives of color as taught by Brooks's walking dons. One week navy blazers hosted striped-oxford button-downs and striped rep ties; the next week herringbone odd jackets befriended tattersall sport shirts and paisley four-in-hands. The curriculum also included primers on how to inject seasonal whimsy into last year's threads, along with stockpiles of approved Brooks classics with which to do so—fox head–embroidered red-corduroy trousers, purple Shetland cable-knit crewnecks, or irreverently patched striped or plaid fun shirts.

Underneath its insiders' chins, sartorial one-upmanship abounded. Saturday was the High Holy Day for "346 sightings": Piping Rock Lockjaws swathed in wild dollops of golf club–colored corduroys spilling out of well-worn navy blazers festooned with club regalia; suntanned Horn Rims rigged out in monogrammed oxford button-downs, yellowed-with-age striped wool belts, maize chinos, high-frequency hose, and Brooks's incomparable brown tassel loafers; or an Old Boy waistcoated in a scarlet-challis hunt scene under an elbow-patched tweed sport coat over threadbare-but-pressed khakis, ankle-clipped to expose his obligatory sagging wool athletic anklets. In his six months working there, Ralph's deposits into his expanding storehouse of taste must have required several new floors.

Inset: When Brooks was still Brooks—Ralph's apprenticeship at 346 Madison Avenue could not have been better timed. Brooks Brothers was to shape his vision more than any other store.

Opposite: 2007. Nobody dresses like Ralph Lauren. Almost forty years after starting his Polo Ralph Lauren business and upstaging Brooks Brothers along the way, you can still trace certain influences back to his early Brooks years. Here Brooks's former sales associate renovates the Brothers' own Ivy League dressing verities into an improvisational and transcendent aesthetic all his own.

Visual spectacle aside, there were the Brothers' classics to bone up on, those venerated perennials that Madison Avenue lore was founded upon—English covert chesterfields with matching fawn-velvet collars, yellow tattersall odd vests, navy-serge smoking jackets edged in burgundy satin, narrow two-and-five-eighth-inch regimental ties, Brooks's Brahmin boxers, and so on and so forth. And lest one not forget those objets d'art for the well heeled: Brooks's red-soled English white bucks, mahogany-brown Peal & Co. captoes, reverse-calf weekenders, and their irrepressibly soigné black-calf opera pumps.

As thrilled as Ralph was to imbibe this blue-blooded and unabashedly privileged cosmos, he found Brooks's clothes disappointing. He felt the tailored clothes needed more shape and side vents, a bit less of this and bit more of that. A revitalized spirit, a new sartorial swagger was passing Brooks and Paul Stuart by. The Madison Avenue habitué was beginning to look elsewhere, outside the Ivy fold for something more exciting to pull on than his shapeless worsteds. The avant-garde had cast their "number-one sack suit" aside to experiment with the more-fitted European designer looks. Like Ralph, the tuned-in wanted to move into a shaped, two-buttoned jacket, whose lower-rolling lapels allowed more necktie to show thereby inviting wider jacket lapels and larger shirt collars to effect a bolder, more expressive look. At the time, these new proportions were impossible to find at any quality or price level. And since none were available at retail, Ralph started going to custom tailors to have them made for himself. Having never aspired to become a fashion designer, Ralph backed into becoming one by virtue of wanting to fulfill his own stylistic cravings.

By the time Ralph launched Polo Fashions in 1968, England's Peacock Revolution and America's hippie culture were in full swing. London's Carnaby Street had unleashed one flamboyant fashion after another, from the Mods' body-hugging Edwardian velvets to Michael Fish's five-inch napkin-wide kipper neckties. By 1966 the youth rebellion and the mass's preoccupation with the "new" began to subvert the elite's long-standing rules of sartorial decorum. Street-driven style filtered up into the highest realms of men's fashion. Yves Saint Laurent's famous dictum, "Down with the Ritz, up with the streets," was no idle prophecy.

Propelled in part by reaction to America's gray-flannel anonymity of the 1950s, anti-establishment fashions started making inroads at all levels of American menswear. The marketplace was ablaze with the youth culture's flowerings as well as the West Coast's double knitted, polyester California leisure suit look. The sixties witnessed Europe's first tailored-clothing broadside with the introduction of Rome's Continental Look. Following quickly on Italy's slippered heels was a second corset-like fashion courtesy of French designer Pierre Cardin. The sexy appeal of Cardin's pagoda-shouldered, *près du corps* silhouette split the American men's tailored marketplace into two opposing camps—the natural-shoulder loyalist on one side and the fitted rope-shouldered Continental devotee on the other. With Europe exporting its designer brands into the States, established women's designers began turning their sights on menswear. By the late sixties, France's Yves Saint Laurent and America's Bill Blass and John Weitz joined Frenchman Pierre Cardin to usher in the new frontier of American fashion—designer menswear.

Once again Ralph managed to connect with those lifestyle arbiters and menswear authorities who could guide him in his chosen discipline. It was as if he had landed in Paris around the turn of the century to study art and ended up cavorting with the likes of Renoir and Degas. But Ralph's tutors were not accredited scholars or university dons but a mélange of style bachelors, opinionated custom tailors, and carriage-trade merchants whose collective wisdom amounted to a doctoral course in the sartorial arts. Not surprisingly, the future designer was drawn to them like a moth to cashmere.

Opposite: From *Apparel Arts Magazine*, 1937. While both ensembles typify a certain type of Manhattan sophistication, each demonstrates its English origins.

Inset: Cliff Grodd, the legendary doyen of Madison Avenue's Paul Stuart and arbiter elegantiarum of menswear style and taste, was one of Ralph's earliest mentors. As Grodd told the *New York Times* in 1985, "Fashion is peripheral to us. I abhor dullness and resist flamboyance."

57

Roland Meledandri was another menswear high priest of the sixties and seventies whose unique personal style was a large part of his authority. Meledandri was one of Ralph's first necktie accounts.

One of Ralph's early taste mentors was the late Cliff Grodd, the movie-star handsome and impeccably dressed son-in-law of Ralph Ostrove, the founder of Paul Stuart Inc. By Brooks Brothers' standards, Paul Stuart was regarded as slightly "fast" and definitely non-U. Ralph would camp out at Paul Stuart while ordering a suit, making sure he got what he wanted. He would constantly question, asking why something was done in a particular way. "I put up with him probably where I wouldn't with someone else because he was so earnest, honest, so appealing," Grodd explains. "He had charm, although on some level I used to cringe when I saw him come through the door. He kept me on my toes."

Jimmy Palazzo was a tailor-for-hire whose expertise ranged from making uniforms for school bands to turning out the odd sample for New York City–based womenswear designers. Ralph would show up first thing in the morning plying Palazzo with something to drink or eat and

then cross-examine him. They could spend hours discussing the expression of a jacket's sleeve head or the correct placement of a lapel's notches. Palazzo understood what Ralph was trying to do and helped him realize his early tailored clothing designs. Using an English bespoke jacket with its characteristic shape and flair as a starting point, Ralph wanted to marry its high armhole and fitted chest to a softer, rounder shoulder and wider lapel for a more casual, American Look. No one was wearing such a silhouette nor knew how to make it, especially when you threw in Ralph's Savile Row particulars like ticket pockets, side vents, and forward-pleated trousers with English DAKS-style extension waistbands.

When Ralph was first starting out, he thought one day he'd have a business like Morty Sills, who made custom clothes of the soft-shoulder persuasion for many of Wall Street's up-and-coming movers and shakers. Cutting his teeth in New Haven working as a salesman for the venerable J. Press, Sills made it a point to absorb all the social lore and tailoring history associated with such pedigreed dressing. Sills was more than happy to bestow his wealth of information and experience on the young and eager beaver. He would council Ralph on such matters as the pros and cons of certain English weaving mills, and introduced him to the famous T. M. Adie handwoven Shetland tweeds that Brooks Brothers started using back in the 1920s. Sills would lecture his student on the sensibility of clothes he had made for certain highborns, how they reflected the man's personal style, how they accorded with his family's ancestry, et cetera.

And then there was Meledandri. Of all the style gurus that crossed Ralph's path, Roland Meledandri was one of the more important. In the sixties and up through the late seventies, Meledandri presided over the country's most elite male fashion preserve. Anyone who was anybody shopped there. A stylist-cum-custom-tailor who held court in the carriage-trade hotel zone of East Fifty-Sixth Street between Madison and Park Avenues, Meledandri was his own creation—pencil thin with a slight hunch, waxed bald head, handlebar mustache, and ever-present pipe or cigar in or around his mouth. His clients were those heavy hitters who liked to dress well and could afford the best—actor Steve McQueen, New York Mayor John Lindsay, Yankees' owner Dan Topping, and Detroit's Henry Ford were just a few of his loyalists.

Around the same time that London was beginning to experiment with the new proportions of larger neckties, longer-collar dress shirts, and broader jacket lapels, Meledandri caught wind of the trend and started making suits and haberdashery with similar proportions. At one point, along with

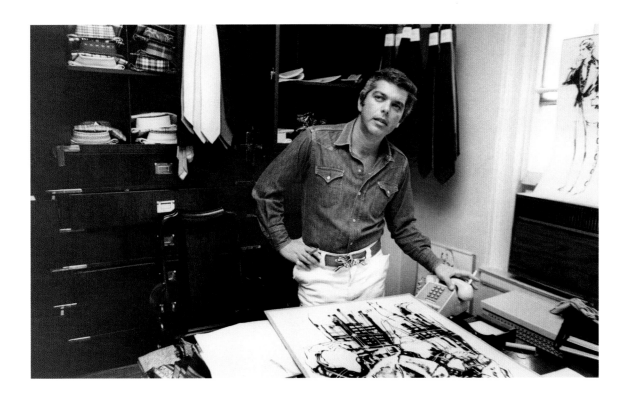

his alter ego in Rome, Carlo Palazzi, Meledandri had an exclusive on deep, rich-toned dress shirts in dark browns, purples, and ocean blues with larger spread collars, until another Italian retailer from Genoa, Battaglia, situated himself around the block on Park Avenue and started claiming them for his own. Clad in one of Meledandri's fitted jackets with wide lapels, accessorized in a bold colored and collared dress shirt and effusively swank necktie, the wearer made heads turn, both male and female.

With the idea of a menswear designer still in its incubation stage, Roland's head-to-toe look must have given Ralph something to think about. That Meledandri's tastes were less Ivy League and more Italian than Ralph's did not deter our young buck from inundating him with questions while filing away his insights for some future application.

Another of Ralph's early teachers and cheerleaders was Dick Jacobsen, the second-generation owner of Hansom Fabrics. They first met when Ralph's bosses at Rivetz would let him accompany them to look at the new season's fabrics and colorings. A fine merchant with

exceptional taste, Jacobsen quickly took a liking to young Ralph. They shared a passion for old fabrics and American menswear circa its 1930s heyday as depicted in vintage men's magazines like *Apparel Arts* and *Esquire*. It was Jacobsen who introduced Ralph to his first business partner, Ned Brower of Beau Brummell and it was also Jacobsen who, after Ralph formed Polo Fashions, worked alongside him to help create the early tie prints and colorings that were to define the Polo neckwear collections well into the future.

Thus commences the fashion career of a young Bronx Brummell, fortified with not much more than a belief in himself, a persuasive manner, and a decidedly maverick ideology. Pulling himself up by his bootstraps, albeit increasingly stylish ones, Ralph arrived at the founding of his business. In trying to represent a plateau of taste and quality would catapult him above the clutches of fashion's artifice and impermanence, Ralph would frequently opine that he designs for himself first, an audience of one. In the beginning that was enough. Apparently, it still is.

In the early days Ralph was a one-man band. Here he works on a new silk print design. The colors and finished layout are to be sent to Como, Italy, for hand block printing and then artisan-crafted into neckwear or scarves. Later on when the business grew, others would come on board to help free up the designer from the obligatory mechanics inherent in creating a fashion collection.

THE EARLY
YEARS

Ralph's early years found him serving up his own menu of Anglo-American taste as the backbone of his menswear vision. Referring to his collection as "anti-fashion traditionalism," he recognized that within the venerable corridors of a Brooks Brothers or an Abercrombie & Fitch lay a trove of specialty items on whose laurels they had been coasting for too long. He sensed there was a deep well of sartorial lore with its own legends and values rooted in the America of Hemingway and Fitzgerald that the tradition-toppling sixties had practically swept away. The designer-in-training would set out to reconfigure their aging parameters of style and quality while introducing some of his own.

Taking the long view, Ralph would patiently explain how his Polo neckwear was not the finish line but the gateway to an about-to-be realized world of upper-class taste and quality that was slowly disappearing but which he was going to recapture through a full-blown men's collection. Although the American peacock had begun to step out of his gray-flannel cocoon, the menswear industry's knee-jerk reaction, much like that of womenswear, was to look outside itself, to Europe for direction and creativity. In fact, much of what should have inspired America's fashion makers had never left home.

Beginning in the 1920s, America's white Anglo-Saxon Protestant class began experimenting with a new fashion ideal, a relaxed manner of dress that reflected their privileged, status-conscious backgrounds. A style initiative born out of a young, exuberant masculinity and a greater measure of leisure time, nowhere was this fascination cultivated more successfully or snobbishly than at the "good-breeding" grounds of America's Ivy universities, where the trend for sport-driven fashions first took root.

As college athletic programs grew in importance, so did the social status of its sports and players, catapulting sportswear from the playing fields onto the campus and then into town. Athletic wear possessed both comfort and casual ease that when coupled with the postwar obsession for fitness made it enormously attractive. Co-opting athletic clothes from their prep school or university's playing fields, matriculates would mix them with other club and collegiate regalia. Most important, they learned to sport these elitist totems with an air of complete and utter nonchalance.

While Britain's Savile Row had long been the style mecca for senior establishment taste, America's younger blue bloods felt more comfortable in Brooks Brothers' looser hanging mantles. Their easy-fitting, natural-sloped shoulders personified the Ivy League's casual dressing gestalt for the next fifty years. Paralleling the Prince of Wales "dress-soft" movement in 1920s England, America's homegrown Ivy League fashions proffered the first real challenge to England's long hegemony over male fashion.

And where did this newly minted swagger first draw its line in the sand, from Boston to Philadelphia, within the Eastern Seaboard's network of old-boy connections forged at its prep schools, Ivied universities, and social clubs? Its mainframe was situated within the cream of the East Coast's colleges—Harvard, Yale, and especially Princeton—where eating clubs and socially stratified conformity ruled the day. Membership carried its own unspoken symbols of recognition; inclusion assumed a certain genealogy and bank account.

Writing in the *Saturday Evening Post* in the 1930s, Arthur Van Vlissingen stated that "trends aren't dictated by manufacturers who couldn't afford to gamble on a fad that may fail, that men only embraced a new item once they saw other men wearing." These style setters were often found at the places where the country's socially prominent liked to loaf, watering holes like Palm Beach and Newport—coincidentally, Brooks Brothers' first two locations outside New York.

61

A 1930s *Saturday Evening Post* article noted: "The fashions in clothing worn by our male population between the ages of fourteen and perhaps twenty-five, usually get their start at Princeton."

The New England propensity for thrift and frugality provided the perfect breeding ground for America's sartorial hierarchies to flower. Fine, well-worn, and cared-for handed-down family clothing became a symbol of breeding, not fashion. Now, not only the clothes but how they were worn would separate the landed from the merely loaded. Frayed button-downs, elbow-patched tweed jackets, balled Shetland pullovers, and down-at-the-heel khakis hovering ankle-height above boned-but-polished loafers confirmed the wearer had social standing to burn.

From this time forward, American menswear began to take on a life and identity of its own. While Hollywood lent an imaginative flair to fashion's New Deal, two developments helped kick-start the American male's fashion consciousness into high gear—the country's cultlike following of England's peripatetic Prince of Wales and the publication of the States' first fashion magazine for men, *Apparel Arts*.

At the same time that England's dashing prince was dragging men's fashion to the forefront of the world stage, the most important publication in menswear history was making its debut. Founded in 1931, *Apparel Arts* was the first magazine aimed at tradespeople, manufacturers, wholesalers, and retailers. It spoke to a "beau ideal," which it defined as "the man of taste, with a sense of style, and a respect for quality." Arnold Gingrich, its creator, wanted to democratize the game of fashion by first liberating it from the closed little circle of high society with its elitist trappings, private schools, exclusive clubs, and grand shopping excursions to London.

Each season a foldout nearly three feet long outlined how to coordinate suits, shirts, and ties according to fabric, pattern, and color. The editors urged change and made suggestions, devoting considerable space to the dressing habits of the well-to-do and the fashion-forward. Articles detailed how Fred Astaire personified spontaneity in dress while Cary Grant had his jackets cut with broader shoulders to make his large head appear smaller. With its large eleven-by-fourteen-inch format, painterly illustrations, and full-color layouts, *Apparel Arts* soon won a place on top of, rather than underneath, retail sales counters. Displayed on a little bookstand like a fashion bible, its entrancing pages could be

Arrayed in America's homegrown sportswear, England's Duke of Windsor relaxes in his incomparably stylish, yet inimitably patterned manner.

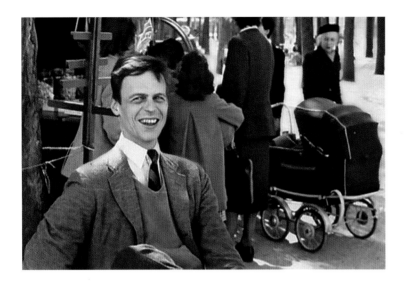

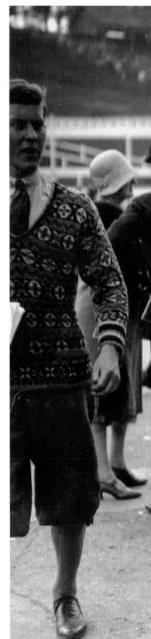

consulted by salesmen and customers alike. So successful, two years later the same editorial team launched *Esquire* magazine, this time aimed at the general public.

Of course, the Prince of Wales's sartorial comings and goings were chronicled in both publications with *Apparel Arts* sometimes devoting an entire issue to his seemingly daily flights from English court and royal dress protocol. As the world's most famous and eligible bachelor, the travels and maverick tastes of the Prince of Wales elevated male stylishness to a public art form. With the close of World War I, he personally birthed the "dress soft" movement, being the first heir to a British throne to abandon the stiff, Victorian dress of his forbearers wherever and whenever he could. Later when he was known as the Duke of Windsor, he would live out his life championing male style as an intimate mix of easygoing imperfection and improvisation. Diana Vreeland, *Vogue* magazine's legendary fashion editor, termed his dressing style *chic fatigue*, or casual elegance. His sporty but elegant chic was not in just what he wore, but the ease and naturalness with which he wore it.

The interwar years became the launching pad for American men's fashion, emboldening its jet-setting males with the sartorial confidence to take their place in and around Europe's toniest watering holes. Role models in the form of smartly dressed socialites, fashion-savvy business leaders, and Hollywood's custom-clothed movie stars were there to direct traffic, making it easy for the rank and file to admire, identify, and ultimately imitate. By the time the States returned to fight World War II, "casual elegance" as a coda for male stylishness moved from the wings to center stage, validating America as its pioneering playground and leading protagonist.

While America's interwar year fashions would influence upper-class menswear taste for years to come, the immediate inheritors of its mantle were those who understood what Brooks Brothers and other American garment makers had long been practicing: the less there is in a garment, the better one feels in it. Compared to the padded, structured

Left: A descendent of America's Mayflower Waspocracy, author and editor of the *Paris Review*, George Plimpton is attired in typical prep school totems: tweed coat, Brooks Brothers button-down, rep tie, and favorite Shetland sweater.

Right: Upper-class lads rigged out in spectator sportswear circa 1920s England.

silhouettes of continental Europe, the American cut left room for both comfort and the imagination. These differing fashion DNAs were to prove instrumental in propelling American men's fashion to the forefront during the spectacular unveiling of its next frontier—sportswear, vacation attire, and warm-weather clothing.

From America's high-stomping grounds like Newport and Palm Beach to the Riviera's better-tailored playgrounds, sun-soaked fashions spread like wildfire. The international swagger of fashion's new dressing ideal was fed by the eclectic chic of France's Basque fisherman shirt, Scandinavia's peasant sweater, Spain's working-class footwear, England's sailor uniforms, and American sports clothing. By the end of the 1930s, warm-weather fashions unglued more

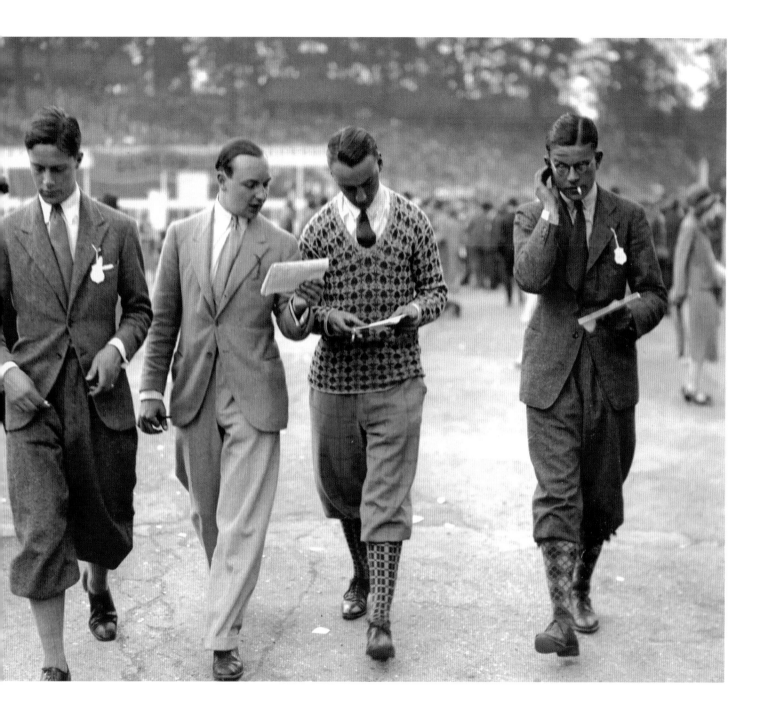

countries' style envelopes with new ways to wear and pair different clothing genres. Not only were these comings and goings evocatively depicted on the pages of *Apparel Arts* and *Esquire* magazines, American menswear took the lead in showing the rest of the world how the new leisure-driven clothes could be mixed and matched.

Passionate to add more range to what he had gleaned about old-world elegance from watching Hollywood films of the period, Ralph had no further to look than within *Apparel Arts* and *Esquire* covers. All was laid out in colorful prose, actual fabric swatches, and gorgeous color illustrations, courtesy of the Beaux-Arts trained and bespoke-attired painters and illustrators who knew their way around the fitting rooms of the world's top custom tailors.

Just as American menswear was about to be invaded by Europe's designer fashions, here came the colonies' own Lone Ranger to save, or for the moment, stave the day. Were it not for the stirrings of this one Bronx native bent on reclaiming his country's abandoned high ground, the nation's Anglo-American style bearings might have forever disappeared under waves of repeated fashion pounding. Thus Ralph set out to build his menswear business while finding his place in the larger fashion firmament. Like other pioneers, Ralph's road was yet untraveled. With no map or directions, it was charted principally by the designer's instinct and imagination. In less than five years, Ralph would turn around to find throngs walking in his shadow. In the words of another visionary, "build it and [they] will come." And that's exactly what Ralph did.

As his confidence grew, so did Ralph's creative prospecting. Just as slipping
behind the wheel of his first Ferrari introduced him to an alternative motoring
aesthetic from that of his British and German roadsters, the designer began
casting his design net toward new fashion frontiers. From Santa Fe to Savile Row,
the Riviera to the Rockies, Ralph was to evolve a larger visual footprint
than any designer before him.

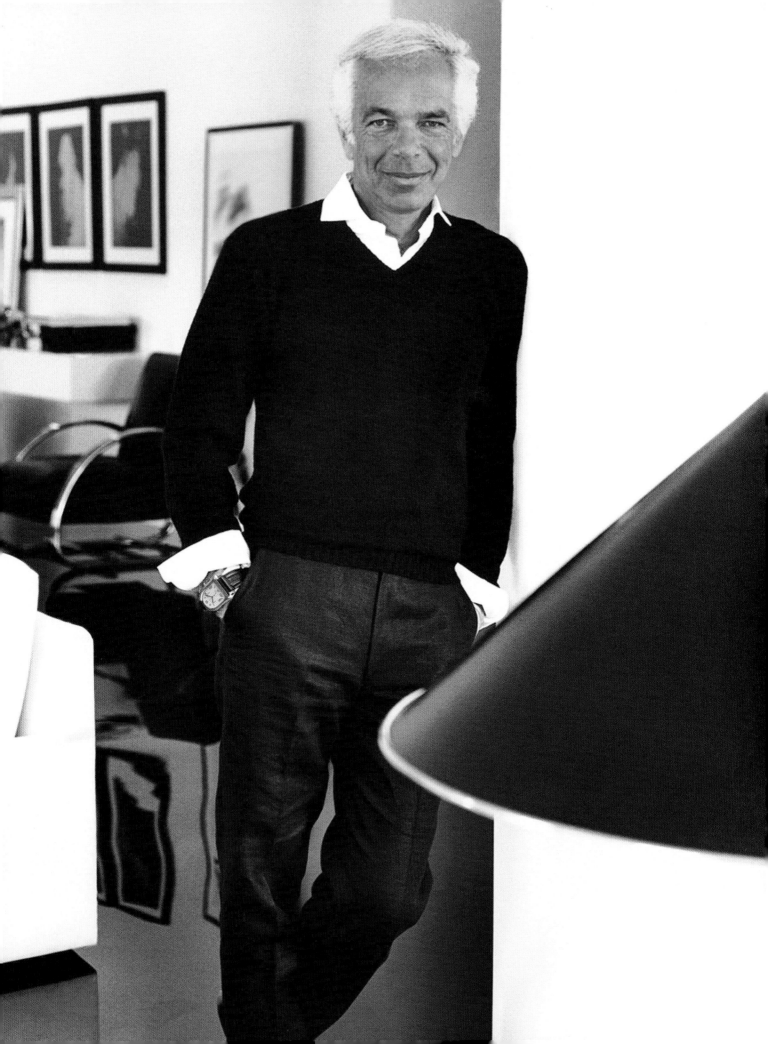

**the
big
knot**

Drawing by Michael A. Farina

This tie is KNOT fashion.

Fashion headlines today are written on the neck . . . and the tie meets the turtleneck challenge with width and the big knot.

It is changing the look of shirts . . . the collars must be fuller . . . wider . . . longer. It all fits the flare of today's shaped clothing.

Ralph Lauren (Polo) makes the big knot his signature . . . and emphasizes it with bulky textures.

Wide knot?

GETTING THE GANG TOGETHER

I t was 1967. Ralph's vision of the Polo customer was that of a man who bought his own clothes, as opposed to his wife doing his bidding. Still a traditionalist but no longer a prisoner of his college button-down persona, he avoids the trends while being quality-minded and taste seeking. From the very beginning, Ralph would state that he wasn't just selling ties but a different level of taste. As Ralph's larger neckties started to become status symbols, it became apparent that they were going to influence not only the look of neckwear but that of dress shirts and suits as well.

"Maybe it sounds hackneyed to say it depends on taste, but the level of taste is so important," asserts Ralph in a 1969 *Menswear* article. "It can't be just a one-shot idea or you flare up and burn out in a season. Longevity of taste is what I'm after and I know most buyers are after the same thing."

Anthony Edgeworth grew up attending boarding school and buying clothes from Madison Avenue's high-prep purveyors. Working for Norman Hilton in 1968 as his Midwest salesman, Edgeworth first encountered Ralph sporting his tailored look while watching him present his collection at the Princeton Club where Hilton was holding a seminar. Later in the year they crossed paths again at the Hilton offices where Ralph was sporting a Gatsby-looking gusset-back suit with pleated pants. "Nobody was wearing pleats in their pants, no one in America could make a fitted jacket with armholes high enough to get a close look across the chest," says Edgeworth, in *Genuine Authentic*. Ralph did. It wasn't long before Ralph recruited Tony to be his first sales manager.

Although Ralph didn't know much about the nuances of crafting tailored clothes, his natural curiosity fed his hands-on learning style. He chose the fabrics, approved the buttons, thread color, pockets, everything. Even if he didn't know what he wanted when he started, he knew it when he saw it. What he lacked were the technical skills honed over a lifetime of working at places like the Hilton clothing factory.

From the very beginning, the Hilton manufacturing relationship was a rocky one. Hilton's chief pattern maker and designer, Michael Cifarelli, didn't understand or agree with what Ralph wanted, clashing with him over how the Polo clothes should look. Although Cifarelli accepted that his name was not going to burnish the Hilton product, who was this young upstart who wanted to put his label on clothes for which Cifarelli was creating the patterns and whose manufacture he was supervising? He just didn't see the value in trying to explain the subtleties of fine tailoring to someone who had risen to prominence designing napkin-like neckties cut from drapery-like materials. Moreover, the Hilton factory made a higher-shouldered garment than Ralph liked. Ralph wanted a jacket with extremely soft, natural shoulders known in the trade as shirt-sleeve shoulders, a shaped body with a front dart for waist suppression, a low button stance, and a skirt that flared out at the hips. In other words, his was a silhouette that significantly departed from what the Hilton factory had historically made and become famous for.

Therefore, when Hilton tried to make Ralph's model, they couldn't get it to fit right. At one point during one of Ralph and Cifarelli's epic head-to-heads, the master tailor calmly removed the jacket-in-question from its fitting

Daily News Record, December 1967.

NEW YORK INTELLIGENCER

By James Brady

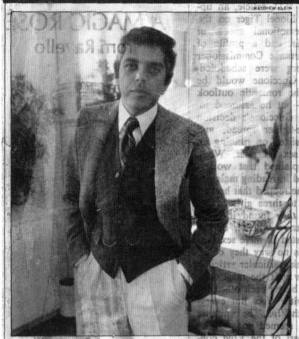

New golden boy in the fashion industry, Ralph Lauren.

Ralph Lauren—the Best-Dressed Man in Town

Last Wednesday evening the annual Coty Awards for fashion were handed out at Lincoln Center, and for the second time in three years Ralph Lauren was saluted for his men's-wear designs. It is the first time a men's-wear creator has been a two-time Coty winner (Coty Awards are the Oscars of the fashion world). A few days before the ceremonies, I went up to Lauren's office at 40 West 55th Street to chat.

He pushed his appointment book across the table where we were drinking coffee and pointed to the names of Robert Redford and Barbra Streisand, inked in on a Saturday page. "I've been doing Redford's clothes since I got him out of jeans," he said. "But I'd never even met Streisand. Her secretary called the other day and asked could I do some clothes for Barbra. You know, I got really excited."

Ralph Lauren is a young man (he turned 34 on October 14) with graying hair and a slight speech impediment. He has become, in a very short time, one of the country's most successful designers, winning not only the Cotys, but this year's Neiman-Marcus Award for his men's designs. (Eighteen months ago Lauren introduced a line of women's clothes under the label Ralph Lauren; the label on his men's line is Polo by Ralph Lauren.)

Recently, he designed the men's clothes for the forthcoming film, *The Great Gatsby.* "It was very important professionally for me to do the clothes for *Gatsby,*" he said. "Of course they paid me for the clothing itself, but no fee. The publicity has been terrific. Now a lot of people want Ralph Lauren clothes."

Like Jay Gatsby, Lauren has come a long way. He grew up on Mosholu Parkway in the Bronx, graduated from De-Witt Clinton High School, and attended C.C.N.Y. business school. "I didn't graduate," he confesses. "At nineteen I was a salesman for Brooks Brothers. Then I went into the Army, and when I got out I was an assistant buyer for Allied Stores. After that Beau Brummel hired me. They are a clip-on tie company in Cincinnati. I sold them an idea —using different kinds of fabric for wider ties. I had the ties made by a contractor, packed them myself and delivered them to the stores wearing a bomber jacket and jeans. They went wild for the ties—it was just after the Carnaby Street mod explosion. Meledandri was the first store to buy them from me, then Neiman-Marcus, Paul Stuart and Bloomingdale's." From ties, Lauren went on to men's suits and separates.

"When I came into the business, there were manufacturers but no designers. I've always loved Fred Astaire and the Duke of Windsor. They had a great deal of dash and style in the way they moved. There was nothing contrived about their clothes. And Katharine Hepburn in boots, jodhpurs and a sweater, with her hair flowing—that's the look."

Lauren's annual volume is now $13 million in sales. He owns a shirt factory in Mount Vernon, has started a younger line called Chaps, and he has just bought out his original partner, Norman Hilton ("I still owe him money, but I'm the sole owner"). He admits that this year has been tough. "We doubled in size. Really, we grew too fast. We didn't make any money at all. When I saw *Save the Tiger,* I couldn't relate to the character at all. Now I understand. You really learn who your friends are."

Seeing his company grow so quickly, Lauren understands now that he must build an organization in order to control costs and make a profit. "I've hired a new financial man and brought in my brothers, Leonard in administration and Jerome in design. I always stayed away from having family in the business. It usually isn't a good idea. But I started the business and now I'm bringing them in. It isn't as if they were in it with me from the start."

Although this has been a lean profit year, Lauren is living well. He and his wife, Ricky, a former schoolteacher, have two boys, aged four-and-a-half and two. They have an apartment in the East Seventies and rented a house in Amagansett this past summer. "We're very unsocial," he admits. "We like to go to the movies and eat Italian food. Gino's is our favorite restaurant."

A New York retailer who works closely with Lauren warned me he had a "monumental ego." When I asked him about it, he said, "If you're good, some people take it as ego or cockiness. Once I went up to New Haven to Gant [the shirtmakers] looking for a job. I was a fan of theirs but I thought they were falling asleep and I told them so. Their reaction was, 'Who's this cocky young kid?' and I didn't get the job. Two years later they wanted me."

The Lauren ego—or perhaps it's simply competitiveness —surfaced when I asked which other designers interested him. He named only two—Norell and Chanel—and they are both dead. "It wasn't Chanel's clothes I loved, but what she represented—taste and understatement. Norell believed in something and he didn't go commercial."

As we walked to the door, I asked why he had chosen that location for his operation.

"I didn't want to be on Seventh Avenue," Lauren said. "Maybe I'll have to be there someday. But not now."

It was after six o'clock and Lauren planned to go back to work after he waved me off. As we waited for the elevator, he looked worried. But he also looked very nice in his Ralph Lauren suit, his Ralph Lauren shirt, and his Ralph Lauren tie.

form, threw it on the floor, and then began to jump up and down on it. No surprise, the first suits delivered to Bloomingdale's didn't fit and were immediately returned. Blame was passed around generously.

In the spring of 1970, Ralph was introduced to Leo Lozzi, another brilliant yet headstrong Italian tailor who had been brought to America years before by Southwick Clothing, a soft-shouldered suit manufacturer in Massachusetts. Some years later, Lozzi decided to strike out on his own and was now a partner in Lanham Clothes, a menswear factory situated in Lawrence, Massachusetts. At one point he showed Ralph a jacket he had been working on and Ralph was smitten. Jeffrey A. Trachtenberg wrote in *Ralph Lauren: The Man Behind the Mystique*, "Lozzi understood what Ralph wanted. 'Norman Hilton made good clothing, but Ralph wanted perfume,' says Lozzi. 'Ralph is not a clothing man and he talks very little, but he has a vision which he gesticulates with his hands. He makes a motion and then another one and I understood what his motions meant, they were very interesting to me. He wanted a garment to look this way, rounder, softer, a longer lapel, high pockets, shaped, he makes this motion and you have to understand . . . and I did in my own way.'"

That would explain why, despite being partners with a company that owned one of the country's premier clothing factories, Ralph decided to have his Spring 1971 line manufactured by Leo Lozzi at Lanham. Naturally, Norman Hilton argued valiantly against such thinking, but Ralph had made up his mind.

Ralph worked long hours, sometimes twelve-hour days, and expected others to do the same. The designer was idealistic and totally lived what he was doing. Charismatic, he inspired great loyalty and a strong desire to please. Maybe it was his soft voice or need for approval, but he could really generate emotion in others. As with family, whoever ended up working late would be invited out for a quick meal to a favorite burger joint like J.G. Melon's.

Ralph operated on instinct, one-on-one. Surrounding himself with people who would get to know him so well they would compete to predict his reaction to new design ideas or products. "Oh, Ralph will like that or he'll hate that." A great motivator, he could make you feel on top of the world or knock you off it if he felt you were not trying your hardest. Some looked to Ralph as a father figure, others so believed in his products that they bought into his dreams as if they were their own. For some it bordered on a cultlike worship, with Ralph as the hero. They believed, preached, and dressed the myth. Everyone stretched themselves to try and make happen what they thought Ralph expected from them. They lived for his approval.

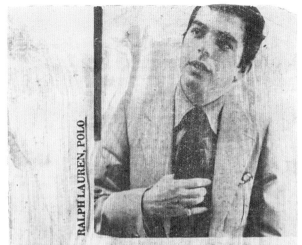

RALPH LAUREN, POLO

"I think the stores have blown it. One reason is they took designers as a lark, not seriously realizing the importance and opportunity for extra sales. They used designers to create traffic to sell regular clothing. They didn't stock the designer shop, they didn't take a stand and really project designer's look and image. They only took this or that designer because the store across the street would have gotten him if they didn't — it was just defensive buying, a list of names to give them prestige. But they didn't even think about the sales. The 'they' is the department stores. They were the first to start designer shops and it could have been a nice way for them to establish a point of view on men's fashions. Most men's specialty stores already have a point of view. Department stores don't because they are so diffuse. I do believe in designer departments as a shop-within-a-shop concept, but a designer shop that has a point of view, that has stock, that has an atmosphere and room for a man to relax and try on clothes. It's like a couture concept."

— BUFFY BIRRITTELLA

73

With expectations riding so high and being a perfectionist, Ralph would not stop until he was sure he had gotten everyone's best effort. "Life with a perfectionist is not without its dramas. He's absolutely terrible at hiding his feelings," says Buffy Birrittella, his alter ego and longest-tenured executive. Charles Fagan, now Ralph's chief of staff, states, "He's an enthusiast for hard work. As he once said to me, 'You'll always be moving uphill if you're any good. Don't ever expect to be cruising downhill; when that happens, it's over.'"

Back when he was the manager of Brooks Brothers' custom suit department in the early 1960s, Joe Barrato tells of coming upon a rounder of neckties arranged so meticulously that each tie looked as if it were standing at attention. Inquiring as to who had displayed them so beautifully, he was introduced to Ralph. They immediately became comrades in arms. Prior to working there, Barrato imagined that the world of Brooks Brothers, with its patrician undercurrents, must be akin to the life he saw portrayed in movies like *Sabrina* and *The Philadelphia Story*.

By the mid-sixties America's traditionalist favored Southwick's or Brooks Brothers natural-shoulder clothing; dress trousers from Major or Corbin; neckwear by Rooster or Rivetz; Brooks Brothers, Sero, or Gant dress shirts; Canterbury surcingle belts, and Bass Weejuns or Brooks

Brothers tassel loafers. Ralph and Joe would grab lunch regularly, and Ralph would rhapsodize how he planned to update these sleepy classics and gather them anew under the banner of his Polo business. One day, running into each other on Fifth Avenue, Ralph spirited Joe back to his Fifty-Fifth Street offices where he convinced him to quit his job and come work for him as his third employee and sales manager. As his newest convert tells it, "I believed in everything Ralph told me."

When they first met, Barrato thought he had a natural feel for taste and clothes. As he told it, "Ralph taught me taste, he could discuss the mechanics and minutiae of men's style for hours. He taught me that we were gentlemen, unlike *garmentos*, who were not always on the up and up, that we were above that." One day Ralph ushered Joe into the Gucci store on Fifth Avenue (which still adhered to the Italian retail custom of closing its doors for lunch between one and two o'clock). Ralph insisted that Joe buy a pair of its classic buckle-trimmed slip-ons. Joe didn't know anything about Gucci or its namesake loafers, trying to explain to Ralph how they would be the equivalent of a week's pay. Walking out with his purchase, Joe experienced the first of his many baptisms into the house of worship Ralph was building where the lack of separation between person and state demanded an acolyte's complete devotion.

As Joe extols, "Ralph's religion was good taste and excellence, and who'd turn down a chance to join that church?" The Polo business was now really beginning to shift into a higher gear. Barrato was the ideal votary, a believer whose personal ambitions were now totally aligned with those of Ralph. Polo needed more staff, more loyalists, just like Joe.

Ralph Lauren was featured on the front page of *The Daily News Record* in February 1969. The name on the byline was its fashion editor, Buffy Birrittella. Growing up in New York's Westchester County, Birrittella attended Skidmore College, a prestigious liberal arts college, graduating with a degree in English and art history. Moving to New York, she went to work for Fairchild Publications. Over the next few years, Birrittella would repeatedly interview her favorite designer, getting to know him better while coming to admire his sense of style and where he was going.

By this time it was becoming apparent that Polo needed someone full time to handle the increasingly

time-consuming demands of the press and public relations. As chance would have it, Ralph and Joe Barrato were out on one of their talking walks on Fifth Avenue when they ran into Birrittella. She kidded them about how they could use someone like her, prompting Ralph to think about it and, in no time, agree.

Birrittella joined part time in January 1971 and started full time that April, and the most important and enduring working relationship of Ralph's career began. As the longest-standing member of the designer's original team, Birrittella has been at Ralph's side for more than four decades and is, as she readily admits, "part of the furniture." Quickly becoming his gal Friday, nobody knows more about the company's history, where it came from, its early struggles, its successes, and most important, the designer's thinking. Buffy continues to bask in the glow of her boss's admiration and respect for her unwavering loyalty and irrepressible competence. Ralph would paint the big picture; Buffy would edit and flush out the story line to ensure it reflected Ralph's intention and vision. Together they breathed life into a singular, and for its time, maverick dressing philosophy of style over fashion as well as the movie that continued to percolate in Ralph's imagination. Part architect, part gatekeeper of the Polo canon, Birrittella can finish Ralph's sentences and often begin them.

Gil Trueddson came on board to develop new products for the expanding Polo collection, arriving as Polo was transitioning from an item business, like neckties, to a collection and lifestyle one. Gil had been designing imported sportswear and outerwear pieces for Norman Hilton where he would present them together, coordinating and layering each item with another. When Ralph visited Hilton's New Jersey factory for meetings, he'd poke his head into Gil's office and they'd sit down and chat. Ralph would take it all in.

With no formal design training, Ralph had to rely on others to help him create that which he could not do on his own. Says Gil, "I have to admire Ralph for many reasons, but especially back in those early days, he had no fear of hiring those who had more product knowledge or were more design capable than he. His deal was to put the best product out there—the best-quality fabric, stitching, packaging, et cetera, so no one could ever complain. He

> "WE'D BE STUCK IN THESE LATE-NIGHT DESIGN MEETINGS WHERE RALPH WOULD GO BACK AND FORTH TRYING TO DECIDE THE EXACT RIGHT SHADE OF NAVY FOR THE NEXT COLLECTION. BY THE TIME IT WAS OVER, ALL YOU COULD DO WAS DRAG YOURSELF HOME."
> —JEFFREY BANKS

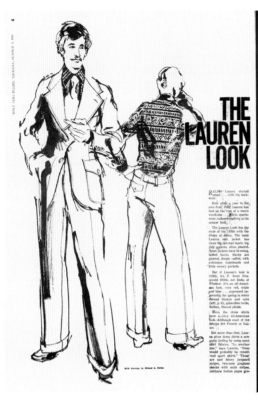

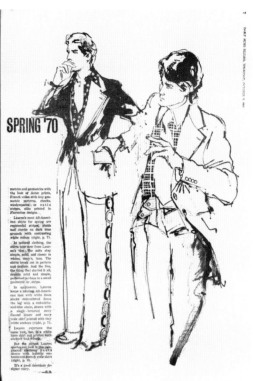

THE LAUREN LOOK

SPRING '70

RALPH: Lauren started small . . . with big neckwear.

Now after a year in his own field, Ralph Lauren has tied up the rest of a man's wardrobe . . . shirts, sportswear, tailored clothing in his unique look.

The Lauren Look has the style of the 1930s with the shape of today. The basic Lauren suit jacket has three big notched lapels, big hip pockets, often pleated. Sport jackets have bi-swing, belted backs. Slacks are pleated, deeply cuffed, with extension waistbands and little money pockets.

But if Lauren's look is 1930s, it's F. Scott Fitzgerald 1930s, not Duke of Windsor. It's an all-American look, very red, white and blue . . . expressed impeccably for spring in white flannel blazers and suits (left, p. 6), gabardine twills, denims, flannel plaids.

Even the dress shirts have a very all-American look, although most of the fabrics are French or Italian.

But more than that, Lauren gives dress shirts a new gutsy feeling by using sport shirt fabrics. "In another line," says Lauren, "these would probably be considered sport shirts." These are new heavy jacquard stripes, two-tone gingham checks with satin stripes, intricate Indian piqué geo-

metrics and geometrics with the look of Aztec prints, French voiles with tiny geometric patterns, checks, windowpanes — or satin stripes, silks printed in Florentine designs.

Lauren's most All-American shirts for spring are regimental striped, plaids and checks on dark blue grounds with contrasting white collars (right, p. 7).

In tailored clothing, the shirts take over from Lauren's ties. The suits stay simple, solid, and classic in whites, navy's, tans. The shirts break out in pattern and texture. And the ties, the thing that started it all, remain solid and simple, patterned perhaps in a small geometric or stripe.

In sportswear, Lauren keeps a nautical All-American look with white linen slacks embroidered down the leg with a red-white-and-blue chain, shown with a single-breasted navy flannel blazer and navy voile shirt printed with tiny white anchors (right, p. 7).

Lauren expresses the same look, too, in a white linen shirt suit printed with anchors and whales.

But the richest Lauren sportswear look is the pale, pleated uniformy PANTS shown with lavishly embroidered down-to-your-shirt (right, p. 6).

It's a good American designer story.

— B.B.

75

trusted my eye and taste and taught me about seeing more than the sum of the parts. He was a genius at conceptualizing the other elements in the larger picture and had great marketing imagination."

Jeffrey Banks was another of Polo's early hires who soon became a member of the extended Lauren family. So enamored of all things fashion and style, Jeffrey may have been the only high-school student in Washington, D.C., with his own subscriptions to the *Daily News Record* and *Women's Wear Daily*. At fifteen he was working as a salesman for the legendary Washington retailer Britches of Georgetown. By his senior year, Banks's very nonteenage wardrobe boasted a liberal sprinkling of Polo merchandise.

Jeffrey first met his idol when the owners of Britches asked him to take the company station wagon to the airport and pick up Ralph and Joe Barrato for an in-store appearance. Rigged out in full-tilt Polo regalia, he set out in the car and it promptly had a flat tire. Fortunately, the plane was delayed and Jeff was able to fix the tire and squire them to

the store on time, afterwards sharing some one-on-one with Ralph. They discussed clothes and Hollywood glamour as well as the pros and cons of Fred Astaire and Cary Grant dressing styles. Jeffrey can still describe the outfit Ralph wore that day.

In the spring of 1971 Jeff was talking to Ralph about his plans after graduation when the subject of what he was going to wear to his senior prom came up. Jeff confided to Ralph that he couldn't find the right peaked-lapel tuxedo, so Ralph offered to lend Jeff his own, as they were both size 37, although the pants had to be let down a bit. When Jeff came to New York to study fashion at the Pratt School of Design, Ralph took him under his wing. Eating home-cooked meals with Ricky and Ralph, Jeff would stay overnight at their house, sometimes babysitting for their kids on weekends.

Jeff recounts, "I took Andrew to his first movie. I think it was *What's Up Doc*, at Radio City Music Hall." As Jeffrey intones, "Ralph was like a proud father to me. He'd taken to calling me 'the Prince' because I liked to dress up. I never felt like an outsider. Ralph made me try my first

Looking beyond the Ivy League's stomping grounds, Ralph was able to steer his way past their high-prep pavilions toward a playing field of his own.

"MOST PEOPLE
WHO HAVE RISEN TO HIS
HEIGHTS START TO
TAKE IT EASY. BUT SUCCESS
HASN'T DIMINISHED THE
SPARK IN HIM. HE
WANTED TO BECOME
THE BEST. HE BATTLED
EACH DAY TO
GET WHERE HE IS, AND
HE'S STILL BATTLING.
RALPH'S THE MOST
DRIVEN PERSON YOU'LL
EVER MEET."

—BOB STOCK

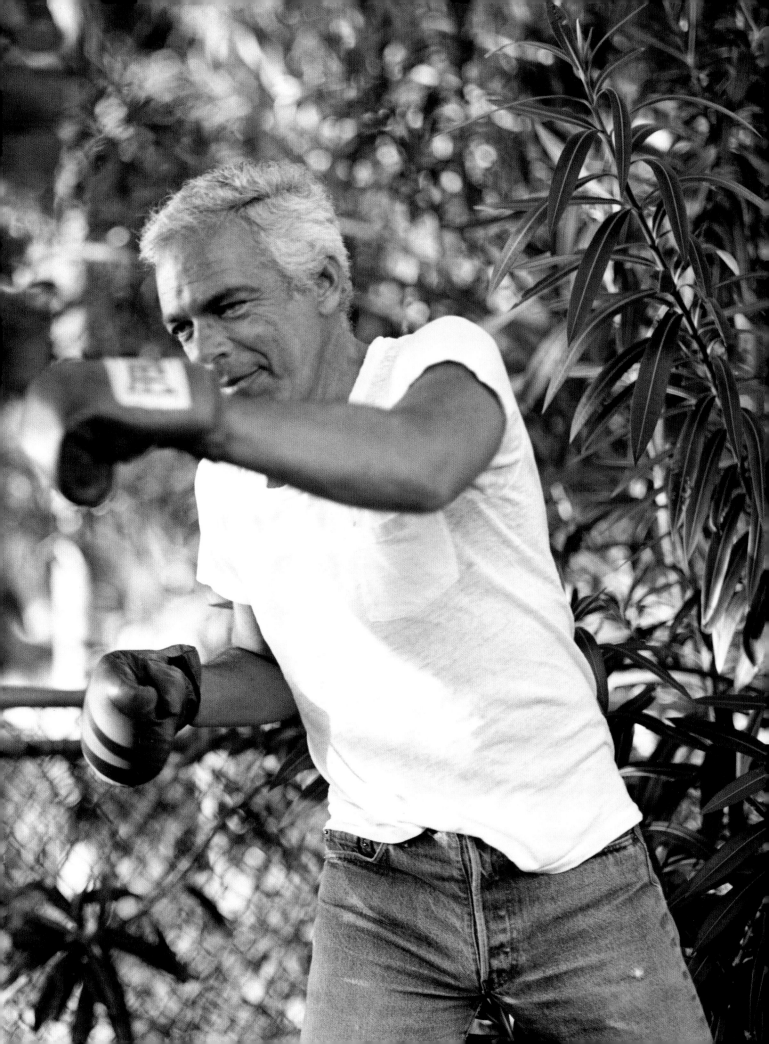

drink. I was seventeen. I'd ordered a Coke and when Ralph found out that I'd never had a drink, not even a glass of wine, he cancelled the Coke and ordered a margarita with salt, which he made me drink.

"On the other hand, you worked there and the hours could be interminable. It was your life, you subjugated everything to it, and it could be intense. On an up note, Ralph has a wonderful sense of humor, and when he laughs you feel the sun shining down on you. Nevertheless, when he's disappointed or frustrated, the temperature can drop very quickly, it can get rough. We'd be stuck in these late-night design meetings where Ralph would go back and forth trying to decide the exact right shade of navy for the next collection. By the time it was over, all you could do was drag yourself home and get into bed."

As for Ralph being able to inspire some to such dizzying heights that they'd "walk through fire" for him, one literally did. Salvatore Cesarani actually charged into a fire at the Lanham factory, risking his life to save the season's samples as designer Leo Lozzi yelled at the top of his lungs for young Sal to get out of there.

Cesarani also knew his way around Seventh Avenue and the women's business, having freelanced as a designer for a number of womenswear companies. In late 1971 Ralph hired Sal to help him launch a full womenswear collection. They had first met when Ralph worked for Rivetz and he'd petition Cesarani, who was in charge of display for the Madison Avenue men's store Paul Stuart, to feature his neckwear in their windows. Over time they became friends, crossing paths in the course of shopping the same stores. When Ralph was in need, Sal would sometimes moonlight at Polo, rounding up display furniture for the Polo offices or creating presentations for the new collections. Although not a trained womens-wear designer, Sal was a graduate of the Fashion Institute of Technology and he possessed all the technical skills to turn Ralph's ideas into three-dimensional garments.

Nobody believed in Ralph like Sal, who was also young, passionate, and a dreamer. He felt Ralph respected his vision, which for Sal was Ralph's greatest gift to him. Sal was the first to arrive and the last to leave. After all, he was working side by side with a man who was becoming famous and whose vision he totally believed in.

Jeffrey A. Trachtenberg writes in *Ralph Lauren: The Man Behind the Mystique*: "Sal recollects, 'Also Ralph was under a lot of pressure. I felt so protective of him. Once we

went to dinner at a club in London where Ralph sat down to order and then said he felt faint. He looked so white I took him downstairs to the bathroom to wash his face and rest. Returning upstairs to wait, I remember saying to myself, 'God, don't let anything happen to him.'

"Sal noticed many things about Ralph—his enthusiasm, his patience, his taste level. But there was something else, something that others may have over-looked. Ralph had to win at everything he did. 'One night we went to a friend's house in Rye, New York. Afterwards we went downstairs to the basement to play ping-pong. Every game Ralph played he won. The others wanted to win. But nobody wanted to win more than Ralph.'"

While the Polo name was gaining recognition with the better men's customer, Ralph was becoming increas-ingly frustrated with those retailers responsible for selling Polo to them. "I'd have to keep him out of the showroom because he took it all too personally, he'd get emotional with store buyers if they did not buy the full collection or the directional pieces of each season," Joe Barrato recalls. "We'd be walking in Midtown by the discounter Sy Syms and find our samples and special production runs marked down for sale there, and he'd say to me, 'Why don't they get it? We have to open our own store.'"

In September 1970 Ralph won the Coty Award, the fashion Oscar created by the cosmetics company Coty Inc. Public relations dynamo Eleanor Lambert, a prime mover in the rise of postwar American fashion, had pitched the idea to Coty to create a Coty American Fashion Critics' Award to honor top American womenswear designers. She argued, prophetically, that the prestige of such an award would help lift the company's drugstore-selling image. And she was right. As American designers gained in prom-inence and status, some of that cachet rubbed off on the Coty Awards, making them the equivalent of the movie industry's Academy Awards.

By the late 1960s everyone was talking about the number of womenswear designers who had licensed their names to menswear manufacturers. Not one to miss an opportunity to promote American fashion and, in turn, herself, Lambert struck again, this time adding menswear to the annual Coty Awards evening festivities. In 1969 Bill Blass became the first menswear honoree and a year later, having been in business only two years, Ralph got the nod. As the States' only award for menswear design, winning the

October 1969. The Ralph Lauren shop opens in Bloomingdale's. Not only
was it the first time the store had given a men's fashion designer his own boutique,
it was also the first in-store men's designer shop in America.

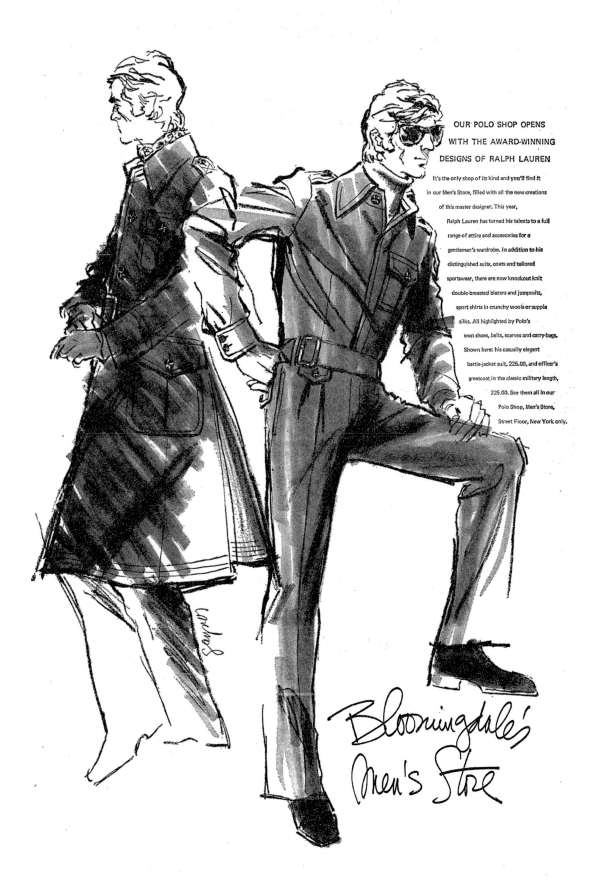

OUR POLO SHOP OPENS
WITH THE AWARD-WINNING
DESIGNS OF RALPH LAUREN

It's the only shop of its kind and you'll find it
in our Men's Store, filled with all the new creations
of this master designer. This year,
Ralph Lauren has turned his talents to a full
range of attire and accessories for a
gentleman's wardrobe. In addition to his
distinguished suits, coats and tailored
sportswear, there are now knockout knit
double-breasted blazers and jumpsuits,
sport shirts in crunchy wools or supple
silks. All highlighted by Polo's
own shoes, belts, scarves and carry-bags.
Shown here: his casually elegant
battle-jacket suit, 225.00, and officer's
greatcoat in the classic military length,
225.00. See them all in our
Polo Shop, Men's Store,
Street Floor, New York only.

Bloomingdale's Men's Store

Coty could overnight inflate a designer's business fortunes. The press would be coming around more regularly to report on the designer's comings and goings while the leading fashion-retailers would also be more compelled to hitch a ride on the designer's publicity coattails.

Becoming a Coty Award winner elevated Ralph's fashion star significantly. That month, the *Daily News Record* interviewed Ralph about his thoughts on the state of retailing and the role of designers in menswear. Ralph was direct and forceful. He was quoted as strongly criticizing the stores for their lack of commitment to the designer business, accusing them of using designer names as lures while not buying enough of their merchandise to present a real point of view. Ralph's answer was a fully stocked and defined shop-within-a shop housing the designer's products where a man could decompress and leisurely try on clothes. As usual Ralph was not wrong, however, his future-looking merchandising vision had yet to ingratiate itself with the retailing community. But one store was about to step up to the plate.

By this time Ralph was now making all kinds of merchandise, and he wanted all his products presented together as opposed to being spread out, like in Bloomingdale's, all over their expansive men's department. Suits were found mixed in by size in separate walled-off spaces while ties hung together in the necktie department, with both merchandise classifications just as likely to be sequestered on opposite sides of the men's department or on different floors. It certainly didn't make for a very consumer-friendly shopping experience, particularly if the client happened to be drawn to a particular brand or designer where a range of products was available.

Ralph reasoned that his broad-lapel suits, wide neckties with their big knots, and dress shirts with their larger scaled collars would add up to more than the sum of their individual parts, creating the potential for multiple sales while providing an aesthetic umbrella for his rainwear, luggage, sportswear, and belts. At the time, nobody had ever conceived of presenting men's clothes that way. Retailers were also not inclined to pull merchandise together and display them as outfits when the sales staff who were typically assigned to a specific department would then have to leave their posts and escort a customer around the four corners of the men's department to hunt down the desired coordinates.

As Ralph tells it, "In 1969 and 1970 there wasn't any real sportswear. One guy would make a jacket or chinos or shirts. There were casual clothes but no sense of development. Most retailers only understood suits and jackets. They carried some sweaters, but there was no rough wear, no activewear. Those were my things, and I went to different manufacturers and had them make them for me. I was aiming at a quality-conscious high-level consumer, the man who wanted change and understood it and was well traveled."

Ralph recognized early on that no man adopted one dressing style all the time; you may be a business executive during the week, a sportsman on the weekend, and a social bon vivant at night. He thought that this new generation of male consumers wanted a choice of clothes that reflected how they lived, just like their cars, homes, and restaurants did. Ralph was persuaded of this multiple-identity approach because like most men he dressed one way for work and another way at home or on weekends.

Taking hold was one of Ralph's most important and game-changing contributions to not only the emerging designer landscape, but the future of modern retailing: lifestyle merchandising. Over the years, Ralph would flesh out his own idealized worlds into panoramic vistas that employed clothes, furniture, and props to advance a larger visual narrative. However, back then, broaching such a subject, particularly to a department store, was like rubbing chalk against a blackboard—its mere suggestion sent shudders of negativity up their executives' collective spines.

Finally Ralph decided to confront Bloomingdale's. He tried to explain to Frank Simon that he was trying to sell not just merchandise but an aspirational image of the way he saw his customers wanting to live. As he was just starting out, he could not afford to advertise and therefore the shop concept was the only way for him to articulate his vision and shape his story. Not surprisingly, Simon's knee-jerk reaction was both stridently negative and dismissive. He warned that putting all the Polo merchandise in one place would diminish sales in the store's other departments and thus reduce overall volume. Simon told him politely, but firmly, "No way."

Ralph looked him straight in the eye and told him he would walk if they didn't build him a shop. Said Simon, "That's Ralph, he's a good, cool negotiator, and he's consistent. He doesn't come in with one idea one day—and another idea the next. He even knew which home furnishings he needed to help stage his merchandise. He had

81

September 1971, Rodeo Drive, Los Angeles. The opening of the first self-standing men's designer store in America. Pictured here are Ralph Lauren, Jerry Magnin, and the store's first manager, former model Bill Loock.

the dream but he wasn't big enough to do it himself—so we helped him."

It also didn't hurt that Bloomingdale's was trying to establish its own designer bona fides to catch up with the other three dominant fashion powerhouses in town, Bergdorf Goodman, Saks Fifth Avenue, and Bonwit Teller. In Lauren, Bloomingdale's had its first exclusive with not only an American designer who had just won a Coty Award, but also a free thinker who seemed to be in lockstep with the culture, if not out in front of it. Precedent breaking and forward-looking, Ralph's thinking fell outside the industry's advertising practice of focusing more on the merchandise than on the man.

The Ralph Lauren boutique opened in the fall of 1969 on the 60th Street side of the Bloomingdale's main floor men's store. Fitted with special chestnut paneling, a stained parquet floor, and an oriental rug, it was the most expensive shop Bloomingdale's had ever built. It was also the first time the men's department had given a designer his own boutique. But for Ralph, it would be more than a place to sell clothes: It would be a setting where he could cultivate the man's imagination and taste in the same hands-on way a couturier does in his fitting rooms, where he and his female client collaborate toward a shared end.

It would also reflect how the designer thought his customers wanted to live. Ralph Lauren was the first designer to set clothes in a context and have that context depict a way of life, a lifestyle. It was like uncorking a magic bottle of champagne and unleashing an enormous lifestyle genie; there would never be a way to go back, to put it back in the bottle.

Bloomingdale's president Marvin Traub said at the time, "Ralph was one of a limited number of menswear designers who had a vision of where he was going. Clothing was on the second floor but Ralph wanted it all pulled together, so we did it on the main floor, opening the first designer in-store shop and thus dramatically altering the way designers and retailers would market and sell upscale designer labels. With its success came wider implications for the rest of the country."

Jerry Magnin was the grandson of Joseph Magnin, founder of the Joseph Magnin department store chain from San Francisco. In 1970 he was working as a men's merchandiser for the family business when he decided to pull up stakes and open his own trendsetting men's store on Beverly Hills' tony Rodeo Drive. On one of his buying trips to New York City, he found himself shopping Bloomingdale's and coming upon a display of Ralph Lauren's sportswear that literally changed his life. "It was the most exciting clothes I'd ever seen. My store sold high fashion and while it was working, my own tastes tended more toward the kind of updated traditional fashions that Ralph was doing. Also, I knew we were excluding the majority of the market by focusing on only the most advanced looks."

Meeting for three hours with Joe Barrato, Magnin tried to convince Joe to let him carry the full collection in his store. Magnin left empty-handed, as Polo had already given an exclusive in Beverly Hills to Berny Schwartz, owner of Eric Ross, a Meledandri-like menswear sanctum situated just off Rodeo Drive. Schwartz was one of the West Coast's most high-end men's retailers and an early believer in Polo. But by 1971 things had changed; Schwartz carried the Polo line but he was not as committed to promoting the Polo image as he was to building his own Eric Ross name and brand.

Returning to Los Angeles, Magnin considered the situation and then decided to call Polo and propose opening a self-standing Ralph Lauren store. Magnin would stock the store exclusively with Polo merchandise, and Ralph would be able to design the store and select the store's staff. Jerry Magnin was prepared to invest hundreds of thousands of dollars, because he believed in Ralph's vision and that together they could make money. Magnin did not have to do much persuading to convince Ralph that having a West Coast flagship store situated on Rodeo Drive, Los Angeles's most prestigious shopping street, could be a tremendous asset in helping to position the brand for growth inside and outside the States.

After a lot of internal discussions and soul searching, Ralph decided to go with Magnin. He wanted his business to grow while Berny seemed committed to prioritizing his own brand's future over Polo. They knew it would be a setback for Berny, but it was clearly the best thing for Polo. History would reward Magnin's initiative, as he remained in the Ralph Lauren business for the next twenty-seven years, finally selling his second, more elaborate incarnation of the original store back to Polo in 1998.

Three hundred guests attended the opening party in September 1971. It was the first freestanding designer men's store in the United States. Like Saint Laurent's revolutionary Rive Gauche store in Paris that pioneered French ready-to-wear, Ralph Lauren's Rodeo Drive emporium would become Polo's design laboratory, giving rise to new products and limited runs of exclusive merchandise. The store debuted Polo belts, the first sweater and shoe collections, and some women's and luxury sportswear items and bags. Its three thousand feet stimulated a voracious appetite for "the new" along with a constant need to flow product; it's hard to make money with unstocked shelves.

By this time the Polo label was drawing so many

customers that the popularity of its shirt and pant business was beginning to court the ultimate industry accolade—knockoffs—the industry's parlance for copying another's products at lower prices. Although the practice is as old as retail itself and on one level self-fulfilling and flattering, at some point the ego must take a backseat to business so as to find a way to capitalize on the spoils of its success. Every time Ralph walked into Bloomingdale's, he'd find knockoffs of Polo's pants at half his prices. It was becoming a big business and more than one store executive advised him that he should be profiting from it himself.

Enter Bob Stock, an old friend from back in the days when Ralph was selling Rivetz ties and Zizanie Cologne to the Alvin-Murray store on the Grand Concourse in the Bronx, where Bob worked as a salesman. Ralph had actually got "Bobby" his first job in the men's wholesale business selling trousers for the Paul Ressler company. As the years passed and Bob went from salesman to self-taught designer, the two stayed in touch. Stock, with two partners, had opened Country Britches, a company that made five-pocketed jeans in non-denim fabrics like tweeds and velvets. After some successful years, they decided to make a double-knit denim jean whose quality problems resulted in so many returns that by the time Ralph called to ask Bob if he would like to help him start a new lower-priced division, Bob saw the writing on the wall and joined forces with Ralph.

In March of 1971, with Bob Stock as a twenty percent partner to head up and run the new division, Ralph opened a new subsidiary, Chaps by Ralph Lauren. Soon the new business was taking large orders for five-pocket gentleman's bottoms in fabrics like corduroys and tartans that wholesaled from five dollars for basic jeans to thirteen dollars for chamois jeans.

As far as Ralph was concerned, why let a competitor exploit his designs when he could do it better himself. Doubling back on his original concept of "a collection under one roof," Ralph now wanted to create volume-priced items to sell on the classification-driven main floors of large department stores, like chinos in the pants department and oxford button-downs in the shirt department. He created Chaps because not only did it make good business sense, it was what the stores were clamoring for. Regardless, there was a longer-term strategy at work: If Ralph could get customers to spend twelve dollars on a Chaps bottom, in time he could trade them up to the better quality twenty-five-dollar Polo trouser and eventually up to two-hundred-fifty-dollar vested Polo suits.

Just as he had done so many times in his career, Ralph sidestepped convention to chart his own way. Striking out

An early Chaps advertisement.

where no designer had ever trod, he traded off his own higher-priced collection to move down to the moderate-price department store world. Although it would be years before a designer's diffusion or secondary line became the norm, here was Ralph Lauren laying the groundwork for the fashion designer business model of the future.

"They thought they were getting Polo at cheaper prices," recalled Robert Stock. "We put the pant line together, and then we had some suits and sport coats. Then it got wild. The business started growing by leaps and bounds. Ralph did this, he did that, and nobody knew what was going on." Despite increasing sales at Polo and Chaps, both companies began to experience production and delivery problems due to a lack of an experienced management team and a strong financial base to deal with the demands of higher inventories, increased staffing, and an expanding, multidimensional business. As Stock reminisces, "We grew too fast. Ralph had a good grasp of what was going on but he really didn't want to know about the financial side of the business. All we focused on was design, design, design. We were just a bunch of creative people who didn't know that much about running a business and thought that expansion would ultimately compensate for any momentary financial bumps along the way."

Although sales continued to grow, Chaps continued to struggle under the strain of Polo's mushrooming volume, as funds were being siphoned off to support Polo's expanding operations. As a twenty percent owner, Stock tried his best to hold on while Ralph got his larger financial house in order. Looking for ways to reduce the strain on Polo's cash flow, in 1974 Ralph decided to license the Chaps business to L. Greif & Bros., a large sales division of Genesco. Not

83

able to pay Stock what he owed him, Ralph offered Stock a choice: Either exchange the debt for a small fraction of Polo stock or pay him out over time. Creative but pragmatic, Stock chose the money and decided to move on.

Having lost the multitalented Bob Stock, Ralph needed someone who he could not only trust with the running of Chaps, but who could help watch out for his larger interests. With Ralph's growing world still feeling like a family to him, he decided that there could be no better place to turn than to his own family. Once again it was Ralph's great fortune that Jerry, his best friend and stylish older brother, was not only willing but capable, having forged his menswear chops at the same time Ralph was making his way up the designer success ladder. Working first for a major American textile converter and then as a stylist for several boys wear companies, Jerry was well-versed in the design and manufacturing side of the business as well as the inner workings of the men's industry.

From that moment on, Jerry would be at his brother's side, first riding herd over Chaps and then later over Polo menswear, where today, for more than forty years, he proudly presides. Other than Buffy, no other employee believed in Ralph's genius more personally or proudly than his brother Jerry. As his sibling's unabashed cheerleader, Jerry is always the first to initiate applause at any Polo outing or fashion show. Although not immune from the occasional brotherly dustup, Jerry was that family member who was always there for Ralph to bounce off business matters in confidence. And as a blood relative, Jerry both personified and reinforced the image of Polo as a family-centric company.

What first took root as adolescents playacting movie fantasies, later blossomed into a lifelong professional relationship that saw Jerry reprise his role as his younger brother's sidekick and coconspirator. How many business titans have had an older brother and best friend to watch their back over the course of their career? While some might consider fame and fortune the ultimate benchmarks of success, basking in your brother's unconditional love and support throughout the good times and bad is inestimable.

84

The Inner Circle: Ralph, Buffy, and brother Jerry helping the polo player to gallop as they nurtured the brand's design footprint forward.

UPON THE TERRA FIRMA OF HIS OWN TASTE

"I started out with a fashion concept, a taste level aimed at the traditional man, the kind of clothes I'd like to wear myself," Ralph told the *Daily News Record* in November 1973. The designer began to focus on the products that would turn Polo and Ralph Lauren into household names. Years earlier Ralph had bought a Levi's denim shirt and when he returned to buy another one, he found it lacked the quality of the first. Realizing that certain men's classics like the British tweed jacket, the cotton chambray work shirt, the Scottish crew-neck sweater, the army-tan chino trouser no longer were made from the same quality materials or with the same design integrity as their progenitors, he set out to revive them and, in the process, make them better than before.

Jeff Banks remembers walking into Brooks Brothers with Ralph one day and having the sales clerk announce that the hand-knitted cable wool socks by Mary's of Scotland that he had just sold them would no longer be stocked. Ralph turned to Jeff and said that these were the kinds of basics that Brooks had built their reputation and following on, and if they were going to abandon their heritage, it opened the door for others to fill it. "He loved the kind of thing people didn't want to make any more," says Banks. "It's the old way of making something, the right way of making something. It's cross-stitching the buttons, it's having real horn or real pearl buttons. The customer may not know the buttons are mother-of-pearl but he knows there's something about the shirt he loves, something he can't put his finger on."

Although he was marketing his clothes around such mythical figures as the American sportsman, the English gentleman, or the New England WASP, for Ralph these were not just idle fantasies, they were options. By the early seventies, the designer had come to understand the Ivy League's style zigzags better than most, and even more important, how to take inspiration from this lost dressing art form and move it forward. Later on he would be accused of appropriating its dressing aesthetic for personal profit, however, what he really did was borrow a few chapters out of its original 1930s style playbook where learning how to wear clothes with an informal air became not only a litmus test of style, but also a badge of membership.

What came to shape the original Ivy set's dressing philosophy in the 1930s was to become an important element in Ralph's larger style signature, that of equating "studied negligence" with sartorial smartness. Back in the Collegiate Look's formative years, an Ivy freshman's first lesson in campus assimilation was that of how to look "well-dressed" without looking "dressed up." It brings to mind lines from F. Scott Fitzgerald's "Winter Dreams": "He had acquired that particular reserve peculiar to his university that set it off from other universities. He recognized the value of such a mannerism and he adopted it; he knew that to be careless in dress and manner required more confidence than to be careful."

Charlie Davidson, the last doyen of authentic Ivy League style and owner of The Andover Shop in Cambridge, Massachusetts, stresses what he calls the "attitude" long associated with wearers of the Ivy League Look, which he describes as a nonchalant approach to dress combined with poise and an air of self-assurance. Whether this poise is real or feigned is up for debate.

Pulling off looking dressed-down while still appearing dressed up could be traced to the undergraduates' more relaxed campus life and their evolving appetite for rustic clothes over the more starched and pressed town clothes. The elder stock, Anglo-Saxon aristocrats, would weigh in on city-sanctioned dressing protocol, their tastes still considered the Maginot Line of the Eastern establishment. Having said that, the increasingly casual university dress code was to impact that of the city's far more than the other way around. It certainly explains the almost overnight popularity for the new textured fashions like oxford cloth shirts, brushed Shetland sweaters, Harris tweed jackets, flannel trousers, and the like. And no garment was to better typify this new ideal of "careful carelessness" than Brooks Brothers' inimitable button-down dress shirt. With its soft collar and longer points that fastened to the shirt's body, instead of lying flat, each side would roll with the head's movement, creating grace notes of casualness just below the face.

Throughout the first half of the twentieth century, Brooks Brothers established itself as the primary, albeit not exclusive, wellspring for the Ivy wardrobe's essential components. Over the years Brooks would introduce a host of English-inspired "musts" that quickly became staples of the Ivy domain: its button-down oxford shirt, Shetland sweater, polo coat, rep ties, argyle socks, et cetera. But it was campus life in and around the Ivy quads where the highborn Tweeds set the standards for how the Brooks and J. Press classics could and should be worn.

Of all the Ivies, Princeton proved to be the main breeding ground for the birthing of the authentic Ivy style. During the Depression and interwar years, the university was home to a privileged student body where more than three quarters hailed from private schools. Its rural setting between New York City and Philadelphia bred a more insular and countrified sartorial independence. Princeton's amalgam of wealth, manners, and aristocratic social construct found the campus more times than not the primary go-to venue for the menswear industry's seasonal fashion reporting.

From "The Rise and Fall of the Ivy League Look": "The inversion of values that took place during the cultural revolution of the late sixties had created a new cultural engine that drove fashion from the bottom up rather than the top down." College campuses became hotbeds of social

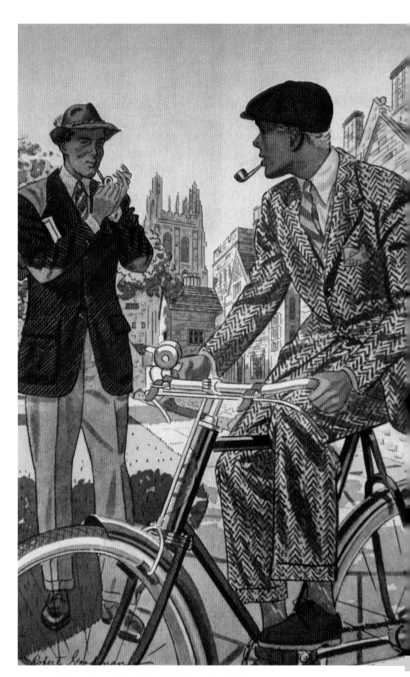

From *Apparel Arts Magazine*, September 1939.
"Irish homespun jacket with patches is the latest trick at the smart eastern Ivies."

POLO RALPH LAUREN
THE CASHMERE CABLE SOCK
NEW YORK CHICAGO PALM BEACH BEVERLY HILLS

POLO.COM

88

a penny loafer or necktie to behold. "The new open admissions standards at elite universities were changing the student body. Style-setting schools such as Princeton and Yale were no longer populated predominantly by kids who had gone to prep school, where they were forced to wear a jacket and tie every day and maintain a neat haircut. Schools were also dropping their jacket-and-tie dining hall dress codes. Once the Ivy League Look ceased to be fashionable on campus, it ceased to be fashionable period. More specifically, one could argue that once the guys at Princeton stopped wearing it, it was over."

The consensus is that 1967 marked the beginning of the end of the Ivy League Look as a living, style-setting force of fashion. For a while it continued to hang on, trying to compete with the new European designer looks for prime retail shelf space. Main Street clothiers along with the emerging boutique culture were quick to align themselves with the trendy fashions now beginning to drive the menswear business. Brooks Brothers would stick to its guns for as long as possible. With ensuing Brooks' ownerships trying to remain relevant to their aging clientele while modernizing to appeal to a younger demographic, the institution's standing as the protector and proponent of classic American style suffered steady erosion.

Pre-occupied by how to get his toe in the door, Ralph Lauren was probably not aware that the influence of the collegiate clubs with their fraternity-row mentality was unraveling, diluting the Ivy League's dressing standards. The irony of having launched his career in the same year that the Brooks Brothers president of twenty-one years decided to quit was also not likely on the designer's radar screen. However, having spent years observing the declining dressing mores of America's upper class, the young designer was keenly aware that both the taste level and quality of the merchandise populating Brooks Brothers and its retail brethren was in a collective free fall. On that subject he could expound with considerable authority and conviction.

As the 1960s slid into the 1970s, the times would finally institutionalize the symbiotic relationship between fashions in clothes and social attitudes. With the faded jeans of the affluence-rejecting hippies and the street-imitating gear of the radical chic, the power of clothes in its emblematic sense had intensified. "Fashion is a code," as Tom Wolfe has written, "a symbolic vocabulary that offers a subrational but instant and very brilliant illumination of individuals and even entire periods, especially periods of great turmoil."

While fashion making was on a "follow the leader" gambol that clearly tantalized the press, the only takers for its avant-garde clothes were a small fraction of the buying public. In the States, department stores and boutiques sought out those looks most likely to curry favor with the broadest swath of the American marketplace. Enter Ralph Lauren with his worn-clothes-look-better credo and his insistence that seersuckers and tweeds looked better beat

insistence that seersuckers and tweeds looked better beat up, as did shirts after washing. "Lauren's tweedy clothes, with their English hunt-country antecedents, arrived at just the right moment. They were perfect for the 'it's-not-fashionable-to-be-fashionable' mood of the early seventies. It was suddenly O.K. to look 'classy,' as long, of course, as it was a quiet classiness. Lauren's choice of a logo heralded a further breaking away from the sixties: an image of the polo player, the ultimate symbol of privilege and elitism," wrote Francesca Stanfill in the *New York Times.*

What would have happened to America's Preppy or Eastern School Look had Ralph Lauren not come along? Consider Brooks Brothers, which, after successive owners' attempts to reinvigorate its aging franchise, was sold to an Italian eyeglass magnate for a fire-sale price. Today its haloed sartorial heritage and patrician button-down stylishness have been co-opted by a one-size-fits-all mediocrity of taste. Other than J. Press's store-cum-museum up north in Cambridge, Massachusetts (now shuttered), the country's last keeper of the original Ivy flame is its next-door neighbor, The Andover Shop, presided over by its octogenarian founder, Charlie Davidson. Never wavering from his soft-shoulder beach-head nor having dipped his taste buds into the designer Kool-Aid, Charlie has willed his surviving bastion of High Preppydom into a fashion standoff.

What actually happened to the Herringbone Faithful? Ralph Lauren came to their rescue. Ralph admired Brooks with its air of quiet, understated status and first-edition American authenticity. He loved the Ivy League Look, the chinos with the buckles in the back, the white bucks, the pink button-downs, the brown-and-white saddle shoes. But Brooks resisted change, and like its archetype No.1 Sack Suit, its Brahmin cache had finally run its course.

To Ralph's everlasting credit, he did not want to live in the past, he wanted to try something new—to get the past to live in the present. Ralph was after what Brooks Brothers used to be and he was certain he could do it better. Thus began a role reversal whereby more of Ralph's Polo merchandise would end up reflecting Brooks' bygone standards of purity and quality than the fountainhead's own output. In 1986, almost twenty years to the day after Polo's founding, the designer unveiled his flagship store on Madison Avenue's Seventy-Second Street, upstaging the former stronghold of American traditional fashion down on Forty-Fourth Street, transporting it, both literally and figuratively, uptown. As the High Dean of Haberdashery, Charlie Davidson of The Andover Shop recently observed, "Much like how Charlie Parker saved jazz, Ralph Lauren basically saved America's Ivy League from certain oblivion."

Opposite: If no one was going to continue to make the outdated classics that Ralph wanted to wear, then Polo would. In almost every case, the designer would improve upon the original while extending its fashion longevity.

Below: Joe College Goes Nonchalant. But now the pendulum has begun to swing the other way, and university clothes, at least for on-campus wear, betray a studied carelessness. Campus leaders from Princeton and New Haven have swung completely away from the favored worsteds of past seasons and have gone in for rough cloths exclusively.

Following spread: By the time his Rhinelander flagship store on Madison Avenue and Seventy-Second Street debuted in 1986, Polo Ralph Lauren had effectively become the new Brooks Brothers. The Lauren magic: renovating America's traditional fashions to be not just more authentic but more stylish as well.

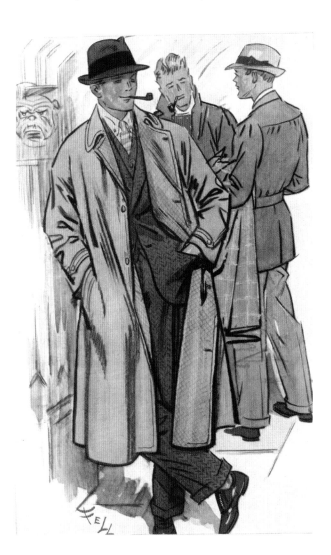

89

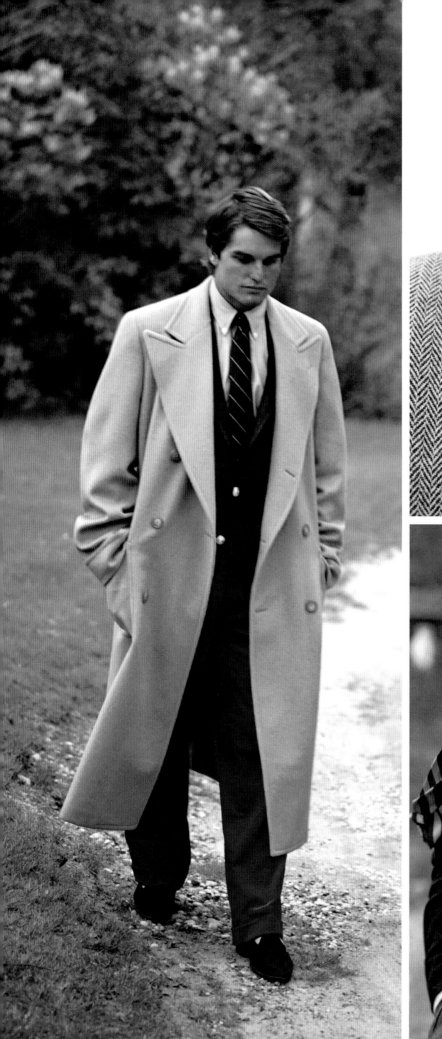

A PORTFOLIO OF STORIES, SITTINGS & SIGHTINGS

THE POLO COAT: THE MAN OF LA MANCHA

NO ARTICLE OF APPAREL better epitomizes Ralph's sweet spot of aspirational style than the polo coat. Likewise, no artifact of menswear lore better embodies Ralph's Man of La Mancha belief system. To right its wrongs and ensure the classic mantle's survival, Ralph had to defend it on multiple fronts and over multiple decades. First, he had to protect it from becoming a casualty of the anti-establishment sixties; then he had to defend its honor during decades of designer-driven fashion excess.

Whether vintage or new, custom or ready-made, this highborn cloak has long been depended upon to convey its wearer's upper-class leanings. From blue jeans to formalwear, bowlers to baseball hats, there is no style boundary that this blue blazer of male outerwear cannot navigate. In the 1920s the coat became the go-to swathing for English polo players wanting to keep themselves warm and stylish between chukkas (periods) or after the matches.

Introduced to America's "polite society" in 1923 when the International Polo Club matches came to Long Island, the polo coat made its official debut as the English lads faced off the Americans. A double-breasted affair made from the soft fleece of lightweight camel's hair trimmed with flapped patch pockets and a half-belt or a separate all-around belt, the coat soon became a favorite of players and spectators alike. Graduates of Yale and Princeton quickly adopted the coat on and off the playing fields, and by 1926 it had spread to America's leading Eastern universities and Midwest campuses.

Brooks Brothers first imported the English original until it started making its own version. When Ralph introduced his polo coat in the late 1960s, there were still a few haunting the hangers of those remaining Ivy League retail diehards. But as the old guard passed on to that big button-down closet in the sky, Polo by Ralph Lauren became the coat's principal custodian and cheerleader. The "Brothers" camel hair managed to survive by virtue of its identification with the company's history; however, today this iconic garment owes virtually all its fashion currency to Ralph Lauren, its shining knight, its Don Quixote. Over the past fifty years, the designer has recharged its vintage pedigree by updating its silhouette and recasting its showcasing.

Due to its higher price and limited selling season, the polo coat will never represent an important revenue stream for the company. Nevertheless, the historic mantle retains its seat at the Polo Roundtable not only because of its shared moniker and aristocratic sporting association but also because of Ralph's belief in protecting menswear's treasures from fashion's temporal clutches. If Ralph is in the process of passing down more timeless articles of apparel than anyone in fashion history, and he is, his polo coat will undoubtedly be one of those so bequeathed.

The polo coat's Man of La Mancha clad in his very own.

THE POLO KNIT SHIRT

ALTHOUGH RALPH IS RESPONSIBLE for introducing many firsts in both product and fashion, no item was to have a bigger impact on the company's fortunes than his knit shirt. Like his oxford cloth Polo shirt inspired by Brooks Brothers' original and his Shetland sweaters of English heritage, Ralph enlivened his classics with doses of finer quality and heightened cachet. Posing them within his beautifully choreographed lifestyle tableaux, they took on a measure of status and appeal all their own. This was one of the ways that Ralph was able to get the early Polo brand better known and distributed to his growing audience.

Back then the Lacoste knit shirt, with its alligator logo, dominated the casual sportswear market. For years the Izod company had marketed a version of its original cotton piqué shirt as first worn in 1933 by French tennis champ, Rene "the Crocodile" Lacoste. By 1953 it was manufactured in white for golf and tennis and then, in the early 1960s, rolled out in a variety of colors. Imported from Europe and initially adopted by America's touring golf pros and top tennis players, the "grinning alligator" soon started turning up at pro shops all over the States. Its bicep-hugging short sleeve, longer back tail, and French-language sizing lent the *chemise* a certain insider panache.

At one point Ralph tried the shirt on, which left him cold. He looked at the label and saw it was made of polyester and cotton. The collar and plastic buttons seemed wrong and it was only available in a handful of colors. Ralph wondered where its natural fiber cotton and celebrated French chic had disappeared to.

Prior to Norman Hilton, Gil Truedsson had been styling golf and tennis knitwear for Saks Fifth Avenue's active sportswear department. He had proposed to Saks that it buy the knit shirt directly from Lacoste, which Lacoste refused to do. Upon moving to Polo, Gil looked forward to going directly into competition with them. As Bloomingdale's president Marvin Traub observed, "The way one makes money is to have season after season basic items in great ranges of colors. That's the core of any important apparel business." The Polo knit shirt was to become the company's bestselling product, a commodity that was to mint money for decades to come.

In 1973 one of the earliest ads for the Polo knit shirt ran. Although it was a better-made product knitted in a softer interlock cotton and finished with pearl buttons instead of plastic, the Polo shirt was proposed as something more than just a better-quality rival to Lacoste. Like owning a fifty-dollar Ferrari keychain instead of the four-wheel, Corso red, twelve-cylinder dynamo, everyone with taste and money could afford this little slice of the designer's fantasy. Customers were not just buying a piece of sportswear, they were purchasing a ticket to Ralph Lauren's movie and entrée into a lifestyle that promised good taste and class.

Although the Polo knit shirt did not become a bestseller until later in the seventies, the seed had been planted. In 1978 Neiman Marcus put the Polo shirt in its famous catalog while placing a national ad for it in the *New Yorker* magazine. Offered in twenty-four colors, the Polo shirt came in five different shades of blue. Sales took off. Greg DeVaney, a former Neiman Marcus buyer, recalled, in *The Man Behind the Mystique*, "Izod/Lacoste then owned the knit shirt business and Ralph was barely known back then, but the whole preppy thing was happening, and we thought that we could take the Polo player and make it the new symbol for people to wear."

95

The ad that put Polo's knit shirt, no less the brand, on the map. With Neiman Marcus's blessing and national advertising, Polo's knit shirt became the low-priced entry point to the brand's high-priced image, minting money for the company and retailers alike.

THE POLO CHINO
Ivy League Redux

THE POLO CHINO BECAME the third fashion staple to join the oxford button-down and knit shirt in the 1970s as the sportswear triumvirate responsible for driving Polo's staying power and growth at retail. Long before and after the designer's stint in the army, Ralph has long been enamored with military clothes and especially the authentic khaki material. "I wear khaki," he said in a 1987 interview, "I love army clothes."

Tracing the chino's design evolution over four decades is like freeze-framing Polo's fashion at any given moment. In the 1980s it came pleated with a longer rise, fuller legs, and dressier detailing. Today, with fashion dictating tighter clothes, the chino has a slimmer line with plain fronts, shorter rises, and trimmer legs.

Cut in either silhouette or anywhere in-between, no article of men's apparel facilitates as many dressing genres and clothing coordinations as this workhorse bottom. Paired with a solid or patterned woven or knit shirt, any color or model of sweater, sport jacket, or outerwear, the chino is the male's idea of clothing heaven, the epitome of default dressing. Which is why most men own several and why every designer, manufacturer, and retailer religiously roll out their prospective candidates each and every season.

Ralph's visual intelligence holds all this staged naturalness together. See the Ivy League's original 1930s playbook, Chapter 2, Rule 5: As concerning button-down fashion, nothing must look too new or too tight. The upshot—increased chino sales and a style-wizened citizenry.

Above: A study in prefabricated naturalness where the clothes have been yanked, puffed, straightened, and pulled to within an inch of their life. The fullness created by the bottom's cinched-in waist plays off that of the sweater above, its leather belt folded over itself just so, the glint of the belt's weathered buckle reflecting the gleam from the partially revealed zipper's teeth as each sleeve's cuff reveals a sub-layer. Having lobbed about as much nuance and detail into this horizontal swath of suppleness as possible, Ralph knows exactly when and where to stop.

Opposite: Framed by a loose hanging cardigan above and bunched-up, chunky wool socks below, the chino's easy cut flows downward into casually rolled-back cuffs. The interplay of the weathered pant, classic gray athletic socks, and brown suede boat shoes conjures up an Adirondack-like virility and come-to-life authenticity. This is Ralph Lauren alchemy at its best.

THE POLO CHINO

RALPH LAUREN

AN UNCONSTRUCTED TALE

IN THE SPRING OF 1969, Norman Hilton asked Ed Brandau if he would take Ralph to Europe and show him around. They landed in Rome where Ralph never stopped looking or thinking about clothes, even when dining. One evening they went to a stylish restaurant in the city's medieval Trastevere neighborhood where Ralph couldn't keep his eyes off the waiter. Finally, he called him over. Neither spoke the other's language but Ralph was able to make himself understood. He wanted the white cotton jacket the man was wearing. To most people, this was a typical waiter's jacket fashioned out of a softly constructed washable shell with no padding or lining. To Ralph this miracle of less-is-more tailoring looked like something he might be able to build a whole look around.

That night the waiter's wallet was decidedly more flush as Ralph relieved the man of his mantle. Upon returning to New York, he began work on his new Spring 1970 collection, trying to get his waiter's coat translated into a design that could be factory produced. Frank Simon at Bloomingdale's was encouraging because he wanted a less-expensive Polo suit that his younger customers could afford.

For Ralph, "the unconstructed look" was a natural extension of his old Brooks Brothers and upper-class British ethos, or how well-made-and-worn clothes should feel and look on the body—supple, light-weight, and relaxed. "It's another ballgame," stated Ralph in an interview with Buffy in 1970. "There is nothing in the coat whatsoever, although there's a little in the collar and lapels so it holds its body. The coat feels like a shirt and looks like a jacket."

The men's industry was thinking along the same lines. They introduced the new "Easy Suit" as a fashion triumph, championing it as a sportswear-like alternative to the structured suit. Unfortunately most manufacturers and retailers hailed it as a less-expensive garment, planting in the customer's mind that *unconstructed* meant both a less-tailored and therefore lesser-quality garment. No matter how vigorously the sophisticated retailers like Neiman Marcus and Bloomingdale's advertised its shirtlike comfort and chic, the

"unstructured" look took its first breath as an acknowledged commercial flop.

From 1970 through 1973 Ralph persevered, designing all manner of unconstructed jackets and suits for his collections, from a year-round denim sport-suit to a warm-weather oxford cloth shirt-jacket. Dressed down to wear with corduroys or jeans, these hybrids were intended to bridge the gap between a tailored jacket and a sweater. To ensure a better fit and drape, Ralph even made his in more-expensive clothing factories. Ironically, manufacturing an unlined garment with its exposed pocketing and visible internal seams requires even more time and extra expense to finish attractively, making it a more, rather than a less, costly garment to produce. As Ralph was quoted, "I'm aiming for a more sophisticated man who wants his unconstructed jacket to fit as well as a fully tailored jacket."

Convincing even the most fashion-forward male of an unlined garment's comparative virtues would take many years of coaxing and rebooting. As Marvin Traub recounted in his book *Like No Other Store*, "Early on, Ralph tried a line of 'unconstructed' jackets that failed—they were about two decades ahead of their time." Not until Giorgio Armani cut the guts out of the tailored jacket in the 1980s, followed in the new millennium by a cabal of Neapolitan tailors exporting their artisan-crafted, partly lined jackets and suits to the States, did unconstructed or unlined clothing finally shed its negative image and assume its rightful place in the cosmopolitan man's closet.

Today the unconstructed men's jacket has insinuated itself at all price and quality levels into modern menswear. More than any other designer, brand, or retailer, Ralph Lauren kept the "unconstructed" flame lit longer and brighter than anyone else. Regardless of a product's lack of immediate commerciality, when convinced of its validity Ralph will not be swayed or alter his plan. He prefers to be first, even if it means waiting for the rest of the world to catch up, which, more times than not, is exactly what happens.

98

polo

The Easy Suit is DNR's name for what the industry calls the "unconstructed suit." It is a suit without most inside construction details, but with the outside look of a business suit.

The Easy Suit is easing its way onto the men's wear scene.

Without fanfare and with much less dramatic impact than the introdution of shape, it is titillating the imagination of some forward fashion thinkers in the industry.

While most large clothing manufacturers are adopting a "wait and see" attitude about the Easy Suit, some specialty firms are already producing them . . . and key retailers will begin to merchandise them this month.

The Easy Suit represents an updated version of yesterday's "wash and wear" suit or standard "built up" construction summer suit.

Today's Easy Suit has shape, flair, fashion fabrics (usually beefy cottons) . . . and even less construction than its predecessors. Shoulder pads, canvas, interlinings are out. So are skeleton linings.

And today's Easy Suit is being promoted for its ease, not its washability. Those who are making and buying it, see the Easy Suit as a fashionable, comfortable summer suit. They also see it as an additional suit . . . rather than a replacement for conventional business suits.

The list of Easy-Suiters is still small and select.

Ralph Lauren of Polo is delivering the Easy Suit to stores this month. Cardin included his version at his March showing; Intercontinental Men's Apparel Corp. — Cardin's United States manufacturer — will introduce them in June for November delivery. Raffleswear's Larry Kane is also working on the Easy Suit for spring 1971.

Palm Beach, and other former summer clothing specialists, are "looking into it." And so are such tailored sportswear firms as Stan-

Important retailers like Bloomingdale's in New York and Neiman-Marcus in Dallas are already Easy Suiters.

Bloomingdale's is showing a knit Easy Suit from Van Gils of Holland in its windows now. And Bloomingdale's and Neiman-Marcus both expect delivery of domestic Easy Suits this month.

While the Easy Suit is just now emerging, it is already being heralded as a clothing breakthrough and new fashion look.

"It's another ballgame," says Ralph Lauren. "There is nothing in the coat whatsoever, although there's a little in the collar and lapels so it holds its body. The coat feels like a shirt and looks like a jacket."

Larry Kane, who's been quietly working on the Easy Suit, says, "I applaud the whole system of less construction." Despite the skeptics, Kane contends he's had "absolutely no problem with shaping" on the Easy Suit.

Neiman-Marcus' Neal Fox, claims Easy Suits are neither flimsy and lightweight nor functional as "wash and wear" suits. "They represent a leisure approach to suits. Suits that are casual — almost like a jacket or shirt — rather than restricted."

Franklin Simon of Bloomingdale's is heralding the Easy Suit as a fashion breakthrough. "We are in an era of almost disposable fashion. This will allow us to take advantage of this trend by bringing the prices down where they belong. We want newness, not a suit of

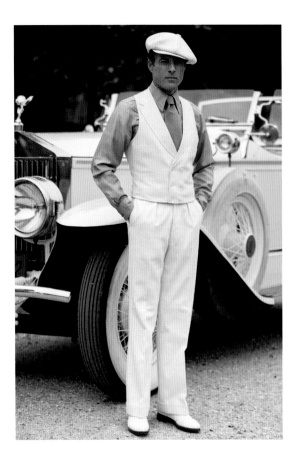

THE PICTURE BUSINESS
The Great Gatsby

BY 1973 POLO RALPH LAUREN was about to step out beyond the realm of men's fashion and into the limelight of mass entertainment. As Marvin Traub, Bloomingdale's chairman, pointed out, "Ralph had been looking for a way to flesh out his image on a larger screen. Now, literally, the screen was presented to him." Ralph had been commissioned to make the men's clothes for a new Hollywood film version of F. Scott Fitzgerald's *The Great Gatsby*.

Sal Cesarani had first met Theoni Aldredge, a costumer for film and theater, when she was trying to acquire two Ralph Lauren sweaters for a play she was working on. When Cesarani heard Aldredge was designing the costumes for Gatsby, he invited her to come see Ralph's men's collection. As Traub observed, "The star was Robert Redford—a Ralph Lauren guy if there ever was one. The notion of creating Gatsby's suits and shirts—the beautiful shirts that made Daisy cry—was a dream assignment."

Aldredge went to the showroom and quickly realized Ralph was already involved in the period and the Gatsby look. She decided then and there to ask him to provide the men's clothes for the movie. In a review of Polo's spring 1970 collection by the *Daily News Record*'s men's fashion journalist Buffy Birrittella: "If Lauren's look is the 1930s, it's the F. Scott Fitzgerald 1930s not the Duke of Windsor." As Ralph was quoted later in a March 28, 1974, article in the *Daily News Record*, "If there were no film, they'd be calling it the Polo look. It has nothing to do with Gatsby himself, but with the style and grace of that era, updated to suit the contemporary man."

Nobody understood the time period relative to men's fashions better than Ralph. He certainly identified with the aspirational persona of Jay Gatsby as it reflected his own belief that upward mobility, or acquiring "class," was an opportunity inherent in the American experience and thus

available to all. Jeff Banks recalls, "I've never seen him more excited. The film is male driven. What the men wear is more important than what the women are wearing."

As Ralph told *GQ* reporter Bill Gale in March 1974, "The trick was not to look like Polo but the period. In 1925 men's shirts were cut fuller with collars that were shorter and not spread so wide, taking a smaller knot made with a thinner, unlined tie. Suit jackets had narrower lapels, no vents, and were slightly shorter. Compare a suit from that period with mine, and you'll need a trained eye to see the difference." In any event, just outfitting the extras in suits and tuxedos was a huge undertaking that could have only been accomplished because the Gatsby look was already a part of the Polo collection.

One problem that surfaced early on and persisted throughout was that Aldredge could not get anybody to understand that she was the menswear designer and Ralph the manufacturer. It seemed that every time she picked up a magazine, Ralph was saying he was designing, not making, the menswear for the picture. In fact, the roles were much less defined. States Gil Truedsson, "Her ideas were only a small part of what eventually got made for the film." As Birrittella recounts, "We not only had the mood, we had the fabrics, and the beautiful shirting, and, above all, the silhouettes. Ralph defined each character. I remember him saying to me, 'Nick should wear only single-breasted jackets and he should wear the belted backs, Redford's going to wear double-breasted vests and he should wear this round collar.'"

The menswear industry started gearing up to take full advantage of Gatsby's promotional tie-ins. The *Daily News Record* and the rest of the menswear press credited Ralph for the design of the men's clothes. Ironically, while it was his work on the movie that was being credited for "launching the Great Gatsby Look," in fact, that sartorial train had long left the station, as Ralph had been referencing Gatsby in his collections for almost two years. Nevertheless, in many ways the press was correct: His clothes were the star of the film.

The film boosted the designer's career as well as raised interest in American menswear in general. The first film in many years to glamorize male fashion, it introduced an entire generation to prewar American male elegance and taste, which back then was on a par with anything Europe had to offer. Unfortunately, by the seventies, American menswear had pretty much taken a fashion powder, bowing to Europe's designer-driven imports. Then along came one of America's own, reclaiming a slice of the fashion high-road for himself and country. Had Ralph Lauren not been on the scene, the interest in upper-class American male fashion that the film ignited would have had very little to hang its hat, or for that matter, its beautiful silk shirts, on.

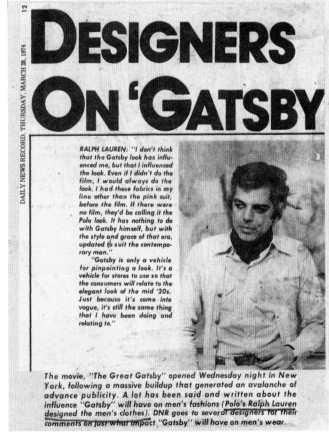

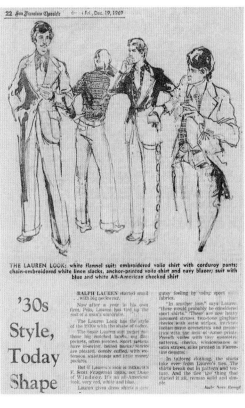

RRL

Ralph's Star-Spangled Fashion

WITH THE INTRODUCTION OF the RRL brand in the fall of 1993, Ralph finally created the collection he had always dreamed about. Growing up in New York City and living within its cosmopolitan borders, he longed for an escape. Whether the Old West existed or not, he was looking for something open, spacious, and authentic; and the West provided him with that.

The brand was named after the sprawling Colorado ranch that he and his wife, Ricky, bought in July 1982. If Polo was the company's heartbeat, RRL was its soul. RRL, pronounced *Double R L*, was launched in September 1993 as a top-of-the-line homage to the Old American West and early-1900s work wear. From the earliest days of the designer's business in the late sixties, the West was a continuing source of inspiration for his designs and lifestyle. As Ralph puts it, "I have always loved vintage things because of what they said to me, but it wasn't until I spent the time at the ranch that I found my true inspiration for western style—the ruggedness, the sensibility. Western clothes are the most distinctively American of all clothing. It's not at all about fashion; it's about heritage and taste. That is my world."

With pre-worn denim as RRL's main hitching post, the jeans are just like one-of-a-kind vintage blues. It's also a heritaged but new world of folkloric-inspired work shirts, vintage button-fly chinos, washed flannels, smudged T-shirts and sweaters, beat-up jackets, and distressed leathers, like the bomber jacket straight out of the cockpit of a P-40—all evocative of vintage American clothing. As Patrick McCarthy of *Women's Wear Daily* once observed about Lauren, "Everything he sees or does comes back to his work, he is totally consumed by it."

As a backdrop for so many great stories and fictional heroes, the West has long been a focus of Hollywood.

Certain clothes or styles of wearing them depicted on film rose to the status of sartorial iconography. There's Sam Peckinpah's 1972 *Junior Bonner*, a rodeo picture where Steve McQueen partnered with a classic white snap-front shirt; or again in *Nevada Smith* where McQueen wore Levi's with rolled-up cuffs and Indian moccasins; or the flashier Roy Rogers or Gene Autry rodeo ensembles with their H Bar C rayon gabardine, smile-pocketed, embroidered, western snap-front shirts. Mosey over to any of the larger Polo retail environs featuring a RRL layout and their kissing cousins will likely be awaitin'.

Entering the RRL design showroom is like stepping back into an original American dry goods store circa 1920, tin stamped ceiling and all, except this one looks as if John Ford just finished filming there. Its homey character underscores the collection's roots—never was a musty, down-market *Grapes of Wrath*, Walker Evans Depression-era imagery made to look so utterly contemporary and appealing. Like Ralph's other stand-alone brands, the RRL presentation is so elaborately yet intimately art directed that its gestalt becomes its own self-fulfilling reality. Call it genius or transmutation, Ralph has managed to fabricate yet another of his wondrous three-dimensional erector sets which, upon entering, immediately touches off desires that were not present moments earlier. Yet Ralph is not just selling clothes infused with their own past. He is also selling an image of the lifestyle that one might expect to enjoy wearing those clothes in—ski lodges in Colorado, vast ranches of Montana, or in and about Manhattan's downtown warrens of champagne-bohemia-in-the-making.

Taking it all in, the backdrop begins to disassemble into bits and pieces: beat-up merchandise fixtures, old locker shelving, pipe racks, vintage highway signs, used

license plates, diner clocks, and neon signs. Samples of secondhand work clothes from thrift shops sit next to new designs-in-progress. Some are hung up, others lay strewn across old suitcases and beat-up leather duffel bags. Shirts aged to look as if they were handed down from your grandfather are hung on wire hangers, covered in paper, as if just delivered from the town cleaners behind the saloon. Some leather jacket linings are "stained" to give them the effect of mileage while the hem and cuff openings of pants and shirts look like they are wearing thin as well, touched with acid for an aging effect. It's hard to distinguish the old from the new. "This is my closet," said Ralph, waving his hand around the elaborately and meticulously decorated showroom for RRL.

But more than a western, work wear, or jeans-based brand, RRL is the spiritual conscience of the Ralph Lauren world. It's where values like timelessness, heritage, and purity translate into mission and then into a physical reality. Clearly this is a collaboration of single-minded, highly-motivated sidekicks who, under Ralph's stewardship, have spent considerable time and energy researching, assembling, and imaging everything in order to bring to market these "homegrown future collectibles."

Picking up a RRL product and having it feel as if the clock has been turned back is the equivalent of trying to recapture time from the inside out—no easy or inexpensive undertaking. It requires a time-consuming, step-by step process that employs various chemical-intensive washes and finishes; the latest in chemical science is married to the best of materials. As a result, to keep the RRL products commercially priced, markups have been lowered.

In 1993, as Spencer Birch, RRL's head of design states, "No one but Ralph could have done this and sustained it over the time period. At the start, RRL's processing of denim was way before its time. Most brands are one-dimensional. This is about authenticity, the right wash, denim the way Ralph envisions it. Uncompromising in the face of public ownership, it's still a design-driven business, and Ralph has maintained that culture.

Spencer's history with the company, like so many others, reads like something out of an American novel. Promoted from part-time salesman to full time at the company's flagship store on Madison Avenue, Birch would eventually go on to head up the newly formed RRL design initiative. "Ralph's instincts about people are phenomenal," says Birch, "He tries to get to know them. A lot of people in Ralph's position don't want to know their people that well. Ralph still pulls people out of stores."

103

Opposite: A collectible unto itself: Ralph resurrects the classic H Bar C western shirt to become more than an imitation of the past, a benchmark against which the original that inspired it can be measured.

Above: The RRL showroom. Time warp—like stepping back and then forward into an original American dry goods store.

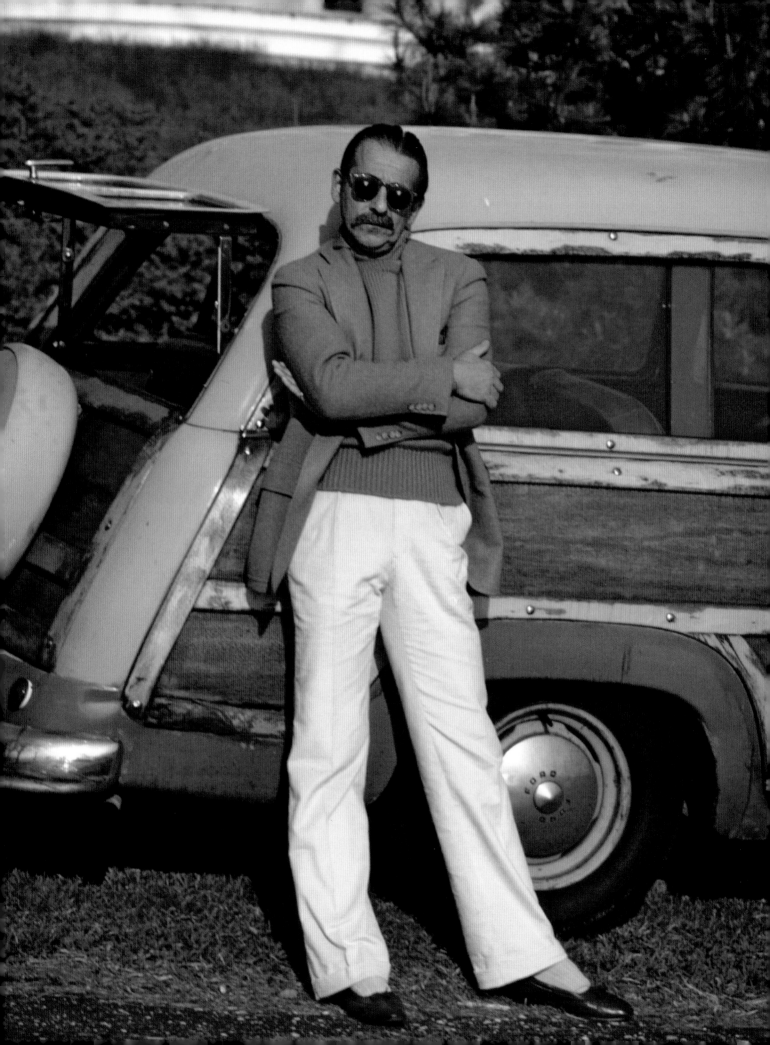

REINVIGORATING THE CLASSICS

DESIGNERS WHO HAVE WORKED WITH Ralph over the years talk about his single-mindedness and unwavering focus to stay the course. He encourages them to be true to themselves rather than looking to be all things to all people. He wants them to innovate, but to do so from within their own worlds outwards. The company does not employ focus groups nor does it subscribe to fashion reports or industry forecasting newsletters. Polo will have gingham shirts for spring but in its own way using new fits, new color combinations, new design detailing. Ralph pushes the designers to take their gingham and make it modern but make it their own.

"Ralph doesn't like to throw away clothes," states Mary Randolph Carter, senior vice president of publishing and one of Ralph's creative insiders. "Having worked on each page of our large fortieth anniversary book, Ralph insisted that there should be no dates on the pictures because he felt the earlier ones could stand up to the new ones." Imagine a retrospective of a fashion designer's work where thirty-year-old photos sit next to five-year-old ones with no identification as to their wildly differing timelines? Motivated by his goal of forever-fashion, many Ralph Lauren clothes being worn today date back five, ten, and, not surprisingly, twenty years.

For innovation to endure, it can't happen in a vacuum—today's modernism is tomorrow's past. So if Ralph's aiming at fashion permanence, he tries to foster the kind of innovation that is at once modern yet timeless.

Ralph has always approached fashion more as a large canvas painter or cinematic movie director than as a designer. The notion of evolution rather than revolution comes from his self-image as a big-picture builder rather than as a trend broker or breaker. He feels that a sense of continuity and consistency is a strength, not a limitation.

Notwithstanding his own drive for perfection, which inspires people to bring something different to the table, Ralph's vision is never far from the creative team's nerve center, serving as both a guide and a jumping-off point for further exploration. The impetus for such a disciplined design aesthetic cannot be found in sales or volume but in look and design. From the outset, perfection has been the driving impulse, not profit.

One of Ralph's senior design staffers, Bobbi Renales, recounts of first being so impressed by Ralph's passion and total belief in what he was doing because he could sit and talk for hours about the smallest detail of each look or design. "I'd be sitting around a table back in the early days with Buffy, Jerry, and Ralph observing all this high-priced talent trying to determine the best color for the second hand on a new watch, to see if it was the exact right shade, that it represented the perfect taste. Sometimes you'd think we were doing this for the first time." The following are examples of how Ralph and his design teams have reinvigorated certain Polo classics and signature looks to extend their allure over the years.

105

COLOR ME: SUMMA CUM LOUDLY!
America's king-of-the-hill color palette: famed artist, writer, and Gotham boulevardier Richard Merkin models a confection of tried-and-true Polo colorings against the weathered hues of a vintage Woodie. In the seventies, courtesy of Polo, America's former Ivy League dressing canon re-emerged as the high ground for dress-down sportswear.

106

RALPH HAS ALWAYS APPROACHED FASHION MORE AS A LARGE CANVAS PAINTER OR CINEMATIC MOVIE DIRECTOR THAN AS A DESIGNER.

Fast-forward a few decades, Ralph modernizes his Ivy League playbook by slimming down his silhouette and brightening up his king-of-the-hill toggery. A fitted tweed jacket anchors the slim-cut western-style gingham shirt and go-to-hell orange trousers. Bright-toned cable knit and rep stripes at waist and wrist add to the collective punch. Keeping the Eastern School Look alive, Ralph was to pass on more than just natural-shoulder tailoring, in this case the life force of America's golf club pastiche of vibrant colors and eye-raising patterns. Our man Merkin would approve. All hail to the chief!

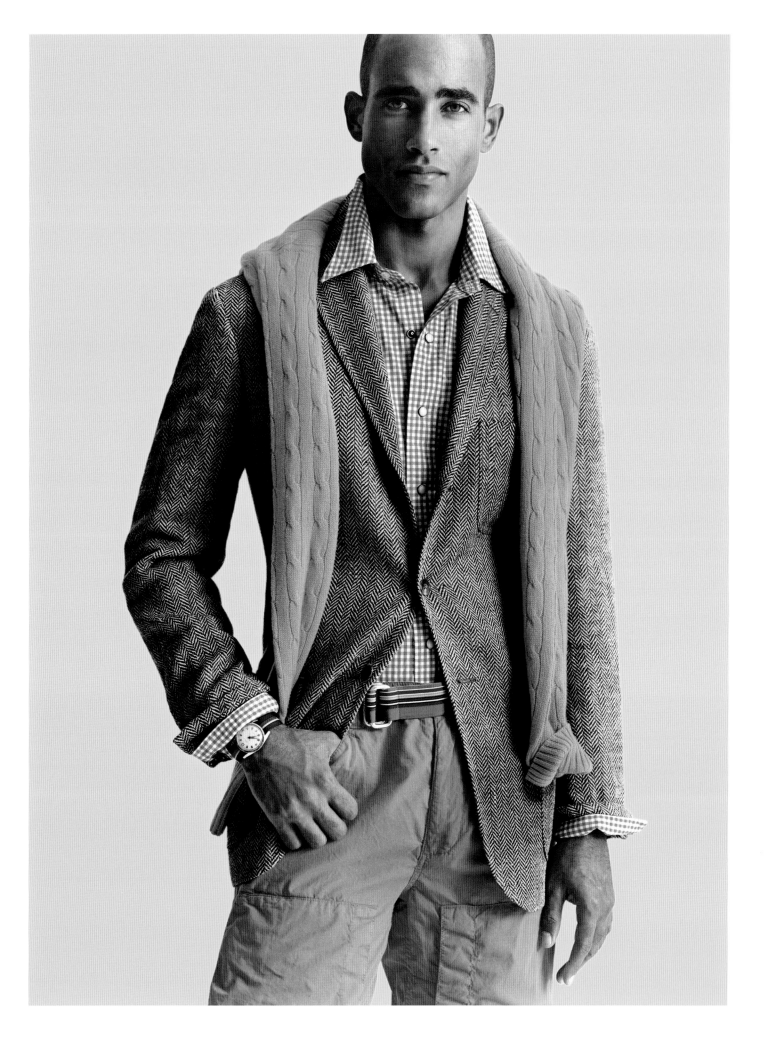

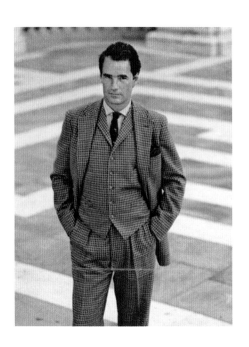

UPDATED TWEED

Above: Ralph has always been a tad dandyish in his classicism, as these Best-of-Brit bearings attest. Here's a castle-warming woolen three-piece, full-cut from Scottish tweed with pleated trousers and accessorized in classic high Bond Street regalia. Only Ralph would pair a citified black club tie with a countrified brown gun-check suit, but that's only one of many roads leading to its in-town country-squire gentility.

Right: Checking in from a different side of town is this blond, long-haired, 33⅓ LP aficionado. Hallmarked with similar British markings, he exhibits a more modern aplomb. Scottish in both heft and pattern, his three-piece tells a younger story with its closer-to-the-body fit, narrower lapels, and quietly scripted array of dandified style points: the hiked jacket collar, the turned-back sleeve cuffs, and the ornately sized safety pin securing his shirt collar. While both ensembles share a common thread of English tweed and tradition, the latter's new-age fit and foppery animates an old idea with new mileage.

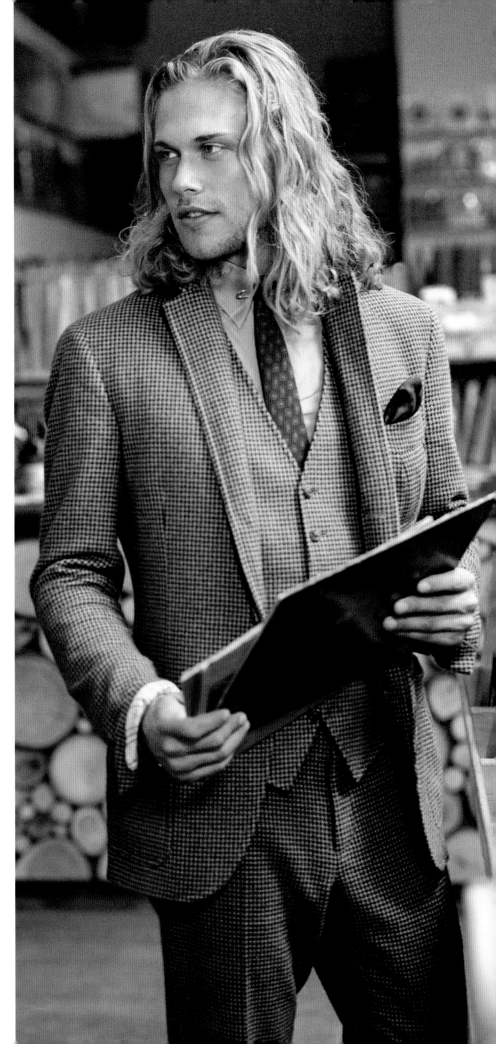

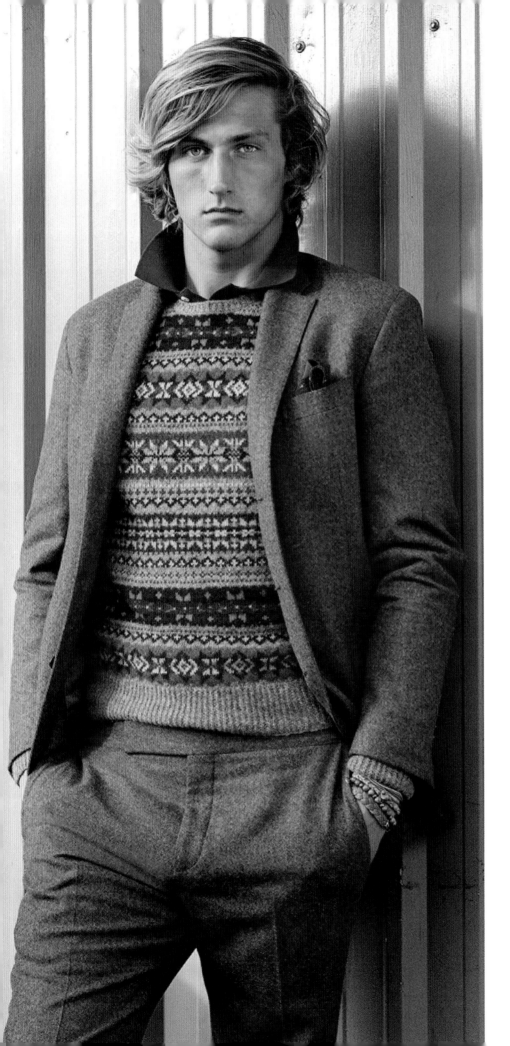

RE-BREEDING THE FAIR ISLE

Above: From *Like No Other Store:* "Ralph didn't invent the Fair Isle sweater, he just made a softer one in more colors than anyone in the United States or Scotland." One of Polo's signature garments, Ralph accessorizes his Fair Isle cardigan vest with a brushed plaid cotton sport shirt, pleated tweed trousers, silk pheasant club four-in-hand, and a fifties-style suede golf jacket.

Left: Same pattern, different decade. Hosted by a not-so-traditionally-cut gray flannel, the suit, like the Fair Isle vest, is for today's moderns who take their fit tight and their fashion downtown. How do you modernize an iconic pattern of vintage knitwear? Look and learn. As one young designer put it, "Ralph is the learning center for anyone involved in men's fashion today."

KEEPING THE POLO SHIRT
IN THE POLE POSITION

Opposite: In spite of all the Polo knit's updates and renditions over the years, today the bestselling
model remains the classic white with original-size Polo player logo in navy.

Above: Layered between a bright-green puffer vest and a long-sleeve underwear top, the uptown polo
takes on a downtown insouciance with a Saturday morning on-the-way-to-brunch cool.

112

THE POLO COAT, STRETCHING
ITS TRADITION AND TURF

Above: Post-chukkas: An English polo team
collecting a championship trophy enveloped by
well-bred and well-worn polo coats.

Right: No designer can romance Ivy League campus style circa
pre-WWII better than Ralph Lauren. Here he creates a modern
construct by dressing down his Polo coat with
how a young man of plugged-in tastes might wear it.

Opposite: Pointing the polo coat in a new direction—downtown—
the designer lobs three alternative perennials into the mix:
a black T-shirt, a leather motorcycle jacket, and tartan jeans.
Notwithstanding the educated eye at work here, the
designer's secret sauce is the understanding that like his polo coat,
for an outfit to transcend trend and enter time without
sale date, each component must be a classic in its own right.

*"THERE'S GOT TO BE AN INDIVIDUALITY AND
STYLE TO THE WAY SOMEONE DRESSES.
THE WAY TO EXPRESS THIS INDIVIDUAL STYLE IS BY
USING ALL THE WONDERFUL ELEMENTS
THAT ARE SUPPOSEDLY CALLED THE CLASSICS,
AND MIXING THEM."*

—RALPH LAUREN

114

While Ralph had always stood for traditional style, he has not stood still. When he started out, his image was more wood, Ivy League, and Persian rugs. Today it stretches from Americana to western to modern and streamlined. Back in his youth, Ralph might have been the first to consider pairing a black motorcycle jacket with white bucks. He did wear a long army coat with tweeds.

Following his long-standing credo of fashion being a reflection of lifestyle, Ralph transitions the polo coat from its Long Island Gold Coast and Park Avenue preserves to the newest frontier of urban affluence, Manhattan's downtown. From blue jeans to formalwear, bowlers to baseball hats, there is no style sphere that this blue blazer of male outerwear cannot navigate. Giving it a fashion face-lift, Ralph trims and reshapes its silhouette while accessorizing it with other modern classics of the day. Folding different genres of clothes into a single outfit has long been one of America's most important contributions to the art form of personalized style.

Here's Ralph on a related subject: "The only way you can break the rules is when you know what the rules are in the first place. I recently read somewhere, I think it was pertaining to architecture, that you have to know the boundaries to be able to go beyond them, and that is exactly the same for fashion. If I didn't know those rules, I don't think I would do it as well. I think that mixing things is the way people live. For instance, whether I was a hunter or not, I've always liked going to hunting stores to look for non-fashion, authentic, equipment-type merchandise to wear. I loved the way real hunters wore it, not as a complete outfit so that it became a costume, but all mixed together so that it was something they were comfortable in. There's got to be an individuality and style to the way someone dresses. The way to express this individual style is by using all the wonderful elements that are supposedly called the classics, and mixing them. You don't have to be gimmicky to make a look. It's taking the classic elements and putting them together with other things that creates the unexpected."

How to make an outfit appear more than the sum of its parts? Other than Coco Chanel, no fashion designer employed his own personal style to move the sartorial goal posts closer than Ralph Lauren.

PURPLE LABEL

The International Toff

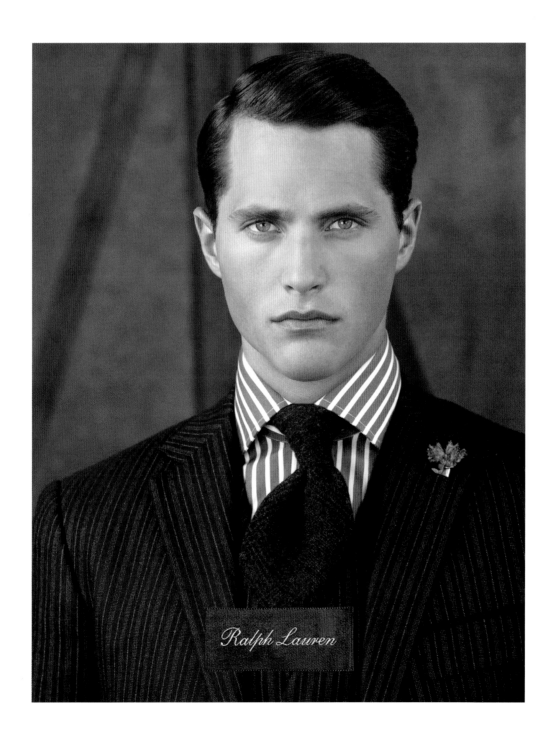

Ralph Lauren

117

In one of Ralph's favorite all-time movies, *The Philadelphia Story*, Mike, played by Jimmy Stewart, says to Tracy, played by Katharine Hepburn, "Well, I made a funny discovery. In spite of the fact that somebody's pulled himself up from the bottom, he can still be quite a heel. And even though somebody else is born to the purple, he can still be a very nice guy."

"Born to the purple" is an old-fashioned way of describing someone who comes from prominent or aristocratic parents, or in earlier times, from imperial or royal rank. The color's special status stems from the rarity and cost of the dye originally used to produce it. Outrageously expensive, purple was for centuries the defining color of wealth and power. Originally the color of the Roman and then the Byzantine emperors, from there purple moved on to the courts of medieval Europe. Queen Elizabeth I forbade anyone except close members of the royal family to wear it.

In the fall of 1995, Ralph added another chapter to the Polo playbook, the Purple Label Collection. The collection is the *ne plus ultra*, the absolute top in luxury and price-is-no-object quality, in short—the stuff of which sartorial dreams are born. As Ralph's most manicured-looking menswear, Purple Label is definitely for those gents who enjoy putting on the custom-made-looking dog i.e., donning a dressy suit, fastening a shirt collar, hiking up a dimpled necktie, pluming a jacket's breast pocket with a purposely folded hank. There is an accompanying sweater-around-the-shoulder sportswear adjunct; however, Purple Label's esprit derives from the dressy habit and haberdashery of a bygone era, with all its pin-collared nattiness and French-cuffed bells and whistles. Purple Label is for making an upscale entrance, whether into a high-powered boardroom, tony eatery, or Park Avenue pavilion of pish posh. Although the clothing is lighter weight, softer, and more fitted compared to pre-air-conditioned times, the look oozes with calibrated swank and currency.

With Purple Label, Ralph has also upped the male aspirational ante in both sum and substance. Although personal style has never been a function of one's ability to pay, the world's shrinking production of artisan-quality merchandise has mandated ever-steeper fares for its increasingly precious output. Purple Label attempts to honor this covenant between price and value. Suits are handcrafted in one of Italy's finest factories while fabrics hail from the world's most historic worsted firmaments. Dress shirts feature costly single-needle construction with high-count two-ply cotton shirting fabrics. Shoes are hand-lasted in England and Italy, ties are hand slip-stitched in sheathings from England and Italy's most legendary silk weavers and printers, and so on. No aspect of quality has been overlooked or compromised.

With that said, Purple Label has no monopoly on quality or luxury. Those random European carriage-trade retailers who purvey merchandise of equal, if not sometimes loftier provenance, still exist. However, Purple Label goes one step further, combining high-class quality with high-class taste, a whole other kettle of caviar. In the rare circumstance where both phenomena happen to coexist, bragging rights are in order.

Ever the maverick, Ralph rarely presents his men's line to the fashion press with a runway show. On some level, male models coursing down a catwalk does not necessarily type with the designer's image of the Ralph Lauren man. Therefore 2002 was an important moment when he and the company staged a men's runway presentation in Milan showcasing his Purple Label clothing and sportswear collection. One of the few times in thirty years that he had decided to do a fashion show for men, Ralph felt he had something important to say about men's fashion and he was demonstrating his intentions to establish a larger presence in Europe.

As Ralph described his Milan debut, "I think there was definitely a statement that I've made that men can look cool, sexy, and elegant at all ages in sophisticated clothes. It doesn't have to be trendy; it doesn't have to be flashy. There's a sense that the chicer dressed-up look is good for young guys now as well as other (ages). Because the word last year was *dress-down*—everyone was saying no one wants to wear ties or suits anymore. But I think my statement was that dressing up looks very exciting and very new again. The most important thing was that it's not this year's look, it's a forever look."

In 2015, the company opened the Palazzo Ralph Lauren on Via Barnaba in Casa Campanini, a twelve thousand square foot private club cum elegant showcase for the designer's luxury apparel and accessories for men and women. The exclusive emporium also serves as the backdrop for the designer's semi-annual fashion presentations and runway shows.

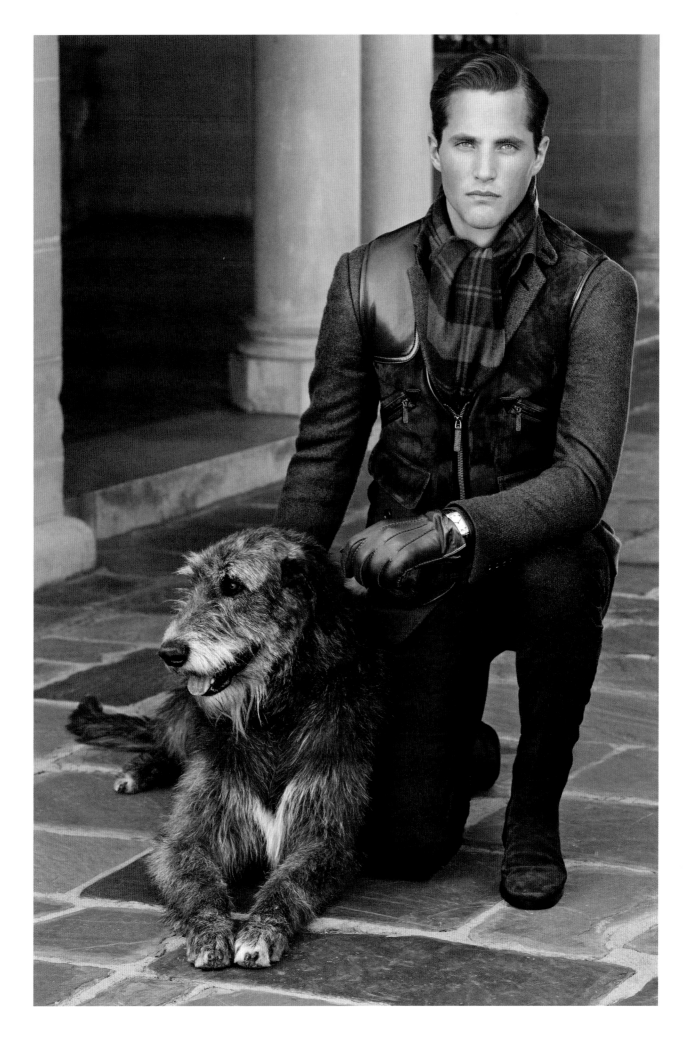

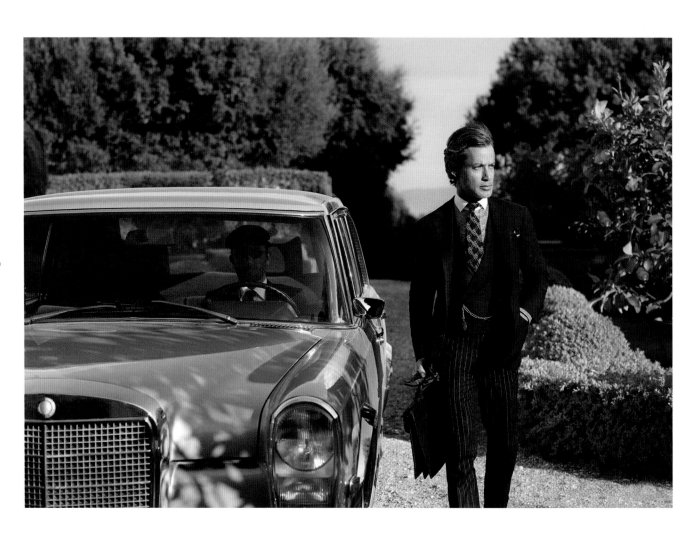

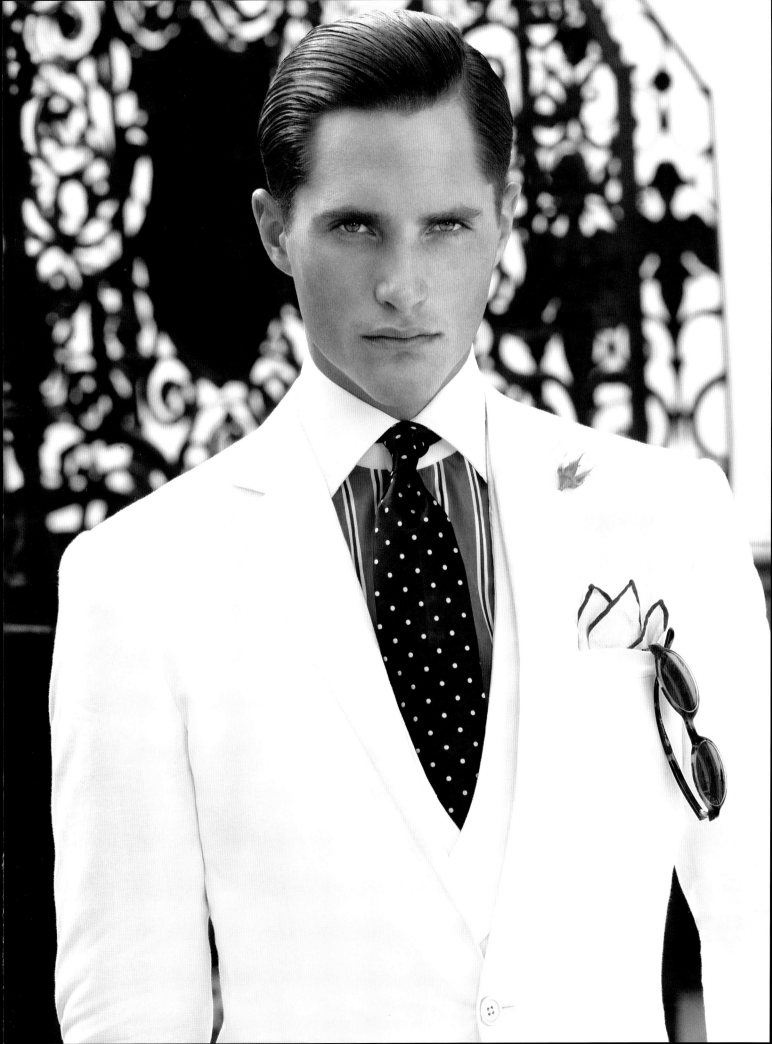

FORMALWEAR

Shirt Fronts for Real Studs

Starting from his earliest days right up to the present, Ralph has consistently featured formal clothes as an important component of his larger style vision. No designer has done more to pass down how to correctly hold your formalwear fork and knife. While Ralph's day clothes reflect the push and pull of modern menswear and fashion in general, the proportions and detailing of his dinner clothes have remained closely aligned with their English bespoke-inspired progenitors. By distancing himself from the red carpet's celebrity-divined trends, Ralph has safeguarded classic formalwear as the ultimate expression of sophisticated male taste.

Ironically, what continues to distinguish high-class formalwear is the seemingly outmoded and definitely unmodern concept of sartorial correctness. Coming up on almost a hundred years after the dinner jacket's debut, the lone opportunity to observe the intersection of fashion and sartorial correctness is in male formalwear where, with few exceptions, high fashion has typically chosen the wrong horse. Should anyone doubt the value holding fashion's excesses at bay, a quick look at any Oscar awards ceremony from the past twenty years will confirm just how far afield the uninitiated lad can be led. Armed with the new-age encyclical of "doing your own thing," tradition-emancipated men wander about the red carpet looking like victims of some failed fashion Ponzi scheme. Fortunately, Ralph has preserved this little corner of upper-class male habiliment from those fashion-addled designers, Hollywood red-carpet stylists, and other self-appointed style gurus whose stock-in-trade is picking up where the search for the "new" got cold.

The classic dinner jacket ensemble is a marvel of fashion perfection. No other era could have produced such a sartorial success because each step of the "semiformal's" evolution was measured by the perfection of the outfit it intended to replace—the grandfather of male elegance, the tailcoat and white tie. Since the culmination of the dinner jacket's design in the late 1920s, men's fashion has yet to improve on the genius of its original design or the unimpeachable refinement of its accompanying finery. As long as its historical proportions and trademark accoutrements are respected, other than lobbing a lighter-weight fabric or a more fitted silhouette into the fray, the classic tuxedo will fulfill its founders' promise of a stylish sanctuary for all comers, no less making all men look their sartorial best.

Too often what has been proposed for formal attire is either a tricked-out dark suit that ends up looking like a denuded tuxedo or another uninformed pass at brokering a dress-down alternative. Ralph's dinner jackets feature proper peaked or shawl lapels faced in silk satin or grosgrain; French cuffed dinner shirts with fronts designed to accommodate studs; cummerbunds or dress weskits to conceal trouser waistbands and suspenders; along with to-tie bows.

The ethos of Ralph's dinner clothes typically harks back to a time when a man owned at least one tuxedo, a woman didn't do housework, and a gentleman was expected to dress for a night's revelry. While keeping the formalwear faith, Ralph has long paid tribute to its glory days by periodically injecting a few newcomers into the semiformal regiment. As the true black-tie aficionado knows, high-class dinner clothes allow for a much larger arena of personal expression than is generally understood or practiced nowadays.

Ralph Lauren has elevated what Americans see as possible for themselves by offering snapshots of storybook lifestyles that feel somehow attainable.

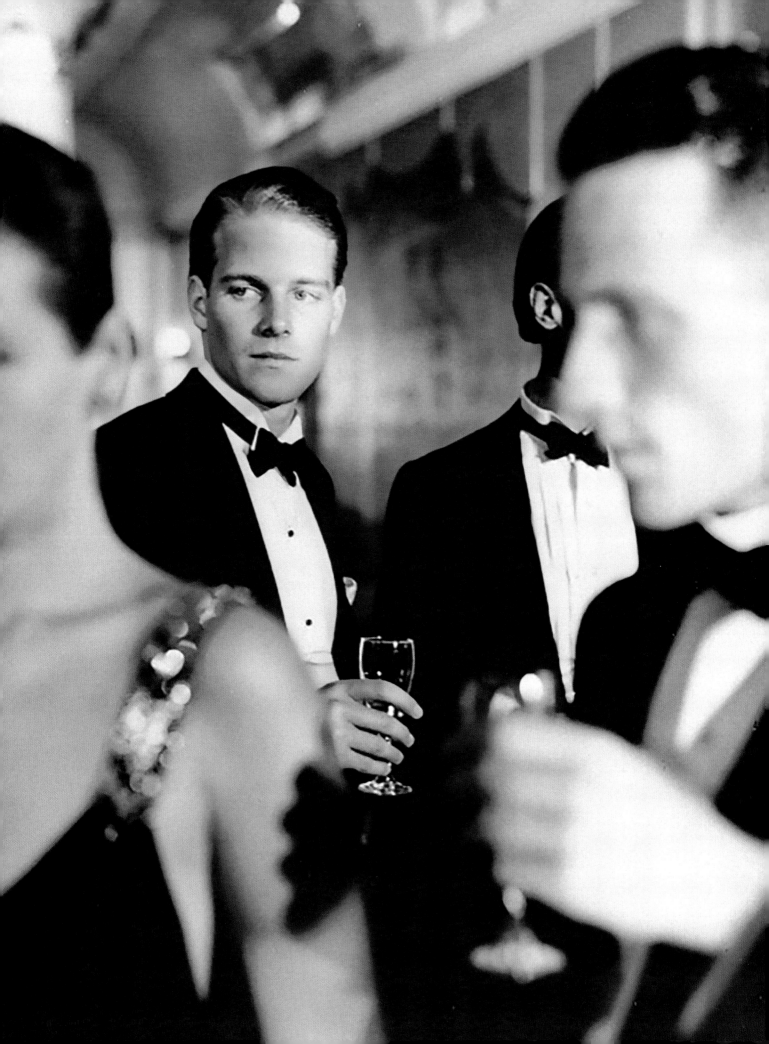

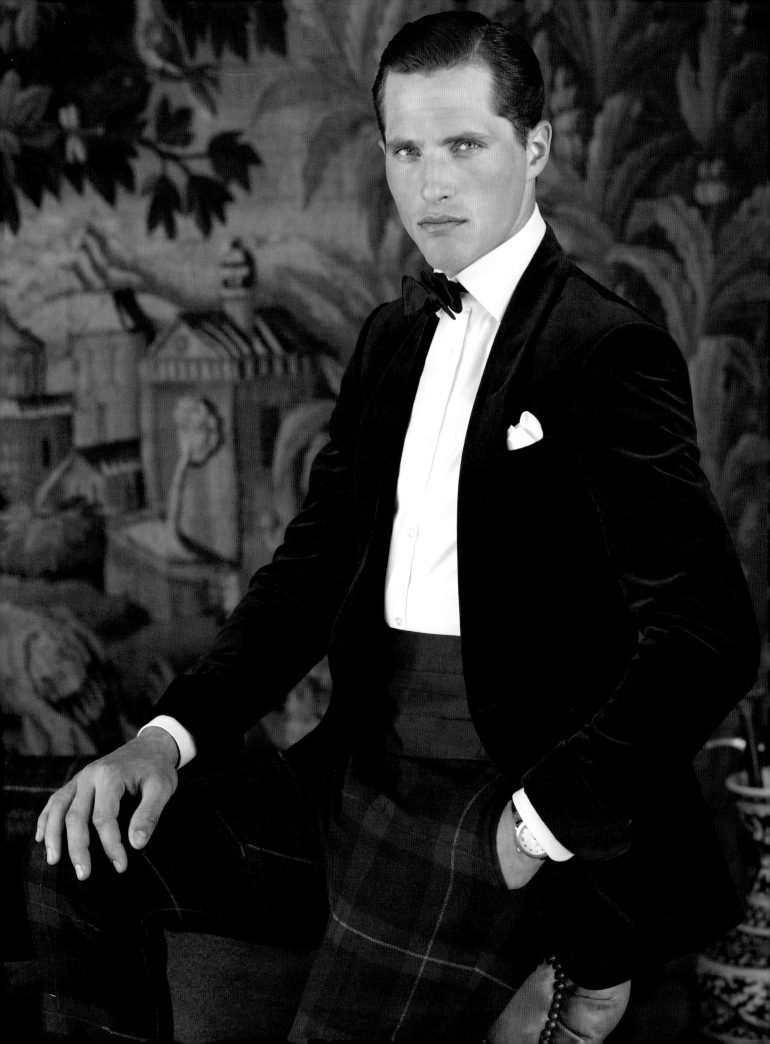

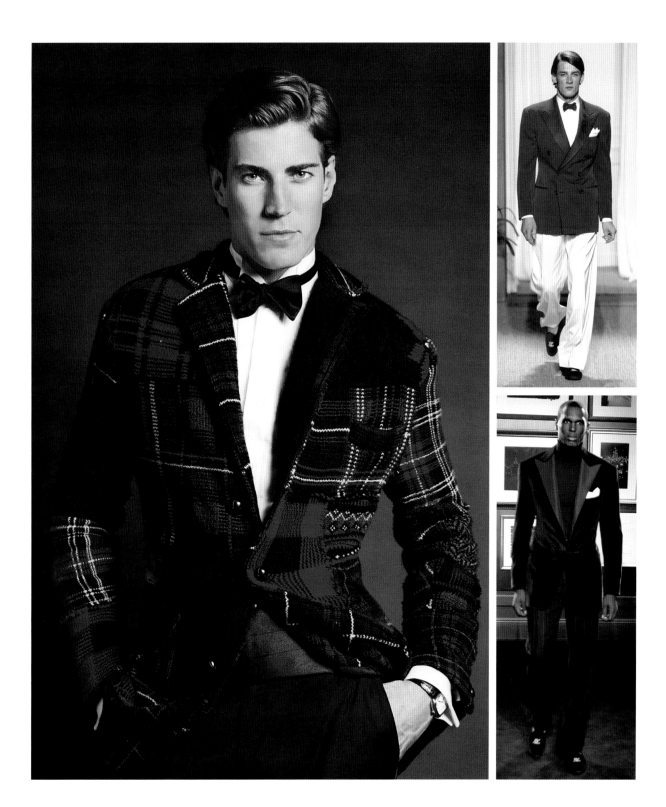

Opposite and above, left: A few timeless formal fashions from the Ralph Lauren archives.
With few exceptions, additions to the permanent black-tie wardrobe began as one man's collaboration
with his tailor or haberdasher, which, after acquiring wider acceptance among society's smart set,
took its seat at the larger roundtable of permanent formalwear fashions.

Above, right: Dinner jackets with white-handkerchief breeding. In menswear's salad days, one style point
was how a man donned his breast pocket handkerchief. Taking formalwear into your own hands
requires an informed style literacy. In the designer's hands, improvisations come off looking both proper and
wearable—the very reason so many men have followed Ralph Lauren's lead for the past fifty years.

While monogrammed velvet slippers represent a break from formal shoe protocol, their presence
usually confirms the wearer's standing among the better heeled.

WOMENSWEAR

FROM COUTURE TO BLUE JEANS, SALON TO STREET

Once upon a time, women's fashion was the exclusive province of Paris's haute couturiers. For three centuries, except in times of war and siege, Paris's dressmakers decreed what women would wear. France had become the European center for richly produced and innovative silk textiles, which served in facilitating the development and sustenance of its haute couture system. Nowhere else in the world was elegance regarded so seriously or nourished by such a confluence of talent, skilled artisans, and willing clients. As London was for centuries the traditional capital for male elegance, Paris was its feminine stronghold.

Up through the 1960s, Paris's couturiers served two benefactors: the private client and the commercial customer. The private and more preferred patron demanded elegant clothes made to her whim and exacting specifications. The couturier was expected to provide the costumes for his or her clientele's elaborately prescribed social life—dinner parties, theatergoing, entertaining, and balls—as enacted behind the grand walls of the world's most extravagant living quarters.

Perfection in quality, workmanship, and details legitimized haute couture as the most elevated art form of international fashion design. Authentic haute couture was intended to be a dialogue between the designer and his or her small private clientele. The choice of a dress or hat could take multiple visits, the color of a lining mulled over for hours. Fittings staged over several weeks required a client's investment of personal time and patience. When women were predominately decorative objects and labor was cheap, when lifestyles were slow and stratified, Paris's haute couture was feasible.

The commercial customer became the couturier's secondary, but no less important, source of income. Starting in the interwar years, the economic basis of the couture houses began to shift from private sales to design sources for the merchants or manufacturers who purchased the dressmakers' designs in order to reproduce them. The couturier would charge manufacturers and store buyers twenty to thirty percent more per dress, as well as a minimum commitment of dollars or models purchased, plus admission fees to view each collection. Manufacturers would pay admission in hopes of finding those future "Fords" that would be the bestsellers when mass-produced and advertised as "Copies of Original Paris Creations." Store buyers attended in order to purchase actual models that they would export at great expense and then sell at a loss to augment the cachet of their own establishments.

Paris in the 1920s. If you were a fashionable young English lady of elevated social standing, you would make a twice-annual pilgrimage to Paris, joining other women from as far away as New York and St. Petersburg. The period between the two world wars, often considered to be the golden age of French fashion, was also one of great change and upheaval. Cars replaced carriages, princes and princesses lost their crowns, and haute couture found new clients in the ranks of film actresses, American heiresses, and the wives and daughters of wealthy industrialists.

Above, left: As *Vogue* magazine wrote in 1947, "There are moments when fashion changes fundamentally, when it is more than a matter of difference in detail. The whole fashion attitude seems to change—the whole structure of the body." Dior's New Look was one of those moments.

Above, right: American manufacturers would pay admission to attend the French couture shows in hopes of finding those future "Fords" that would be the bestsellers when mass-produced and advertised as "Copies of Original Paris Creations." America's finest stores would purchase actual models that they then would export at great expense and sell at a loss to augment the cachet of their own establishments.

Opposite: As the founder and catalyst of the sixties space-age fashion movement, André Courrèges was one of its most revolutionary figures. With his innovative 1965 Couture Future collection, the French designer introduced miniskirts, peekaboo A-line dresses, and his infamous white ankle boots. Along with fellow French designer Pierre Cardin, Courrèges brought modernism to clothing design through his geometric forms and primary colors, becoming known as the designer for "Tomorrow."

Each season top American stores looked to Paris for inspiration. The progression of trends seemed predictable, if not inevitable. Spawned in the European couture, they migrated into America's high-priced ready-to-wear collections in limited line-for-line copies or in watered-down versions for mass consumption. America's Seventh Avenue provided the more accessible versions of the Paris look at popular prices.

Twice a year, in frigid January and humid July, the world's merchants and fashion editors would assemble in the salons of the haute couture houses, predominately situated in or around Paris's Eighth Arrondissement to perpetuate the then semiannual fiction that fashion had just been conceived. One year, broad shoulders and longer jackets were de rigueur; the next year, narrow shoulders and looser waistlines reigned supreme. Hemlines were raised or lowered according to the couturiers' dictates.

World War II effectively cut the world off from French fashion. However, on February 12, 1947, Christian Dior resurrected France's authority by unveiling his "New Look." Hemlines fell. Breasts were pushed up. Waistlines were pinched. Hips were curved. And skirts billowed. The New Look was an inevitable reaction to the wartime austerities. While the United States had just lifted restrictions on fabrics a few months before, leading Seventh Avenue designers such as Norman Norell had gradually been lengthening the skirt. But when Dior did it, he did so with the imprimatur of Paris's couturier establishment. The spotlight was on him, and he gave the lengthened skirt meaning with a nostalgically feminine silhouette. In a single stroke, he restored the stature of the Paris couturier to that of a cultural oracle, bringing women back to the stores in droves. All of a sudden, Parisian fashion became front-page news again.

It took almost eleven years for the next radical change in fashion silhouettes to take center stage, in 1958 with the chemise. Paris couturier Cristóbal Balenciaga had been loosening the silhouette since the early fifties, as had Hubert Givenchy, an aristocratic young giant who made his presence known starting in 1951. From the mid-fifties to the mid-sixties, nothing happened to the basic sheath shape that was not an evolution or a reworking of Balenciaga's original intention. The A-line, H-line, and Saint Laurent for Dior's pivotal *trapèze* shape, anchored the era's silhouette. The absence of a waistline signified a new freedom for women. Nevertheless, it actually took until 1965 for the looser look to be embraced across the board, due to the American husband's resistance to its less form-revealing shape.

In the spring of 1957, six months before his death, Christian Dior described couture's fashion muses as being rich, chiefly Parisian between the ages of thirty-five and fifty, and no more than seven to ten thousand in number. By the end of the following decade, the couturiers saw their client's ranks diminish significantly. With the outbreak of France's May 1968 rebellions, a certain way of life that was already dying out was finally rendered démodé. What started as a students' protest against the autocratic practices of a French university in the western suburb of Paris quickly morphed into a general strike that mobilized ten million people and brought the country to a standstill. Said the writer Edmonde Charles-Roux, "France exploded like a champagne bottle left out in the sun."

As one young American fashion editor working in Paris recalls, "At the time, we all believed it was the end of couture. I remember doing interviews with major couturiers and they were all desperate; they tried to believe in it,

but May 1968 shattered a certain idea of luxury and fashion." It was not just that the rich had become any fewer in number; if anything there were more of them as the provenance of one's money mattered even less than before. But the minuet speed of their private lives had now accelerated to jet speed. The world-shrinking jet airplane that went into wide-scale service in 1960 brought Europe even closer in time to New York and Chicago than a train trip from either of those cities to their own domestic resorts. Faster travel meant that people brought ideas and accessories from abroad more easily. Jet travel spawned a "jet set" that partied—and shopped—as happily in New York as in Paris. Rich women no longer felt that a Paris dress was necessarily better than one sewn elsewhere. Now that status derived from the latest ready-to-wear fad in London or New York, the elitist appeal of a couture dress with its three fittings and four-week delivery began to fade.

With the anti-establishment sixties in full swing and the dissolution of the couturier–client dialogue under way, the laws governing fashion's top-down leadership began to drift away from the Paris couturiers and the women of educated taste whom they dressed. In its place emerged a new alliance between the mass designer's fast-percolating and affordable ready-to-wear and the increasingly trend-conscious populace. No longer would *la mode* be handed down by a rarefied aristocracy nor left to a small cartel of stentorian, dictatorial designers. The making of fashion would become different from everything that preceded it; fashion as an Olympian decree, Paris-centric monopoly was about to topple.

French clients began to fall away as the haute couture increasingly became a market for evening clothes, American buyers, and licenses. In just one year, from 1966 to 1967, the number of couture houses in Paris plummeted from thirty-nine to seventeen. The reality for many of those houses that closed was that the real estate was now worth more than the business. By the end of the sixties, Paris's couturiers were struggling with the greatest identity crisis in the history of dressmaking.

In 1958, shortly after Dior's death, Yves Saint Laurent, then twenty-one and a promising assistant, was hustled up from the backrooms and formally presented as the new dauphin of Dior. In his first collection, the *petit prince* was credited with saving the moribund house of Dior with his new *trapèze* silhouette, displaying a daring that would flourish through much of his career. His next few collections attempted to reflect the trends emanating from the street culminating with his spring-summer 1960 beatnik-inspired collection, complete with leather jackets, alligator raincoats, and turtleneck sweaters. It was Saint Laurent's generation beginning to speak through the couture. Not surprisingly his collection was widely disparaged within the couture establishment, proving too visionary and experimental for the ivory towers of Avenue Montaigne. Notwithstanding, it did serve to lionize Saint Laurent as the first designer to elevate the look of the street to haute couture.

By 1960 a group of young designers who had trained under masters like Dior and Balenciaga began to leave their august "houses" to open their own establishments. The most successful of the new generation were Yves Saint Laurent, André Courrèges, Pierre Cardin, and Emanuel Ungaro. One of the leading shakers of the time was the couturier André Courrèges, who improvised on the design themes of Balenciaga, his former mentor. First he hacked off the hard sheath shell that was Balenciaga's prescription for the modern woman. Then he replaced it with a short boxy silhouette whose skirts soared three inches above the knee. When rendered in stark white with tall white boots, his

"space look" dovetailed more with the concrete glass architecture of modern cities than the contours of traditional dresses, coats, and suits. By exposing a longer span of leg the abbreviated skirt required a new proportion. Along with his futuristic trouser suits, Courrèges's head-to-toe ensembles became billboards for contemporary taste. The woman who chose to wear them, whether flattering or not, served notice that she had cut her ties with the past.

After Courrèges it was obvious that fashion could broadcast a far more inclusive message than merely the duty to consume clothes. Big business soon discovered the selling power of pop or youthful fashion. One of the fashion industry's earliest rallying slogans was that appearance could control one's destiny. Fashion stopped being just clothes and became a value, a way of life, human packaging. For the first time a total, top-to-bottom look could be merchandised for instant fashion and mass consumption.

The sixties were to set the general mood for the balance of the century with the operative word being *youth*, as fashion became something marketed mainly to young people. The changes in attitude also reflected the aging of the baby boomer generation, as most were no longer young and had jobs and incomes. In the States their sheer number impacted everything, their economic footprint now huge and inescapable. As the decade progressed, the implication of the word *youth* changed from a freshness and simplicity, at least within the fashion world, to a kind of mock innocence, signifying a hip or with-it attitude. By the end of the decade, it had acquired a decidedly nonconforming, anti-fashion call-to-arms ethic.

In 1961 John F. Kennedy became America's president, bringing with him a young, beautiful, and fashion-inspiring wife as first lady. Jacqueline Kennedy was to wield as powerful and widespread an influence over fashion as the turn-of-the century Gibson Girl and for much the same reasons—she was pretty, charismatic, and she dressed simply, making her style easy to adopt. Jackie's appearance was so pared down that it looked fresh. Not long after the Kennedys moved into the White House, Jackie's little-nothing dresses along with her perfectly matched accessories, unadorned cloth coats, plain pillbox hats, and pumps became mass-class fads. In no time at all, women around the United States had memorized the high-fashion mathematics of multiplying chic by subtraction. Jackie put a lot of care into her look, and women in the States and abroad took to wearing her shift dresses and simple accessories with enthusiasm.

With Jackie's clothes front-page news, the pared-back ladylike look that first appeared to project a youthful spirit, rapidly became the mainstay of the establishment. Sadly, after her husband's assassination, Jackie receded from the

If the fashion gods were to assemble the world's most influential female fashion icons, Jackie Kennedy Onassis would likely top the list. From her role as first lady during the White House Camelot years when as America's first culture queen she no longer had admirers but fans, to her post–White House years and beyond, her look continued to be admired and copied worldwide, decade after decade. Although she never spoke with the press, America's *Reader's Guide to Periodical Literature* consistently listed more articles about her than any other American woman. According to Marylin Bender's *The Beautiful People*, her 1967 classic on the jet set, "The most significant lesson that Jacqueline Kennedy imparted to the public was the continuing education in the simplicity of fashion editor taste." A reputed Jackie adage: Embrace only what works for you, keep it modern, and make it your own.

Opposite: Brigitte Bardot will live forever as the French "baby doll" sensation of the 1950s and 1960s. With her tousled blonde locks, pouty lips, deep cleavage, and signature heavy eyeliner with its thick winged flick, she would tear at men's hearts and loins for the next thirty years. In the process she sensationalized the bikini while introducing the world to gingham, rompers, and her beloved St. Tropez.

Above: Among the many revolutions of the Swinging Sixties, from the Beatles to the first man on the moon, the miniskirt remains one of the era's most enduring images. Although opinions differ as to who invented the abbreviated garment first, with England's Mary Quant and France's André Courrèges among the leading contenders, its launching pad was London designer Mary Quant's Chelsea boutique. Supposedly named for her favorite make of car, the Mini, the waist-skimming skirt's length measured no less than six to seven inches above the knee. The miniskirt changed fashion forever, and by 1967 to be the only girl on the block not wearing a mini was tantamount to social leprosy.

public eye. Women had to find a new fashion idol. Although the decade produced a wide range of alternative fashion archetypes, the most luminary was Brigitte Bardot—Jackie's polar opposite. Her French "baby doll" look of shorter skirts and big hair with pronounced makeup suggested a kitten-meets-Cupid allure, a far cry from Jackie's rigorously modest, but grown-up demeanor.

Whereas movie stars and the costume designers who dressed them had long influenced global fashion, by the early 1960s Hollywood had become a wasteland of style icons for American women to emulate. Audrey Hepburn, the only actress with reliable taste and high-fashion sense, operated as an international figure on a distant plane. Her Givenchy-French-couturier-inspired school of dressing served as a kind of high-brow bookend to Jackie Kennedy's own polite, ladylike American classicism.

But by the middle of the decade, the tides of fashion had almost completely reversed. Mirroring the social upheavals of the day, pillboxes and pearls began sharing the spotlight with tie-dyed undershirts and blue jeans. In 1964 women's fashions would change forever with the London designer Mary Quant's introduction of the miniskirt. Quant's dresses were short, very short, in either A-line shapes or sleeveless shifts in bold colors and prints. The miniskirt was eventually to be worn by nearly every stylish young woman in the Western world, pushing out the longer skirt lengths of years past. Quant's message was, "You'll see the world differently from within a mod minidress than a shirt-waist and girdle." Pushing the boundaries of acceptable streetwear, she helped spark a quantum shift in fashion.

The sixties saw the fashion industry allow itself to become tyrannized by all things "youthful." It was as if the kindergarten teachers had abdicated to the children. Elegance was mortally wounded because too many fashion editors and merchants lacked the maturity and integrity to resist the sound of profit by rationalizing that obsolescent fashions could be tolerated as long as they continued to ring the registers. Determined to stay one step ahead of the costume party, those Paris couturiers and American high-fashion designers who had traditionally set the styles and might have answered the demand of the other half of the population instead decided to join the free-for-all. Proposing baby dresses and bloomers, many betrayed their customers while making fools of them.

In the spring of 1962, Diana Vreeland, the doyenne of American fashion and the undisputed generator of high-flying pizazz, took command of American *Vogue*. As its editor in chief, she cast off her snood and blue hair rinse to proclaim that no longer was there a great divide between the so-called young and mature woman. Whereas fashion

137

Above: In 1958, Max Raab and his brother Norman launched *The Villager* line of women's clothing that would become a mainstay of boarding-school girls and country-club wives throughout the 1960s. Featuring a casual look of separates with small Liberty-style prints, pleated skirts, and Peter Pan collars worn with a circle pin, the proto-preppy label grew to be one of the preeminent brands in American sportswear. However, with the advent of the late 1960s counterculture, the All-American college girl look began to lose favor, ultimately deferring to the Swinging London mod girl look.

Opposite: Opening his own stand-alone Paris shop called Rive Gauche in the fall of 1966, designer Yves Saint Laurent gave his couturier's approval to the legitimacy of ready-to-wear clothes, which, in turn, helped to further democratize fashion.

magazines had previously served to instruct their readers in the nuances of social proprieties, they now switched, urging them to keep up to date, to lose their inhibitions, to be experimental. Women were now told to shape up and shrink down via diet and exercise to fit into the younger-cut clothes. The slavish conformity of the fifties was essentially exchanged for the slavish nonconformity of the sixties.

"'We have edited out the vulgar,' declared Mildred Custin, the president of Bonwit Teller, in the spring of 1966, after viewing the designer showings on both sides of the Atlantic. She admitted that for the first time, tastelessness was a factor to reckon with in the so-called better fashion houses of Paris and Seventh Avenue. That season was just the beginning. Standards of propriety and intelligence have been plummeting ever since," wrote Marylin Bender of the *New York Times* in her book titled *The Beautiful People.*

All of a sudden, patrons of society's established taste standards faced an existential crisis, that of personal censorship and where to draw the line between the latest trend and good taste. The sixties ushered in a time period of warp-speed fashion innovation for women. From Yves Saint Laurent and André Courrèges in Paris, to Norman Norell and Bonnie Cashin in New York came the first universally adopted female uniform since Chanel's skirt suit—the pantsuit. As shocking as the mini was to perceptions of public decency, acceptance of the pantsuit was not far behind.

In Western culture, trousers had long been viewed as masculine; but by the late sixties they had become acceptable for women to wear in certain public venues. Some offices and public establishments forbade women to wear trousers, unsure whether they constituted an insult or an empowerment to femininity. Regardless, women loved them because of their practicality and comfort. They began to mate them with dressy tunics, shawls, and matching suit jackets. As casual pants started being worn everywhere, trotting out a pant for dress-up seemed only natural. By adopting a look copied directly from men's suits but tailored down to feminine proportions, women seemed to be voicing their equality to men. Trousers also carried with them the social values of personal choice and freedom, liberties identified with the emerging women's movement and the individualism of the time. As fashion magazines debated the issue, women flocked to the stores to buy them.

Although Saint Laurent did not invent trousers, he did propose them as the absolute pillar of a modern woman's wardrobe, to be worn every day, all day. "The difference between day and evening clothes is outdated. The new fashion freedom permits people to be as they are or

In 1958 store president Geraldine Stutz turned the main sales floor of carriage-trade retailer Henri Bendel into a "U-shaped Street of Shops." Many consider that initial configuration as the forerunner of today's shop-within-a-shop merchandising approach. Ms. Stutz's concept was narrowly focused on a young, sophisticated urban woman. Ms. Stutz described her taste for what she called "dog whistle" fashion: "Clothes with a pitch so high and special that only the thinnest and most sophisticated woman would hear their call."

140

as they want to be—go to dinner, for instance, as they were in the morning in black jersey, or anything else," Yves Saint Laurent said.

With Paris no longer its singular capital, the center of women's fashion dispersed and new hatcheries surfaced. French couturiers began to take inspiration from the United States and Britain, trooping to America to return bearing blue jeans, button-down shirts, flowered sheets, and barbecue equipment. Likewise, American designers made their bi-annual pilgrimages to Europe, returning to Seventh Avenue arrayed like weekending Rothschilds in blazers and foulard neckwear. Anglomania also raged among those French youth who wanted the instant fashion packaging of England's landed-gentry look.

By 1965 the fashions of the American college girl— Scottish kilts, Shetland sweaters, and coats worn with knee socks and Norwegian moccasins—took Paris by storm. Up and down the East Coast, in that American provincial period before the invasion of international brands and before the film *Love Story* had engraved the word *preppie* into the national consciousness, boarding-school girls and country-club wives swathed themselves in the American brands of Villager and its younger offshoot, Ladybug. This

was the post–World War II, Eastern Seaboard WASP edition, when the Ivy League and the Seven Sisters colleges still deferred to Britannia's sartorial supremacy with their diamond-studded circle pins and man-tailored Scottish tweed suits. That is, until the zeitgeist swept them off to become mods and hippies.

Not surprisingly, the retailing of fashion was also ready for a new incubator. By 1966 small, independent owner-operated retailers had managed to upend once and for all the conviction that creativity in fashion filtered down from the couture into ready-to-wear. Trends that had started at street level now trickled up to influence the runways. Although couture was sometimes described as a laboratory for fashion, trendsetting had moved from its salons, *cabines*, and design studios to the sidewalks, shop windows, and manufacturer's ready-to-wear workrooms. Starting in the 1960s, these hole-in-the-wall shops became the new-age fashion ateliers, functioning as hangouts with ideas springing from the air as owner-designers sat around chatting with friends. What vitality remained in French fashion now came from young freelance designers' ready-to-wear that was sold in boutiques— those small shops that had sprouted like wild daisies in the most unpredictable districts during the decade. The French word *boutique* meant shop or studio, as distinct from the large store.

In the States the smaller fashion-forward retail boutiques carried some lines of inexpensive ready-to-wear from those Seventh Avenue firms specializing in teenage sizes and styles, but much of the clothing was made in-house, using rudimentary techniques such as hand-studding, painting, tie-dyeing, et cetera. The industry's semiannual collections, or those clothes made according to season, couldn't keep pace with the little shops where new clothes seemed to bubble up all the time. By the midsixties, more American fashion emanated from the small-store scene than from the street.

As the sixties declared itself, it became obvious that the wave of the future was in mass-produced, relatively inexpensive clothes. The more profitable ready-to-wear market necessitated new initiatives for the haute couture houses, which began to create less expensive, off-the-rack lines. In Paris the three most alert couturiers, Pierre Cardin, Yves Saint Laurent, and André Courrèges, looked for survival in affordable prêt à porter.

Adjusting to the realities of the mass fashion era, they became preoccupied with applying the techniques and materials of industrial technology to popular fashion rather than costly works of art for a few.

In the fall of 1966, Saint Laurent launched a ready-to-wear collection under the name Rive Gauche, opening

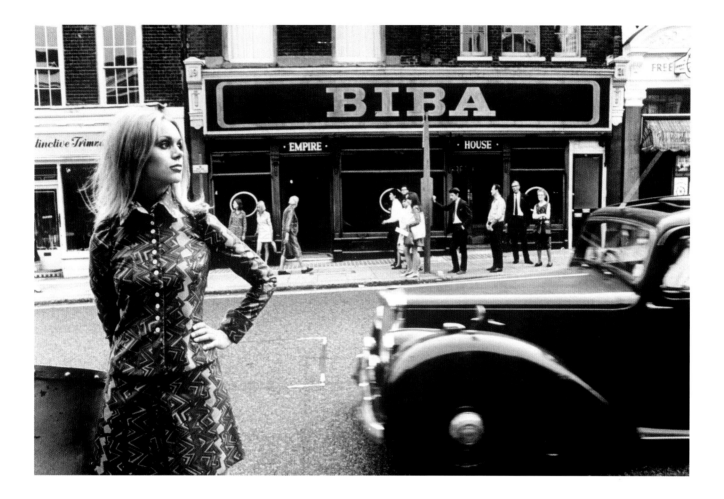

his first prêt à porter boutique on the Rue de Tournon. The Left Bank name and identity was a stroke of genius that set the collection apart from the couture and gave the ready-to-wear a badge of youth and cool. Marking the first time a couturier had successfully launched a ready-to-wear line in France, it was a manifesto, a complete departure from the grand and gilded environs of his haute couture salon. Nina Hyde, fashion writer for the *Washington Post*, wrote at the time, "it was he who made mass-produced fashion acceptable in France, lending his couture prestige to boutique shopping."

According to Saint Laurent's business partner, Pierre Bergé, the philosophy behind Rive Gauche derived in part from the British designer Terence Conran who, two years earlier, had opened Habitat, an interiors store. As Bergé explained, "We very much admired Terence Conran's idea for everyone in the world to have a well-designed salad bowl. With Rive Gauche, we wanted to ensure that every woman in the world could have a 'well-designed wardrobe' to go along with her salad bowl." Aimed at "young women,

Biba was a fashion store in Swinging Sixties London that redefined the High Street shopping experience. A fashion label, a shop, a look, Biba perfectly encapsulated the mood of the time. The clothes were made specifically for young people, girls in their late teens and early twenties, because in typical sixties spirit, Biba wanted to draw a line of demarcation between their clothes and those of their mothers. States its Polish-born designer and owner Barbara Hulanicki, "You were part of one of two camps: if you loved the Beatles you shopped at Mary Quant, if you loved the Rolling Stones you'd shop at Biba."

ladies from fifteen to still young-at-heart," with prices to match, Rive Gauche was an immediate, phenomenal success. Some customers waited up to three hours just to purchase items. Fashionable girls and women thronged to buy Saint Laurent's sexy safari minidresses that tied low over a plunging décolleté.

While designer ready-to-wear was nothing new to Americans, it was a revelation to the French consumer. This new system of consuming high fashion caught on so quickly that many of the couture's clients rushed to join the Rive Gauche craze. Within weeks it was clear that the Rive Gauche boutique was the new inner sanctum of Parisian youth culture. The shop quickly turned into Saint Laurent's de facto atelier. As he was quoted at the time in a television interview, "I've chosen to present my fashion through my ready-to-wear rather than through my haute couture."

In 1967 Pierre Cardin, the other go-getter from Paris's haute couture ranks , followed Saint Laurent's lead to the Left Bank and the Saint-Germain-des-Prés area with two boutiques, one for teenagers and another for older youngsters. The word *boutique* became a cliché encompassing everything from the sublime to the salacious—an oasis of freedom where a woman could find self-expression in wearing apparel. Shopping in boutiques certified that a woman was a swinger.

From then on, most of fashion's international elite wanted it to be known that their clothes came from the small shops with the low prices. Fashion aristocrats like the Duchess of Windsor could be seen buying prêt à porter items, like an Emmanuelle Khanh coat at Dorothée Bis, a legendary Paris boutique. It was the latest form of the inverse fashion snobbery that started when Coco Chanel took the humble jersey of the stable boy and made it more à la mode than satin and velvet for duchesses. When Audrey Hepburn initiated a shopping blitzkrieg in the small shops of St. Tropez followed later by one on Paris's left bank, the press treated her boutique conversion as ceremoniously as if she had been filing for divorce from her husband Mel Ferrer.

With Paris's haute couture houses no longer connoting the last word in status, shops like London's Biba, Paris's Dorothée Bis, and New York's Paraphernalia became the new watchwords for insider stature. At the same time, New York's fashion vanguard began to patronize alternative spots in search of future classics—antique clothing stores, army-navy outlets, and ethnic emporiums. These stores were to became enormously influential in helping men and women establish a preference for assembling their own eclectic looks as well as

furnishing Seventh Avenue with a constant influx of new ideas.

American fashion retailing was likewise entering a new era. New York City department stores were closing their by-now obsolete custom or couture departments and phasing out their formerly huge millinery salons, trying to make room for in-store boutiques to compete with the many independent little shops cropping up all over Manhattan. Unlikely areas like downtown's Greenwich Village and certain Midtown cross streets in the Fifties and Sixties between Second and Madison Avenues were attracting more young people than the traditional fashion byways on Fifth and Lexington. The boutique had become the new retail panacea for big business with tired blood.

The first to apply the boutique concept to a large and dignified American institution was Geraldine Stutz, one of the era's pioneering retailing talents. In 1958 thirty-three-year-old Stutz, a former shoe editor at *Glamour* magazine who then became vice president of the I. Miller retail shoe stores, was handed the presidency of Henri Bendel. Sensing the beginning of an era of women as "individuals" in fashion and, therefore, the need for a new kind of personalized store, she transformed the declining carriage-trade store into a visually stunning emporium of new and upcoming designer brands. "We were the first people to have what became known as a 'street of shops,' that is, 'boutiques within the store,'" she was quoted.

Ms. Stutz's concept was narrowly focused on the young, sophisticated urban woman. She rarely carried clothes larger than a size 10. In a 1987 article in *New York Magazine*, Ms. Stutz described her taste for what she called "dog whistle" fashion: "clothes with a pitch so high and special that only the thinnest and most sophisticated woman would hear their call." She was also one of the first retailers to consider merchandising food and furniture alongside fashion. "She recognized that fashion was more than just about clothing; it was about lifestyle and how one lives," said Joan Kaner, the fashion director of Neiman Marcus, who worked under Ms. Stutz from 1967 to 1976.

By the late 1960s, Ms. Stutz had taken the in-store shop concept even further with elaborately merchandised boutiques dedicated to the smaller, independent collections of designers she felt could succeed with the store's support. Stephen Burrows opened his boutique there in 1969, an experience he recalled as the defining moment of his career. The store heralded the introduction of a new generation of fashion stars: Mary Quant, Jean Muir, Sonia Rykiel, Mary McFadden, and later on, one Ralph Lauren.

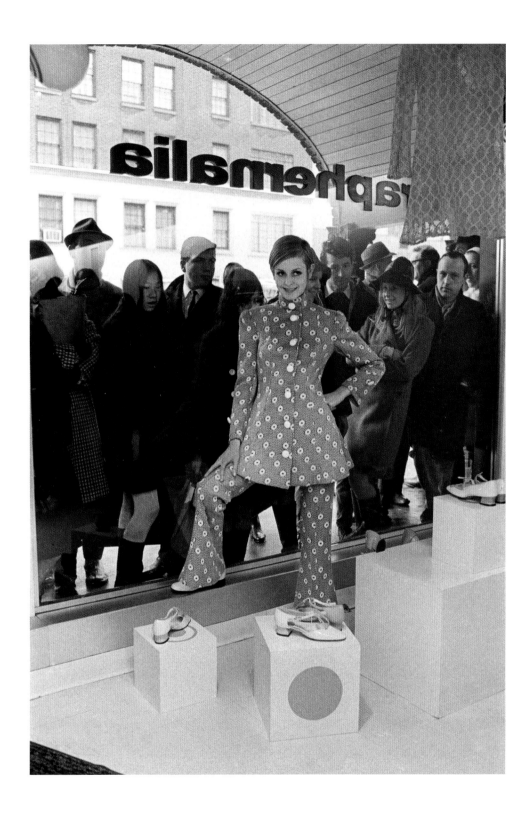

In 1965, as if from outer space, the mini arrived, touching down in New York City in
a spaceship-sleek boutique on the corner of Sixty-Seventh and Madison called Paraphernalia.
Once British entrepreneur Paul Young opened his doors and installed a go-go girl in the window,
fashion would never be the same. Clothes were displayed like art in a minimalist gallery sold
by cooler-than-thou young salesgirls with rock and roll blaring from the speakers. The first to market
must-have trends to a young audience at relatively low prices, Paraphernalia was a laboratory
and showcase for fresh design talent; Betsey Johnson got her start there, becoming one of their most
important in-house designers. As playwright Wendy Wasserstein remembers of the salesgirls,
"I thought that just by working there, they were practically sleeping with Mick Jagger."

THE BIRTH OF MODERN AMERICAN SPORTSWEAR

What the English had managed to achieve by rebellion and the French were moving toward at a slower pace, America had long been the birthplace of ready-to-wear fashion. As the cradle of mass culture, America was the first to make good-looking, mass-produced, off-the-rack apparel for the masses. That had never happened before in any country. Not surprisingly, the technical and financial prowess of the American manufacturer to create less-expensive to moderately priced apparel was constantly improving. American buyers scoured the world with the result that their stores sold a staggering variety of international merchandise. Here the shop girl and the stenographer could be the style equals of the boss's wife.

Ready-to-wear clothing was to become both the foundation and future of American fashion. From the interwar years forward, New York's Seventh Avenue functioned as the epicenter of America's ready-to-wear industry. Up until the sixties the factories controlled Seventh Avenue; most of the names on a label were manufacturers, not designers. According to Bill Blass, designer and America's first unofficial fashion ambassador, "There used to be a stigma about designers. The designer was hidden away in the back rooms, encouraged to take his vacation as soon as the collection was shown, so the manufacturer and salesmen could make changes to his work. Back then when people at a party asked me what I did, I would say something vague like manufacturing."

By the early sixties American designer names finally began to appear as the stars of the label. The pop generation catapulted the fashion designer to new heights of adulation; lionized by hostesses, ennobled by the press, they emerged as celebrities in their own right, becoming friends with their movie star and society clients.

Designer Claire McCardell is generally credited as the mother of the American Look, pioneering the style of casual sportswear. Her approach was to design affordable, mass-produced, unfussy clothes that busy American women needed in order to live their active lives both inside the home and workplace, and out. Inspired by activewear and menswear, she pushed the aesthetic limits of what mass-produced clothing could look like, thus helping to redefine modern American style.

Travel also helped forge mass fashion, not only by homogenizing taste but also by encouraging the development of on-the-go clothes. Economics and the swift pace of modern life called for fast-paced but practical fashion. A traveling woman must have a dress that can suffer the crush of a suitcase without wrinkling while not binding her as she dozes in an airplane seat. Her coat must be able to deal with a succession of differing climates.

Sportswear, or the concept of dressing in separates, started in America. It was synonymous with the country's active, sportive way of life. European designers had never thought of fashion in terms of sportswear until it became a big thing in America and then throughout the world. As Yves Saint Laurent was famously quoted in *New York* magazine in November 1983, "I have often said that I wish I had invented blue jeans. They have expression, modesty, sex appeal, and simplicity—all I hope for in my clothes."

From then on it was no longer a question of hemlines; fashion would be all about attitude. Americans carried with them a whole new culture of fashion that was underpinned by a cornucopia of homegrown visuals: contemporary American art, Andy Warhol's pop mentality, the American West, Hollywood movies, and the throbbing beat of soul and dance. It was an approach that heralded the future, an easy merging of street, screen, art, irony, music, and the individual. Sportswear ruled the sixties, highlighting a new American fashion movement, which—led by designers like Halston, Calvin Klein, Perry Ellis, and Ralph Lauren—began to exert a world influence equal to that of Paris.

Claire McCardell is generally credited as the mother of the American Look.
Like Chanel, she had a genius for making clothes that not only suited
women of her own time, but also continued to hold appeal decades after her death.
American design legend Norman Norell once said that McCardell could take five
dollars' worth of common cotton calico and make a dress a smart woman could wear
anywhere. During the war years with its cloth restrictions, she designed dresses
out of surplus balloon cloth and evening clothes with matching aprons for hostesses who
prepared the evening's dinner. According to McCardell, the modern woman
could both be chic and do the cooking.

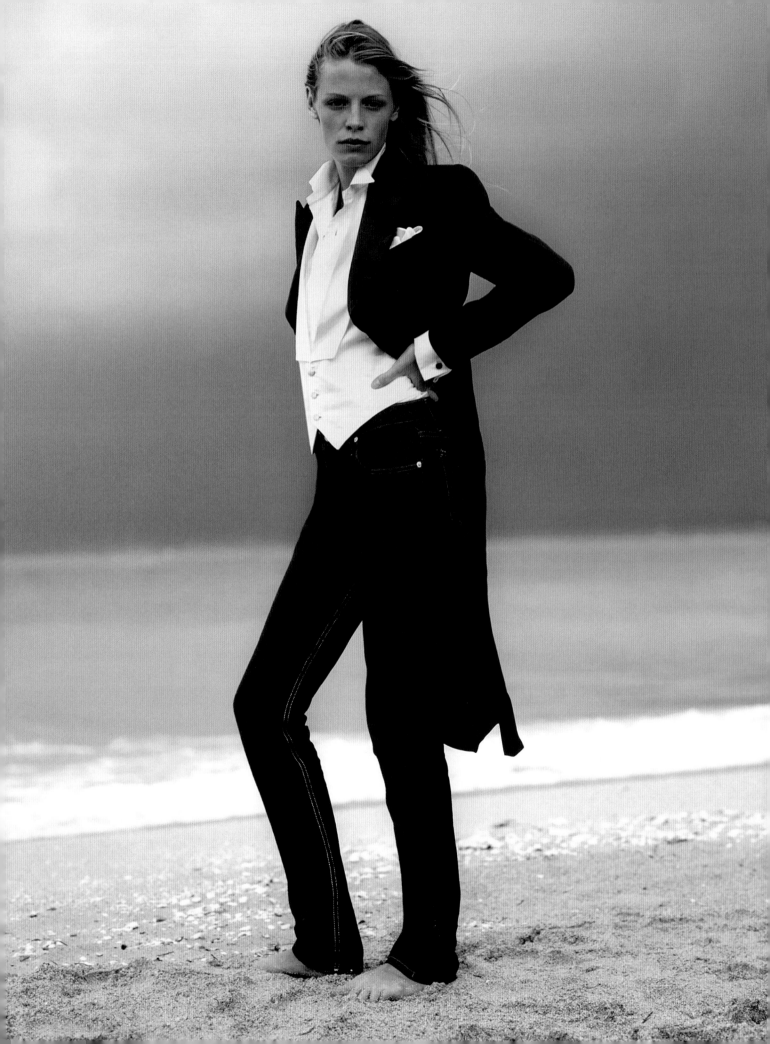

"I ALWAYS THOUGHT MENSWEAR
WAS A BOLD STATEMENT FOR WOMEN."
— RALPH LAUREN

BORROWING FROM THE BOYS

147

The year was 1971 and the polo player logo had just made its first appearance. So had Ralph Lauren's womenswear. Inspired by the woman he loved, Ralph looked to his wife Ricky, a blue-eyed blond with model-like looks. Refined, delicate, and ladylike, she was everything a Ralph Lauren woman should be. In Ricky he had found the perfect companion dresser. How she looked, how she wanted to look, were of vital importance to her husband. "I like long hair, I like her sexy, I like her in a man's suit. I didn't know what designers were, but I knew when a girl walked into a room why she looked great. I had no credentials in design except I dressed well."

From Marvin Traub's *Like No Other Store:* "At the time, the industry was promoting the midi, but that was not a look that appealed to Ralph's wife, Ricky, and the other young women he knew. They were buying riding jackets and boys' blazers. Ralph always liked the look of a Garbo or Dietrich, a man-tailored look." Stated Ralph, in *Ralph Lauren: The Man Behind the Mystique* by Jeffrey Trachtenberg, "The only look in the early 1970s was the Anne Klein look. Women's

sportswear was hung on T-stands. It was all color-coordinated. But they were so dowdy, Ricky couldn't wear them. They were boxy, big, not quality."

Just as Ralph had designed his first clothes for himself, he made his first women's clothes to fit and fashion his wife. Ralph Lauren became a women's designer by putting Ricky into a hacking jacket he bought her at a riding store one day. "His wife was a major reason for Ralph deciding to go into womenswear," recalls his then assistant, Buffy Birrittella. "In Europe everyone was wearing these shrunken little Shetland sweaters and shirts with a very tight fit. Ralph had fallen in love with French Cacherel shirts which he bought for Ricky, who was tiny, a size two."

According to Joe Barrato, Polo's sales manager, "At the time there were excess piece goods in inventory. We were producing a nice men's tailored shirt. Rose Wells, an executive at Federated Department stores, used to grab me by the lapels, shake me, and yell, 'Tell your boss to make a lady's shirt like he makes a man's shirt.' I mean she would bang the hell out of me, and I would then tell Ralph what she said. Finally he said, 'Okay, we have nothing to lose. But we'll make our shirts different. We'll use white collars and cuffs.'"

Insisting on an exclusive in New York City, Bloomingdale's opened a Ralph Lauren women's shirt

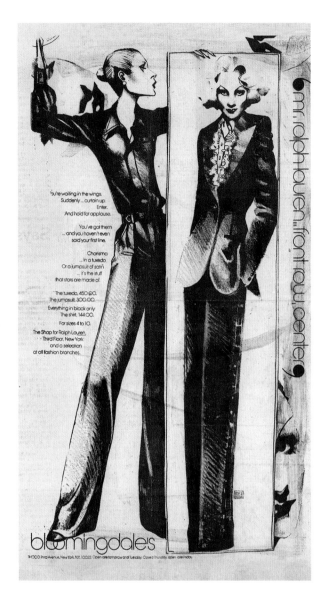

Above: "So that was my first women's line, making shirts for women," states Ralph. "I made these skinny little men's shirts with white collars, and people were buying them like candy. It was unbelievable. Bloomingdale's said, 'What else can you do,' and I said, 'I can do it all.'"

Opposite: What he started to do was make women's clothes the way he made men's clothes, because he knew smart society women would sometimes go to their husband's custom tailors for a jacket or tweed suit for the country. The designer said, "It became an 'in' thing. I never went into the business to be all things to all people, and lots of people didn't like the look. Some people thought it was too mannish."

shop on the third floor near the escalators. A tailored shirt business for women did not exist. Here were man-tailored, folded shirts cut expressly for women. Single-needle stitched to ensure quality and made from luxurious imported cottons and wool blends, some came with an ascot, some not. They were fitted, slim-cut shirts, and poking out from underneath one's jacket sleeve was a cuff with an embroidered polo pony on it. Response was so good that Bloomingdale's decided to run a seven-column ad in the *New York Times* lauding its Polo women's shirts. At twenty-four dollars and priced ten dollars higher than any made by the competition, they sold out. The customers didn't care.

Birrittella remembers the first shirts: "We made beautiful candy stripes with white collars and cuffs, Ascot shirts, paisleys, and so forth. Everything was fitted on me and I was very slight in those days. It was a very trim fit, but that's what Ralph wanted. The fit had to be very precise, tight to the body, and very feminine. Ralph didn't want bust darts, he wanted the shirts to look like men's shirts, but very fitted and cut high under the arms. So, if you were normally a size 8, you had to buy a size 10 or 12. Not only that, if you had a bust, the front would pull open. The strange thing is that it became a status symbol just to be able to fit into them. But women wanted them and . . . they sold."

Marvin Traub, president of Bloomingdale's, gives another side of the story for Ralph's women's shirt success. "There was already a large business in women's blouses in the early seventies, you only have to think of Anne Klein, the most important sportswear designer at that time. But her appeal was to the older fashion-conscious woman who was looking for something very feminine and soft. Ralph was thinking of what his wife and other women of her generation wanted to wear. He'd uncovered a new retailing opportunity. He wanted to replicate the quality and class of his men's shirt line. It was to be a shirt, not a blouse."

The label inside Ralph's menswear read *Polo by Ralph Lauren*. But if he was going to compete in the women's business, he wanted something more intimate, more firsthand. Other designers had begun using their own names so he decided his label would read *Ralph Lauren*. Then he decided to have his polo player embroidered on the shirt's white cuff, like a piece of jewelry. Business books are filled with stories of enterprising souls brimming with determination and skill; however, luck and timing can be of inestimable value. Adding that label and logo to his women's shirts was to prove to be one of the most providential things Ralph Lauren ever did. The polo player would become the new status symbol for women at a time when career women wanted to dress

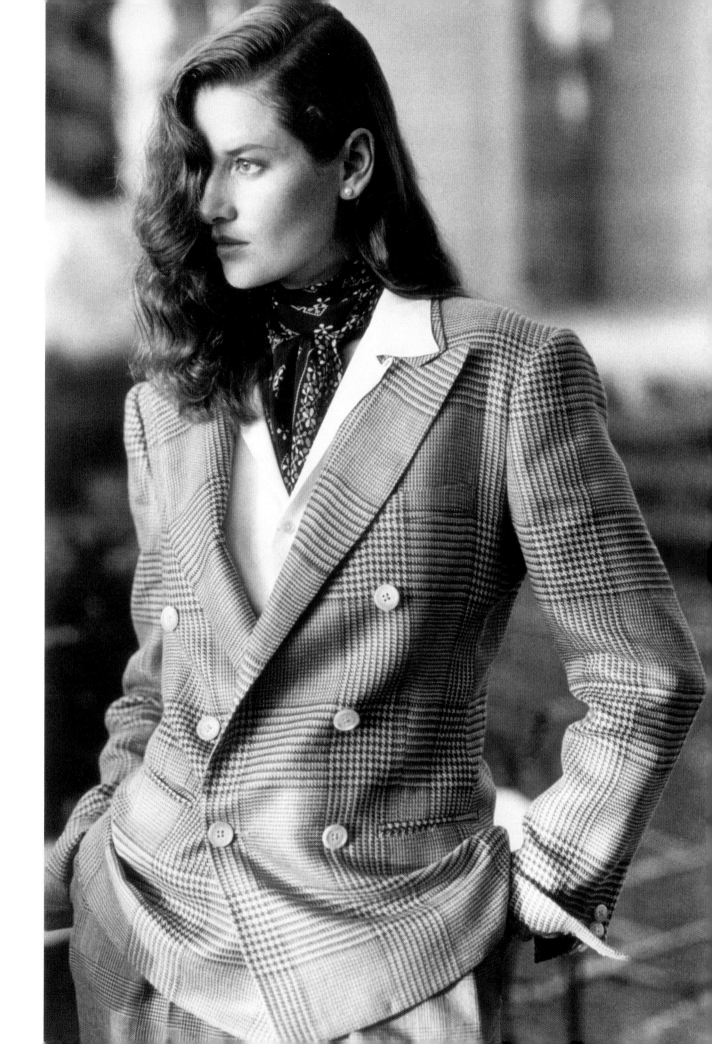

Above: "Male clothes are the only type I like wearing." Greta Garbo became renowned for her gender-bending dressing style: wide, soft trousers, flat shoes, crisp shirts, sloppy sweaters, and trench macs. A long-time Garbo devotee, shoe designer and tastemaker Manolo Blahnik believes that her appeal was in her ability to always be herself, sartorially speaking. "That's what I like about her—she got an idea and she did it forever. She is timeless."

Opposite: No one could present his Society Look or explain his non-fashion fashion philosophy better than the designer himself. Ralph's polo coat was to become one of the brand's staples and signature classics.

150

with the same authority as men. The fact that the shirts were male-inspired and tailored for women by a men's designer imbued them with even more panache. And by adding the cache of the designer's name to the label, the product escaped being viewed as another womenswear brand.

The Society Look was how the then-thirty-three-year-old Ralph Lauren described his first women's collection in May 1972, inspired by "the kind of woman who could afford to go to Europe several times a year and whose family kept horses and owned houses with lots of grounds around them." Consisting of sexy, fitted glen plaid and striped suits, tuxedos, Fair Isle sweaters, and pleated pants, it was a collection

of men's clothes adapted for a woman. Although Ralph labeled the look "sophisticated sportswear," tailored suits were its foundation. They came in gray flannel, herringbone tweeds, classic checks with button-down shirts or vests. Recalls Ralph, "It was so new, no one had it, and no one really understood it. None of the magazines wrote about it; *Women's Wear Daily* never even came up to see my show. But Bloomingdale's recognized something early, and they loved it and gave me a shop as big as Yves Saint Laurent's."

Ralph explains in *Vogue on Ralph Lauren,* "I didn't know anything about the women's business, I just went and had the clothes made in a men's factory. I bought the factory later. The tailors there laughed at me. I said, 'I want this for my wife; take this suit, scale it down.' I shortened the jackets, made them slim, with skinny arms. . . . I went in without rules. If I felt something, I just let it happen. I learned how to do everything as I did it. I have always believed in quality mixed with fashion and I just kept hitting at that. I never knew a slow moment. Everything I did at the time was right. I made the mistakes later on, but at first the newness covered the mistakes up."

Though he was pleased to dress Ricky in his own modern image of her, Ralph realized that his career was at a point where it needed buzz. The publicity his menswear generated would never compete with what his female fashions could muster. Women chat with each other about clothes, men do not. Whereas womenswear would open up new doors for the designer, the specter of Seventh Avenue and its fast-moving fashion cycle gave him caution. As recounted in *Ralph Lauren: Celebrating 40 Years*: "But because of Bloomingdale's I had to go on, so I started to stretch and learn."

The press's reaction to Ralph's first womenswear collection was both guarded and encouraging. American designers like Bill Blass and Oscar de la Renta had already established themselves with their dresses and evening wear, but there was a definite void in the marketplace for Lauren's higher-quality jackets and pants which, when tailored to fit a woman, imbued her with a sense of importance and place. Says Ralph, "They didn't get it. They got Yves Saint Laurent and Valentino but they weren't used to Americans doing expensive stuff. There was Oscar de la Renta and Bill Blass but they were mostly dressy, special-occasion clothes."

From the book *Ralph Lauren:* "'When I was growing up, people dressed for the weekends the way they did during the week,' said Lauren, explaining the emergence of lifestyle clothing. 'It wasn't until American life evolved and people started moving to the suburbs and having cookouts and enjoying more free time that there was a need for more comfortable clothes. I was creating clothes . . . for play, clothes for living as opposed to outfits for special occasions or work.'"

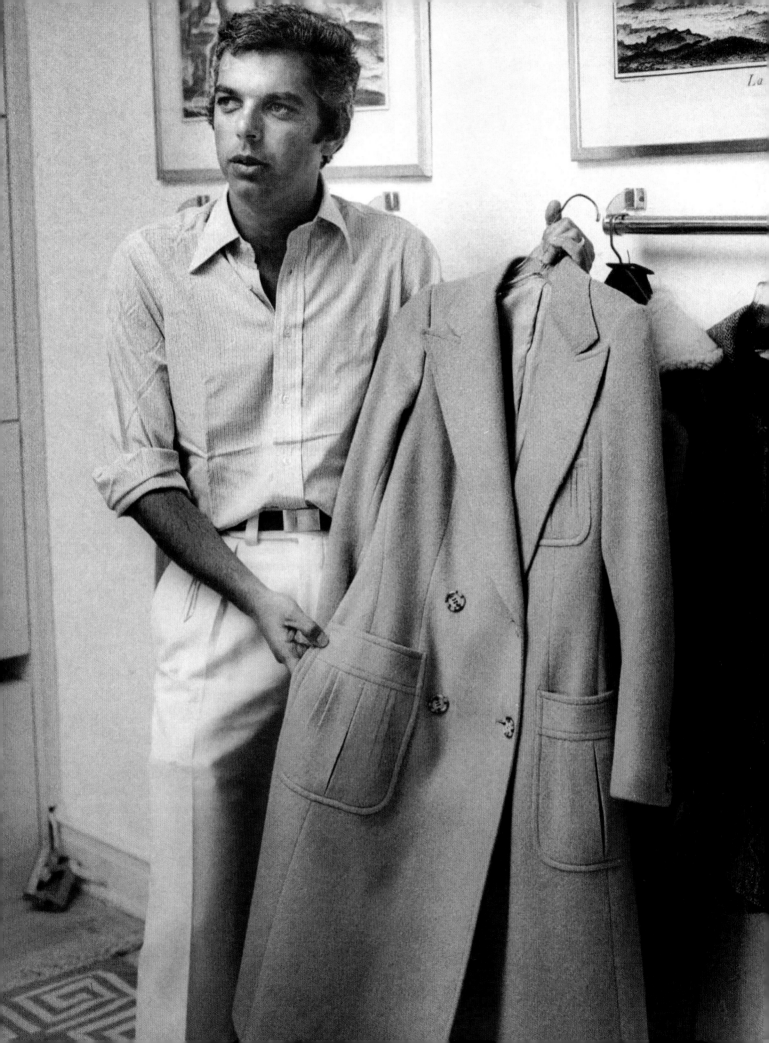

By 1970 women were choosing how they wanted to dress. From a 1979 *New York Times* article: "Through all the changes wrought by fashion and fad in the '70s, individualism remained a constant leitmotif. Take the anti-establishment '60s, for instance: the untamed manes of the flower children, the faded jeans of the affluence-rejecting hippies, the discarded bras of the women's liberation movement, the knee-freeing skirts of Courrèges, and the street-imitating gear of the radical chic. At first glance, the sartorial symbols of the '60s—wacky, vinyl-bright miniskirts and tattered hippy garb—may seem to have little in common. What they share, however, is a rejection of classical high fashion—an antifashion attitude that became, in the end, the most powerful and pervasive fashion of all."

Anne Hollander writes in her seminal 1993 book, *Seeing Through Clothes*, "What many people sense is that wearing the very latest creation announced in the fashion press and available in shops produces the effect not of elegance but only of modishness. Wearing the latest thing indicates submission to the desire to look fashionable, and this state of mind is distinctly unmodish itself among many groups of people." Geraldine Stutz of Henri Bendel summed it up at the time, "Being in fashion is out of style."

Ironically, the menswear approach of women dressing in separates was simultaneously attracting a higher profile in Paris. Saint Laurent, in a 1972 interview with *Washington Post* fashion editor Nina Hyde, explained, "Now it is ridiculous to think that clothes must change, that hemlines must change, that women want pants this season and not the next. What is modern in clothes today is to have a skirt, pants, sweater, coat, and raincoat and to mix everything. Women will develop a way with clothes the same as men. Clothes will be simple, basic categories like pants, shirts, in other words, a style based on separates."

In proposing such, Saint Laurent readily acknowledged his debt to one of his most revered mentors, Coco Chanel, the twentieth century's most important couturier. In 1910, when Chanel started out, women were pretty much prisoners of fashion, their clothes were highly structured and generally imposed on their bodies. Chanel was committed to showing women a modern, emancipated way to dress. It would revolve around a kind of eternally stylish uniform created with functionality in mind and designed for a woman on the go with a career and an active lifestyle. She wanted to devise a formula for women that was the equivalent of the suit for men.

Chanel had long understood the appeal of the boyish, gamine approach to fashion. She loved wearing men's clothes and uniforms, freely borrowed from her lovers' closets—trench coats, sweaters, blazers, tweeds, boots. According to Chanel, she took the "English gentleman" look and made it feminine.

Opposite: Chanel and Englishwoman Vera Bate Lombardi cross-dressing in English tweeds and sweaters. In Chanel's case, her clothes were borrowed from her suitor, the Duke of Westminster, the richest man in the world.

Above: Coco Chanel invents sport fashion. Chanel was the first designer to establish the supremacy of her own taste and then use it to set new styles. In 1913 women had neither fashions nor clothing for sport; here Chanel models her own sport fashion. The couturier would invent a whole new style for relaxation and outdoor living.

Chanel was the first French designer to adopt English tweeds and knitted jersey, both considered humble and hardly luxury fabrics. Taking the jersey fabric out of its underwear context, Chanel created the one-piece jersey dress—so elegant and comfortable that every woman had to have one.

Interestingly, Saint Laurent's infatuation with menswear-inspired pieces was more than simply the sexual frisson of women dressing in men's clothes; it was about appropriating a male approach to dressing. Like Chanel, Saint Laurent was inspired to revolutionize womenswear with a "uniform" of his own. In 1966, Saint Laurent designed his first male-inspired couture evening suit for women, *Le Smoking*, a dinner jacket with satin revers and trousers worn with white shirt and satin cummerbund. It was his first step in the exploration of masculinity within a feminine

153

framework. The idea of girls dressing like boys and the tension it could evoke was a daring new fashion concept, particularly coming on the heels of a decade characterized by graphic, doll-like dresses worn with white tights and bouncing hair. Yves Saint Laurent: "For a woman, *Le Smoking* is an indispensable garment with which she finds herself continually in fashion, because it is about style, not fashion." Where mannishness in women's clothes was interpreted playfully and self-consciously, it bred a stylish sexiness. When it was used to bulk and broaden shoulders, eliminate waists, and obscure a woman's figure, it lost much of its feminine allure.

What Ralph was proposing was not unique; in class-conscious Britain where aristocratic sartorial freedoms could be flaunted, many grande-dames had their husbands' tailors run out their own estate shooting clothes, just as they'd commandeer his bootmaker to cobble them suitable brogues for the paddock and moors. In affecting their non-fashion, upper-class credentials, along with the clothes' exacting cut and exemplary workmanship, the implied message was of understated taste and "hushed" no-design.

Not only did Ralph appreciate such quiet, elitist climes, it was a sensibility he understood and felt more comfortable around than the look-at-me fishbowl of Seventh Avenue. From his own clothes, he knew about the sartorial underpinnings—the proportions, the stitching, the padding. "English aristocratic style is slightly raggy," Ralph admits, "That's why I liked it." In England the suede elbow-patches are really there to conceal the cloth's wear, confirming the jacket's treasured history. For Ralph quality was something that lasts while getting better with age—it's a pair of broken-in English brogues, the worn jeans that mold to your body, the heavy wool overcoat that warms against the winter's blast, the leather briefcase faded and scuffed to perfection. Ralph Lauren was determined to forge his business and the promise of his fashions out of these time-honored traditions.

Ralph wanted to design clothes for the kind of woman who was not deeply interested in fashion but liked her clothes to reflect the elegance and sophistication of her life. As noted in a 1992 issue of *Vogue*, according to Ralph, "There's nothing complicated about the way I like women to look, natural and not pretentious. Not a lot of makeup, a masculine edge to the clothes—you know, the way Garbo and Dietrich could do it and still look sexy. I don't like someone who's a fashion freak. I just tried to do simple clothes that you thought were out there but never were."

154

Top left: An actress who defied the pressures of Hollywood, Marlene Dietrich was famous for saying (among other things) "I dress for myself. Not for the image, not for the public, not for fashion, not for men." During the 1930s, Dietrich, along with Katharine Hepburn, helped to popularize and make pants acceptable for women to wear.

Bottom left: There isn't a woman alive who doesn't owe some debt of gratitude to Katharine Hepburn, one of the early female champions of trousers—she wore hers wide-legged and roomy, on and off the screen. Sporty and casual, she played tennis every morning, preferring to spend her days in the timeless menswear-inspired uniform of tailored blazer, blouse, and slacks instead of the fitted dresses popular at the time.

Like Katharine Hepburn, it was the lack of pretense and a uniquely American sporting, outdoor-girl simplicity
that gave a woman like Grace Kelly not only her sex appeal but her class. One of Hollywood's golden girls,
Kelly's minimalist yet elegant style allowed her beauty and impeccable taste to shine through. Famously known
as Alfred Hitchcock's muse, Kelly's blue-eyed beauty also captured the heart of Prince
Rainier of Monaco at the Cannes Film Festival in 1955, as she went on to become his princess at the age of
twenty-six. Mastering the art of looking chichi in just a simple twinset, immaculately cut Capri pants, flat Gucci
shoes, and a string of pearls, Kelly became a world-renowned fashion paragon, inspiring Hermès to rename one
of its most popular bags "the Kelly" after the actress who regularly sported the tote.

156

According to Hollywood's legendary costume designer Edith Head, "Audrey Hepburn knew more about fashion than any actress except Marlene Dietrich. This was a girl who was way ahead of fashion." Recalls her son Sean Hepburn, "My mother believed that a woman should find a look that works for her and use fashion and its seasonal changes to accessorize it, rather than to be a slave to fashion, recreating one's look over and over again." Although it may not sound revolutionary, this simple idea goes a long way toward illuminating why so many fashion designers have long placed Hepburn on their highest style pedestal. In an age of the bouffant hairdo, tight skirts, and even tighter sweaters, Audrey's boyish figure, gamine haircut, slim Capri pants, fitted shirts wrapped at the waist, ballet slippers, and extravagant dark glasses ushered in a new ideal for feminine beauty. Her lifelong collaboration with couturier Hubert Givenchy became one of the most important fashion pairings ever, with the Audrey Style becoming as timeless as it was timely. "There is not a woman alive who does not dream of looking like Audrey Hepburn," said Givenchy.

Today's socialites would wither next to the likes of a Babe Paley. Born into a well-connected New England family, she began dominating over the society pages upon her official debutant coming out in 1934, continuing throughout her life. In 1941, *Time* magazine named her second on its best-dressed list, after the Duchess of Windsor. Hers were the days of the style-setting Ladies Who Lunched, and Babe was the woman every other socialite wanted to look like. A photograph of Babe with a scarf tied to her handbag, for example, created a tidal wave of imitation by millions of women around the world. Tasteful at all times, Paley was ahead of her time. She liked to mix expensive jewels with cheap costume baubles and embraced letting her hair go gray instead of camouflaging it with dye. The American designer Bill Blass once observed, "Babe Paley is the best-dressed woman in the world. You are never conscious of what she is wearing but only that she looks better than anyone else. She dominates the clothes instead of the other way around."

Although Hollywood legends like Greta Garbo and Marlene Dietrich precipitated the female crossover into high-styled masculine apparel, Ralph contemporized it and made it more acceptable and accessible. As for those lady style icons who inspired Ralph, there were the quick-witted, patrician characters played by Katharine Hepburn, dressed in perfectly cut pants and a cashmere sweater. Hers was an essentially American sporty, outdoor-girl simplicity, which gave women like her not only sex appeal but class as well. The same went for Hollywood's other variations on the sexy siren with class: Carole Lombard, Greer Garson, Lauren Bacall, those who, on and off-screen exuded a relaxed elegance, hair-blowing-in-the-wind bred from confidence. In the fifties and sixties, there were their counterparts, preeminently Grace Kelly and Audrey Hepburn, who could never be called anything as crass as sex symbols. Their sexual appeal was about allure, something much more subtle.

But by the early sixties and up through the seventies, America's movie colony was no longer the wellspring of fashion that it had once been. Other than Grace Kelly and the Hepburn girls, society women received far more coverage than screen stars. Socialites like Babe Paley, C.Z. Guest, and Mona Bismarck were, in effect, film stars without a screen. Endlessly photographed by the likes of Beaton and Horst, the perfection of their appearance rivaled that of any screen goddess. They inspired the designers whose clothes they wore and served as models for other women. Some had the advantage of beauty, others created their own. Supermodels had yet to come upon the scene, however, they would have paled in the presence of such style luminaries as C.Z. Guest or Slim Keith. These women were the personification of

Slim Keith was the apotheosis of the American Californian look: long, lean, and tawny. Acclaimed for her entertaining and the originality of her decorating, she came to the attention of Carmel Snow, the renowned editor of *Harper's Bazaar* magazine, who featured her four times, not as a model but as herself. Keith insisted on being photographed in her everyday clothes. Unpretentious yet wildly individual, her populist approach was light-years away from Hollywood's airs with its snoods, pompadours, and frills. Keith's house uniform—suede jackets, men's jeans, and thin blue-denim work shirts bought at Sears paired with soft leather moccasin-like loafers and thick angora socks—was modeled on her husband's. It is today a style that is still in vogue, celebrated through the classic design sensibilities of American designers like Calvin Klein and Ralph Lauren. Sexy and outdoorsy, wholesome and athletic, Slim Keith was the genuine article, an original style icon. Lauren Bacall liked to call herself the *Celluloid Slim*.

Ralph's vision of perfection: cool but also warm, dignified but capable of fun. Their panache was not purchased. Money was just incidental.

As John Fairchild, the often witty, always outspoken, and largely feared publisher of *Women's Wear Daily* and *W,* once proclaimed, "When I think of fashion, I conjure up a lot more than body covering. Good fashion is simple; bad fashion is when a woman exaggerates. In fact when a woman walks into the room, I rarely look first at the clothes. I regard the face, the sense, the mood, only then do I look at the dress, which if it's right for her, flatters and enhances all the rest. I can't stand fashion victims, but true style is something else again. If a woman feels comfortable in her own skin, and then in her clothes, she'll be fine."

As far as Ralph was concerned, his 1970s girl was someone who led a physical, engaging life. She left the city for the country on weekends and therefore she needed active, outdoor sportswear, so he gave her down vests, lambswool cable-knit sweaters, plaid flannel shirts, and lumberjack-check barn jackets. As the designer explained, "I aimed at models, I aimed at sophisticated young women. Lean and tall. And then I started to make more sportswear: chino skirts and safari shirts and jump suits and blazers and tailored coats and British warmers. Women had never experienced quality clothes like that. They were cut differently, women could never find a jacket cut with high armholes, and slim shoulders . . . lean and shapely . . . it was sexy, not boxy or dowdy."

Continued Ralph, "No one did that stuff. It didn't exist for women. You can say Eddie Bauer or L.L.Bean, but I took a mood and created a look when there was none. That's what I ignited: American sportswear."

Designer Bill Blass recalls seeing C. Z. once in Paris: "She came into the bar of the Ritz wearing a knee-length tweed skirt, a twinset, and moccasins, and in a time when everyone else was tarted up in Dior's New Look, she stopped traffic." Born a Boston Brahmin, she was a tall, slender, ash blonde with a greyhound's elegance who attracted the attention of Winston Guest, a scion of the Phipps family. As a child, she was trained by champion riders and went on to compete in horse shows across America. Decade after decade, C. Z. Guest was regarded as America's most elegant sportswoman. Her unfussy, clean-cut style was the prototype of the classic American thoroughbred look. When asked about her style, she responded that style is what you are inside. "All the girls today want to be famous, but they haven't earned their spurs. They want to inherit at a young age, what it's taken me thirty or forty years to achieve." Here's designer and CFDA President Oscar de la Renta escorting C. Z. with the council's Fashion Icon award.

Above: Ralph was after what Brooks Brothers once had, redesigning it and updating more effectively so
as to anticipate, appeal to, and satisfy hitherto unrecognized longings among consumers. He said, "I loved it
when Lauren Hutton said she wore Levi's and Ralph Lauren."

Opposite: Rekindling that masculine style with a strong feminine curve. "I felt there are women looking
for elegant clothes, much of which have disappeared from the market. These might fall into a
category just below couture clothes and might be described as worn by young suburban women in the
so-called horsey set," Ralph told the *New York Times* in 1973.

From the beginning, Ralph believed that fashion should be a function of lifestyle. On his sportswear-for-lifestyle approach to women's clothes: "And there was always a story—activities of life, not of fashion," says Buffy Birrittella.

UPWARDS AND ONWARDS

The Learning Curve

164

For Ralph Lauren 1972 was a blue-ribbon year. Business was great, awards were piling up, his menswear was well received, and his first full collection for women had been a success at retail. But there were tremors in the Polo foundation. Sales were in the process of rising from 3.8 million dollars for the year ending March 31, 1972, to nearly 8 million dollars for the year ending March 31, 1973. Nobody in the garment industry plans for growth to double in one year. It's too much, too fast. There were rumors that Polo was going bust. Polo Fashions didn't have the necessary equity to finance the faster turning of its expanding inventory, and the fabric houses wouldn't extend any more credit.

Even though Polo's sales and revenues were increasing sharply, Ralph discovered his business was nearly bankrupt because of the rapid expansion and lack of proper financial controls. People would stop Ralph in the market or on the street to ask him about the rumors. Ralph would go into a fabric showroom to review the designs and write the orders for the Macclesfield silks and ancient madders that he had built his neckwear business upon. The salesman would then have to tell him that he needed to pay upfront and leave a cash deposit—the credit of Ralph Lauren, Coty Award winner, was not good.

"I'll tell you the truth," he says. "I was living in the middle of a panic and I was scared. People left, and I was under the most pressure I've probably ever been in my life. But somehow I felt I wasn't going to go out of business and that it was going to be all right. It was painful, but it was the sort of pain I had to have to know my feet were on the ground." "It was a rite of passage," recalls assistant Buffy Birrittella. "He realized how fragile and ephemeral this business is, and he's never closed his eyes to anything from that point on."

Jeffrey Banks, one of Ralph's menswear assistants, tells the story of being told one morning that Polo was not going to be able to make its payroll that week. As the lowest ranking staffer in seniority, Banks reasoned he'd be the first to be let go. Later that morning when Ralph called Banks into his office, Jeffery assumed it was to fire him; however, Ralph wanted Banks to accompany him to his apartment

Ralph Lauren's alter ego, Buffy Birrittella. He is instinct, she is reason; he works by sight and touch, she has a computerlike memory for every garment Polo ever produced.

so they could talk in the taxi. To Banks's astonishment Ralph told him that he'd won a second Coty Award and asked what he thought they should do for the show. Ralph was returning home to put on a suit because he was going to ask Marvin Traub, the president of Bloomingdale's, to extend him the extremely unorthodox favor of advancing Polo money against future orders, which Traub subsequently arranged. Ralph came back, everyone got paid, and they started working on Banks's idea for the Coty presentation of a black-and-white montage of 1930s Hollywood. As Banks intoned, "Ralph had confidence; the man was not to be deterred."

Ralph's bankers insisted that in order to survive, he had to put into place four things. First, he had to license his womenswear business, as it was draining cash from the company. Next, he had to arrange for more equity to be put into the business. Third, he needed to negotiate a more preferential payback schedule on the five-hundred-thousand-dollar loan owed L. Grief & Bros., the manufacturer of Polo's suits. And finally, he had to improve upon the deal that required Polo Fashions to pay Norman Hilton four hundred eighty thousand dollars for buying back its fifty percent share of the company's stock. In December of 1972, Ralph had become the sole owner of Polo Fashions, but the buy-back deal had virtually wiped out Polo's net worth, putting a serious crimp in its operating capital.

Ralph proceeded to do all four things. First he pumped his entire one-hundred-thousand-dollar savings into the business. Then he signed a ten-year license for his womenswear line. Securing a two-hundred-fifty-thousand-dollar signing bonus plus a royalty of five to seven percent of sales, Ralph gave the rights to make Ralph Lauren womenswear to the Kreisler Group, a new company formed in 1972 that specialized in making and selling designer clothes. This would allow him to focus on the design but leave the costs of sales, manufacturing, and distribution to an outside party. Stuart Kreisler, its founder, was one of the first people on Seventh Avenue to foresee that fashion designers would soon recast the American ready-to-wear landscape.

Design people don't usually start companies and then try to run them on their own. Most fashion designers fail not because of talent, but because they fail to find someone capable enough to manage their business. Successful fashion brands are typically stories of two partners, Yves Saint Laurent and Pierre Bergé, Calvin Klein and Barry Schwartz, Valentino and Giancarlo Giammetti, Giorgio Armani and Sergio Galeotti.

In 1972 Ralph turned to Peter Strom, who had been Norman Hilton's righthand man for seventeen years.

Instrumental in orchestrating the early partnership of Ralph and Hilton, Strom had decided to retire. Periodically Ralph would call Strom for advice and finally, tempting him with a ten percent share of the business, Ralph persuaded him to become his partner, a relationship that would last until Strom decided to step down in 1995.

Here was someone who could restructure and stabilize the business. Strom's role was to prove crucial. "I brought Peter in because I knew he was somebody I could trust. I hired him because I liked him and thought I could build a business with him. Not everyone thought he was the right guy. Not everyone agreed. But I wanted him. I thought he was right for the company. You can see what he's done."

Looking back, there were many in the industry who believed choosing Peter Strom was the most visionary business decision Ralph Lauren ever made. "When I joined the company, it had five hundred accounts, was doing about five million dollars in sales, and wasn't making a dime,"

Of course, part of the company's delivery problems could be traced directly back to Ralph and his need for perfection that led him to make changes right up to and often beyond any deadline. As Strom recounted, "If Ralph were to spend too much time fussing with the line, it was because nobody explained it to him properly. Once we started talking, he understood and it wasn't a conflict. I would say this: A designer has the right to change his mind about things, that's what makes a designer a designer as opposed to a production person. A good production person is like a marine, a designer though is creative and the creative process is stressful, trying to get something to come out like you want it to look. Ralph is a perfectionist and he will frequently change his mind at the last minute. Everyone then has to scramble . . . and I wouldn't say it didn't bother me, but I understood it and wanted that for him because I knew it was one of the things that distinguished him from others."

As Strom explained, "Ralph designs, does the advertising, the public relations, and I do the rest." "The rest means that Strom runs the day-to-day part of the business, is responsible for the wide-ranging licensing activities, as well as overseeing the manufacturers of the Polo clothing and the growing Polo shop network. "We discuss everything, he makes the final decisions, and I execute them," Strom remembers stating at the time, "I thought we'd be lucky if we ever broke twenty million in sales. Ralph loves to remind me that I said that."

Marvin Traub said, "A funny thing happened when Ralph became a women's designer; he discovered the world of fashion shows, press, and publicity. But the fashion press, for the longest time, took little notice of him. It didn't matter that he had won his third Coty Award in 1974, this time for womenswear, and that three years later he was inducted into the Coty Hall of Fame. It was always the other designers, Halston and Calvin Klein, who the press wrote about—not Ralph. To read the fashion press, Ralph was barely a blip on the screen."

In part, it was Ralph's independence that played against him with the press. In trying to create high-class, wearable fashion, Ralph was not interested in sending down the runway revolutionary or headline-grabbing fashions. Nor was he driven to capture the limelight through high-visibility trendsetting like London's Mary Quant or France's André Courrèges, whose fashions were so tied to the moment that they failed to live much beyond them. Like Chanel and Saint Laurent before him, what Ralph aspired to early on was not to "make a fashion statement" or to even "be in fashion." For Ralph, the goal was to "become his own fashion," a distinction as defining as root beer is from beer.

Peter Strom joined Polo Fashions in 1972, eventually becoming president and ten percent partner. At the time, the company generated approximately five million in sales. By the time Strom retired in 1995, worldwide sales of Ralph Lauren had reached nine-hundred-twenty-five-million dollars at wholesale.

recalls Strom. Deliveries to the stores were not only undependable but invariably late. A high percentage of what the company sold did not get manufactured and what did get produced ended up being shipped to the stores late into the shipping cycle, leaving the retailer that much less time for selling.

Strom had started his career working on the floor of a clothing factory, giving him invaluable firsthand experience. Understanding the various production cycles, he could speak the manufacturer's language. On the retail side he changed deliveries so that the majority of the merchandise got shipped as early as possible, thereby giving the stores more time to sell Polo at full price. Later on in the early 1980s, Strom would inaugurate the opening of outlet stores. Today an important profit-center for most larger designer businesses, it allows the company to control the distribution and sale of any items that it does not sell by the end of the season.

Championing his ethos that fashion is antithetical to style, the designer's thinking pretty much flew directly in the face of the press's need for the newsworthy fix of the "new" and the "next." A builder, Ralph was prepared to track his progress over time rather than moment-to-moment.

The other reason for the press's sluggishness in coming to the table was the designer's family-centric lifestyle and need for privacy. Notwithstanding, the press thrives on publicity, not privacy. Designers Bill Blass and Oscar de la Renta, pillars of Seventh Avenue's fashion establishment, would spend considerable time wining and dining the editors as well as entertaining their socially prominent clients. Two of the fashion press's most lionized designers and regulars on the Studio 54 party circuit, Calvin Klein and Halston, could be found out dancing and partying into the wee hours of most mornings.

Although Ralph was always ready to talk to reporters about his clothes or his outlier fashion philosophy, he was not prepared to have his private life become public grist. His women's collections were often exceptional, as some in the press were quick to acknowledge. However, the Lauren name did not conjure up the same kind of notoriety factor as that of his more publicity-minded confreres. The Laurens kept to themselves, and the press deferred to their wishes to lead normal, married-with-children lives. "I don't spend a minute of my time for the wrong reasons," says Ralph of himself. "I'd really rather go out for a hamburger with my kids." By no means recluses, Ralph and his wife, Ricky, would often turn up at industry events, although they could hardly be considered partygoers. Some in the industry felt the press held it against him and that the price of privacy was high.

Designing now for both men and women, Ralph found the latter more challenging in part due to the female's attraction to novelty as well as not having a traditional style around which to build on. Ralph's menswear was all about what he wore and how he wore it, and he had a pretty clear idea of how his male customer wanted to look. Plus high-end menswear was not as subject to the seasonal drama as women's.

In point of fact, the design time frames leading up to the release of a womenswear collection had to be more deadline sensitive, if for no other reason than it had more seasons and shorter production schedules than menswear. Hatching new ideas, devising innovative themes, and rolling out original fashion statements for each collection did not come easily to a tastemaker who needed time to perfect wardrobe classics. It took some practice and the addition of the right assistants to help Ralph come to terms with ready-to-wear's particular time demands and intensity, where the only constant was change.

"Designing womenswear is completely different," insists Ralph. "Women are more particular about how things look on different parts of their bodies. The women's collection—you're giving birth. Some days I have a knot in my stomach because I've got to sit down and come up with something that no one else came up with." After his first few shows, Ralph recalls feeling that for women he'd made pleated pants, gray flannels, tuxedos, and then he wanted to quit. He thought he had said it all, that there was nothing left to do.

Ralph needed input and feedback about his womenswear. While Birrittella was his day-to-day sounding board, the opinion of his wife, Ricky, really helped to keep him plugged into what his core customer might be thinking or wanting. As Ralph explained in an interview in the 1980s, "She's the best barometer for me. Living with a woman gives you real insight, you get a firsthand knowledge of what a woman wants, what she'd like to wear, what she's tired of, and what I'd like to see her in. She's also my toughest critic; what could be worse than having the woman in your life not want to wear the clothes you design?" Just as Ralph was the ultimate male Polo consumer, Ricky was his female counterpart.

By the mid-seventies Ralph had found his womenswear niche, and the fashion press was clearly beginning to take notice; sophisticated sportswear had become the look of the times. In 1975, *Women's Wear Daily* wrote, "No more hit or miss, Ralph Lauren is evolving into a top-drawer sportswear designer. Ralph's Fall 1975 suit belongs in everyone's wardrobe." No longer a strict offshoot of his men's clothes, the new looks were softer and prettier than ever before. The collection featured skirts either full-cut and swingy or super slim. And for the woman who realized that man-tailored separates could make her look even more alluring, Lauren's suits were the answer.

During this time, Ralph single-handedly remade the suit into a virtual matrix of building-block-inspired sportswear. Based on the integrity and interchangeability of the suit's matching parts, a wool plaid suit with matching skirt or trouser could be pulled apart and reassembled with other classic pieces to make a week's worth of outfits. The jacket could be worn belted like a shirt or with a tie or turtleneck; the bottom could anchor a cashmere twinset, a cardigan sweater, or tailored shirt. Textured fabrics would play off one another: a Donegal tweed with velvet, a Shetland herringbone with corduroy, a Harris tweed with suede.

By the mid-seventies Ralph was ready to expand his new womenswear bona fides at retail. In 1975 he began to sell other stores around town who were competitors of Bloomingdale's. Bergdorf Goodman opened two Polo by

167

Ralph would try to be home for dinner, wanting to keep his personal life low-key and centered around his family, so his kids could enjoy normal childhoods. In this he is unique, as few fashion designers are married with children. Watching his informal family-team grow up around him helped keep the designer connected to the real world.

Ralph Lauren boutiques in its Fifth Avenue store while Henri Bendel debuted its own Polo by Ralph Lauren outpost. Henri Bendel's president, Geraldine Stutz, recalls, "Ralph was enjoying great success with his menswear, and so I went to look at his very small women's collection in his showroom. I thought what he was doing was terrific. His things had enormous quality and integrity. It wasn't just men's stuff turned into womenswear, I could see he was the dreamer of dreams. I got his message completely.

"I said to Ralph, let's present you. And that was it; we did it together. I've never run into anyone who had such a clear-cut idea of how he wanted his merchandise to be presented. We spent a lot of time going around to second-hand places on the West Side, looking for odd things to furnish the space. In the end it all came together, with a very big personal involvement from him. Its spirit was exactly what Ralph would do on a much bigger scale later in the 1980s when his own flagship opened uptown. The space was no bigger than a large dressing room, but the merchandise just walked out. He was such a wildly eager beaver, so passionate not to be moved from his dreams by anything. His strength lies in his determination to stick with what he believes in and do it exactly in the way he sees it—the clothes, the presentation, the lifestyle."

For many, the seventies will be remembered as the nadir of style and sophistication. Nevertheless, by accelerating the relaxation of dressing codes, the decade cleared the way for a more personal and multifaceted approach to fashion. Instead of a designer's head-to-toe look or a mandated arrangement of coordinated separates, women began pairing different dressing genres together that had previously been considered incompatible. Folding time-honored classics from menswear, ethnic clothing, army uniforms, vintage, or designer clothes into a single outfit begat a new, more adventuresome spirit of personal décor that not only quickly outflanked mainline fashion but, in no time, quietly outdistanced it as well.

All of a sudden fashion was more about every woman or man choosing for themselves. The most luminary of all style bibles to emerge was Caterine Milinaire and Carol Troy's anti-fashion manifesto, *Cheap Chic*, published in 1975. With calls-to-arms like "fashion as a dictatorship of the elite is dead" and "nobody knows better than you what you should wear or how you should look," *Cheap Chic* quickly established itself as the insider's guide to the new dressing aesthetic.

Through interviews from seventies style luminaries like *Vogue*'s Diana Vreeland and couturier Yves Saint Laurent to fashion newcomers like Betsey Johnson, Zandra Rhodes, and the writer Fran Lebowitz, the handbook

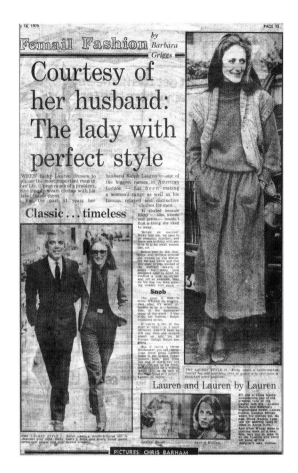

Ralph Lauren can be said to have found his own screen version of perfection in his wife. "She's not a fashion girl, she's more active than fashion-conscious. Ricky's the kind of girl who can look good in anything: elegant and chic, rugged and outdoorsy—that's the kind of girl I design for."

championed mixing together classic items sourced from a worldwide global village. Its thesis was, rather than a closet overrun with ill-chosen, time-sensitive fashions, choose a number of wardrobe basics that made you feel comfortable, confident, and sexy that you can always return to, and then hang on to them like old friends.

The timeliness and relevance of the book's message just happened to parallel what would later emerge as the preeminent dressing philosophy of the twentieth century—Ralph Lauren's anti-fashion traditionalism. Talking about what differentiated him and his women's clothing from that of Seventh Avenue, Ralph was quoted at the time, "Status fashion isn't what's in today and out tomorrow. . . . The new status symbols are all about permanence and durability. . . . Fashion needs to unburden women of fuss, feathers, and fanfare. . . .

By proposing an individual medley of, for
example, military surplus apparel, sporting
goods classics, and Cape Cod power dressing,
Cheap Chic helped crown the cognoscenti's
long-held notion that authentic personal style
will always trump high fashion.

In 1977 Gatsby was followed by the second great style movie of the decade, Woody Allen's *Annie Hall*, costarring Diane Keaton and Allen himself. Keaton and Allen had been fans of Ralph for some time. Dressing as if she had just grabbed some random pieces from her boyfriend's closet and flung them together, Diane Keaton and her character, Annie Hall, showcased a truly groundbreaking and uniquely American way of wearing clothes. Keaton's mixing and matching of oversized menswear jackets, loose-fitting khakis, tailored waist-coats, and blousy men's shirts sparked a trend for an androgynous, eclectic look that revolved around the refashioning of the masculine wardrobe. Not only did it flatter the actress's boyish frame and make a style icon out of her, it sent thousands of women out to raid their boyfriend's closets while searching for oversize men's jackets at vintage stores.

From *Vogue on Ralph Lauren*, Joan Juliet Buck wrote: "After we saw *Annie Hall* in which Diane Keaton wore Ralph's long skirts, vests, and a man's jacket over every-thing, we suddenly began to borrow our men's jackets and wear them with the sleeves rolled up." While the 1977 Annie Hall look was not a Polo-sanctioned collab-oration, Keaton's adopted dressing aesthetic reflected Ralph's own vision of a classic women's style defined by a strong menswear theme.

The film's success not only glamorized the layering of boy-borrowed clothes to affect a gamine charm, it also provided a cinematic gateway to Ralph's first blockbuster collection with his 1978 *American West* runway show. The collection was to set in motion a decade-long run of brand-energizing fashion shows, print campaigns, and television commercials that fueled the company's phenom-enal growth up through the late 1980s. Ralph was to enter that charmed period in every great-to-be designer's life when what he divines for his own loyalists transcends those borders to engage the wider tastes of the public at large.

Spurred by Ralph's intuitive design and marketing skills, the company expanded the variety of merchandise under its umbrella. Following on the heels of its founding product lines came licenses for eyewear in 1976, men's and women's fragrances, luggage, and boys' clothing in 1978, a girls wear line in 1981, and home furnishings in 1983. As the number of new products bearing the Polo moniker quickly disseminated the designer's aspirational imagery to the four corners of the country, the merchandise began to make an impression beyond the Polo world. Soon people were speak-ing of the "Laurenization of America," crediting Ralph Lauren with birthing a unique American Look while label-ing the 1980s as the "decade of Ralph Lauren."

The world is full of women who aren't clothes crazy but they are sure as hell interested in style, especially their own."

By 1977 what had begun as a few items for his wife had morphed into a full-blown women's business. Whereas the seventies witnessed the first fizzling of the sixties postwar economic boom, it was to catapult the Polo Ralph Lauren look center stage, courtesy of an unexpected medium—Hollywood. In March 1973 Ralph was commissioned to do the menswear for the movie *The Great Gatsby* by its cos-tume designer, Theoni Aldredge. At a time when many were protesting the war in Vietnam and John Lennon was sing-ing, "Give Peace a Chance," Ralph was showcasing old-world taste and upper-class imagery with his menswear for the film. Not only did his clothes end up as the real stars of the film, Polo Ralph Lauren became a recognized brand.

WOODY
ALLEN

DIANE
KEATON

TONY
ROBERTS

CAROL
KANE

PAUL
SIMON

JANET
MARGOLIN

SHELLEY
DUVALL

CHRISTOPHER
WALKEN

COLLEEN
DEWHURST

173

"ANNIE HALL"

A nervous romance.

A JACK ROLLINS·CHARLES H. JOFFE PRODUCTION
Written by WOODY ALLEN and MARSHALL BRICKMAN · Directed by WOODY ALLEN

PG PARENTAL GUIDANCE SUGGESTED
SOME MATERIAL MAY NOT BE SUITABLE FOR PRE-TEENAGERS

 United Artists
A Transamerica Company

Annie Hall's quirky, yet accessible look of oversized menswear garments styled and worn by women became
a rallying cry for that generation's do-your-own-thing dressing mindset, continuing as a recurring
trend up though the present. Even today the donning of an oversized tweed jacket suggests a rejection of fad-driven
fashion in exchange for more enduring values, like what will go the distance.

Ralph Lauren

CIRCLING THE WAGONS

The year was 1978. The setting: the rooftop of Manhattan's legendary St. Regis hotel. The Bee Gees hit song "Saturday Night Fever" was all the rage. Walking out on the runway to Gene Autry's signature ballad, "Back in the Saddle Again," Ralph Lauren's models sported a mélange of western-inspired regalia not often seen east of the Rockies, nor likely west either. The lyrics contained the line "I go my way," a fitting rallying cry for the designer's work-in-progress career and an early example of his courage to strike out on his own, distancing himself from the proven success of his man-tailored looks to prospect for his urban woman's inner cowgirl. "I was inspired by the spirit of the rugged West, the romance of the prairie, and how a modern woman would wear it," stated the designer.

The clothes included fringed buckskin jackets over flounced ankle-length cotton prairie skirts, chamois blouses under shearling vests, velvet pantsuits trimmed with silver belt buckles, and satin cowboy shirts for evening. As Kathleen Madden of *Vogue* magazine described them, "Un-hokey pieces that can slip into—not rupture, a woman's wardrobe." For all its western style, there were also many of the Ralph Lauren staples: tweed jackets worn over suede dirndl skirts, along with duffle coats, jodhpurs, and plus fours. Kal Ruttenstein, Bloomingdale's legendary fashion director, described the scene in *Women's Wear Daily*: "He took us through Matt Dillon, Miss Kitty, the Marlboro Man, cowboys and Indians, through the riding school and pilot girl, and the New York City girl to get a wonderful amalgam of all-American looks."

1978. Riding point for American fashion, Ralph Lauren introduces a collection of western clothes that were to influence every retailer in the country.

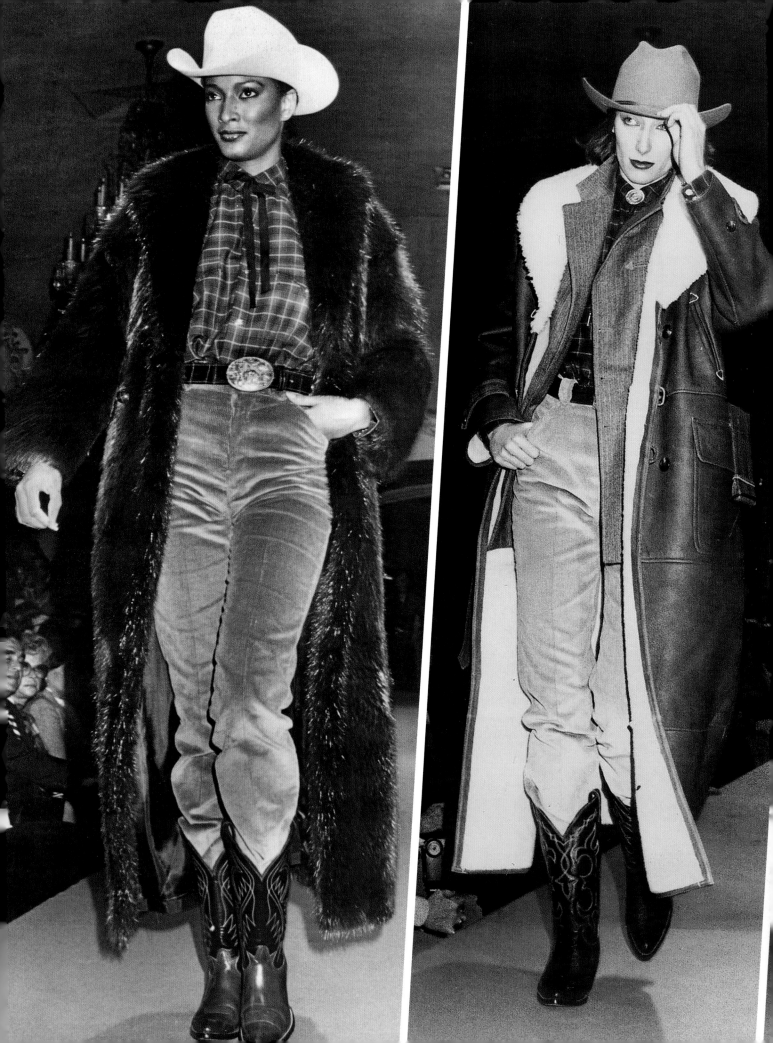

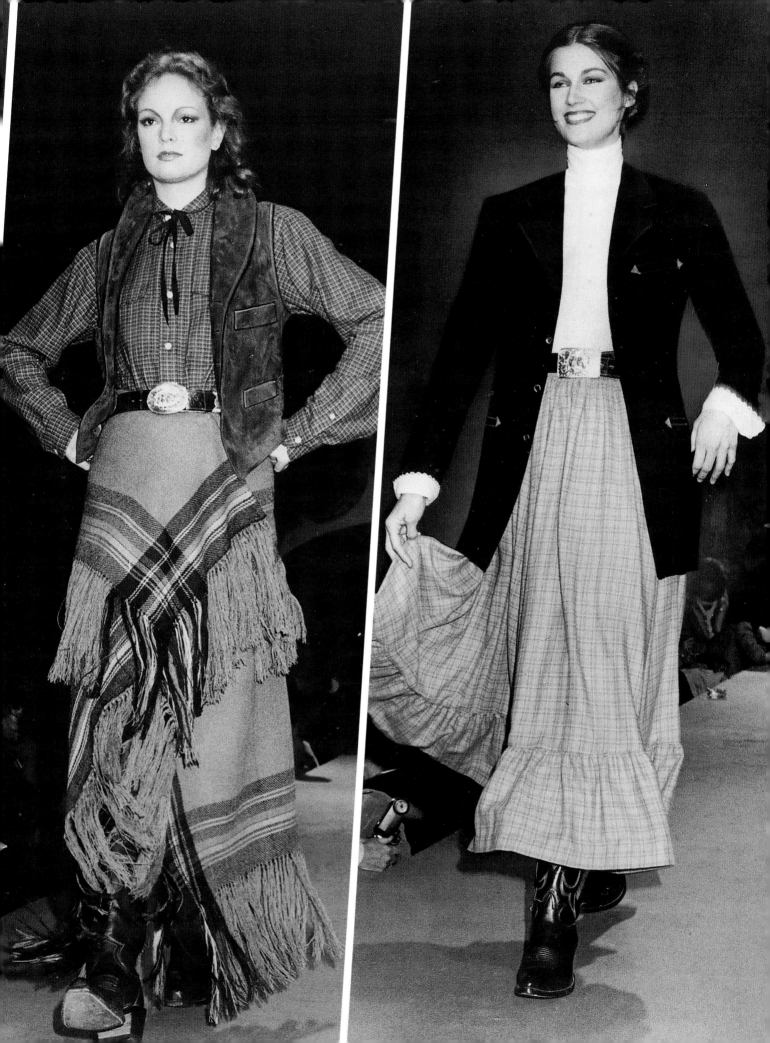

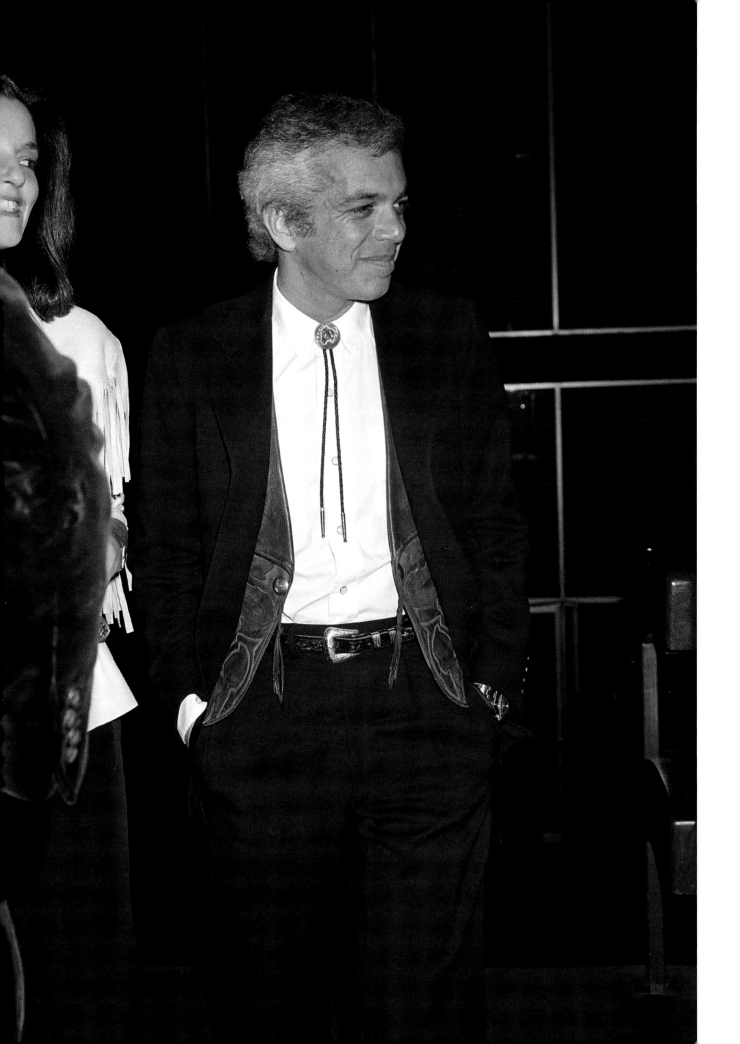

Ralph's western fashions struck a national chord, causing giant waves inside and outside the fashion industry. Here was an authentic American Look that for so long had been an integral part of the country's heritage and worldwide persona, yet no American designer had ever thought to partner up with it before. The collection also signaled just how emboldened Ralph the fashion designer had become, not caring what his European rivals might be up to while he charted his own course.

The Old West with its frontier spirit now became the stuff that dreams were made of, with urban cowboys turning up everywhere. By June, customers at fancy Manhattan restaurants like La Caravelle were seen wearing wide-brimmed cowboy hats. "New York has become something of a cowboy town," wrote the *New York Times*. "Men whose idea of a canyon is the space between two rows of skyscrapers take the air in full regalia—10-gallon hat, yoked shirt, embroidered denim jacket, hand-tooled belt, jeans, and boots. And the women beside them wreath their throats in bandanas, wear ankle-length shirts fit for a hoedown, and—faced with inclement weather—don hats and ponchos worthy of the crew of a cattle drive."

Ralph's boldness left retailers all over the country wanting in. The stores were only too happy to jump on a bandwagon that offered something new to talk about and promote. Women had grown tired of the past few seasons' full-cut fashions and suspicious of the padded shoulders Europe was beginning to show. "Lots of New Collections, But Lauren Steals the Show," headlined the *New York Times*. From *The Man Behind the Mystique*: "His look is American and he manages to make foreign attempts to produce, say the western look, seem heavy-handed and awkward."

The American West would always belong to Ralph Lauren, first because he reinvented it but also because his love for it would persist. Returning to it over and over again as one of the recurring themes of his design vision, he would do collections and then spice them up with a concho belt, or a pinch of silver and turquoise, or a vintage-looking denim piece. Sometimes it would be bolder, as with his Navajo-patterned chunky knit sweaters and suede fringed coats, or more romantic with antique lace blouses and full-cut petticoats. Several items from that

original show such as the fringed leather jacket and denim western-detailed shirt went on to become permanent members of the Polo Icon collection.

Referencing his 1978 collection in *Ralph Lauren: 50 Years*: "I was looking to get away from preppy, so I went out West. I filled the runway with cowgirls in dusters and chaps, fringed jackets, prairie skirts, and cowboy boots." The finale featured a disco with model Beverly Johnson dancing in a long mink red coat cinched with a concho belt and high gold western boots to a backdrop of flashing lights. "I went from the prairies to a disco in the city. To me, this was a whole new kind of western movie."

As Ralph was personally responsible for the consumer's awakening to America's western wear look, it was no surprise that he wanted to ride herd over its widening appeal. Just as the department stores had made less expensive copies of his Polo line, Ralph assumed it would not be long before lower-priced versions of his western wear would be resting like sunning leopards on mass retailers' shelves across the country. He had set up the Chaps business to counter the Polo knockoffs; now he would follow a similar strategy with his western wear.

At the time, Wrangler and Levi Strauss dominated the denim and jeans market. The Gap, a California-based retailer whose sales had reached 205 million dollars the preceding year, was selling popular priced Levi's jeans, work shirts, and rugged outdoor clothing in 310 stores around the country. In June 1978 Ralph decided to sign a contract with the Gap, which, having previously formed a personal relationship with Don Fisher, the Gap's president, gave him a modicum of comfort. "When the Gap came and asked me to do a jeans line, I said, 'I don't believe in designer jeans. I believe in a total concept.' So they agreed to set up a separate company to manufacture, sell, and distribute the western wear that I design. This way it can be affordable for everybody."

Polo Western Wear became a new division of the Ralph Lauren company with the Gap supplying the funding and the production. The men's line, Polo Western Wear by Ralph Lauren, opened with denim and corduroy jeans retailing between 33 and 36 dollars and corduroy western coats at 125 dollars. Ralph Lauren Western for women offered jeans, skirts, and shirts priced from 22 to 130 dollars.

179

A fan ever since he was a boy, Ralph would regularly turn up at formal events lobbing a western item into the fray, like a bolo tie with a tuxedo or a pair of cowboy boots with a tailcoat. "You know, western clothes could be dumb. They could be corny; they could be glossy. I sense a romanticism, and I express this in texture, the spirit I believe in. My Western clothes look like me, they don't look like Roy Rogers."

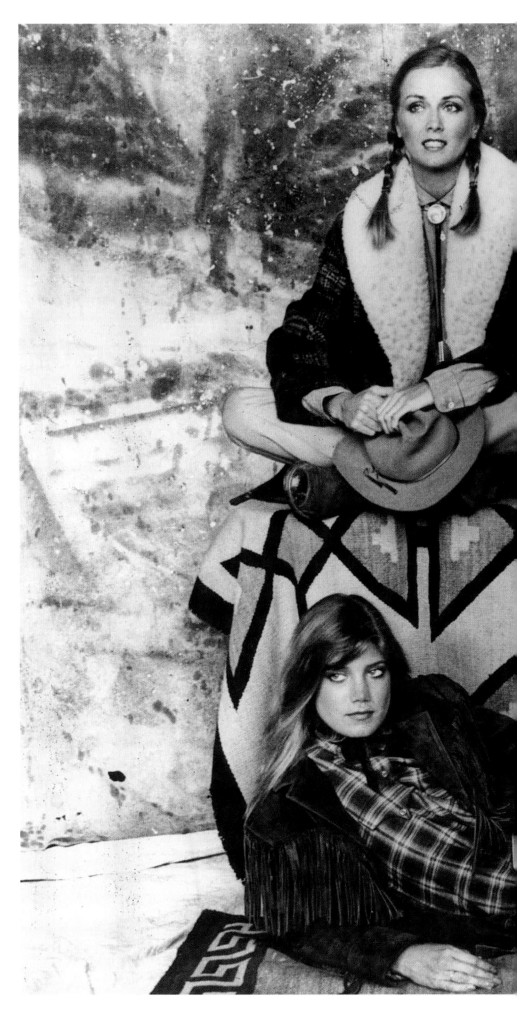

180

Ralph once said, "Western clothes are the most distinctively American of all clothing." Western wear would continue as a recurring leitmotif in Ralph's design vision throughout his career. Many classics like his fringed leather jacket and denim shirt with snap closures and western detailing went on to become part of the Polo Icon collection.

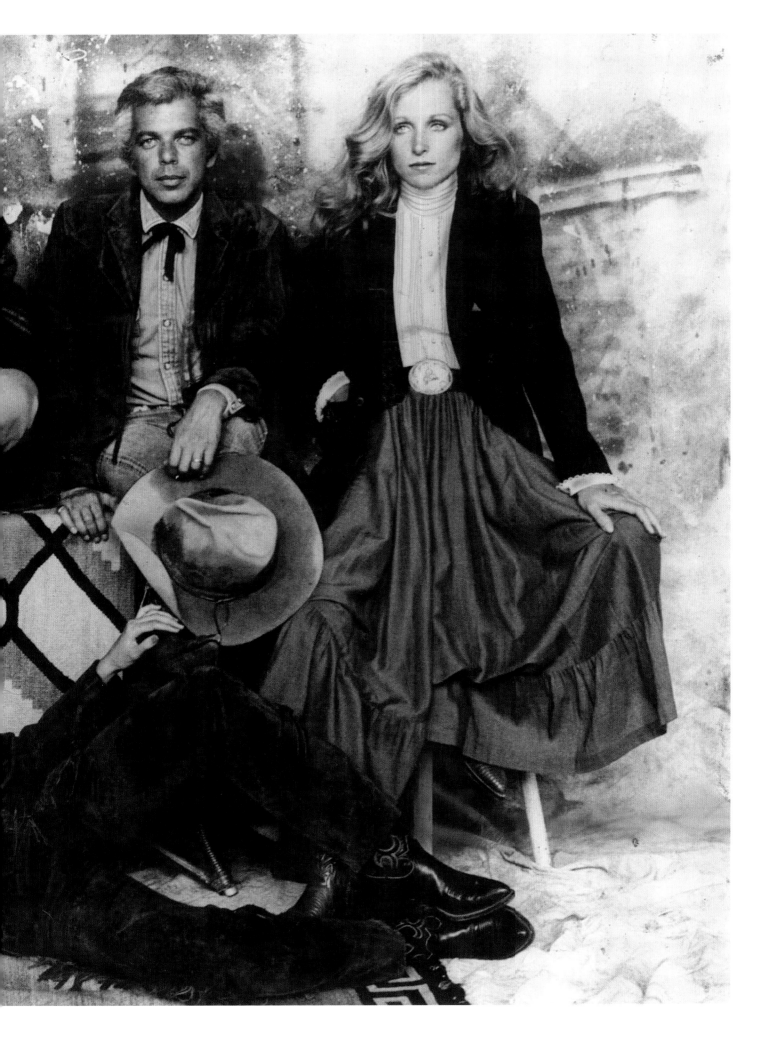

182

Women's Wear Daily reported that "Ralph Lauren's pioneering effort in the moderate-priced sportswear market could prove a gold mine if early reaction to his womenswear holds up. Stores were quoted as describing the business as alternatively fantastic, incredible, or wonderful." Sales the first week at Bloomingdale's amounted to ninety thousand dollars, despite late shipments and the women's jeans being too tight to fit most customers. Although New York City had regularly set the bar for idiosyncratic street fashion, even the locals stopped to stare at those East Siders heading out for the evening festooned in duds more in keeping with a rodeo or square dance than some swanky Manhattan eatery. Unfortunately, the city's cement corridors were not the clothes' natural stomping grounds, and as their novelty started to wear off, customers began to retreat to their more citified toggery. By 1980, the commercial dust had finally settled; the Gap was not happy. Having lost money from the fit and delivery problems, it decided to pull up stakes and shutter its Ralph Lauren Western Wear division, absorbing a one-time charge of six million dollars.

Fisher and Ralph saw the business differently. Ralph didn't want to end up competing with himself, so he refused to let the Gap put his polo player logo on the jeans. He also imposed retail price ceilings for the merchandise. As the shirts could not retail for more than twenty-five dollars, when Ralph finished adding the bells and whistles that gave his products their distinction, the Gap's profit margins evaporated. And then there was the fit problem. "We had troubles with the fit," says Don Fisher. "There was a disagreement with Ralph Lauren as to what the fit should be. He wanted a designer fit, something more narrow and tighter than the generic market was looking for. I also think western wear was too narrow a category to support a big business. That may have been the biggest obstacle."

Ralph's original motivation for doing a western look was to get into the designer jeans business. Had there been more time, he would have expanded the jeans presentation, democratizing its fit without cheapening the look. At the end of the day, while there were people who wanted to license the Polo Western Wear business, the Lauren organization concluded that they were too burned at that point. It was a setback, a bitter disappointment, as Ralph loved western clothes. However, as Peter Strom promised, "They'd do it later themselves."

Above: Ralph was beginning to star in his various advertising campaigns; here he's promoting the introduction of Polo Western Wear, his West-is-Best, mass-market collaboration with the Gap.

Opposite: In 1982, the designer purchased a twelve-thousand-acre working cattle ranch at the base of the San Juan Mountains in southwest Colorado. Named Double RL for Ralph and Ricky Lauren, it's a place that brings to radiant life Lauren's long-held fascination with the American West. "Colorado is for enjoying the land," says Ralph. When the family goes to Colorado for their summer break, Ralph and Ricky ride every day, excited by the sheer joy of seeing their land in the best way possible—from the saddle.

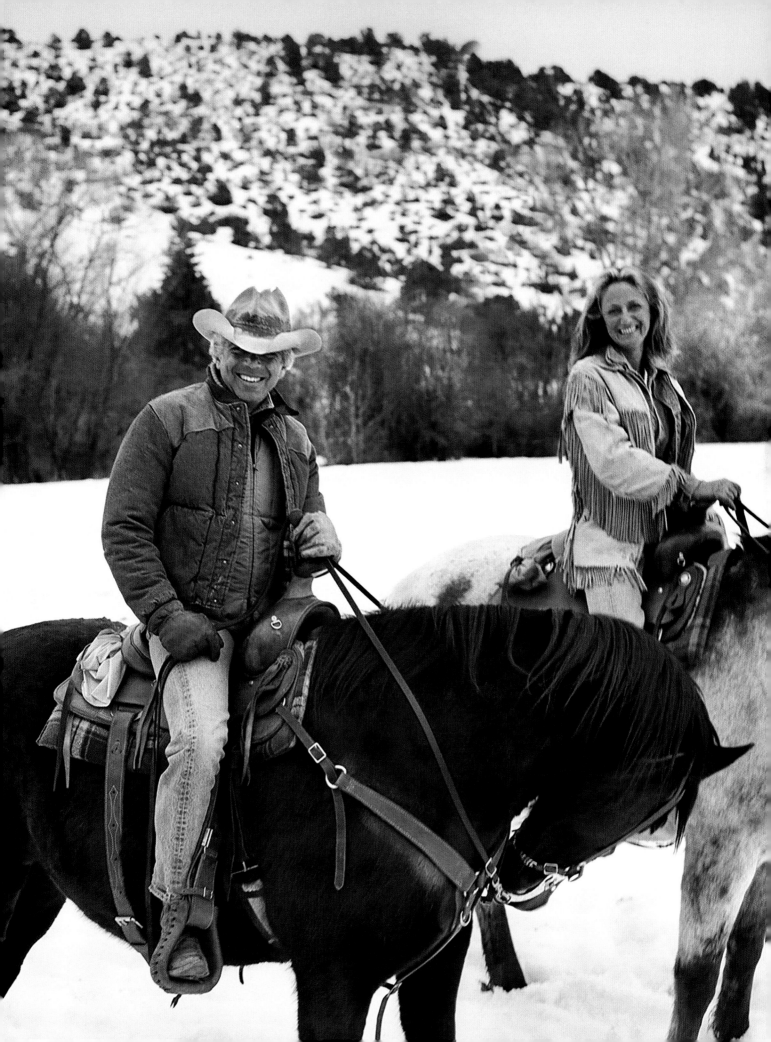

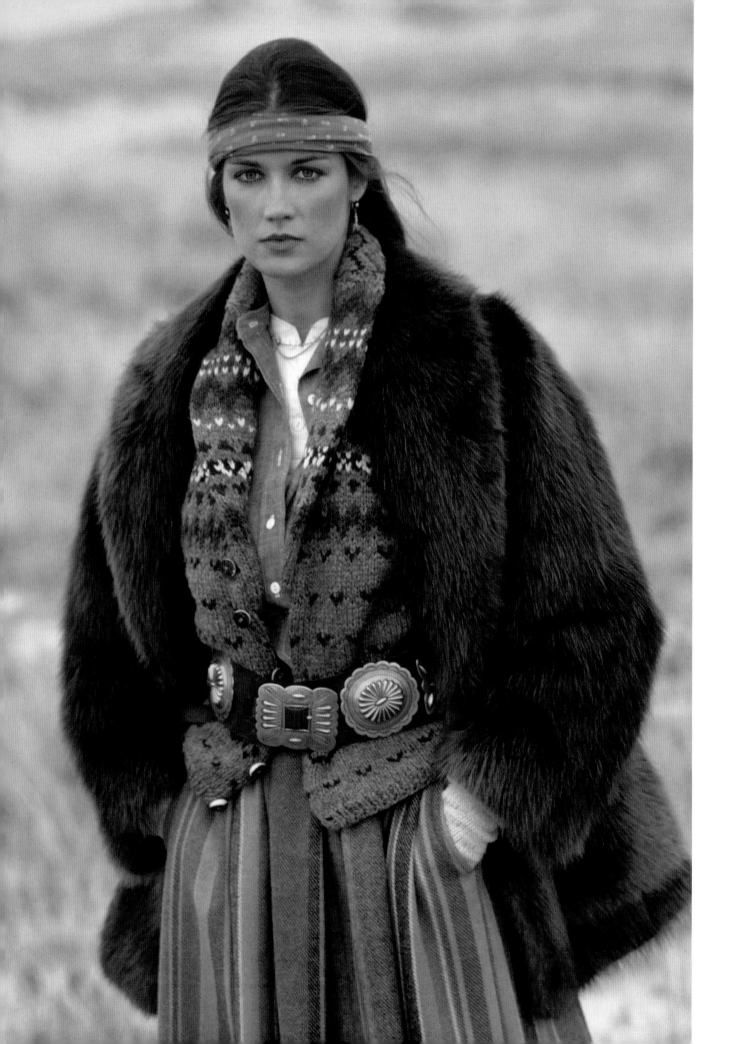

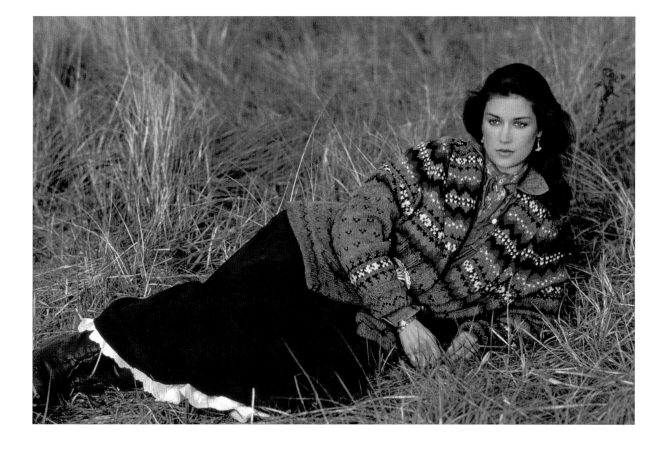

THE SANTA FE
COLLECTION, 1981

Most people who go to Santa Fe return with a great belt or a native-looking
basket. Ralph Lauren came home with an entire vision of a Southwestern inspired
collection and how a modern woman might wear it.

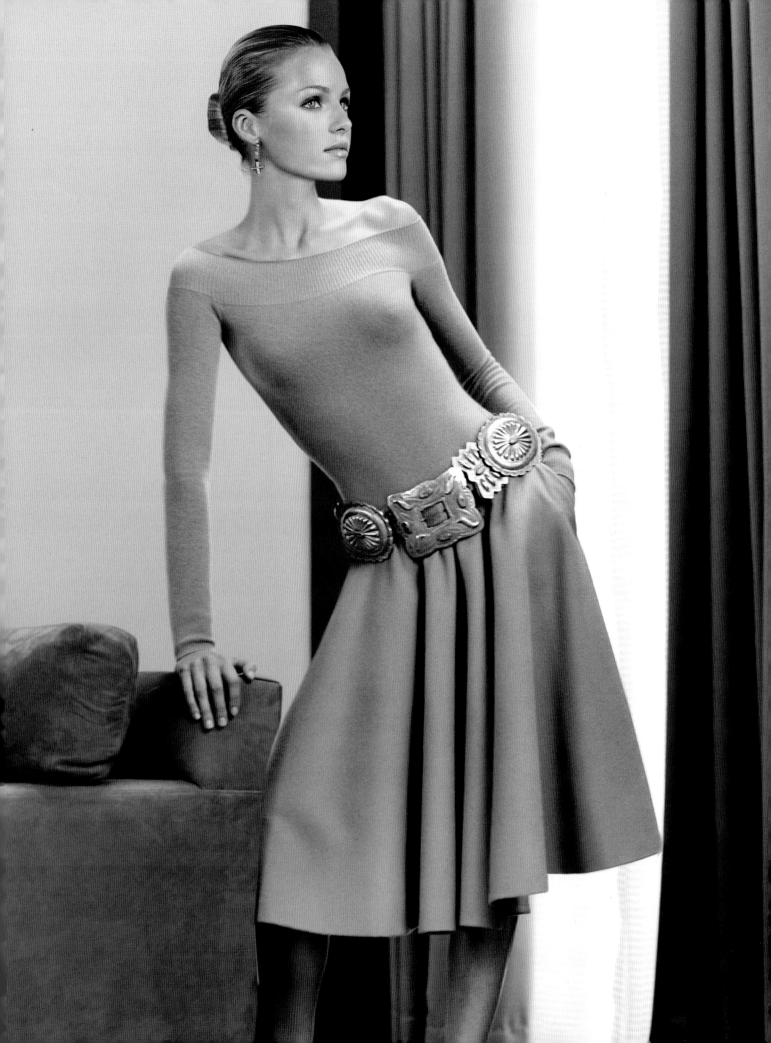

In 1980 Ralph took Ricky and their children to Santa Fe, New Mexico, for a vacation. Most people who go to Santa Fe return with a great belt or a native-looking basket. Ralph Lauren, inspired by the culture and history, came back with a sweeping cinematic vision for a collection of women's clothes and home furnishings. Ralph said that he doesn't remember what originally inspired him to visit Santa Fe but he assumes that he was looking for cowboys. "Folks there still talk not only about the charm of the Laurens but also about Ralph's insatiable curiosity. He wanted to know what the wranglers' Stetsons meant to them, whether they wore the hats for style or shade, how long they'd had their denim jackets and how they felt in them, what was it like to wear chaps, how to know real turquoise from fake, all about Indian jewelry," wrote Lyn Tornabene in a 1987 issue of *Cosmopolitan*.

In April 1981, inspired by the culture and traditions that he had seen on his trip the previous year, Ralph debuted Santa Fe, one of his most successful collections. As with his Western Wear, mixing a chamois skirt, turquoise hoop earnings, or a jacket-sized Navajo-inspired sweater with his own updated classics produced looks that rang true to his own eclectic taste, while priming the imagination of the international fashion press. The collection's hand-knit sweaters with their graphic patterns and bold combinations of colors evoked across-the-ocean praise when styled over a white peasant-style blouse and long prairie skirt with a white petticoat peeking out underneath.

With Santa Fe following closely on Western Wear's Americana sensibility, suddenly the Southwest look and the idea of "wearable art" were all the vogue. The designers' all-American fashions were much copied while his Navajo-inspired designs became a global calling card. Stores such as Saks Fifth Avenue decided to make hay with the look. Setting up Santa Fe boutiques, they dispatched camera crews to film Native American artisans at work. Articles about Santa Fe cuisine, vacations, jewelry, and home décor started appearing in prominent national magazines.

The designer made the concha belt into a collector's item. Crafted from silver pieces developed by the Navajos and then adapted by the Pueblo tribe of New Mexico, Ralph's adoption imbued them with a must-have fashion status. As Ralph stated, "It's a classic, like a good watch you keep forever—a wonderful investment and I believe in that kind of product. It looks great whether you wear it with corduroys or thin summer cottons. It's the antique of the future."

From *Ralph Lauren: The Man Behind the Mystique*: "Lauren's Santa Fe Look was so popular that when the Sunday *New York Times Magazine* published its first pictures of the collection, the phones at the Museum of the American Indian in New York City rang nonstop. The museum typically stocked some concha belts as gift items that ranged in price from 200 to 1,500 dollars, which the callers bought sight-unseen. Although the museum was open for only four hours, at the day's end, only two belts were left. A second shipment arrived Monday when the museum was closed to the public. By Tuesday evening those belts were gone."

From there Ralph's romance with America's Southwest virtually assured it a permanent chair at the Polo design roundtable. From frilly cottons to Native American inspired embellishments, Southwest-inspired style added another playing field to the brand's expanding design landscape. For Ralph, garments like cowboys' chaps, the original Shetland Everest sweater, and the fur hats of the Arctic hunter were more iconic than any "designed" fashion look, as they possessed a natural elegance born out of a confluence of purpose and form. As benchmarks of design integrity, they set the bar for an authenticity of taste and style that kept the Polo design teams on the straight and narrow.

In spite of this, as with his trail-blazing Western Wear, controversy followed the designer's Santa Fe collection alleging that he mined the nation's treasure for personal gain. States Ralph, "I remember going out West. I was inspired by the Old West, by things no longer here that I wanted to see again." In fact, he was excited by the possibilities afforded by Santa Fe's native crafts such as pottery, beadwork, weaving, and silverwork. Conscious of their historical lineage, each Navajo pattern was painstakingly researched to ensure that no sacred tribal symbols were compromised.

Ralph Lauren has a longstanding history in celebrating the importance and beauty of our country's Native American heritage. In recognition of his support and design contributions, in 1988 the American Folk Art Museum honored Ralph for pioneering excellence in American style.

187

Long a proponent of tiered dressing, Ralph single-handedly validated the concha belt as the ultimate layering component.
Perhaps the first wearable status symbol ever developed on the North American continent, it was deemed by Ralph as
"the antique of the future." Today the concha belt continues to offer the fashion savvy an endless array of opportunities
to turn an otherwise dull ensemble into something of premeditated dazzle and poise.

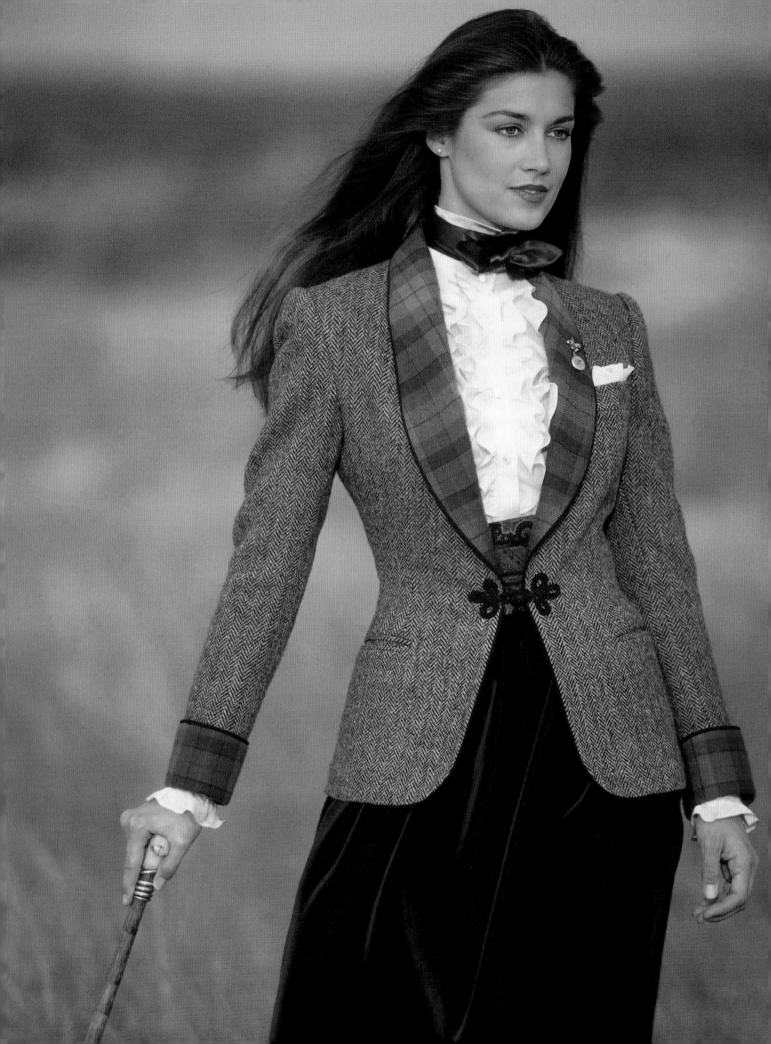

BACK TO THE FUTURE, FALL 1982

Just when everybody started to copy his southwestern prairie-themed clothes, Ralph once again struck out on his own. Turning from frontiersman to romantic, Ralph cites his fall 1982 show as one of his best collections. One thousand retailers, friends, and celebrities packed themselves into the ballroom of The Pierre hotel. After the show most of them stayed to cheer. He started the show with his playful recall of the Old West, this time expressed in patchwork skirts and pictorial sweaters long on charm. The sweaters depicted horses and houses in a childlike manner that combined easily with the patchwork skirts. The big, flouncy skirts swirled over cotton petticoats and were shown on models wearing heavy socks and sandals. They were received as marvelous clothes for country living and for ski resorts, looking as cozy as they were colorful. There were also romantic Victorian-inspired blouses with huge lace collars and velvet dresses.

Explained Ralph, "The lace was the breakthrough. That was the beginning of romantic clothes. It was a simple show with quiet music. Everyone else was blasting the music and showing a lot of flash, and I did this chic, quiet stuff with lace and antique suits and hand-knit sweaters. It was very inspired by an old-world sensibility. Your grandmothers had this stuff, but when I showed it to the customers, they couldn't find it. Maybe they could find it in the thrift shops, that was it."

Ralph's show stirred the *New York Times*'s esteemed fashion critic, Bernadine Morris, to reflect on the larger state of women's fashions. "Some insisted it was Lauren's best collection, Seventh Avenue's best collection. The clothes look exceedingly well-bred, and though they are nonassertive, they make a powerful statement. The effect was totally satisfying, as few collections are these days, and the viewers stayed in their seats applauding to indicate their approval. It offers a quiet excitement, without reaching into the bizarre, and is a landmark in Lauren's career. Besides producing designs that are serene and beautiful in themselves, he hastened the demise of styles that are sleazy and noteworthy for nothing but their shock value. If it does nothing else but open people's eyes to tawdry designs, it will have served a major purpose."

Morris continues, "This perception has eluded the majority of European fashion designers, who still think in terms of astonishing cuts and seductive designs when they prepare their collections. The vast majority of women no longer think of themselves as clothes horses or care about being the first on their block with whatever is the shock fashion of the moment. Whether working or not, they want their clothes to be efficient as well as effective."

189

"It all came together. This is the best I've ever felt. Clothes should make you feel good. I design movies not fashion. My goal is to always look like Lauren, just with newness." From *Time*, September 1, 1986.

190

Above: You don't have to be living out on the frontier to feel at home in her husband's Folk-Art Look.
Here wife Ricky wears it to comfortable aplomb in their Manhattan duplex.

Opposite: Ralph came to the rescue with "old-looking clothes you can coordinate or re-order"—one more
instance of real life made better. Ralph knew what people wanted but couldn't find so he provided it new.
There was a great deal of activity at the neck through the early eighties; a paisley ascot in a bow
over a lace jabot under a tweed jacket; the sweaters often have lace collars, with a scarf or collar of lace
anchored by a cameo or bar pin, melding the antique and modern look.

THE SAFARI CAMPAIGN, SPRING 1984

Headed for the African veldt in rich, romantic, old-world colonialist looks.
While not necessarily de rigeur for fleshing out today's Serengeti wildlife, they fit
perfectly with the fantasy safari of the designer's storyteller mind.

"I do the things that I would love to see if I went on a trip," Ralph says. "I don't think my designs are idyllic. But in a funny way, they are what people want to see." A lot of places I've visited in my clothes I've never been. I designed safari clothes before I went on a safari, English clothes before I went to England, the Russian look before I went to Russia. Those hats in my Russian collection were from the Russia of my mind. Sometimes it's better if you haven't been there."

Thousands of miles removed from the racial and political tensions of South Africa, Ralph Lauren unveiled a personal vision: his 1984 Safari collection and his safari woman. To Ralph it is not a vision of the Great White Hunter, or even of Africa, but of the kind of woman who picnics with her silver tea service on the Serengeti plains. It was about comfort on safari, elegant people in the bush, and about keeping standards up no matter what the circumstances.

Ralph's idealized worlds were invariably better than the real thing. Whether his world existed or not, Ralph chose to see the world as he thought it should have been rather than how it is. The Safari Look was, in Ralph's words, all about "the contrast of sturdy khakis, jodhpurs, and camp shirts against the elegance of pearls, romantic lace blouses, and cream linen suits worn over dusty riding boots." It's his fantasy of what colonial life might have been like as interpreted by modern times.

The 1984 Safari campaign photo shoot took place, prophetically, before Hollywood director Sydney Pollack began shooting his award-winning 1985 movie, *Out of Africa*. It was a Ralph Lauren–Bruce Weber production. Africa was decided against, as Weber had worked there in the 1970s and had found its logistics too difficult. Although Hawaii was proposed and a private ranch unearthed complete with African trees and vast landscapes, the rather complex and legalistic issue of how to acquire and import the appropriate lion cubs and even a zebra remained.

Birrittella picks up the story: "Lions only breed at a certain point and all the cubs were already too big to be handled safely. A friend came to the rescue, the actress Tippi Hedren, who had a ranch in California where she raised lions. She let us have three lion cubs and one ten-month-old lion that was almost full-grown. But I still needed that zebra!" Birrittella found one, only to discover that the zebra needed to fly in a cargo plane at a cost of twenty-two thousand dollars. After considerable bargaining and much cajoling, Pan Am brought the price down. Builders, carpenters, and upholsterers were then dispatched to create the set. Nothing was too much trouble, no expense was spared, compromise was not an option.

The photo shoots enabled Ralph to present his clothes as total, top-to-bottom looks set in environments that conveyed his unique vision. In that way he was able to contextualize his clothes within the larger narrative of an aspirational lifestyle. "I'm not an artist working alone in his studio designing the perfect armhole," Ralph once said. "I was the guy looking at the magazines and movies, and saying, 'Wow, that's where I'd like to be.' The way I see it, you've got to paint the environment. It's not just the car, it's where you're going in that car. I'm trying to paint a wonderful world, a life that makes you feel good. That's my movie. What's yours?"

Based on the success of the collection and campaign, a perfume of the same name, Safari, was planned for an eventual launch. Ralph and Buffy felt that the television spot needed the authentic environment to capture the evocative light, colors, and exotic atmosphere of East Africa and Kenya while inhabiting the project's two guiding literary inspirations, Ernest Hemmingway's *The Snows of Kilimanjaro* and Isak Dinesen's *Out of Africa*.

The Safari perfume, a three-hundred-dollar-an-ounce fragrance in a bottle of cut-glass crystal and sterling silver, would go on to become a classic. Its cut-crystal bottle sealed with a gold cover is now part of the permanent collection of the Cooper-Hewitt National Design Museum in New York.

Shot by photographer Les Goldberg, it was conceived as a sweeping David Lean–style narrative about an adventurous young woman on safari. A complex undertaking, it had over fifty tents alone to house the crew; everything for the shoot was flown in with locally hired Maasai warriors standing guard for protection. The Safari perfume, a three-hundred-dollar-an-ounce fragrance sold in a cut-glass crystal and sterling silver bottle, would go on to become a classic as well one of the brand's most successful perfume campaigns.

As Henri Bendel's president, Geraldine Stutz, stated at the time, "You've got to realize what was going on between Ralph and the American public—us, the American purchaser—was a very subtle thing. What he gave them through his clothes, but preeminently in his advertising campaigns, was the big outline of a life. They knew it was a make-believe world. He gave them the perfection of make-believe. And Americans wanted it. That's what you have to understand."

THE ENGLISH THOROUGHBRED CAMPAIGN, FALL 1984

Fashion has never been the issue for Ralph;
it was always the story, the subtext that framed the clothes. Surely one of the
designer's singular talents is tuning into the elegant iconography of a
vanished world and handing it back to us better than it ever was. English
Thoroughbred projected a comfortably aged oldness; it was about the
continuity and the transcendence of ownership, not the purchasing of taste.

The English campaign projected a feeling of high style coupled with an unattainable
component. Ralph wanted the shoot to have a city-country feel to it.
As Birrittella explained, "It's for someone who doesn't want to look like they're trying too
hard. She's wearing the clothes, the clothes are not wearing her. She's confident,
so the clothes do not look forced or costumey." The Ralph Lauren collection has always had
a basic premise: "To offer something to wear when life demands clothes that feel good
but don't make you look as if you are trying too much."

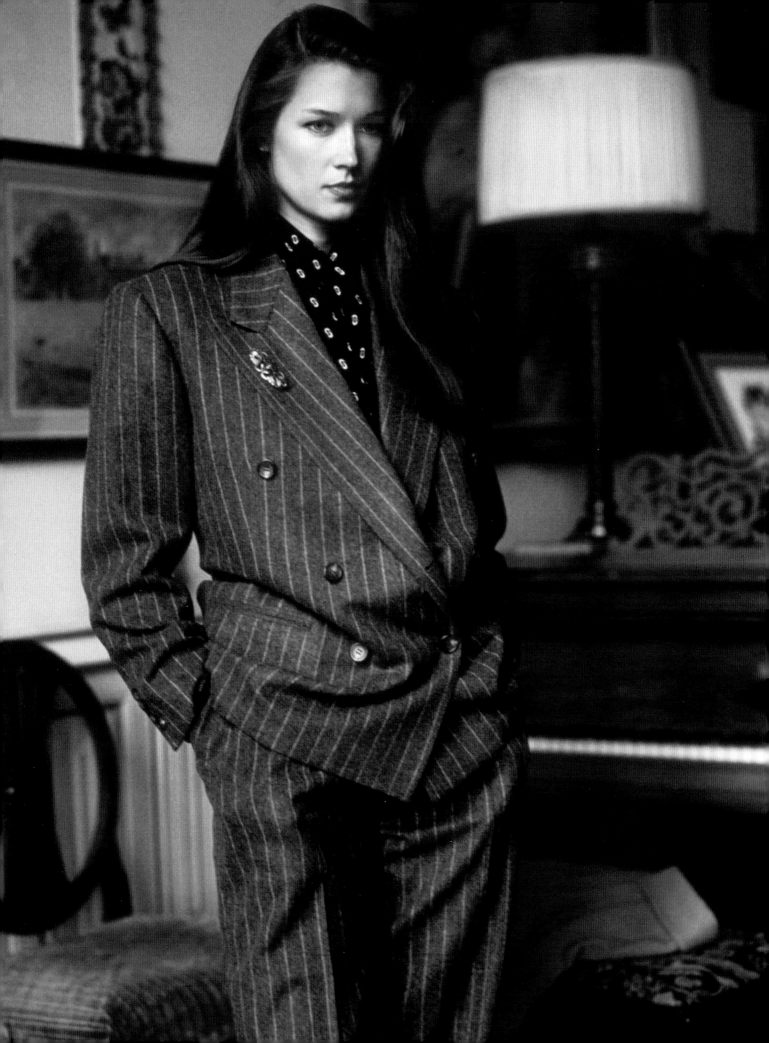

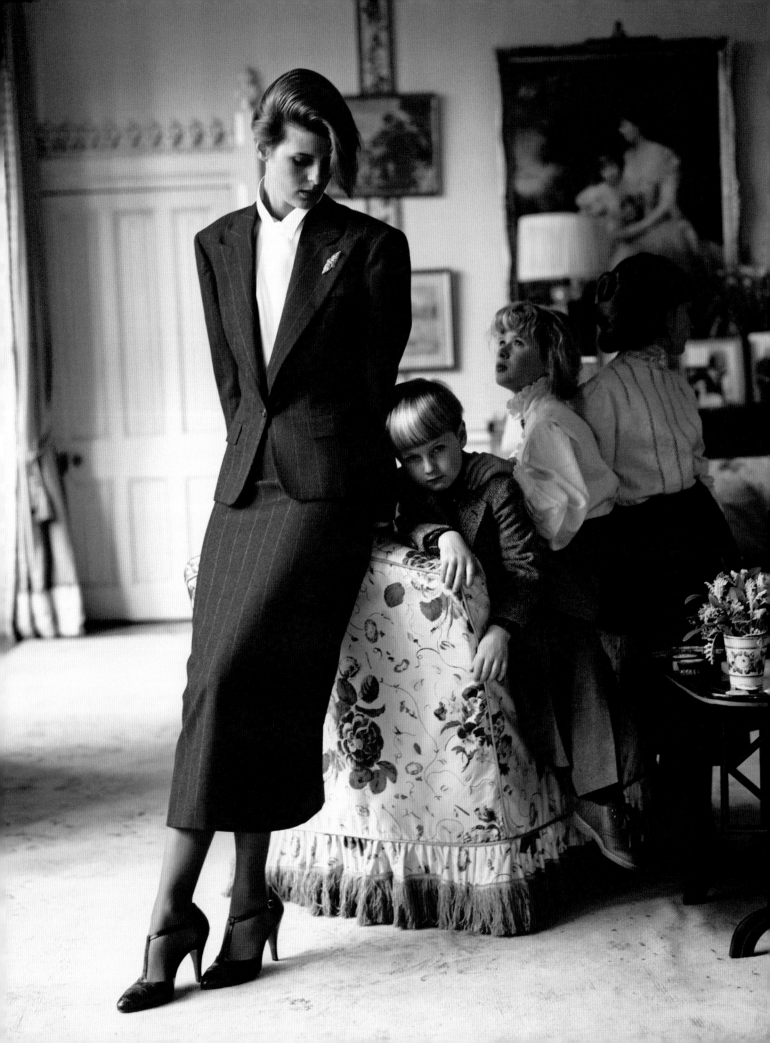

In the fall of 1984, another monumental Lauren-Weber shoot took place. This time it was in England, at a stately home formerly owned by the Astor family and now an elegant country hotel. If being born "to the purple" no longer measured up, it would not matter. A virtuoso of visual narration, Ralph Lauren saw the life of the British aristocracy as flush with potential story lines as the prairies of the Midwest or the grasslands of the Serengeti.

Ralph referred to the English Thoroughbred collection as world-class and to the women's clothes as the "Duchess of Windsor," or in Buffy's words, "grown-up, custom-tailored, and luxurious." Given the sumptuous quality of the collection's flannel suits and cashmere sportswear, everyone felt England offered the best backdrop for setting off the clothing's posh textures and intrinsic quality. With the collection's preponderance of Scottish tweeds, Ralph also wanted a city-country feel to everything; for example, a couple of landed gentry arriving at a London hotel for a night at Sadler's Wells and dinner at The Grill. If Ralph Lauren's clothes are essentially extensions of an upper-class style of life then the photographs need to do more than just show clothes; they need to be conduits into that world. Although the Polo campaigns were sometimes accused of encouraging an elitist view of life, they did manage to stoke the consumer's aspirational yearnings.

A team flew over from the States with cast and crew settling in at the hotel for the shoot. Photographer Bruce Weber was in charge of the mise-en-scène wizardry. Everything was propped, styled, and accessorized down to the last detail, from exactly how worn the carpet should look to how many walking sticks were positioned in the hallway. The right type of dog was never far from hand—spaniels, fox terriers, Scotties, Jack Russells, Dalmatians, Yorkies, Bedlingtons, collies, or Pomeranians. Remembers Weber, "Ralph always agreed when I wanted lots of dogs and children to pose alongside girls dressed in sumptuous evening gowns and men in impeccably cut suits."

The goal of each day's shooting was to delineate another corner of Ralph's dream world with imagery that offered ready access for the viewer. Weber insisted that everyone be dressed for the entire day, so those impromptu, unrehearsed moments that usually make for the best pictures could be captured. Weber aimed for naturalness, encouraging the models to relax and forget the camera. Nothing was posed; everything was geared toward that split second when an iconic scene or mood converges with a moment of Ralph Lauren stand-alone stylishness. And no one has managed to forge more of these magical tableaux than Bruce Weber.

The choice of England reflected the designer's appreciation for the country most responsible for mentoring him in the verities of aristocratic taste and the muted elegance and genteel refusal of ostentation that are its hallmarks. Steeped in a heritage of royalty and generations of inherited titles and lands, flaunting one's wealth was considered poor form and a sure giveaway as to the newness of one's station. Luxury was better hidden, rather than on display, like the simple trench coat with fur lining, its underside being more valuable than its exterior. Carelessly throwing it over an armchair with its rich underbelly peeking out implied connoisseurship rather than consumerism.

Being among the landed gentry and its gentrified taste for so long bred a regard for well-worn-in raiment such as twenty-year-old tweeds and frayed golf sweaters. Sun-drenched riding habits held more allure than something bought new and fresh off a retailer's shelf. The age may have passed when the master's valet would iron his shoelaces and press his Bank of England notes for the day's activities; however, England was still host to more of these charming passports of privilege than anywhere else. In large part, Ralph's feel for the fine print of upper-class style enabled him to paint a picture-perfect world in prime time. According to Buffy Birrittella, "We are always making Ralph's movie. It does not have a script, but it does have a plot. It's always about the clothes and how people live in them."

203

THE AMERICAN BLUE-BLOOD

Shifting gears, not to mention continents, the peripatetic Ralph turned his Ray Bans back to his own shores. The next chapter in his lifestyle manual was the American establishment and its WASP (White Anglo-Saxon Protestant) social order that inhabited Manhattan's Park Avenue and the rolled lawns of Newport, the Hamptons, and Palm Beach. Two influential shows of the time, *Brideshead Revisited* on television and the film *Chariots of Fire,* had helped to rekindle interest in old-world, Brahmin-inspired lifestyles.

Ralph sensed that like himself, his customers were both aspirational and nostalgic. The collection was a fantasy of the nation's well-born harking back to a time when standards of behavior were inextricably tied to conventions in clothes. Genealogy notwithstanding, while money could not buy class, Ralph Lauren was going to make sure it could still buy classy things to wear.

Without knowing it, Ralph was following in the footsteps of a prominent earlier tastemaker, Dorothy Draper, the doyenne of American interior design. In 1923 Draper established the first interior design company in the United States. "Draper was to decorating what Chanel was to fashion," states her protégé and business partner, Carleton Varney. By injecting color into the dour and ordered world of interior decor, she broke away from the historical "period room" styles of the day, providing an idea of design that revolutionized the way people look at living spaces today. In creating an original and identifiable look, she is credited with single-handedly birthing the interior design industry.

Like Draper, Ralph Lauren wanted to sell a thoroughbred image to the masses. But of all the aspirational lifestyles Ralph Lauren was to mythologize, it was his "alleged exploitation" of the American blue blood and their Ivy League Look that drew the most backlash. Critics condemned him for marketing a fantasy package of WASP life for his own commercial advantage. Deep down there seemed to run a strong current of resentment that a Jew from the Bronx was not entitled to the style of the Connecticut gentry.

Ironically, decades before Ralph Lauren was to even dream of owning a Brooks Brothers button-down shirt, generations of America's socially mobile gentiles and Jews were not only trying to dress like the ruling-class Protestants, some even managed to launch businesses selling clothes to this exclusive slice of American society. Max Raab was the son of a Jewish Philadelphian garment manufacturer whose business ambition was to make the cheapest blouse in town. Raab, a lifetime maverick with a passion for jazz and movies, flunked out of high school and fought in the Korean War before coming up with the idea for his first fortune. He created the Villager and Ladybug brands based on the style Philadelphia debutantes adopted when they borrowed their boyfriends' oxford cloth shirts. While most assumed the brands were outgrowths of those WASP fashions populating Ivy citadels like the Merion Cricket Club or The Union League's Father-Daughter Dance, they were actually the brainchild of a man who might be described as the quintessential outsider.

At the height of the brands' popularity in the 1960s, there were over a hundred Villager shops nationwide selling the upscale sportswear to the tune of 140 million dollars. As Raab said in a *New York Times* interview: "I know

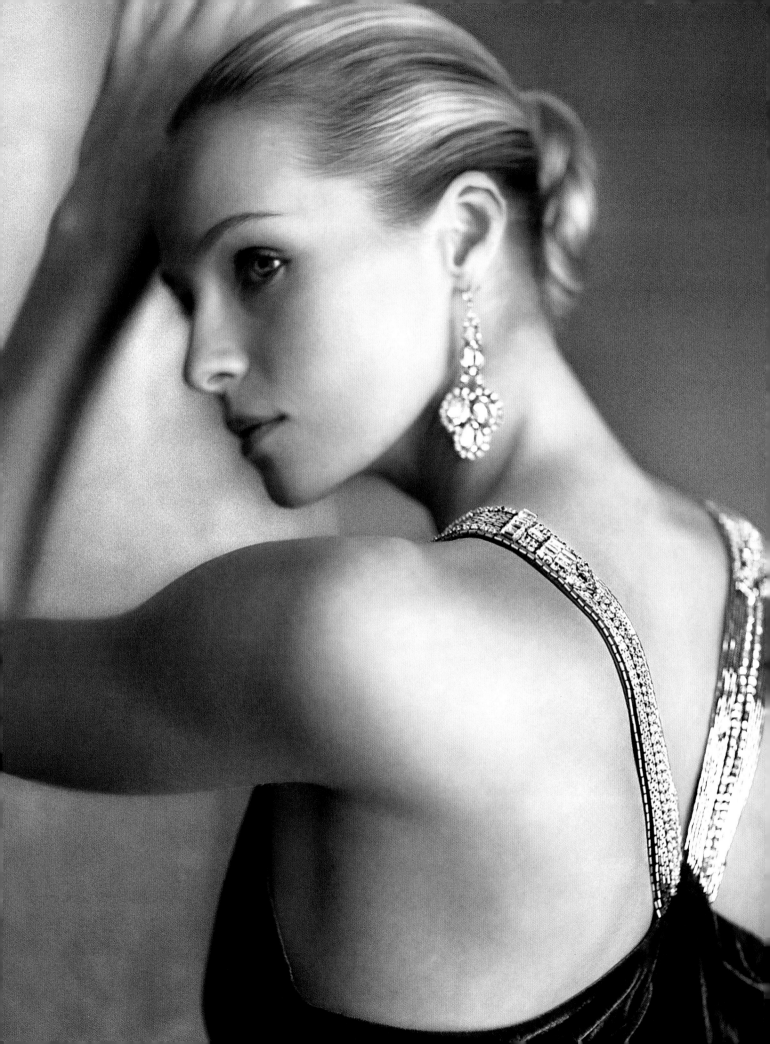

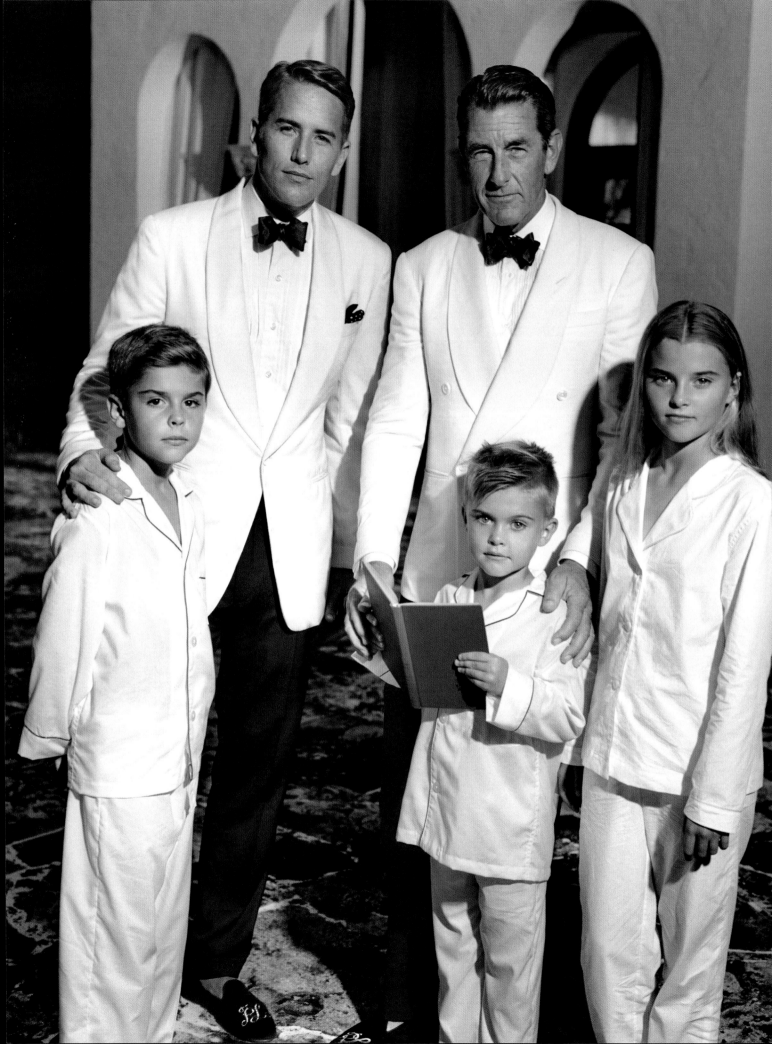

Ralph's most ambitious outreach to date was a magisterial eighteen-page pictorial saga in the *New York Times Magazine* that reached out with the implicit message that relaxed style and humble elegance was every bit American and now, courtesy of Ralph Lauren, accessible to all. If America was, in part, based on the idea that everyone should have an equal opportunity to live a quality life, then Ralph's idea was that everybody should have an equal opportunity to avail themselves of products that reflected the values of heritage and longevity.

Left: The dyed-in-the-wool WASP learned to never apologize for his sartorial excess nor be deterred by its potential for effrontery. This was to be the last epoch in which a gentleman's eye-catching bravado implied an upper-class lineage.

Following spread: Dubbed by the editors as his League of WASP fashions, the *New York Times* wrote of the designer's 1984 Fall show: "Despite efforts by several European designers to capture the American sportswear business, it's hard to beat Ralph Lauren. Lauren showed his meticulously man-tailored clothes so dear to the heart of would-be blue bloods. His 1984 Fall and Spring 1985 shows saw Lauren 'do' Lauren, in that he revisited his past, evolving and perfecting the styles that he calls classics. On display was his skill to take certain strands from the past and create a look that may well have started there, but ended up essentially modern."

women better than they know themselves. The Waspy girls all want that country club look, and the Jewish girls want to look like the Wasps. I knew I had a winner."

Although it's not exactly clear how the Ivy League Look came into being, what is clear is that first, much of it was honed in and around New Haven, Connecticut, and second, Jewish immigrants played an outsized role in its evolution. Beginning in the 1920s, scions of America's White Anglo-Saxon Protestant ruling class began toying with a new style ideal, a relaxed manner of dress that reflected their class-conscious backgrounds. Arthur Rosenberg, a Jew and New Haven's foremost tailor, began to exploit this emerging campus style among Yale's undergraduates. Jacobi Press, another Jewish émigré from Russia, followed suit, situating his store directly across from the Yale campus, founding what was to become one of the Ivy League Look's preeminent purveyors, J. Press, with outlets in New York City, Washington, D.C., and Boston.

As the decade progressed, more and more Yale undergraduates began patronizing the Jewish tailors. But regardless of the increased acceptance by the ruling class, Jewish applications to Yale were still subject to the unspoken quota of five percent. Despite such covert anti-Semitism, the New Haven order of J. Press birthed a generation of predominately Jewish retailers, tailors, and salesmen who were to become the Ivy League's most storied clothiers. Sydney Winston founded Chipp and Company in New York City, while Fenn-Feinstein settled uptown; Henry Miller put down roots in Hartford, Connecticut; Arthur Adler decamped to Washington, D.C.; and Princeton's lionized campus store, Langrock, debuted under the name of another J. Press alum, David Langrock.

These men were to form a close-knit fraternity whose mission was to plant the natural shoulder banner deep into the soil of each Ivy's quad and consciousness. Central to the Ivy League's flowering as a living American campus,

fashion was the collaboration between these two social forces: the proselytizing gray flannels on one side and their preppy converts on the other. Shaping the Ivy League's evolving dress canon became the defining occupation and skill set of this East Coast cabal. No wonder that throughout the fifties and sixties, the aspiring middle-class Jew and the upwardly-mobile gentile tried to drink from the same Harvard/Yale/Princeton sartorial well.

What was to differentiate designer Ralph Lauren was how he pictured it in such a fully formed panorama. Ralph's campaigns tapped into a vision of an idealized America winging down somewhere beyond the last stop of the subway. Even ethnic minorities far outside the charmed WASP circle that Ralph glamorized felt there could be a place for them in that enchanted world. When you bought a Polo product, you gained entrée to Ralph Lauren's movie. And dressed by Ralph Lauren, you are unlikely to be turned away at the door. "No one understands his customer as truly as Ralph does," says Donna Karan, another leading U.S. designer. "He creates designs that match his philosophy, and he never loses his integrity."

Fortunately, Ralph's fascination with all things Ivy League happened to coincide with the look's second renaissance in the late fifties and sixties. For that brief spell of time, the real-life chic of the Prep's vibrant color combinations and eyebrow-raising patterns was in full bloom. Increased leisure time found the silver-spoon set spending more and more time at their social clubs in town and at country clubs on weekends. One of the most engaging parlor games to emerge was a kind of King-of-the-Hill one-upmanship whereby the outlandish mixing of colors and patterns branded the participant as a person of self-assurance with banking privileges to burn.

Not born into such a world, Ralph would pour over old college yearbooks from Princeton, Harvard, and Yale. An eager beaver with his nose pressed to the glass, Ralph had long cherished what the Brooks-bred largely took for granted. Gifted and with an outsider's eye, Ralph could decode the look of the collegians without being circumscribed by it. Trying to identify some of the keys to sartorial enrollment—the bespoken origins of a school blazer or the prescribed detailing of a club's regimental trim—the self-schooled designer would studiously file everything away for future application. As he was quoted, "Sometimes people have something and because they live with it all the time, they don't know they have it."

Although the American WASP might have come into the world buoyed by a full birthright and bankbook, it did not entitle him or her to a seat at the proverbial style round-table. Enchanted by the Ivy Leaguer's flaunting of his "summa cum loud" clothes, Ralph would create all kinds of color-saturated classics. The growing appeal of the designer's clothing was not just his familiar use of color, but the way his boldest designs still managed to connote upper-class taste. Upon the eve of his so-called League of Wasps fashion show, Ralph was quoted, "I was looking for the unusual pieces that were preppy and had a heritage that no one made any more. I felt there were women looking for elegant clothes, much of which had disappeared from the market."

Returning to the designer's alleged sartorial transgressions, to ascribe the premature dissolution of the ruling class's dressing style to the machinations of one Ralph Lauren is to ignore those trends coalescing at that time. Fast-forward to the early 1980s, when Ralph Lauren's first lifestyle-themed fashion campaigns came upon the scene. America's preppy look had virtually run out of steam, owing to the psychedelic ragtag sixties followed by the European designer explosion of the early seventies. Younger members of the establishment were abandoning the upper-class look while the middle class no longer aspired to dress like a blue blood, at least not overtly. The English retailer Marks & Spencer, having purchased America's venerated Brooks Brothers for 750 million dollars in 1988, ditched it thirteen years later for the fire-sale price of 200 million.

In large measure the unraveling of the WASPs' authority as a style hegemony can be attributed to its ranks' inability to fully objectify their dress as something worthy of updating and revitalizing. As Giuseppe Tomasi di Lampedusa famously wrote in *The Leopard*, his novel of nineteenth-century Sicily published posthumously in 1958, "If you want things to stay as they are, things will have to change." Ironically, by glorifying these highborn fashions, the designer actually helped prolong their staying power, at least as a living iconography of American stylishness. Ralph Lauren was to save the Ivy League Look from certain extinction not only by keeping its flame alive but also by keeping alive the taste for it.

Yes, it could be argued that by supposedly commodifying the country's upper-class lifestyle, Ralph was helping to feed the culture's growing obsession with materialism while advancing the misconception that money could buy class or a pedigree. On the other hand, as Paul Goldberger, the Pulitzer Prize–winning architecture critic of the *New York Times*, proposed, "Whether it is the perfect shingled summer house by the sea, the sleek ski lodge, the western ranch, or the streamlined penthouse. Everybody loves that stuff, and whether you think of it as your birthright or as something you aspire to hardly matters. . . . And that, in the end, is the essence of Lauren: luxury for all. . . . He has made aristocracy feel entirely democratic. What could be more American than that?"

209

WOMEN'S WEAR DAILY, FRIDAY, MAY 4, 1984

Lauren's League

Ralph Lauren's navy cashmere coat, gray cashmere sweater, white silk campshirt and gray wool trousers

The wool tweed jacket, worsted wool shirt and paisley skirt in wool challis

The gray wool pinstripe trouser suit and white silk blouse

of the WASPs

The chevron herringbone wool tweed jacket in brown, with a gray cashmere sweater and green velvet pants

The black cashmere pullover with a white linen blouse and deep green velvet skirt

The gray wool wrap jacket and side-pleated skirt

Photos by THOMAS IANNACCONE

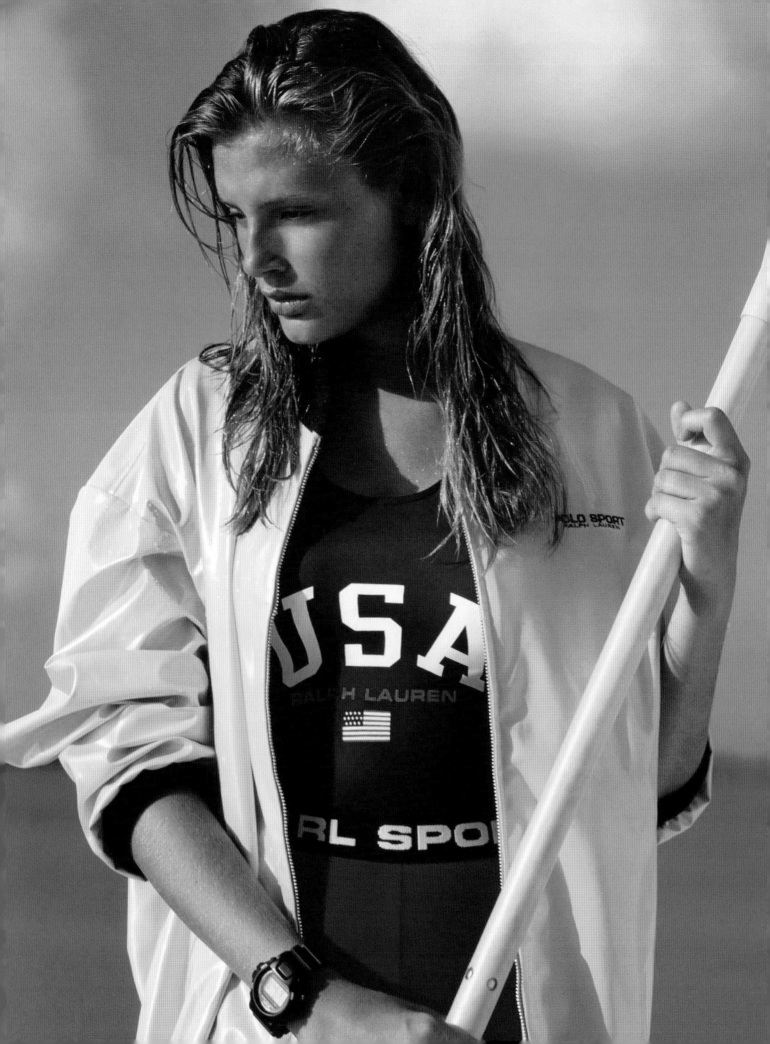

POLO SPORT

Putting the Sport
Back into Sportswear, 1992

Nineteen ninety ushered in an era of staying fit in America. The preceding year found American *Vogue* proffering the headline: "Fitness: changing the shape of fashion." Workouts, fitness regimes, and sport stars were assuming center stage. Inspired by Jane Fonda, supermodels sprinted to make their own workout videos showing women how to exercise themselves into the desired shape. Pictures of women in sport moved to the mainstream sports pages with national publications devoting more space to the athletic prowess of female volleyball players, tennis players, and marathoners. And it wasn't long before these freshly minted heroines found themselves being profiled in the same newspaper columns typically reserved for the activities of more established socialites.

"Dressing down" became the overriding fashion trend of the 1990s, dispensing with the wide-shouldered "power suit" of the 1980s. Simple, understated, slim-fitting clothes replaced the cluttered, over-the-top glamour of the preceding decade. Office attire became more casual and low-key, as working from home became more popular. *Vogue*

magazine noted that body-hugging actionwear made of high-performance textiles had sparked an interest in fitness fashion for more than exercise. The translation of athletic apparel into sportswear made perfect sense, as the increasingly active and busy lifestyles of the late twentieth century necessitated fashions that freed women from rigid and cumbersome clothing.

With the invention of Lycra in 1959, America took the lead in exploiting the new synthetic yarn's possibilities. Lycra and spandex were mixed with cotton and wool to improve the stretch of garments, making them more comfortable and less prone to wrinkling. Blended fabrics became important in everyday casual wear because the skin-tight fabrics had the stability to showcase lean and toned bodies while looking fresh and modern. As Joan Juliet Buck wrote in *Vogue*, "It explains the overwhelming popularity of leotards and sweatpants and running shorts among people who are not only thinking of exercising."

Not surprisingly, Ralph Lauren was at the very forefront of the fitness explosion. Quietly digesting the fact that his family and staff had become increasingly fitness conscious, Ralph decided that the trend for athletic-driven dressing was not some passing fashion infatuation—it was here to stay. He also believed there was an increasing number of well-to-do women in good shape who were eager to wear more body-conscious casual

clothes. Ralph proclaimed that "fitness was the real fashion of the nineties; health spas, good healthy food, working on your body—that's the real fashion of the nineties."

Ralph's interest in putting the "sport" back in sportswear also came from his lifelong attraction to sports with fitness being an important part of his daily regime. Not a guy who likes to sit still, mornings typically began with a jog around Central Park or a workout session at home. However, in 1987 a medical scare gave him a new sense of urgency relative to his health and the importance of staying fit. In the fall of 1986, a tumor was found in Ralph's brain, a benign meningioma that his doctors wanted to remove immediately. What they hadn't bargained for was Ralph's commitment to work; he wanted to wait until January, after the Fall 1987 show, to have it removed.

As Marvin Traub, Ralph's close friend and president of Bloomingdale's, tells it, they were having lunch two months after Ralph had a cover story in *Time* magazine. Traub remarked to Ralph that he looked worried. Ralph told him it had been a tough time, as some family members had been going through a patch of serious illnesses and six months ago, he was told he had a tumor that was probably benign but needed to be operated on. Feeling that he would be letting down his whole organization and his stores if he didn't do a show, he hadn't told anyone but his family and a few close friends. As Traub recalls, "I've always remembered the few weeks when he was King Ralph to the public and facing his own mortality in private. Lauren finished the show then had the operation and the tumor was indeed benign."

As reported by Pam Fiori in *Town & Country*, Ralph Lauren said, "I've always been sensitive about life and am grateful for what I've had, but when I came out of the hospital, I was more scared than when I went in—maybe because it dawned on me that anything could happen to me . . . just like that. I went back to work with a much greater fury. I had all this pent-up energy. Everyone noticed." Ricky Lauren felt her husband had been deeply affected by the experience, that it had made him more appreciative and spiritual, realizing the specialness of the gift that had been bestowed upon him.

Whereas Ralph had always been an athlete and a devotee of the sportsman's life, after the operation he turned into a fitness addict. Returning to work with a vigorous, youthful spirit, he felt a "sense of renewal" from the successful surgery. For Fall 1988, inspired by his collection of classic racing cars, the designer started making sleek, simple clothes, incorporating clean body-hugging lines into his designs for day and evening, fashions that celebrated the well-toned figure. At the end of the season's show, Ralph danced down the runway.

The message was "lean and clean." The "lean" was tapered clothes that hugged the body suggestively without being tight or overbearing. The "clean" was the spareness of the design in a move away from the ruffles and flounces of former seasons. Ralph took his classic tank and T-shirt shapes and with the help of stretch materials cut on the bias like matte jersey, fashioned them into form-sculpting dresses for daywear. Want to ski down to a beach party? Then slip on a long, sinuous tank dress that rolls up into a ball and fits into your hand luggage wrinkle-free.

There were slinky dress clothes that fit like sportswear but, given their striking sleekness, came across like glamorous evening gowns. "You can imagine women wearing these clothes, which can't be said of a lot of what goes down the runway. The look is exactly like the clean, racy minimalism seen on fashion editors—skinny pants, sexy heels. Except Mr. Lauren had the good sense to view it as a woman from the Midwest might—from a safe distance," wrote *New York Times* fashion correspondent, Cathy Horyn.

The classic polo was given a slimmer fit and an appropriate fitness-sounding alias: "the Polo Mini." Offered in an expanded range of colors, its trim shape engendered a whole new fashion quotient of being paired with heels and a miniskirt or 1930s-style shorts. Wrote Mark Holgate of British *Vogue*, "No designer has eulogized the practicality or the romance of a T-shirt and jeans more than Ralph Lauren."

If Polo's performance-enhancing clothes were becoming the go-to uniform for those wanting to look action-packed, now it would become the professional's uniform, too. In 1989 Ralph expanded his sports apparel business with a line of golf clothes and accessories. In 2006, Polo debuted uniforms for the most prestigious tennis championships in the world, England's Wimbledon, clothing all the on-court personnel including umpires, line judges, ball girls and boys. In 1992 Polo became the official outfitter of the American team for the America's Cup sailboat race, which, despite being the underdog team, went on to win the event.

Additionally, in 1992 Ralph launched a new line of performance-based activewear called Polo Sport. Hoping to attract the next generation into the Polosphere, the sons and daughters of his core customers, Ralph felt it was time to go more contemporary and create clothes for a lifestyle he had long been living, both as a runner and athlete, and someone committed to personal fitness. "It's not that they are elitist clothes," Ralph told the *New York Times* in 1993. "There is just an attractiveness about athletes in general. Athletic clothes say that people have energy."

He also signed an exclusive two-year agreement with model Tyson Beckford to be the face of the new brand. Whereas Ralph had used African American models before, in

214

Said Ralph, "The new shape opens up a whole new realm of ways to wear it. It works just as well with heels and a mini as it does with shorts."

Beckford, Ralph saw the perfect man to personify the image of Polo Sport. A stunningly handsome male model with a proud athletic look and an all-American image, Beckford became the first African American male to sign an exclusive contract for the brand. Not unexpectedly, some in the African American and fashion communities viewed such a choice as tokenism, like a kind of Jackie Robinson, break-the-barrier kind of thing. But as Beckford observed, "The Polo ad says that I'm not a basketball star or rap star but an all-American type. It separates me from those stereotypes, which is good." Beckford's appeal, to the public as well as to Ralph, was that he was the embodiment of male power in its modern form.

Beckford's look was special; he was such a strong-looking man, no one looked like him. From a 1994 *New York Times* article interviewing Stefan Campbell, former fashion editor at *Vibe*: "'Tyson is not, of course, your traditional black male model,' said Mr. Campbell, who has worked with him several times. 'Other successful black models weren't as dark, and they had straight noses and thin lips and curly or processed hair. He represents a beauty that people weren't willing to acknowledge before.'"

From Colin McDowell's *The Man, the Vision, the Style*: "Photographer Bruce Weber believes Lauren deserves a lot of credit for using a black model for advertisements that, even in the early nineties, were still more likely to pull in more white customers than those from ethnic groups. 'Ralph knew Tyson was right for the moment,' he insists. 'But it was quite a thing for Ralph to do. He [hired] Tyson because he believed in his look, not because he felt it would sell more clothes. I think it was really great that Ralph took such a strong stand.'"

The designer also opened a new retail store opposite his Madison Avenue Rhinelander showcase called Polo Sport. "It shouldn't be a surprise that Mr. Lauren is devoting a whole new store to the sports-minded. Ralph Lauren first rode into the American lifestyle with athletic-based dressing: jodhpurs, hacking jackets, cricket sweaters, tennis whites, and his signature polo shirts," wrote Amy Spindler in the *New York Times*.

"Sport is a beautiful store. It's a beach house in the summer and a ski lodge in the winter," says the designer. Inside, the store is as clean as a whistle. Walls are white lacquer, bannisters gleam with stainless steel and burnished wood. The freshly swabbed floors are polished cherry. Canoes and kayaks are affixed to the walls, a racing scull hangs from the ceiling. Vintage skiing posters and a bank of video screens helped articulate this new-age shrine to the nineties' most elusive luxury: leisure time.

With Bruce Weber's first multipage advertising spreads starting in 1981, the opening of the Rhinelander Mansion in 1986, and his gleaming new Polo Sport store in 1993, the

fashion world was just beginning to realize just how high Ralph had set the fashion-as-lifestyle bar. Observed writer Lisa Armstrong, "Polo Sport has been phenomenally successful. Further proof, though hardly needed, of Lauren's extraordinary ability to preempt the needs and dreams of the times."

In 1998, Ralph took another leap forward, launching RLX, a collection of competition-ready athleticwear for men and women. The brand's mission was to design the ultimate in high-performance, functional athletic apparel and accessories. Quality, innovation, and technical performance were infused with the Ralph Lauren sensibility, thereby distancing RLX from its category competitors. Polo also sponsored a World Cup mountain-bike team, national and world champion triathletes, and even snowboarders. When asked why he wanted to get involved in activewear—an area that involves technology as well as style, one that's not always understood by department stores and that is dominated by authentic megabrands such as Nike, Reebok, Adidas, and Fila—Ralph said that he felt he had "something to say" in the category. As Ralph was quoted, "You need function, why not meld it with style."

Yet despite the authentic appeal of the clothes' many details and finishes, their power resides in the fact that they are utterly luxurious. For all their outdoor image, they are meant for urban living, not riding the rodeo or doing a tour of duty overseas. And the price tag reflects this. As André Leon Talley noted, "That's what's cool about Lauren, this simple elegance, everything pared down, then made hot with a dash of luxury."

Polo by Ralph Lauren continues to keep itself closely involved with the world of sports and fitness. In 2005 the United States Tennis Association selected Polo as the official outfitter for the US Open's Grand Slam tournament. Moreover, in March 2006 Wimbledon in Great Britain designated Polo by Ralph Lauren the first-ever exclusive outfitter of the tournament. Ralph stated: "Wimbledon is a sporting event rooted in English tradition. . . . It embodies elegance and classicism, elements that are the core of my creative vision."

In addition to outfitting successive US Olympic teams since 2008, as well as being named in 2014 the official outfitter of the PGA tournament and Ryder Cup, the company continues to take its wearable technology innovation to the next level, unveiling at the 2014 US Open Championships the PoloTech shirt that merges biometrics into active lifestyle apparel. For the Pyeongchang 2018 Winter Olympics, the company introduced the Polo 11 Heated Jacket that features an updated heating component controlled via Bluetooth through the new RL Heat app. In addition to controlling the jacket's inside temperature, the app also displays the current weather outside.

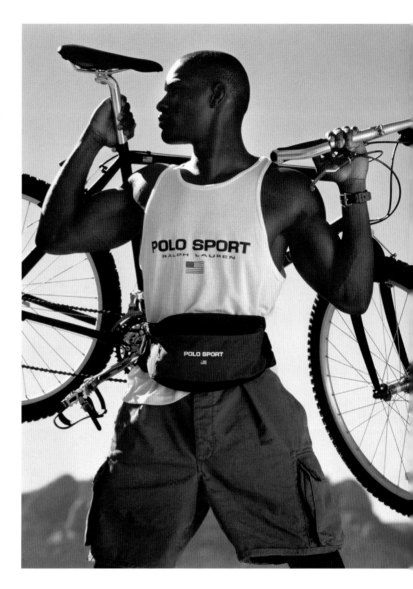

From Colin McDowell's *Ralph Lauren: The Man, the Vision, the Style*: "Photographer Bruce Weber believed the designer deserved a lot of credit for using an African American model for advertisements. 'Ralph knew Tyson was right for the moment, he insists. But it was quite a thing for Ralph to do. He used Tyson because he believed in his look, not because he felt it would sell more clothes. I think it was really great that Ralph took such a strong stand.'"

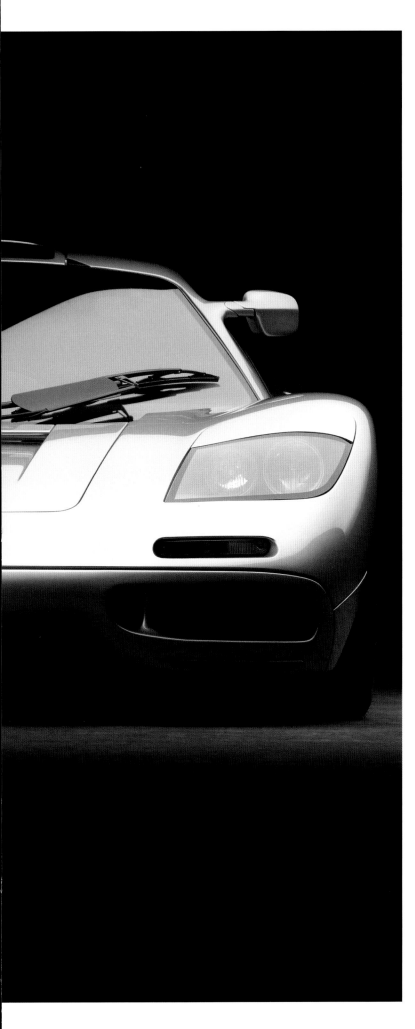

"IT'S NOT THAT
THEY ARE ELITIST CLOTHES,
THERE IS JUST AN
ATTRACTIVENESS ABOUT
ATHLETES IN GENERAL.
ATHLETIC CLOTHES SAY THAT
PEOPLE HAVE ENERGY."

—RALPH LAUREN

Left: Luxe meets function: After a health scare,
Ralph started making sleek, simple clothes
that he said were inspired by his collection of
classic racing cars.

Above: For après ski, an ankle-length cashmere
sheath dress in soft gray took the T-shirt shape
in a new direction.

From a 1993 *New York Times* article: "'The environment of the store sells the clothing,' says Charles Fagan, the managing director of Ralph Lauren New York stores. 'We create environments to take people places and get their imaginations stimulated. People like to go to the movies because they like to escape and be in another world, and I think that's what our store is. This will be a movie about the glamour of Sun Valley, or climbing Mount Everest, or having lunch after you work out with someone. It's part of the experience. It's not just retail; it's theater as well.'" In September 1993, the Polo Sport store opened across from the Rhinelander Mansion at 888 Madison Avenue at Seventy-Second Street. A bi-level, 10,000-square-foot ski lodge meets all-white yacht meets Bauhaus gym with a barrel-vaulted ceiling above its atrium, Sport is a showcase of function-meets-fashion sportswear with the designer's antiqued-new RRL collection making its retail debut. Ralph will take sweats, pair them with a cableknit cashmere sweater and a hip, distressed leather jacket to push the whole athletic street aesthetic into something upscale and more sophisticated.

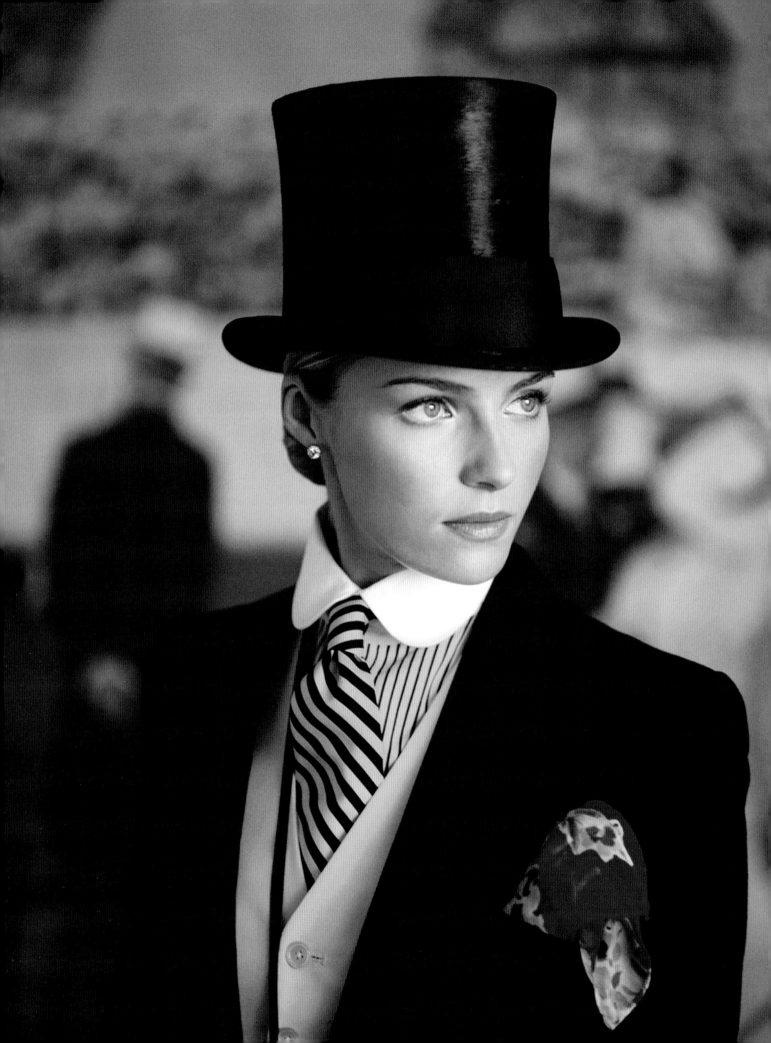

FROM HIGH CLASS TO WORLD CLASS

A s the twentieth century came to a close, the power and influence of the fashion designer started to wane. Never before had the definition of what was fashionable become more subject to individual interpretation. Being more informed and selective in what they wanted, women became tougher critics that designers had to listen to. Fashion design was certainly not dead, nor even defunct; however, it was a very different world from when Ralph Lauren first started out.

From *Vogue on Ralph Lauren*: "'By the time businesses like Gucci, Donna Karan, and Polo Ralph Lauren went public in the mid-nineties, the climate of the consumer culture had radically changed,' wrote Katherine Betts in American *Vogue*. 'For the first time, Middle America knew as much about Gucci's stock listing as they did about Tom Ford's latest snaffle-bit stiletto. Women had a much bigger choice and a much more complicated role in the global market—they could buy the shoe or shares in the company.'"

Women, at least most women, continued to view the fashion industry as a service business whose job it was to make them look attractive. Nonetheless, after years of designers beaming their runway fashions into their closets, women had become increasingly skeptical as to whose interests were actually being served. Much like the artist whose stature increases when a museum purchases his or her work, the runway became the ultimate arbiter in assessing a designer's value. But the runway was also where Fashion—the clothes that designers seasonally rolled out to make their statement about the times—and fashion— what people actually wore to make them feel good about themselves—frequently parted company. That is, until Ralph Lauren came along with his philosophy about how fashion, the runway, and wearable elegance should intertwine.

For many, the notion of elegance as a pillar of upper-class fashion may have unofficially expired sometime in the late sixties. As Saint Laurent proclaimed at the time, "elegance is no longer significant; clothes have to be fun." Most designers came to feel that qualities like refinement and staying power were instruments of a former elite and therefore had no place in the new fashion order; elegance was usually pleasing, sometimes reassuring, but ultimately irrelevant. The new generation of fashion designers tend

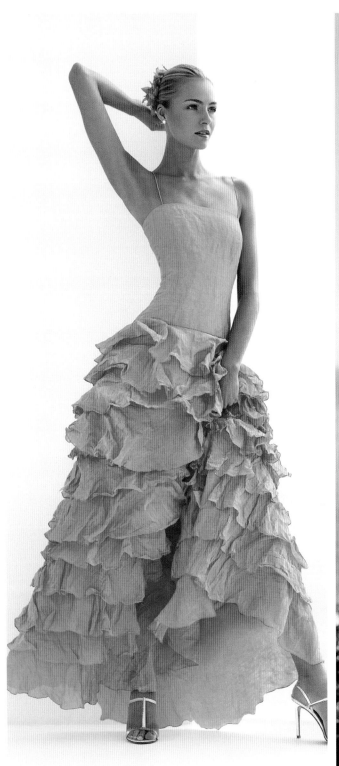
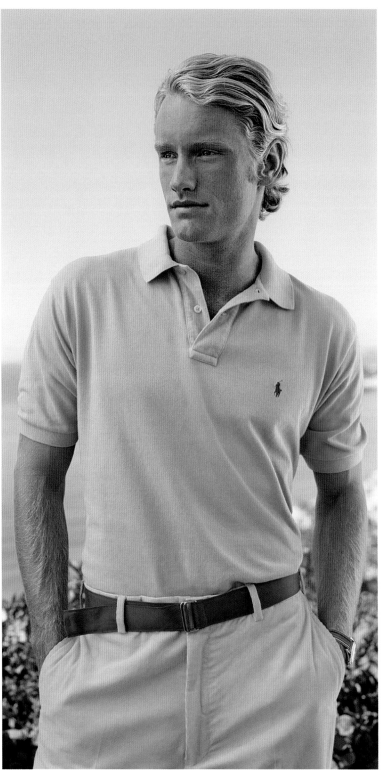

Palm Beach Pastels

to bask in modern fashion's uncertainty, believing that its fast-paced nature and seasonal fickleness were what made it so alluring and alive. For them, its impermanence was not off-putting but that which enticed them to dream and innovate, creating clothes that may momentarily fall by the wayside only later to be picked up and reworked.

For Ralph, who valued timelessness over trendiness, nothing could be further from his worldview. For this designer, with his style-over-fashion philosophy, elegance needed to be subtle yet noticeable for any personal style to emerge. Distancing himself from mainstream fashion, Ralph became a kind of industry outlier, a maverick who rejected catwalk flamboyance and disposable fashion in favor of cultivating his up-and-coming customer's appreciation for clothing that could last. From *Ralph Lauren* (Rizzoli, 2007): "When I started out forty years ago, I made all the things I couldn't find. My vision continues to be what it was in the beginning, it hasn't changed. I don't want what I created in 1967 to be old or what I created in 2007 to be new," stated the designer in 2007.

By this time, Ralph had pretty much forged his own self-contained universe that reflected what he believed fashion should be on multiple fronts. Not content to simply be just another player, by the new century's arrival the designer had created a full-blown design world with its own style vernacular and an interconnecting matrix of pure-bred taste references. Wrote *Women's Wear Daily*'s Bridget Foley, "Many of Lauren's themes have shifted so seamlessly into the public domain that it's easy to forget where they started. Rugged wear as an urban option; the expansive Southwestern motif, from frilly cottons to Native American embellishments; he pioneered them all. He de-nerded the preppy, made activewear chic, and made red, white, and blue fashionable colors. And he has lived the dream every step of the way."

Not surprisingly, Ralph's product demographic had grown exponentially from Polo Sport's function-meets-fashion sportswear to the Ralph Lauren Collection's couture-quality evening gowns, with many stops in between. Having built temples of luxury in international cities like London, Paris, Moscow, and Tokyo as well as his latest Madison Avenue women's store in New York City, Ralph began to add the dressy habiliment—cocktail dresses, embroidered evening gowns, fine jewelry, and his own collection of Swiss-made timepieces—that his newly minted femmes du monde now demanded.

Being born in the country that pioneered sportswear, Ralph was able to mine America's expansive trove of color exemplars providing him with a decided leg up over his European counterparts. Ralph first unveiled his call-to-all color wheel back in the early seventies, thanks to his now ubiquitous polo shirt. Noteworthy for its initial twenty-four different solid shades, it spanned the color spectrum from Palm Beach's old-guard pastels of lime green and rose-petal pink to the regiment-inspired primary shades of Scottish tartans. As the designer went along, the addition of his Safari collection's saddle-leather naturals to his Thoroughbred theme's deep jewel tones to his Americana's native shadings to Polo Sport's carbon-fiber chromes and presto: a comfort zone of color that virtually outflanks any comer.

From Santa Fe to Savile Row, the Rockies to the Riviera, Ralph Lauren cuts a creative swath wider and more encompassing than any fashion designer before him.

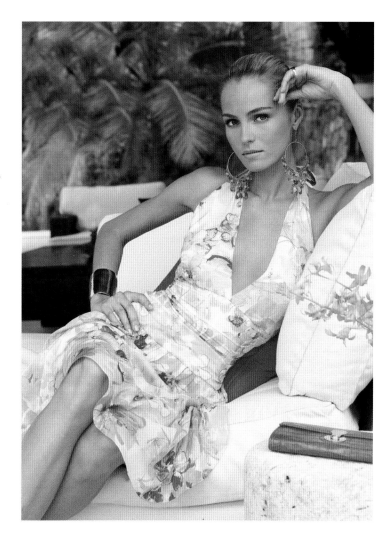

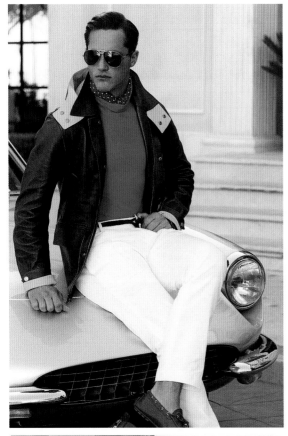

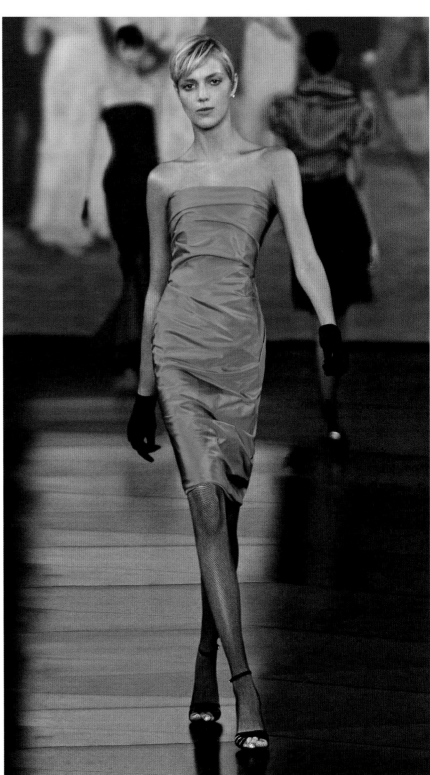

Jewel Tones

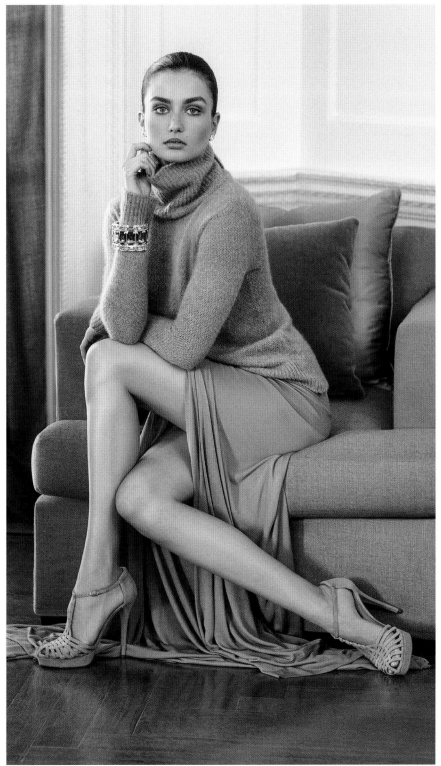

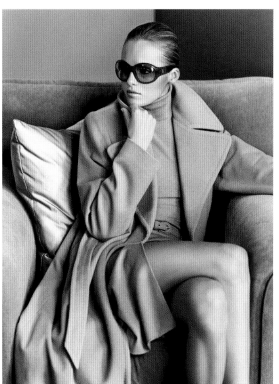

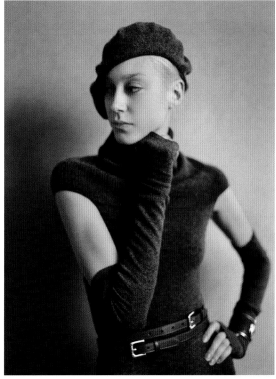

Sophisticated Neutrals

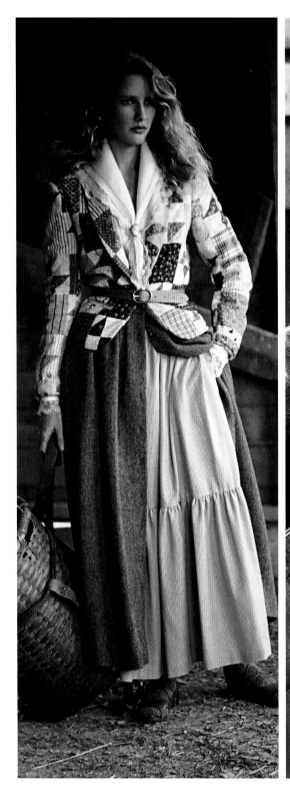

New England Americana

By comparison, the color footprints of a Calvin Klein or a Giorgio Armani, two of global fashion's most influential image makers, do not cover as much terrain as Ralph's. Not that the two designers' visions are any less original or important, it's just that their understated, earth-toned color fields make any attempt to redraw their easily recognized borders a highly conspicuous transgression.

If Ralph's non-fashion fashion philosophy shares any overt compatibility or sense of mission with that of another designer, it would be first with Coco Chanel and second with Yves Saint Laurent. Not only do all three share a strong menswear affinity, their views about personal style versus high fashion intersect on many fronts. At the height of his glory, Saint Laurent articulated a vision that women of all ages aspired to. "Fashion is a kind of vitamin for style. I always believed that style was more important than fashion." It could be argued that Chanel's and Saint Laurent's attitudes on fashion were more latently American in spirit than French, with their unfussy, athletic version of femininity and blend of democracy and elitism.

As the most casual of fashion investigations readily attest, all roads lead back to Coco Chanel. Proclaiming early on, "Fashion is designed to become unfashionable," she ran screaming from the latest fads, feeling them to be cheap grandstanding and rarely holding to her standards of simple elegance. Talk about designing clothes that were beyond or outside of fashion, in 1916 Chanel created what she described as the "fashion statement of the century." Her simple knitted wool cardigan with a matching skirt was to turn fashion upside-down. After a brief interlude from the limelight, in 1954 at age seventy, Chanel made a comeback and with it, the classic Chanel bouclé jacket with braided trim and corresponding skirt reasserted itself, shining even to this day as one of fashion's brightest and most iconic cynosures.

As to their ideas about the role of runway fashion, Chanel would ordain early on, "Fashion that does not reach the street is not fashion." Yves Saint Laurent: "The street and me is a love story. Nineteen seventy-one is a great date because, finally, fashion took to the street." Ralph Lauren, on his runway-to-reality fashions: "My clothes—the clothes we make for the runway—aren't concepts. They go into stores. Our stores. Thankfully, we have lots of them."

Speaking of Ralph's success in dressing women for the ages, take for example the pink Oscar dress he designed for Gwyneth Paltrow in 1999 when she won for her role in the film *Shakespeare in Love*. "I felt that she should look like a princess, not a fashion model. She had just made this movie, and it was a romantic and charming movie, it wasn't modern and edgy. If she had made an edgy movie, I probably would have made an edgier dress. I was very proud of it, because I think she's a very stylish girl, and she looked so classical. What she was wearing was a lot of the look I believed in, and the interest in that dress was so tremendous, and it was all my philosophy, all I believe in. It confirmed my sensibility."

The consumer certainly got Paltrow and Ralph's taffeta gown and wrap. The dress became almost as much of a celebrity as the star herself. The retail version of the pale pink gown remained a bestseller.

230

Above: Gwyneth Paltrow after winning an Oscar for *Shakespeare in Love*. The consumer certainly got Paltrow and Ralph's taffeta gown and wrap. The dress became almost as much of a celebrity as the star herself. The retail version of the pale pink gown remained a bestseller.

Opposite: In 1916 Chanel created the timeless Chanel suit, combining tweed (associated with hunting and masculine sports) with a well-fitted skirt and boxy collarless jacket. Like her suit, Chanel was to survive in the fashion forest longer than anyone else. No other single individual has wielded anything comparable to her degree of style influence on so many women, for so long. Photo circa 1959.

FASHION SHOW PREAMBLE

The seasonal fashion show sets the tone for how a designer's collection is perceived by the press and the public. The more frequently a fashion show is referenced in print and on social media, the more impactful the collection becomes once it's released to the stores. Designers cannot expect their fashions to be used in editorials, to be declared must-have items by publications, or to attract customers if they arrive in the stores without any pomp and circumstance. A movie studio would not release a film without some form of advance promotion such as billboards and trailers; the same goes for each new season's clothes.

Increasingly, fashion shows are planned on two levels: to hold the interest of the small, in-person audience while resonating powerfully with the vast, device-wielding, clothes-buying public around the world. Needless to say, a lot of time, effort, and money are put into a show, from the invitations to the seating arrangements to the set itself. It's a high-stakes, high-wire enterprise; a designer's reputation and millions of dollars in potential orders are riding on the results.

All fashion designers struggle with the fact that runway shows are like seasonal report cards and that half a year's labor, extraordinary expense, and unimaginable work hours are then scrutinized and judged in the flicker of twenty minutes.

From a 1987 *Cosmopolitan* article: "'I think about them coming and I don't want to do them,' Lauren says. 'As much success as you think you have, I'm working on my next collection as if I never did it before. I thought I'd get past that but I work on it with the same nervousness in my stomach, the same anxiety, the pressure. You do it because that's your inner workings, your own challenge to yourself, your own motivation that keeps you going.' Ralph continues, 'The women's collection walks down a runway with everyone staring and sitting around judging. They even judge what I wear and how I look. Then they go out to the elevators and they say, "I don't think his collection was so great. You should have seen Armani's." You live with that kind of world. That's pressure. In that fickle world you've got to turn yourself upside-down and come out with something that looks like you, that's special, that's a big winner.'"

For Ralph, his twice-annual runway shows come with their own set of challenges: that of balancing the press's need for break-out, fashion-generating news with his goal of looking like himself but with newness. Frequently, both sides have come away feeling less than ideally served. There is no question that Ralph has suffered for his independence, which can, depending on the season, place him outside the trend radar. If that season his look happens to coincide with fashion's other instigators, so much the better; however, he fully understands the risk of going his own way.

As senior vice president of advertising at the time, Mary Randolph Carter says, "Ralph definitely does not like to follow." Sometimes he will admit that it may not be his time, that he may not be the trend of the moment, but that he has to do what he does. Ralph opines in a 2002 issue of *Women's Wear Daily*, "I do my thing, but if the look is not there in Europe, no one knows what to do with it because it didn't fit into the mold. So I don't get editorial play. It looks like I don't know what I'm doing."

On one hand Ralph understands that the fashion press is important; they help breed word of mouth, which can be valuable in building a designer's image. The press's coverage carries weight, as their reviews get read over breakfast, on commuter trains, and in the back of town cars the next morning. But Ralph designs for his customers first and the fashion paragraphers second.

Grace Mirabella, editor of *Vogue* in the seventies, and another Diana Vreeland alum, watched Ralph's career grow over three decades and found his progress very interesting. As stated by Colin McDowell in his book, *Ralph Lauren*, "What fascinated me about Ralph was his consistency of style and image. In fact, he is faulted for what any other designer would relish having. I mean, what's so terribly wrong about having a real, developed style? He doesn't reinvent himself day by day. He moves forward inch by inch, and surely that is style! We are not talking about dumb clothes here. We are talking about important clothes. Sadly, they don't always fit into the journalese of fashion, which is, and has to be, about change. But he was a standard bearer. And he has talent where many others have merely got the games which designers can play to manipulate the media."

At its most commercial, the fashion show can help galvanize the kind of global brand building that generates sales of less expensive, volume-driven products like knitwear, perfumes, and cosmetics. At its most dynamic, the catwalk can inspire subtle forms of desire that permeate the culture by shifting the way people think and dress. It could be that piece of the designer's dream wafting down the runway, of the longing it inspires, insinuating its way into the minds and onto the bodies of those attending. For those who have been lucky enough to experience one or more of those magical runway moments that transfix and remain a memory forever, the live show remains the ultimate fashion sensory fix.

Having said that, for many big brands, notions like taste and practical chic are perceived to be way too complex to sell nowadays when most of the world's population is preoccupied with either social media or basic survival. Fortunately, Ralph Lauren never saw himself as simply a pitchman for his own dreams, he wanted to become something more, a purveyor of high-class taste, or even better, the mentor of personal style.

From the perspective of trying to teach people how to dress better, no one has spent more time, money, or effort in the advertising, lifestyle merchandising, or retail display of apparel invested with such an ambitious goal. For fifty-plus years, Ralph has preached the gospel of time-honed personal style over time-wired fashion. Like those influential tastemakers before him, Ralph concluded that focusing on the long term would always be fashionable.

> "AS MUCH SUCCESS AS YOU THINK YOU HAVE, I'M WORKING ON MY NEXT COLLECTION AS IF I NEVER DID IT BEFORE. I THOUGHT I'D GET PAST THAT BUT I WORK ON IT WITH THE SAME NERVOUSNESS IN MY STOMACH, THE SAME ANXIETY, THE PRESSURE."
> —RALPH LAUREN

234

Imagine how brave and confident a new, young cub designer had to be to stake out such seemingly counter-intuitive ground, trumpeting the call for keeping fashion at arm's length to America's own fashion establishment. But Ralph did more than simply dream about such an ideal—he took personal responsibility for making it happen. From the get-go, Ralph understood that to construct a timeless yet personal dressing style you needed building blocks or, in this case, fashion staples. Over the ensuing years, he ended up designing more apparel that would go into the market-place to become a wardrobe basic or a vintage collectible or both than any other fashion designer in history. Should such a claim appear to overreach, consider which brand enjoys more high-quality clothes in current usage whose purchase dates back five or even ten years and older.

As for the function of the fashion show in this broader context, every Ralph Lauren runway operates on at least two fronts: a lineup of stand-alone, future classics and a tutorial on how to put them together stylishly. For women lusting after clothes they can see wearing well into the future, no designer routinely sends more high-octane ward-robe workhorses down the runway. Ralph is without peers at revisiting his own former classics, and then reinventing them by pairing them in new ways. Whether it's a sexy rain-coat in a new cut and fabric, an emblematic RL tailored knit riding coat, a western-detailed H Bar C–inspired leather shirt, or a gold mylar-looking, drop-dead evening skirt, Ralph consistently delivers an exceptional number of what his admirers and clients have come to expect from him: street-ready, forever fashions that go into their closets as long-term investments and wardrobe-building pieces. "My concept of designing has always been to see each of my new ideas as a future classic. Each innovation is meant to stimulate the wardrobe, blend with it and stay."

Fashion shows have long been considered crucial vehicles
for designers looking to woo the attentions of the all-important
press and buyers, which ultimately helps to build brand
recognition and sales. They do not come cheap. It's hard to put on a
modern fashion show during fashion week for less than six figures,
which can run considerably higher for a major designer.

MARRYING THE RUNWAY TO REALITY

RALPH'S ROLE as the standard-bearer for runway fashion that is both style-setting and street-ready dates back decades. Instead of the typical procession monopolized by the never-to-be-manufactured designer one-offs, the majority of Ralph's runway progeny live to be purchased by actual consumers. The Ralph Lauren shows also provide a gateway to visualizing next season's fashions as they are likely to be seen off the catwalk. As former American fashion designer Oscar de la Renta once famously cautioned, "Never confuse fashion with what happens up on a runway, it's only fashion when a woman puts it on."

Whereas the primary attraction of any fashion show is the clothes, for the serious student of style, the Ralph Lauren runways function on yet another level, as opportunities to ratchet up one's own dressing skills. Fashion-making aside, the next twenty minutes can double as a master class on how to wear clothes with a sense of custodianship as Ralph's moving feast comes alive as a virtual hothouse of mini style tutorials. As Birrittella says, "It's never just clothes, it's really about how to wear them."

Starting with this beret-to-boot ensemble where each component qualifies on its own as a timeless collectible, the following outfits represent but a droplet in a career-long downpour of runway fashions that have gone on to become style-steeped wardrobe classics. No designer is responsible for more clothing designs developing longer fashion lifespans than Ralph Lauren. In terms of how he puts clothes together, he does it the way he feels a stylish woman might dress. As Ralph observes, "I don't think there is one thing, one look, one length. I look at the woman I'm designing for and she is not one style. She's not gimmicky and wants a variety of looks to express her lifestyle."

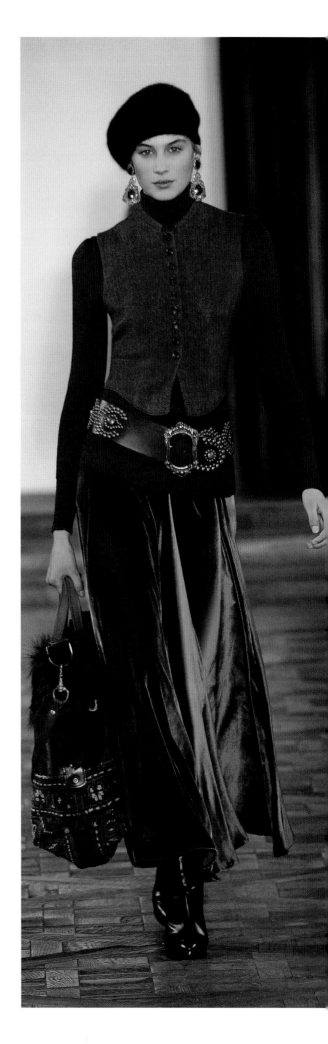

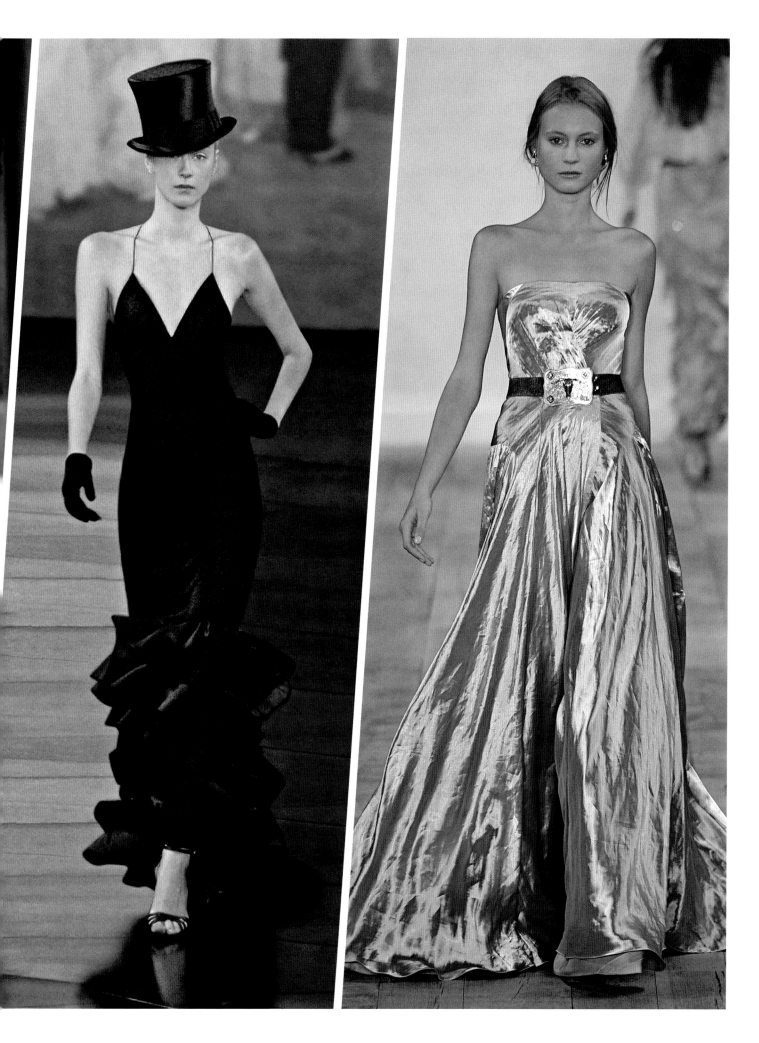

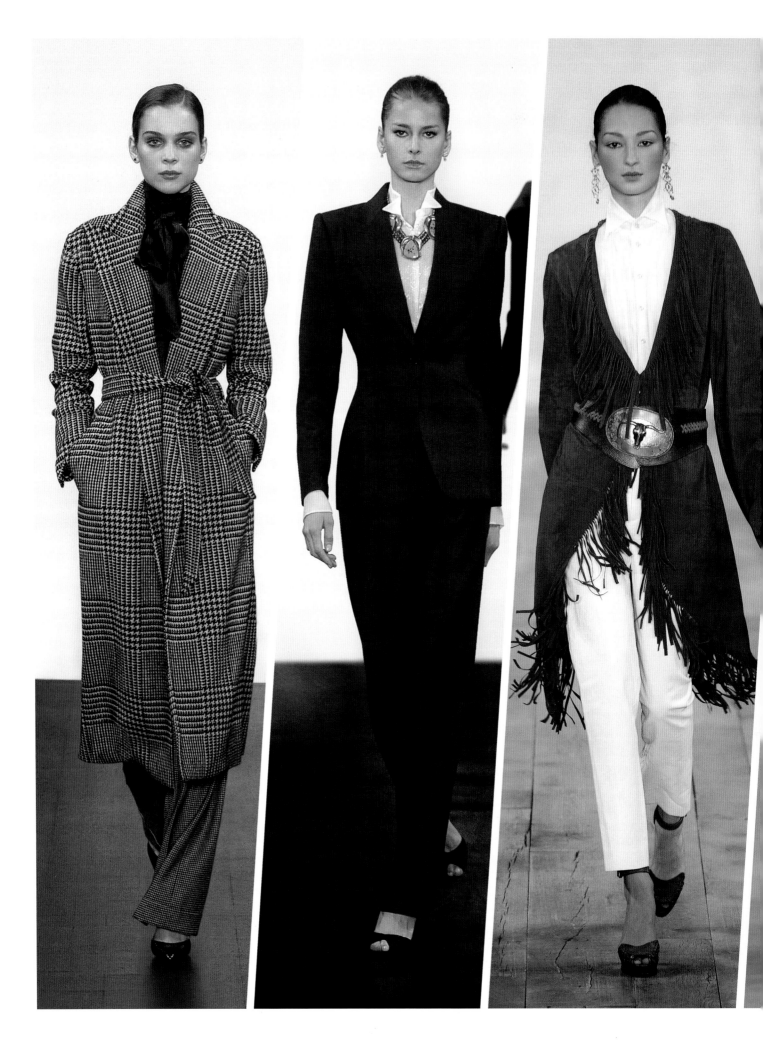

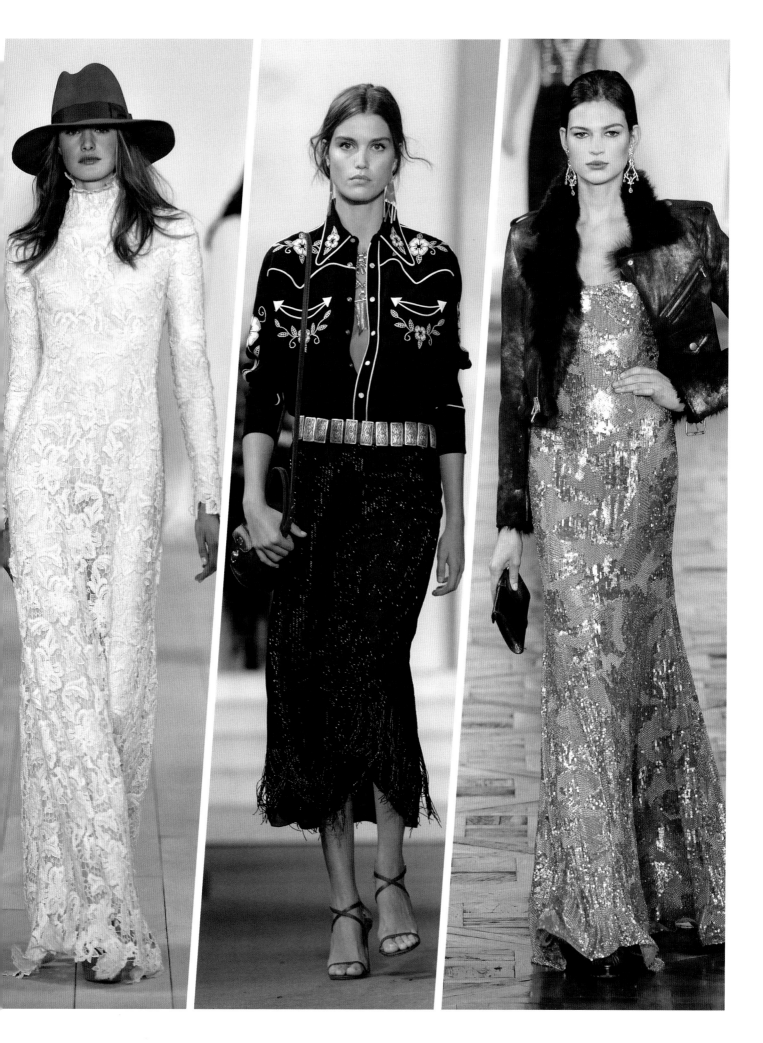

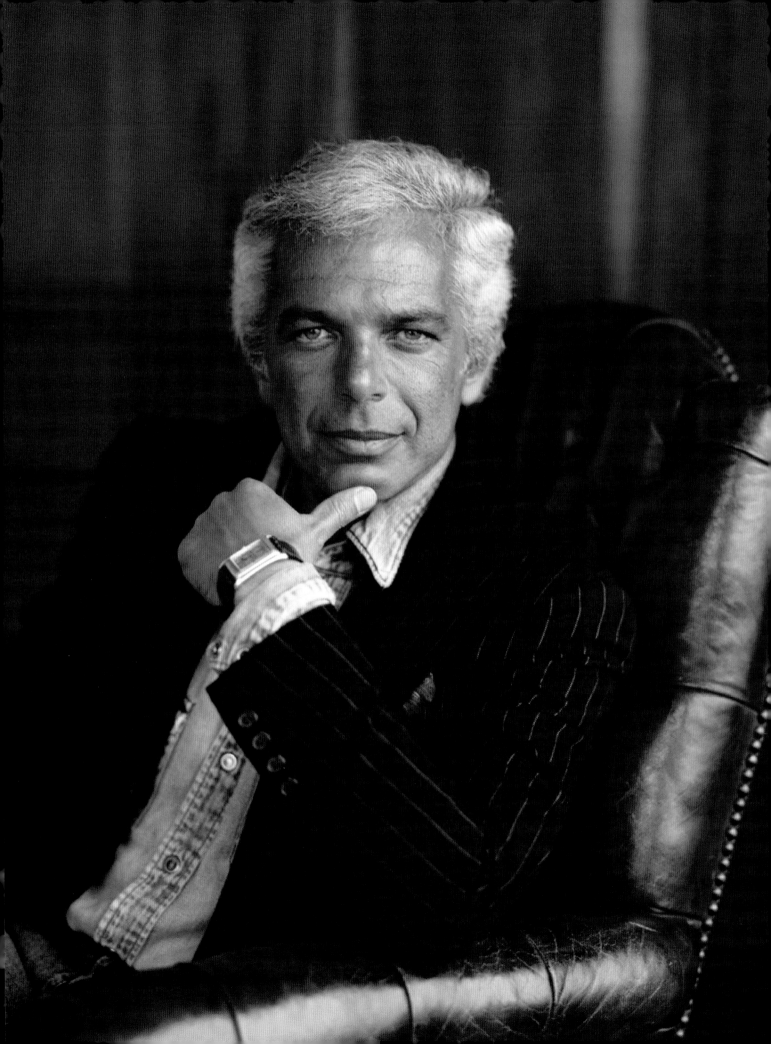

THE MAESTRO OF MIX

COMBINING DIFFERENT GENRES of apparel into one outfit has long been a defining characteristic of American-inspired fashion. Central to the Ralph stylebook is that each ensemble must add up to more than the sum of its parts. Frequently such math is realized through a methodology known as "the mix," blending different styles of apparel to create a spontaneous and personal-looking ensemble. Leave it to Ralph to take a colorful Polo knit sweater or top, shrink it down, and then team it with a flowing ankle-length ball gown–like skirt, or throw an old army surplus–inspired safari jacket over a beaded evening dress. As long as each component is a stand-alone classic, the likelihood of overkill is lessened.

Here's a journalist recounting a story Ralph told about his woman customer, what her needs are, what works for her, and what is the most important for him: "I ask Ralph to tell me the story behind a knockout photograph in *Elle* magazine of one of his favorite models wearing Ralph Lauren evening clothes. He has had a long and difficult day, he is tired and admits it, but when he takes the pages in his hands, he crackles with excitement. 'This girl,' he says, 'this is very much my girl. She says everything I've ever said about what I do. She's not wearing a gown—she's not going to knock you dead with her Galanos or her this-or-that name. She's wearing a lightweight-wool man's tuxedo, an old western shirt that's faded, a string of pearls, and a crocodile belt. It's eclectic, it's classic, but it's original. If I'm a rebel at all, this girl is my counterpart. She's not off the wall . . . but she's as sexy as you can get, and everyone in the room is looking at her. She's very confident, very clear, very together; she's got a real sense of herself. She could wear a gown anytime she wants to, but she wants to walk in this way today. She's easy and comfortable. And she didn't go to the beauty parlor. Does she have a date? She's looking for one.' He laughs. 'No. She's married to the chairman of the board. And she drives a Range Rover.'"

Opposite: Fashion without borders. Here's Ralph in the early years practicing what he preaches: a manner of dress that embodies a signature style all his own. Whereas a striped suit jacket, faded denim work shirt, and blue jeans are all iconic American garments, when combined knowledgeably they add up to more than the sum of their individual style quotients. Only in the hands of Ralph's dressing intelligence does such genre-bending come off looking eccentric yet informed. The man who began by teaching men how to wear a tie with their jeans dons a suit jacket with a nonmatching bottom, a combination that over the next thirty years will become standard issue for the seasoned fashion insider.

Above: Over his lifetime, Ralph Lauren has probably worn more different items of clothing than any man in modern history. Duded up here in Paris like only someone born and bred in the states might, the designer sports a black motorcycle jacket, white dress shirt, thin black tie, vintage jeans, and silver-tipped western roping boots. Ironically, no country appreciates the iconic appeal of such apparel more than the French, no less a septuagenarian with the éclat to carry it off.

241

242

Above: In the bohemian manner of layering a filmy skirt atop clunky Doc Martens footwear, here's a few
examples of how to meld different weights and textures from the designer's style-book of
downtown moxie: thick leather bomber over thin chiffon dress, voluminous shearling coat over slinky
silver lamé evening gown, rough tweed jacket belted over ruffled lace skirt.

Opposite: Combining rugged and refined: accessorizing a vintage cracked-leather jacket with diamond
earrings and other luxury furbelows, Ralph stretches the jacket's street-tough archetype into a
salon-ready look. The ensemble's assertiveness would suggest the bearer enjoys self-confidence in spades.

Opposite: Who knew the classic plaid-flannel sport shirt could be repurposed to deliver so much fashion mileage? One of the more difficult dressing skills to master is the stylish marrying of differing clothing genres. As usual, RL's disciplined taste keeps the practice from crossing over into contrivance.

Above: Stretching the plaid shirt's archetype: under a striped flannel suit, atop a silver fringed skirt, beneath a tweed jacket and Shetland jumper. "They're clothes to add to, season after season, not throw away," the designer says. "I like when people mix up the pieces. I try and do that myself."

THE CURTAIN GOES UP

246

As longtime associate Mary Randolph Carter observes,
"Ralph has been designing women's clothes now for over forty years; he's learned a lot. I've seen
him fit an evening dress, take the shoulder off, have it shortened completely, and then say he still
doesn't like it. He knows about fabrics and about proportions, the length of a skirt versus the
length of a jacket, he knows how to fit a jacket, its shoulder, that its fourteen-and-one-half-inch
point-to-point width is both a guide and jumping-off point, whether to change it, and why."

As Joan Juliet Buck wrote in American *Vogue* in 1992, "The clothes of Ralph Lauren are a form of cinema, they fulfill the private function known in movies as the back story— telling you who you are and where you came from—and the public function of demonstrating these things to other people." Ralph is very much about the back story. He can talk to someone and very quickly sense what they are thinking, their dressing style, and even what kind of car they drive. He can picture how the man riding in a steeplechase competition is outfitted as well as what his wife in the stands is wearing.

Claiming to imagine a scene of a certain activity, Ralph then proceeds to dress each person in the way most suitable to that moment, activity, and place. Out of a make-believe event will come a totally scripted visual landscape populated with multiple head-to-heel tableaux. And once Ralph gets an idea—Russia, the South of France, Safari—he does it as authentically as possible right down to the shoelaces.

Ralph's design process is much like everything else about him: uniquely his own. Self-taught, he hardly works in the manner of a grand couturier or trained fashion designer—Ralph begins with the big picture in his mind's eye and then sits down with his design team to flesh it out. And anchoring it is always Ralph's imaginary heroine, an idealized female protagonist around which the mood and style of the clothes then get built. Whether a modern duchess, a Chelsea rebel, a chic aviator, or a royal bohemian, for Ralph they are all the same woman, one who is outside fashion, playing out different roles in any given season, in any given collection. Modern and independent in her thinking, she's drawn to beauty and understated glamour, yet adventuresome in her tastes and not afraid to embrace contradiction and spontaneity. From a 1988 *Women's Wear Daily* article: "'I work like a writer, with a theme that connects everything I do,' explains Lauren. 'The story starts with a girl. Who is she? What is she doing? I imagine her life: she gets up in the morning, she goes to work, maybe she's a lawyer—whatever. Or maybe she's horseback riding or she's driving a car in the country. In my mind I create a world based around this girl.'"

Under the supervision of Buffy Birrittella, whose recall includes every garment the company has ever turned out, Ralph is constantly being presented with a steady flow of physical objects and images to look at and consider. "It's a give-and-take process, the creative thing we've got going here," Birrittella adds. "Ralph has to be inspired, and we have to be inspired by him. He could get excited by the way one of the design assistants has worn a shirt that day, the way she's put it together with what she's wearing. Reveling in her individuality and personal style, it gives him a new perspective, a new energy. It's all Ralph Lauren clothes, but he's stimulated by how the people wear them. He needs to be around people who are living and breathing the lifestyle."

Those working on Collection, the company's top-end women's line, meet with the designer sometimes twice a week. With his women's Collection reviewed by the press at the Ralph Lauren fashion show twice a year, its significance cannot be overstated.

The presentation boards contain all manner of design stimuli: tear sheets from old magazines as well as reference books, vintage garments, bits of fabrics, odd fashion photos and illustrations, et cetera. The boards are meant to stimulate his imagination and lead him to something in the far corners of his memory bank that he may not have realized is there until his eye is triggered. Inevitably, it's Ralph's responses that cue the process toward its next phase.

Pushing sartorial borders, a prototypical Ralph trio: fine jewelry, vintage motorcycle jacket, and glamorous evening gown. When Ralph first introduced the fashion for combining different dressing genres back in the seventies, he was not only ahead of the curve, he was the curve.

Prior to sitting down and engaging directly with Ralph for the next Collection, design teams have been amassing for months those reference materials they hope will pique his back-of-the-mind imagination and help spur his transition to the next Collection's zeitgeist. These days it's totally about what he and his design teams develop, as there is very little that exists in the way of a classic or archival design that he hasn't already seen.

When it comes to a certain color or an old piece of fabric, or even a skirt he designed fifteen years ago, the recall is precise. Cross-pollinating between his men's and women's clothes, he'll insist on the same shade of tan gabardine that they used in men's ten years ago; he's unwavering, a perfectionist.

Birrittella says, "As long as he's given the right input, his instincts will take it to another level. He has these incredible antennae that instantly tell him what feels right and what feels out of step with the world around him. Always with a fresh eye, he's able to focus on the best of the best, putting it together to give it a new spin. And he always stays true to what he feels his customer wants."

Like most designers, Ralph comes to the design meetings with his own ideas. He'll sit with his creative team and tell them what's on his mind. It's clear he likes the process, the repartee. He feels it's his job to get the best out of people, to give them opportunities and responsibilities that they could never imagine they could have in their careers. Watching them mature creatively is one of the most satisfactory parts of his job. Notwithstanding, as all his creative colleagues come to know or learn, this is not a design-by-committee enterprise. Ralph is very big on soliciting everyone's opinions and allowing each participant to offer his or her comments, but he is the ultimate decision maker. This is not some kind of ego or power-fulfilling exercise, it's that he has been trusting his gut and instincts for many years, and while he likes to have a roundtable to bounce his ideas off of and hopefully build upon them, he can turn on a dime if he hears something better or stick to his guns in the face of considerable pushback. Comfortable in his skin, he's prepared to take full responsibility for his directives.

Ralph Lauren is a modern designer. Although he wants everything to embody the Polo DNA as far as its respect for heritage and quality, he doesn't want to be held hostage to it. For Ralph, tradition does not mean being bound to the past, it means bending it so as to allow it to breathe anew. The backbone of the work remains, the body of it changes. Although Ralph rarely looks at what other designers are doing, he's aware of it. In spite of his encyclopedic memory bank of design references, he always wants more. Like most designers, he's never completely satisfied, invariably looking and searching, like something is not quite right. Constantly pushing himself and his people, he challenges them to go beyond their comfort zones. Like Steve Jobs, he cares about "the back of the dresser"—nothing is ever too small or too last minute to be ignored. The design teams understand this and are inspired by his energy.

New Ralph Lauren collections continue to take inspiration from earlier ones. Like those established couturiers before him, Ralph revisits his past, taking what did well while making sure he moves it forward. Each collection is an outgrowth of carefully judged variations on carefully considered themes, representing Ralph's sense of what is wanted, what reflects the moment, and most important, what looks like Ralph Lauren.

Occasionally he'll dress to promote his design theme. Sometimes he'll even give them something of his own, which, having been in his wardrobe for some time, takes on the aura of a precious treasure with the added pressure of making sure its whereabouts are constantly known. He might say, "I'm feeling shirting stripes; let's do evening gowns in the finest quality men's dress shirt stripes." He might describe his thoughts as very New England or want everything to look streamlined and clean without frills. He might suggest for spring/summer a new take on Cap d'Antibes circa 1920s and the high/low bohemian stylishness of its American protagonists, Gerald and Sara Murphy. He might start a collection based on a specific color like the *rosso corsa* red of his vintage Ferraris.

The design team's presentation includes all sorts of visual cues: There are idea boards for themes, for color, for environments, as well as samples of clothing from previous Ralph Lauren collections—anything that might inspire or further existing ideas. There may have been a Sonya Delaunay fabric exhibition at the Guggenheim Museum, with several colors being particularly inspirational. A discussion will ensue where Ralph will nod, and those elements will be added to the fray. It's Ralph's reactions that carry the enterprise forward. The team leads Ralph through everything that's on the boards and arranged on the tables. He listens intently to what the design team says, probing with questions, spending a great deal of time walking around and examining the boards. Moving from one wall to another, he points out what he likes or what he feels doesn't belong or may fit better with another theme.

Then he'll start to pull out ideas, taking fabrics and piecing different things together. You feel the wheels spinning, as he begins to curate a picture in his head, pulling out swatches, mixing a palette of colors, throwing a jacket over a slip dress. There is the inevitable dismantling, switching fabrics and photos. On a good day, pushpins can take flight as in orbit. You have to pay

attention and follow closely as he starts collaging various elements to create his mixes, which are always changing, moving around. He could pair a vintage silk velvet collar with a lace blouse or a tweed swatch with a gold shoe. Any little thing can spark or set his mind ablaze—a pin, a lock, an earring. Putting a rhinestone button on a Donegal tweed can change everything—it could be a whole collection. Ralph says, "I set the tone and then we begin pulling out fabrics, old photographs, movie photos, or old books. We keep searching for things that fit into that mood."

As the ultimate consumer, Ralph will recall a key sweater from a former men's collection and repurpose it into something feminine and contemporary. Everything is grist for his visual imagination; anything can be turned into something else. All the time he's leaving signposts for the others to build upon. Ralph compares the editing process to cleaning out his closet and keeping only those things he loves.

Were you to ask any member of the creative teams what might be Ralph's most remarkable design talent, pulling together widely disparate and opposing items into an unexpected but stylish whole would likely get the nod. The design staff itself is brilliant, but Ralph's visual intuition is said to be of another order entirely. He simply sees things—it's said—that nobody else sees. As Cezanne said of Monet, "Only an eye but what an eye!" Several admit to having broken into spontaneous applause after watching him transform an improbable hodgepodge of seemingly unrelated design elements into a tableau of surprising beauty and originality.

The meeting moves on and by the time he leaves, the design team has a clearer idea of what he's thinking. By the next get-together they have fleshed out and built upon what he has chosen. The addition of more garments and new material broadens the presentation with the sessions reconvening over and over again until Ralph feels he has the foundation for the new collection's bearings. All the while, sketches are being produced with Ralph signing off on them or asking for new permutations. With everything in a constant state of flux, what Ralph saw and liked three weeks back may no longer resonate with him. Former president Peter Strom would often counsel the designers when meeting with Ralph, "If he agrees, move on quickly before he changes his mind."

> "HE HAS THESE INCREDIBLE ANTENNAE THAT INSTANTLY TELL HIM WHAT FEELS RIGHT AND WHAT FEELS OUT OF STEP WITH THE WORLD AROUND HIM."
> — BUFFY BIRRITTELLA

249

As one of Ralph's longtime designers muses, "Why do we struggle so over every minute detail of a handbag's design, the perfect patina for its leather shell, the exact shade of green, the ideal color for its interior trim, whether its fittings should be English brass or Italian? We make this personal commitment to perfection out of which comes the customer's own response and emotional connection to the product." As Ralph states, "My things come out, they touch people."

Months before the actual clothing design is to take place, the fabric designers go off to Europe to meet with different textile mills. Armed with their latest arsenal of design references—antique swatches, odd vintage fabrics, particularly colored cashmere scarves—anything Ralph may have singled out for possible color or pattern direction, the designers arrive ready to put into work specially woven sample "blankets." Each blanket becomes a kind of blueprint, a "jigsaw-looking color puzzle" made from multiple repeats of one pattern in different color variations that the fabric design team has spent days agonizing over. Sixty to ninety days later, the mosaic-like throws arrive in New York to be cut up into squares of individual colorways to show to Ralph and the design team. Specific colorways are then chosen to be woven into sample lengths that will be mated with those finished muslins that have been accorded sample garment status.

As Ralph points out, "Where it really starts out is on the fitting model. I'll have a tailor and a few other people with me, and we'll work directly on the girl. Maybe I'll realize that everything I originally tried was wrong, that it doesn't work. That's when I start molding the collection like a sculpture. I can tell at a glance if there's a mistake. I might take off a collar and all of sudden the jacket will click."

The first fittings are when everyone sees whether the weeks of work and hours of discussion are heading in the right direction. Because Ralph is known for the exacting cut and detailing of his tailored jackets, he gives their development his highest priority.

Ralph could work on a shoulder for days. Head tailor Nick Mitrione was prepared to labor as long as it takes to get every detail picture-perfect: the exact height of the gorge and cant of the lapel's notch, the ideal fit of the armhole, the desired fullness and expression of the shoulder's sleeve head, et cetera. As a designer, Ralph knows what he wants. He has an uncanny sense of proportion; you may show him something ten times, but he'll wait until he gets it exactly right. With a painstaking eye for

> *"I CAN TELL AT A GLANCE IF THERE'S A MISTAKE. I MIGHT TAKE OFF A COLLAR AND ALL OF SUDDEN THE JACKET WILL CLICK."*
> —RALPH LAUREN

detail, Ralph can point out a misplaced pocket or a vent that needs shortening from twenty paces.

Much of Collection is now produced exclusively in Italy, including the show's final samples. Changes take place, alterations abound. Sketches both animate the new designs and record their latest revisions. At each juncture everything is presented to Ralph. Things are coming together, the mood of the new collection is emerging, details like buttons and fitting specs are firmed up. As with almost all designer collections, the most nerve-racking phase is the advanced fittings, which come next. This is when the finished and the about-to-be-completed garments come from the workroom to be tried on by the house model for Ralph's evaluation. At this stage, out of ten garments, three may survive to see another day. Anxieties are on the rise as time is ticking, as everyone is keenly aware that for a collection of sixty-five to seventy-five outfits comprised of different tops and bottoms, hundreds of first-time patterns will have to be executed before the fabrics can be cut into finished samples.

As the long days wear on, drawings are replaced by Polaroids, the new visual aids by which the show's progress as well as the editing of its evolving format can be judged. In-house models now try on each prospective outfit, walking about as Ralph asks them how an individual garment feels and whether they like wearing it. Outfits get restyled, hems change, new belts are tried, a skirt is shortened, a collar added, everything is shifting yet moving forward. Continually returning to the Polaroids, Ralph reshuffles them, spreading them out to make new potential groupings, new story lines. Most will be regrouped, recast, and then reinstated many times before he gives them their final marching orders.

Fast-forward to the final days leading up to the show. As always, the battleground is 550 Seventh Avenue where the women's workrooms and fitting rooms are situated. The action takes place in a small mirrored room with tables and chairs set along the walls, strangely evocative of a doctor's reception room. Days get longer, blurring into late nights. Time takes on surreal dimensions, alternating between periods of intense activity and minute decision-making to stretches of calm and waiting as in limbo. All is set against a backdrop of seamstresses, tailors, and pattern- and dressmakers working fiendishly against the clock.

Anyone who's ever worked with the designer quickly comes to understand his drive to create something

251

identifiably his own. From continually redefining the spirit of each collection to styling each and every outfit, nothing distracts him from his ultimate goal, the perfection of his look. There can be no other explanation for Ralph's ability to sustain such a consistency of style and vision over his now fifty-plus-year career than his hands-on, control-centric, "himself-as-end-consumer" ethic.

At this point, the proceedings are now presided over by an informal panel of rotating insiders, some who will momentarily decamp to run down one or more of the show's myriad moving parts. Like elder statesmen they will help Ralph make the final decisions on everything, from the models and their hair and makeup to the music, the editing of one hundred or so looks down to fifty or sixty, and how they will be grouped and in what order . . . ad infinitum.

As the countdown continues, the pressure mounts. Fortunately, this is where Ralph's leadership skills come into play. With the quiet confidence of a battle-tested field

general, he uses his formidable people skills to drive and inspire his often-diverse throng. Aware that everyone is working very hard as well as watching him, he exudes an air of single-minded focus, keeping a check on the drama and on the morale. There is none of the bad temper or sense of panic that typically accompanies the backroom runup to a major fashion show. The campaign-calm profession-alism is just another reason why Polo Ralph Lauren has been profiled as one of America's top employers. And like all owner-operated, top-down-managed companies, the modeling of behavior starts at the top.

Some designers, like Ralph, insist on showing their col-lections in an intimate, personal environment. Ralph feels very strongly that the fashion editors and buyers should be close to the clothing, that they should be able to almost reach out and touch the different textures. As the designer explains, "The clothes are often very subtle. It's important to pay attention to the detail, such as an antique pin or lace stocking, and if you're too far away, you lose that."

As the show nears, drawings get replaced by Polaroids, the new visual tools for
organizing and rooting out any imbalances or weaknesses in the show.
Ralph returns to them frequently, spreading them out, rearranging them to make
new groupings or stories out of them.

Right: At this stage Birrittella is never far from the designer's side. As she has done longer than any Lauren associate, she shadows him, gauging his reactions, interpreting his body language, trying to anticipate what he may need next.

Below: The actual show itself is about execution and perfection, everyone is focused on preventing even the slightest oversight from derailing the dream. Here are two of Ralph's most trusted keepers of the flame, wise women Mary Randolph Carter and Buffy Birrittella, monitoring the moment to moment.

Opposite: Ralph's first stop on his postshow amble is always center seat front, getting a celebratory kiss from his lifetime champion and fashion muse, wife Ricky. On the occasion of his fortieth anniversary show, Ralph upped the ante, taking Ricky for a Fred and Ginger–like foxtrot around the runway.

252

Right: Son David escorting his father out to the mound to throw the first pitch. Notice they're both wearing pin stripes. Father and son confer on matters Lauren. Ralph and Ricky Lauren's multitalented and visionary middle child, David, joined the company in 2000 and today is the chief innovation officer, strategic advisor to the CEO, head of the Ralph Lauren Foundation, and vice chairman of the board. On the micro day-to-day, David leads the company's efforts to create those initiatives that will help drive the Ralph Lauren brand across all channels of business. On the macro level, David is basically responsible for keeping the company responsive to its global role in helping to make the planet a better place to live.

Opposite, top: A family moment. Older son, Andrew, the face of Purple Label and an actor and award-winning indie-film producer in his own right, oversees the fashion show's music for his father.

Opposite, bottom: Enjoying a postshow moment of celebration with his daughter, Dylan. The Lauren family's youngest study in start-up empires, Dylan Lauren is the founder of her almost twenty-year-old Dylan's Candy Bar business, a chain of boutique candy shops now operating twenty-seven candy store locations as well as in wholesale venues around the globe. In May 2011 Dylan was featured on the cover of *Forbes* magazine for reportedly inheriting her father's entrepreneurial genes. Her New York City flagship store, located on Sixtieth Street and Third Avenue, is a kind of promised land for the-candy-at-heart and a must-stop for visiting celebrities, especially those with children in tow. Wife and mother of twins, Dylan is bubbly, beautiful, and big-picture driven. Much in her parents' mold, she is out to make a mark for herself and her charitable causes.

255

The music also needs to reflect the mood of the show. Ralph's older son, Andrew, is principally responsible for creating the musical mix for his dad's shows. States Andrew, "Dad shows us the clothes and gives us the key words. The music can never be too literal. Dad wants a hip, current mix with a Sinatra-like sophistication. Sometimes it's a club mix or an under beat. He hates being old-fashioned."

From Lyn Tornabene's 1987 article in *Cosmopolitan*: "'I don't like long shows,' says the designer. 'I like them short and sweet with a beautiful story. Fast, not slow, I edit very tightly. Not skimpy. Not lacking, but I don't want anybody falling asleep. I put the clothes together, I pick each outfit, and I pick which outfit each model wears. I'm excited, my adrenaline is going. I want to make it perfect.'

"Ralph expounds, 'After all the long days of work, there are four days when you're really putting everything together, the music, the models, the lighting, the accoutrements. You're working with a little team, your team, and you get high together, and it's very exciting. I don't sleep at all. I'm so high. I'm flying. As soon as you're finished, someone comes up to you and says. 'Listen, next spring, are you ready, because we want to do some previewing.' You just gave birth to a baby and someone says, 'When are you getting pregnant?'"

A DRESSING PORTFOLIO

Chapeau to Shoe

Like Alfred Hitchcock's distinctive use of montage, camera angles, and symbolic images that helped create much of today's film grammar, the Lauren aesthetic has been built on a living, actionable body of style-rendering dressing techniques that do not depend on the fashion spotlight for their place in the sun. In the abstract these signature style cues constitute the visible part of the designer's unspoken language. "We've always tried to show an eclecticism and a stylish way of wearing clothes that goes beyond fashion, that shows an individual way of dressing," says Ralph.

The following is a selection of mini style tutorials drawn from the designer's archives, some dating back decades. They represent some of the many moments he managed to expand the proverbial envelope of timeless style without puncturing it. The presentation starts at the top, at the head, working downward through the key areas of a woman's anatomy that have traditionally required the most decision-making. Although many of the clothes and accessories have already become, or are in the process of becoming, future collectibles, the focus here is on how they are put together and worn.

Someone once said, "Fashion is something in a window; you don't wear fashion, you wear clothes." While the designer does not take "fashion" very seriously, he does relish the way things develop incrementally, seemingly by chance—the artful coordination, a pleasing dissonance, the surprising juxtaposition, the flourish of unexpected pizazz—the spark of the spontaneous over the studied where fashion transmutes into style.

This is the equivalent of a two-minute teaser relative to the designer's fifty-year treasury of timeless styling techniques and signature coordinations. While almost everything pictured is a wardrobe classic, the point here is how the clothes and accessories are put together and worn. Each Ralph Lauren fashion show is a mini-tutorial on wearing clothes in real time. Here's an up-close look at a few of his styling eye-cues for all time.

Head Wear, Tips of the Lofty

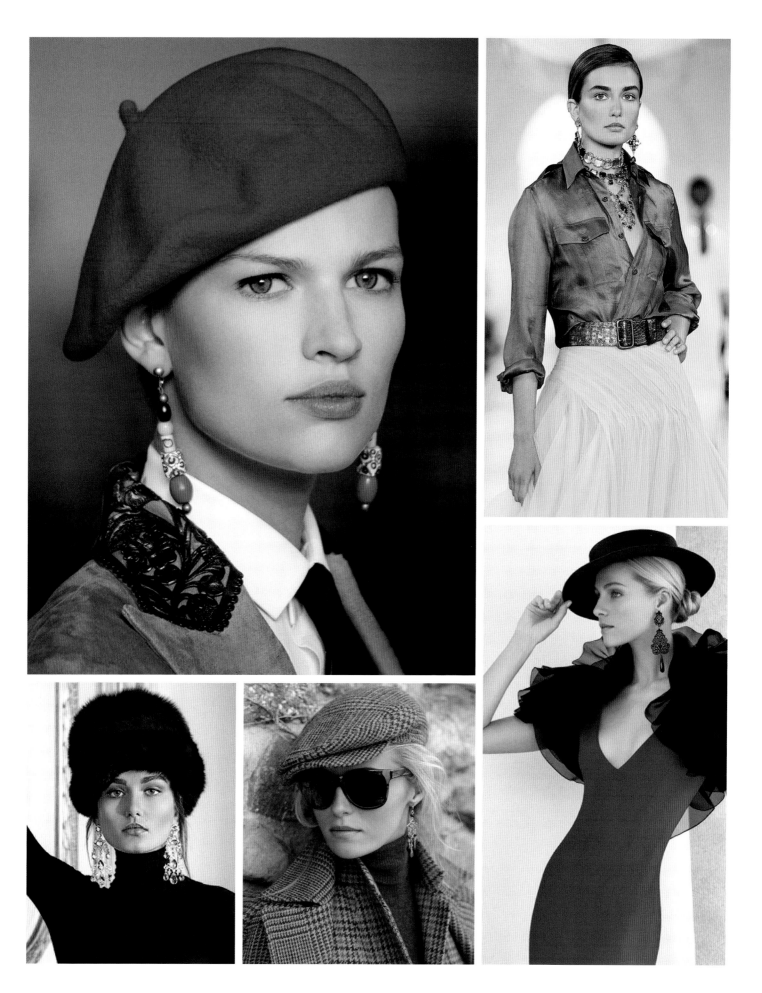

Earmarking Fashion

Bedecking the Neck

Wrist Watching

Waist Management

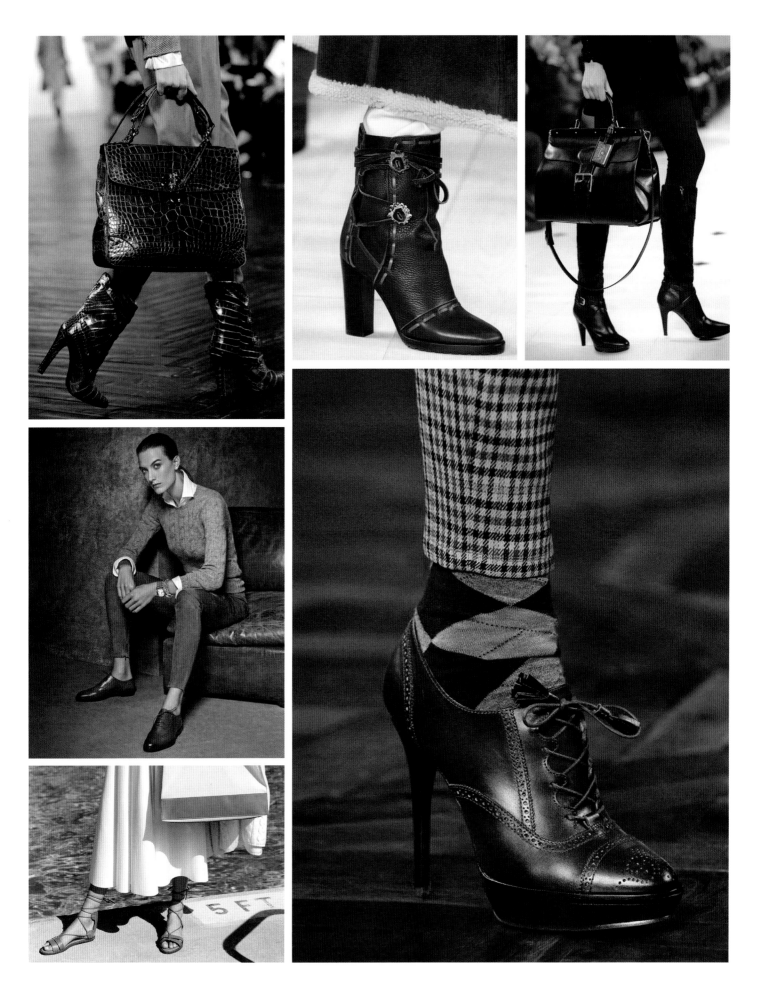

Ankle Aplomb

RESIDENCES,
HOME,
PUBLIC PORTALS
& VROOMS

RESIDENCES
There's No Place Like Home

From the very beginning of their marriage, Ralph and Ricky Lauren shared a passion for their home and how they wanted it to look. Growing up in modest circumstances, Ralph's earliest dreams of aspirational living were partially formed through the elegant and sophisticated images playing out before his eyes in Hollywood's prewar classic films. Being exposed to the creativity and interior designs of the world's greatest art directors and set designers could not have been a better school for stimulating and training his eye. Ricky, who was born in the United States and grew up as the only child of parents from Austria's elegant Vienna, brought her own European flavor and charm to the equation. Although they had little money to spare, living up to a higher standard of style and taste was becoming important to the budding designer.

When it came to organizing and decorating their own living quarters, the Lauren family's earliest apartments reflected their eclectic approach to interior design. What the couple lacked in disposable income, they made up with ingenuity and an eagerness to develop their taste in the new and rapidly changing looks of modern interior design. Married in the sixties and finally putting down roots in Manhattan, the Laurens were part of a generation of newlyweds who enjoyed spending Saturday afternoons shopping about in hopes of unearthing something affordable and unexpected as they figured out what worked within the context of their evolving tastes and pocketbooks. This meant numerous excursions to Bloomingdale's and Sloan's, near the former Lord & Taylor, as well as to the numerous smaller design shops that specialized in imported goods from Europe.

They searched out the newest ideas featured in the design magazines or on display at antique fairs and home decorating promotions in the New York stores. Says Ricky, "We were always flagging pages—not for an item to buy but for a look we found interesting, something we could adapt and personalize to make work for us."

As they frequented thrift and vintage stores for offbeat things, their creativity often led them to experiment with unconventional arrangements, like using a beautiful old rug to cover a couch. They remember staying up until two in the morning painting their first little apartment the exact color to go with a brown velvet throw on a sleeper sofa. From Colin McDowell's *Ralph Lauren: The Man, the Vision, the Style*, "Ricky recalls, 'We had eclectic taste and we mixed it with rattan and wrought iron chairs.' She remembers the bedroom, it had light blue walls and floral curtains and a bedspread in aqua and green. 'We had a princess phone next to the bed, quite different from the one in the living area. We thought it was very special because it was blue, and it was quite something to have a blue telephone when everyone used a black rotary dial.'"

Always involved in the decoration of their homes, Ricky enjoyed figuring out how to make things work. When Ralph traveled for business, Ricky would keep herself occupied with all types of home improvement projects, from wallpapering the kitchen to making louvered doors. As their fortunes grew, so did the number and dimensions of their homes. While best known for his lifestyle-influenced fashion designs, the designer has also given the public an equally expansive vision for a life lived stylishly at home through his Ralph Lauren Home collections. "It's all an extension of something I wanted in my life—or my dream life," he would recount.

Today the Laurens own five mood-altering homes, each with its own clearly defined point of view and design aesthetic: a sleek, Manhattan duplex looking out on Fifth Avenue; an oceanfront compound in Montauk, New York; a nineteen-thousand-acre ranch in the San Juan Mountains near Telluride, Colorado; a two-house retreat in tropical Jamaica; and a stately Westchester estate. The most accomplished interior designers love nothing more than the challenge of creating a home that is unique, where they feel both proud and comfortable. Most feel that their home, through its rooms, could speak like chapters in their life story. Asked what links them all together, Ralph states, "I think it's the eye, the taste, and the spirit of the dream."

Ralph is a visionary in conceiving worlds that people want to live in, but more than anything else, it's his innate understanding of what gives a space its beating heart that accounts for his decades of continuing success. Ralph insists that the key to bringing a room to life is not furniture, art, or even the intangibles of mood or style, but a design that captures the individuality of their owners. "A room doesn't come alive at all without people," he says, "and there needs to be a sense of their connection to it."

Individually, the Lauren homesteads are as consummate as wealth, lack of compromise, and a grand vision can muster, each telling a different but complimentary story. While clearly conceived to deliver a distinctly different version of the good life, they are undeniably Ralph Lauren in that they balance the designer's sense of glamour and personal style with his need for a family-centric living experience.

As Andrea Robinson, former L'Oreal president of Ralph Lauren Fragrances worldwide, observed, "Ralph's much more than a designer; he designs much more than fashion. Ralph is a house guy, an apartment guy, a beach guy, a workout guy, a western guy. He taught America how to live again, what families should look like again. While TV has dumbed down the taste of America, Ralph Lauren has improved it."

Black and white, white and black, Ralph and Ricky Lauren at home. How wonderful for a couple to be able to share a passion for home design and decorating. When it comes to their own living quarters, not only do they happen to enjoy eclectic environments, together they have created five totally different lifestyle-driven domiciles.

"I deal with colors and patterns all the time when I'm working," the designer says. "This is a way I feel
like I can live in New York and be comfortable and simple. When I'm at home, I need
to feel like I'm floating on a cloud. It's exactly what we needed as an escape from our hectic lives."

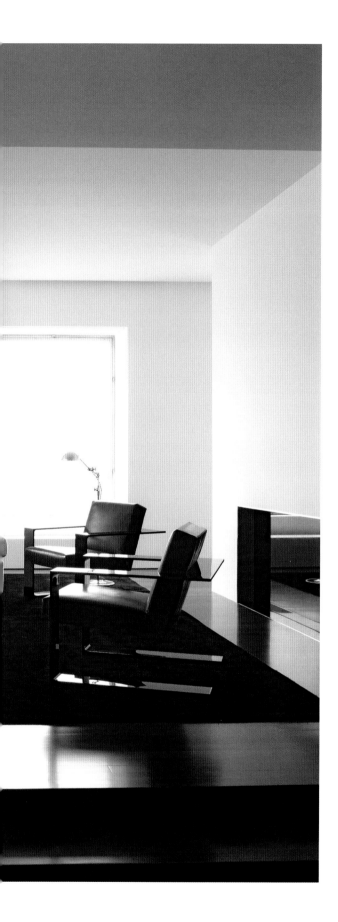

FIFTH AVENUE,
NEW YORK CITY APARTMENT
Perch Perfect

EVER WONDER WHEN the very first penthouse was built in Manhattan? The year was 1925 when the George Fuller Construction Company decided to develop a fourteen-story apartment house on upper Fifth Avenue in the neighborhood known as Carnegie Hill.

However, before he could proceed, Fuller had to convince the cereal heiress Marjorie Merriweather Post Hutton to abandon her home, known as the Burden Mansion, that occupied the site. She agreed, but only if Fuller committed to virtually re-creating much of her fifty-four-room mansion on the building's top three floors, plus a for-her-use-only porte cochere on the building's southern cross-street side leading to a private lobby staffed with a doorman and concierge.

Mr. Fuller agreed to fundamentally resurrect Hutton's home on the top three floors of the new building. The result was not only New York's first penthouse, but also its largest—a spectacular fifty-four-room triplex with its own private entrance. Mrs. Hutton's apartment was later described by architectural historian Andrew Alpern as "certainly the largest and very possibly the most luxurious apartment ever created anywhere."

Ironically, Fuller had no idea that the wealthy socialite had become increasingly exasperated by the noises and fumes emitted by the street's cars and buses and had decided to pack up and take her leave permanently. The triplex remained empty for about ten years until the building was converted to a co-op in the early fifties, after which the space was divided into six nine-room duplexes. When Ralph Lauren purchased one of them in 1976, the *New York Times* reported that "the arbiter of argyle" was the only fashion designer at that time to reside on Fifth Avenue.

Minimalism is not a look one typically associates with Polo Ralph Lauren, but when the designer thought about the design of the Fifth Avenue duplex, he admits to being driven by the almost primordial instinct for open, naked space. "'The original space had been a warren of rooms spread out on two floors overlooking Central Park. It was beautiful, but not me,' the designer stated. 'I wanted a Fifth Avenue loft. I'm too casual to live in a stuffy apartment.'"

269

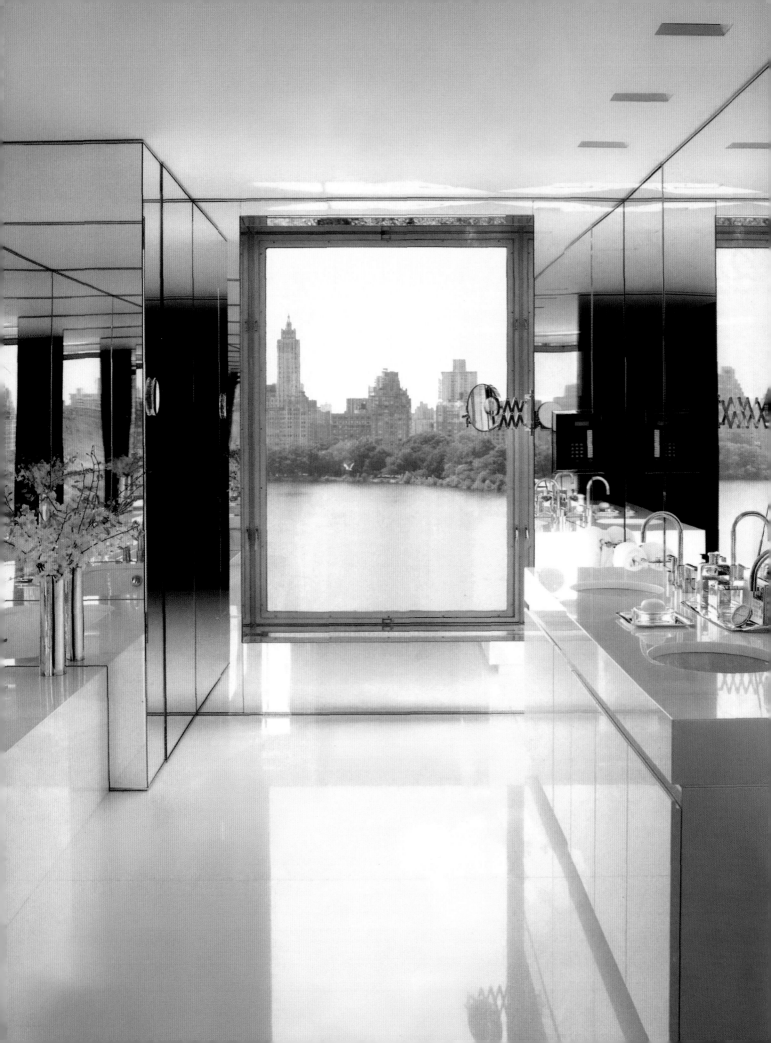

After interviewing a variety of designer-decorators, Ralph hired Angelo Donghia. Known for his simplicity of line and sensuality of textures, Donghia later went on to become one of the designer's closest friends. Ripping out the boiserie covering the walls and stripping the apartment down, Donghia turned the space into an all-white, stark sanctuary. The overarching feeling of the huge, white apartment was of unfettered openness with even more expansive views, reinforced by arrangements of thirties-style bamboo furniture mixed with oversized lounging sofas and club chairs loosely slipcovered in white duck and linen with lots of flowers and simple accessories. At the time the designer was quoted, "I deal with color all the time when I'm working. . . . This is a way I feel like I can live in New York and be comfortable and simple. It's exactly what we needed as an escape from our hectic lives."

Fast-forward thirty years to the apartment's most recent incarnation, a renovation that transformed the Lauren hermitage into an even more modern and open expanse. Enlarged by the acquisition of an adjacent apartment along with the repurposing of three bedrooms formerly inhabited by the couple's now-grown children, the space's original floating feeling was made even more atmospheric through the creation of different spatial planes such as raising the living room so it was stepped up into. Another space-enhancing perspective traded the medium-brown herringbone floors for a darker, more highly polished cherrywood in a simpler pattern. An enlarged structural beam that stopped the eye was whittled back down to minimalist dimensions. Kitchen and bathrooms were streamlined to become layers of pristine lines and satiny surfaces.

Removing Donghia's matchstick blinds left the large windows looking like they now encircled the apartment, inviting the outside in. "There's a flow and a comfort I like better now. . . . It's about the windows and the light that comes in from the park. In the evening, with candles lit, it's almost like an event."

The dining room's low-contrast bamboo tones and textures that harmonized with the white apartment in its early years have been replaced by the high-tech color scheme of black and chrome. Likewise, the room's leafy banana plants have been succeeded by reflective vases full of red roses or other such floral counterpoint lit from ceiling-suspended vintage chrome lanterns. The dining room's earlier rattan and canvas dining chairs have been swapped out for Ralph's own carbon-fiber modern thrones inspired by the McLaren race cars he owns.

The Laurens' freewheeling space does embrace one thing that the former residence did not: More art hangs from the walls and stands on the floors. "'I love the architecture of the blank walls, so the art had to be personally important to me,' he says. 'I'm not about status paintings—they have to be important to me or Ricky.' The Star Wars storm trooper figure that now occupies the spacious entrance gallery was a Father's Day gift from his family. 'I have always liked toys—my office is filled with small toys and characters,' he says, 'and we saw all the Star Wars movies with our kids.' He likes the piece—'so stark and so white and graphic'—paired with a gutsy motorcycle painting that previously resided in his office. Other artworks include a Batman painting by his nephew Greg Lauren and a Bugatti sculpture of an elephant that appealed because, he says, 'I have Bugatti cars. Like everything else, it's very personal. All of them have a connection to my life or point of view.'"

The designer acknowledges that the apartment was not designed exclusively for entertaining and while they have entertained there, it was really created for solitude and privacy. As to whether he periodically decamps to the apartment's two telescopes to enjoy the stars and heavens that come out to play from dusk to dawn, the designer retorts that while engaging, they pretty much play second fiddle to the dramatic light-show from the wrap-around city's vistas.

The master bath, like the kitchen, is a profile of clean lines and layers of glossy white lacquer and marble surfaces. Looking over the Central Park Reservoir and beyond, it seems like the perfect perch from which to take in the scenery while you towel off. *Inset*: A 1930s Fred Astaire look-alike figurine echoes the couple's glamorous black-and-white color scheme. Here's a hundred-year-old tailcoated object d'art that looks right at home.

MONTAUK

Knowing When the Imperfect Will Suffice

AT THE TIP OF LONG ISLAND'S PENINSULA on its southern shore rests Montauk, the easternmost town in the state of New York. An area of intense natural beauty with inland lakes, pine forests, and endless stretches of dune-covered beaches, it's also a place rich in American history. Once home to the Montaukett Indian tribe (from which it gets its name), Teddy Roosevelt's Rough Riders took time to recuperate on its shores after the Spanish-American War, and rumrunners found refuge there during Prohibition. Later it became a summer escape for artists like Andy Warhol and surfers, who rode the break at Ditch Plains. More recently, it has become the eastern outpost of the Hamptons' emerging Sancerre set.

Back when Ralph was first making a name for himself, the family rented in the Hamptons for eleven years on a year-round basis in Southampton, East Hampton, and Amagansett, until finding the perfect setting farther out in Montauk. Perched high on an ocean bluff that might as well be the end of the earth, the seven-acre beachfront property's nearest neighbors were sand, driftwood, and the ocean. Tucked away in the pines, the compound once served as a summer escape for the likes of John Lennon and Diana Ross. In 2018 the Laurens purchased their next-door neighbor's property, that of the famous former American playwright Edward Albee, increasing their footprint by four acres and two hundred feet of beachfront.

After renting the property for several years, the Laurens decided to purchase it. Its main structure, a low-slung shingled cottage, was small but well sited within the landscape, hidden from the road with uninterrupted ocean views. Designed by a Frank Lloyd Wright disciple, architect Antonin Raymond had also practiced in Japan. Low-key and simple, its feel was Zen and organic, typical of Wright's aesthetic.

Needing more commodious living quarters but reluctant to add to the original house and possibly compromise its integrity, the Laurens decided to create a surrounding constellation of buildings, an arrangement they would call upon for some of their future properties. The main house would be at the center with different structures positioned around it.

The original compound contains four low-key dwellings with a secluded pool, plus the original house with its living room, dining room, den, and master suite. They added a guesthouse and a cottage-style living quarters for their three kids, as well as a gymnasium, and the inevitable screening room, as movies have long been a source of enjoyment and inspiration for the designer.

All the new buildings have been constructed in the same rough stone and wood with shingled roofs like the original buildings. Built to lay low and appear native, the structures are blanketed with climbing plants, mostly ivy, making them practically disappear into the background. And as with Ralph's other homes, window views are carefully orchestrated so that each one, whether a panorama or a fleeting glimpse, looks out on a quietly spectacular landscape.

As for the interiors, the Lauren approach was pretty straightforward—to maintain the simplicity and character of the place the family had come to cherish. Low ceilings, wood and stone walls, sweeping fireplaces, sliding doors, and cedar columns were the interior's linchpins. It didn't take much to transform the blank spaces into something familiar: Ralph Lauren touches like pristine-white surfaces, white-linen upholstery, bamboo, rattan, and wicker seating along with warm-wood vintage furnishings made it a home of their own. Add to that saddle-brown leather pillows, polished nickel accessories, black-and-white photographs, updated appliances and presto, you have classic RL style: low-key, timeless, and quintessentially American.

Montauk is the Lauren family's refuge, an escape to nature where outdoor activities can be enjoyed in total seclusion. With its organic architecture and Zen-like atmosphere, Montauk reflects that wisdom to appreciate when the imperfect is best left as it is.

The Laurens added a guesthouse, a gymnasium, and three bedrooms for their children,
all built in the local cottage style of rough stone and wood with shingle roofs. Built
to lay low and appear native, the structures are camouflaged by climbing plants, mostly ivy,
making them practically disappear into the background.

272

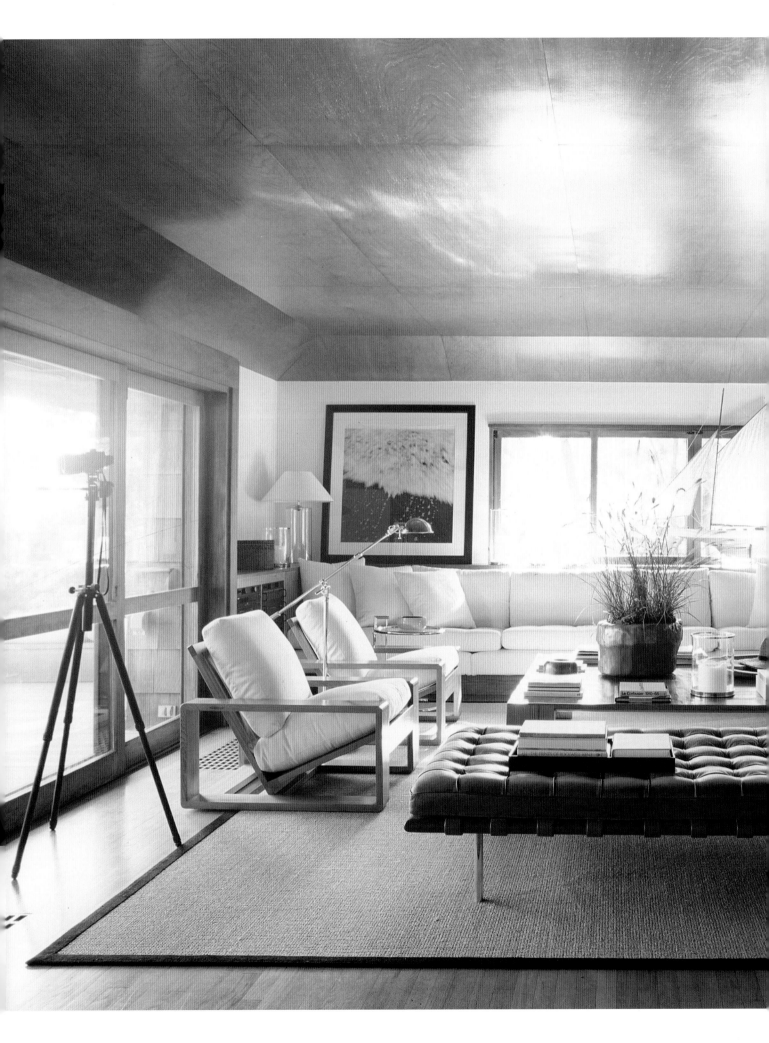

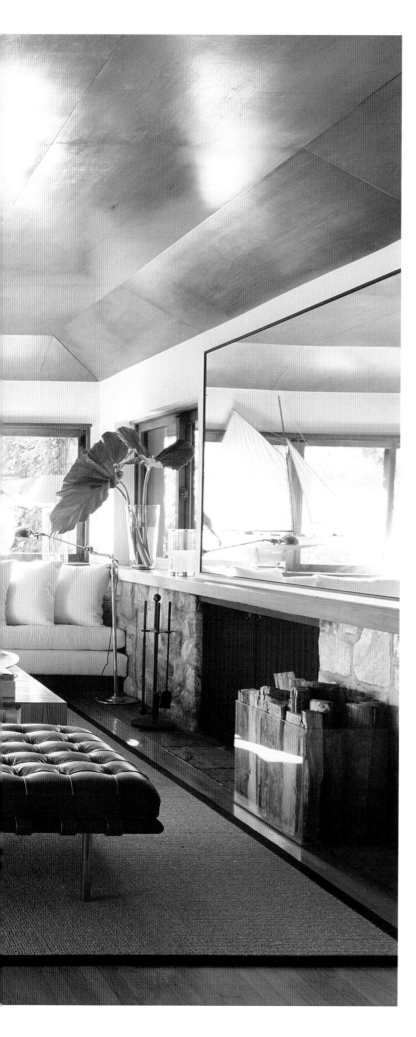

In the early years the family rented in the Hamptons
on a year-round basis until they found the perfect house
and vistas farther out in Montauk. After renting
the property for several years, the Laurens decided to
purchase it. Its main structure, a low-slung shingled
cottage, was small but well sited within the landscape,
hidden from the road with uninterrupted ocean
views. The property was designed by a Frank Lloyd
Wright disciple, architect Antonin Raymond, who had
also practiced in Japan. Low-key and simple, its
feel was Zen and organic, typical of Wright's aesthetic.

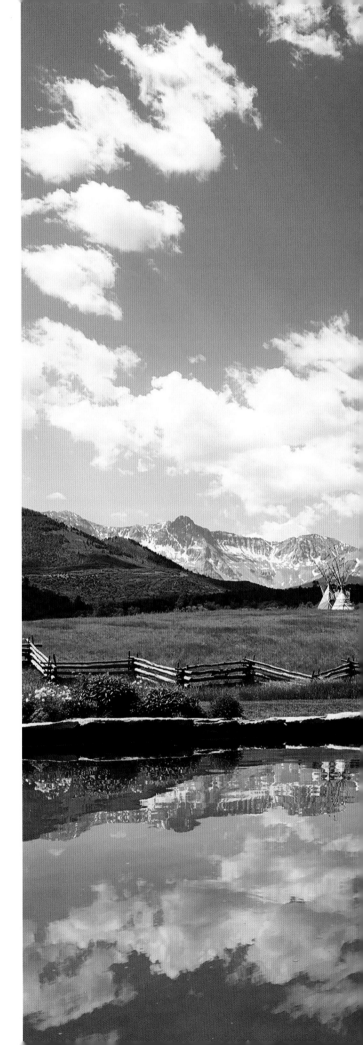

COLORADO
Home on the Ranch

ON THE FLIP SIDE of Ralph's sleek Manhattan aerie is the designer's nineteen-thousand-acre working cattle ranch at the base of the San Juan Mountains in southwest Colorado. Purchased in July 1982 and named Double RL for Ralph and Ricky Lauren, it's a place that brings to radiant life Ralph's long-held fascination with the American West. "When I first came out to Colorado, I didn't want to build a new house," Ralph said in 1990. "I wanted to find an old one. I love the land for itself—the look, the beauty of undisturbed land," rhapsodized the designer.

As he will point out, Double RL is not just a family retreat but a commercial ranch run for profit where over a thousand head of Black Angus steers are being bred. Managed by professional staff who still hold the cowboys' traditional ways and skills in high esteem, they, like the owners, understand their responsibility to the land and the close-knit history of the area. Ralph's set of instructions for his ranch manager was pretty succinct: to protect the land as a cattle-producing range while turning out the highest-possible-quality beef.

For many growing up in postwar America, the West represented a repository of the nation's youthful memories and dreams. Songs like "Home on the Range" and black-and-white television westerns featuring Gene Autry, Roy Rogers, and Hopalong Cassidy colonized the collective unconscious. Western heroes like Gary Cooper in *High Noon* and James Stewart in *The Man Who Shot Liberty Valance* evoked a reassuring, morality-based way of life.

"We always loved the idea of the West," exclaimed Ricky Lauren. "When I was a little girl, I dreamed of horses. I had a fantasy cowboy brother. My parents were from

276

The backdrop: The San Juan Mountains and Sneffels, one of the range's star peaks. "The minute we saw it, we fell in love with it," Ralph recalls of the first time he saw the ranch back in 1981. "I am always looking for a wow factor in things, and this place screamed a particular wow. The place wasn't just some little ranch, it was a knockout. It had a natural extravagance of beauty that we found irresistible."

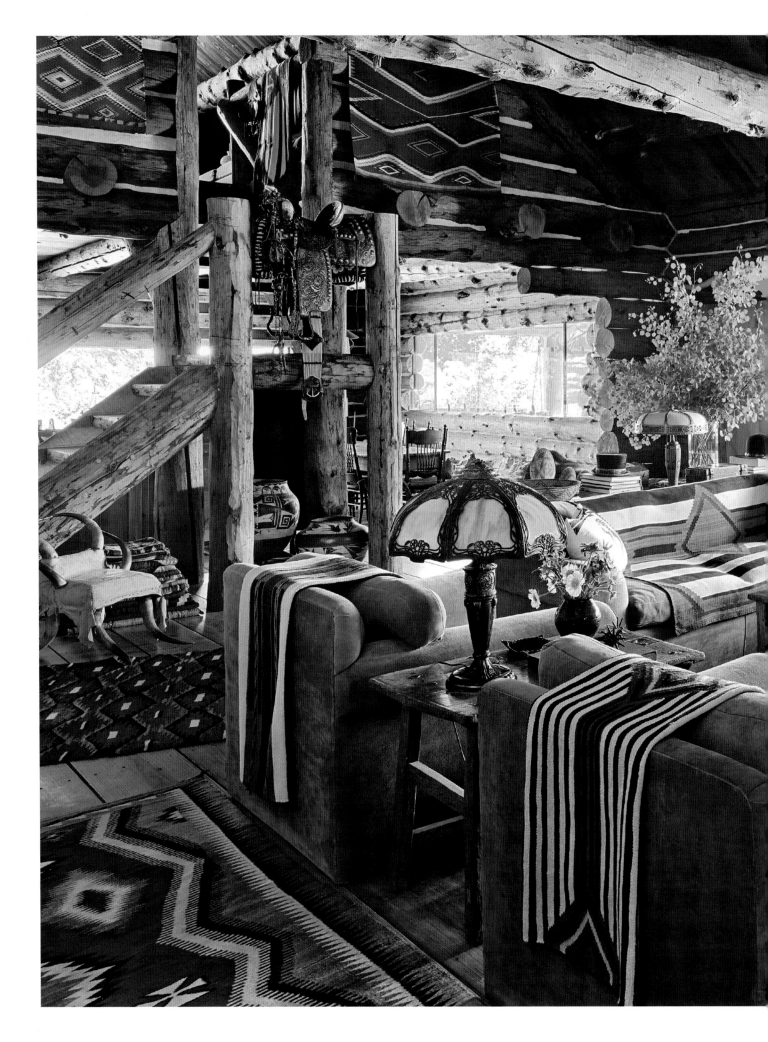

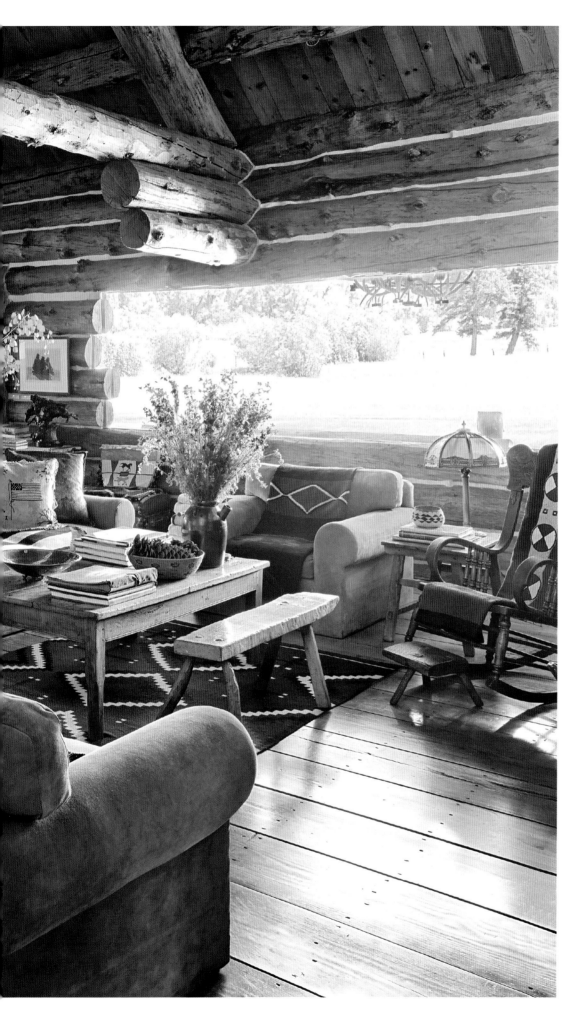

When visiting the ranch, the Laurens stay in the main house, called the Lodge, a unique log-cabin home with interior lofts, spectacular proportions, and monumental views. The living room of the ranch's main residence was constructed using local pine logs and appointed with late-nineteenth and early-twentieth-century Native American rugs and museum-quality western memorabilia.

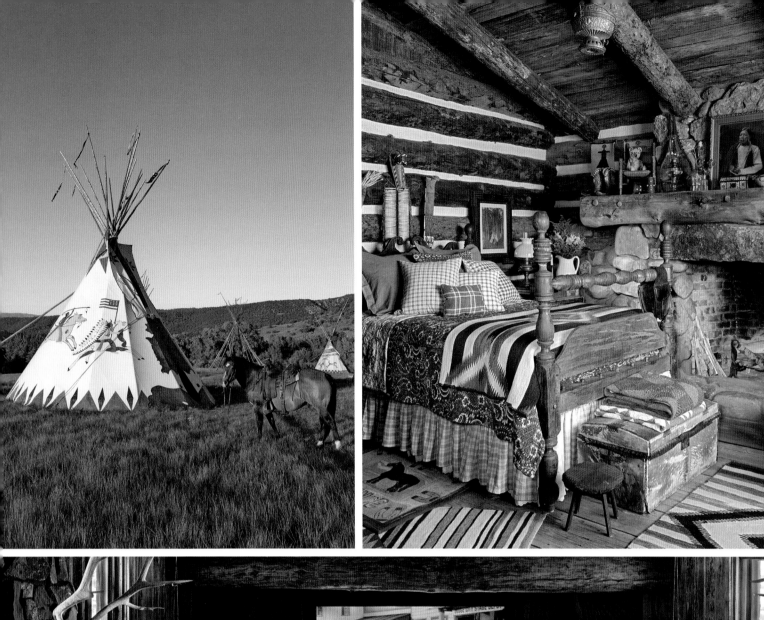
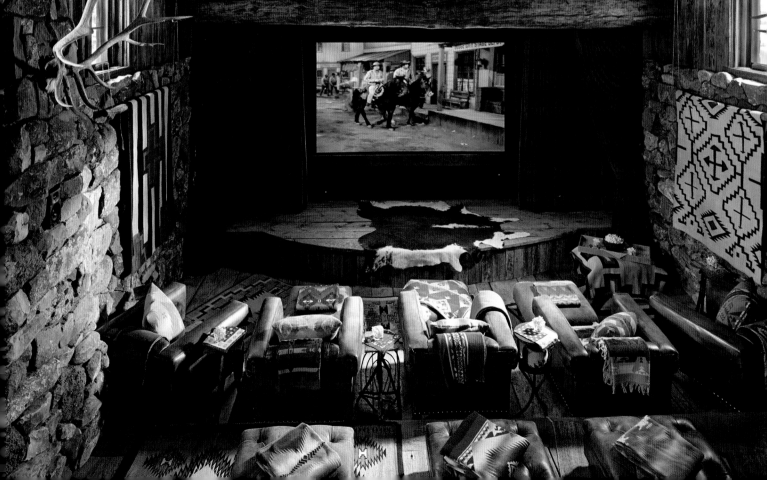

Vienna, so I led a very sheltered life, but I had Roy Rogers and Gene Autry coloring books and was allowed to watch cowboys on TV. My parents bought me a cowboy hat and boots, and I remember hopping all over the place, I was so excited. I wanted to be a cowgirl so badly! There's a picture of Ralph as a cowboy when he was a little boy and there's a picture of me as a little girl dressed as a cowgirl." She continues, "So you can see," she jokes, "we were ready-dressed for it."

The story of how this corner of the West was won, or in this case Laurenized, is that after purchasing the ranch, the designer began working with local people to bring the property up to his expectations. He would sit down with them, outlining detailed instructions while explaining his broader vision and then leave for New York assuming they understood what he wanted. Upon returning three or four months later, he'd find that little had changed and while the ranch was totally exhilarating in its own right, progress came at a snail's pace. After multiple iterations of the same sequence of events, the Laurens, who were living out of a double-wide trailer with no closets, were becoming frustrated.

It was 1983 and the firm had just launched the Home Collection. Ralph's consigliore of making things happen, Buffy Birrittella, had supervised the building of a log cabin showroom designed by Naomi Leff for one of the collection's lifestyle presentations. While out west she had commissioned a local craftsman to make a log bed for a photographic shoot. When Ralph walked through the decorated log cabin display room, he became so excited that he immediately implored Leff and Birrittella to commandeer their magic for his ranch.

The mission statement was simple, if not daunting: to turn the ranch-in-progress into the western Valhalla of her boss's dreams and, oh yes, deliver it in less than six months. Countless hours and many exhausting weekends found Birrittella, Leff, Polo's head of creative services, Jeff Walker, and later followed by vintage doyen, Doug Bihlmaier, cajoling, supervising, and basically willing Ralph's latest fantasy into reality. "When the day for the unveiling arrived, it was raining and as the Laurens drove down to the Lodge, a rainbow arched above it," reminisces Birrittella. "It was perfect. I was crying and so were they." Ralph said to everyone, "I don't know how to thank you for doing this for us." Buffy recalls the experience as yet another example of her boss placing his complete trust in the hands of his most valued employees and then providing them with the necessary resources to transform the impossible into the possible.

The Lodge is the name given to the main house where the Laurens stay when visiting the ranch. Upon entering, you step into Ralph's prairie fantasy: fire blazing in a stone fireplace, tan-leather sofas strewn with Navajo rugs, wide-planked floors blanketed with more Navajo rugs and upholstered walls. Museum-quality collections of Native American baskets, pottery, and jewelry are grouped on tables; rugs and blankets cover every conceivable seating surface with the leftovers stacked in corners; vintage western memorabilia adorn the walls. Says Ralph, "I love the character of old things so we did the ranch with sheets and wool ski blankets made by the company but mixed with antiques and serapes and Native American paintings. Against the dark wood of the cabin's walls, it all looks really beautiful."

Opposite, clockwise from top left: The five tepees and six guest cabins, each overflowing with collector's items are western-movie reveries brought to stage-set perfection—no roughing it required here, Bucky; Ralph Lauren Home linens mix with antique and vintage bedding on Blue Pony's 1870s cannonball bed. A circa-1900 hooked rug and two 1920s Navajo rugs line the floor; Antique Navajo rugs decorate the walls of the ranch's screening room, which features club chairs, ottomans, and velvet curtains, all by Ralph Lauren Home, as well as antique Pendleton blankets. Here you can watch the American Dream unfold in surreal time and then ride off into it in real time.

Below: As a young'un growing up in the States but who was brought up in an old-world Viennese family, Ricky watched classic black-and-white cowboy movies every Saturday morning while dreaming of being a cowgirl. Here's Ricky getting an early start at age eight by sticking up her dad.

281

JAMAICA

The Miracle of Summer in Winter

IN THE OPINION OF MANY who know the family well, of their five refuges, Jamaica is where the Laurens feel the most mellow and laid-back. Says Ralph, "When I was a kid, I always looked forward to summer because I could go out and play ball and go swimming. Then years later, here it was: Jamaica. I didn't have to wait a year to get back in the sun. We can leave New York in rain or snow or with temperatures way below freezing and arrive here and it's a tropical paradise, in just four hours. Everything is so lush, the air so warm and light you're bathing in it."

From December to March the Laurens can be found Jamaica-bound at least two weekends a month, flying there like clockwork after each February fashion show. Regardless of how late in the night they might arrive, they recharge by retreating to the portico where, gazing out across the pool, they take in the deep blue sky as they delight in the scented jasmine wafting on the island's night air.

A favorite of sunseekers since the 1930s, Jamaica is where many of the most celebrated literary lions were to leave impressions in the sand. "I found your footsteps in Noel Coward's bungalow," Evelyn Waugh, visiting Ian Fleming, wrote to Graham Greene. Two men were to put Jamaica on the international map: novelist Ian Fleming, creator of James Bond who bought an estate he named GoldenEye; and the English theater wunderkind, writer, actor, playwright, and entertainer Noel Coward, whose home Firefly became a magnet for the global glitterati.

There was also Jamaican-born entrepreneur John Pringle, who, in 1953 built a hotel complex called Round Hill on a peninsula located less than ten miles west of Montego Bay. Dividing the original estate of around one hundred acres into plots, he sold them to prospective investors to put up villas designed to his own specifications. A favorite of celebrities for years, John and Jackie Kennedy honeymooned in Villa 10. Oscar Hammerstein was the first owner of Villa 12. Alfred Hitchcock, Bing Crosby, and Adele Astaire were also regulars. Today Round Hill consists of a small hotel with thirty-six oceanfront guestrooms and twenty-nine villas.

The most coveted of the Round Hill properties look out from the very top of the resort, affording more space and privacy than the hillside-staggered bungalows below. This is

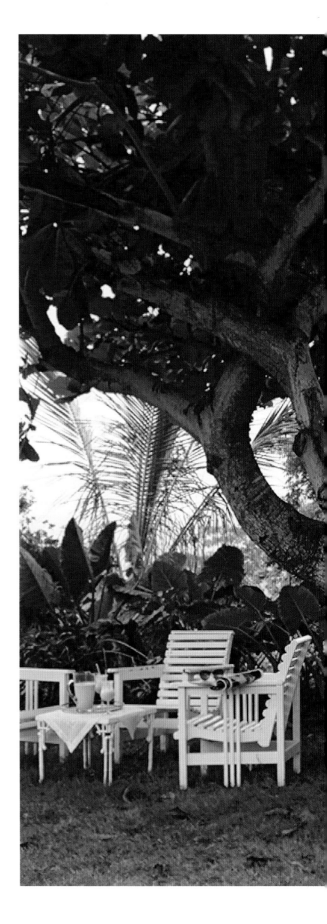

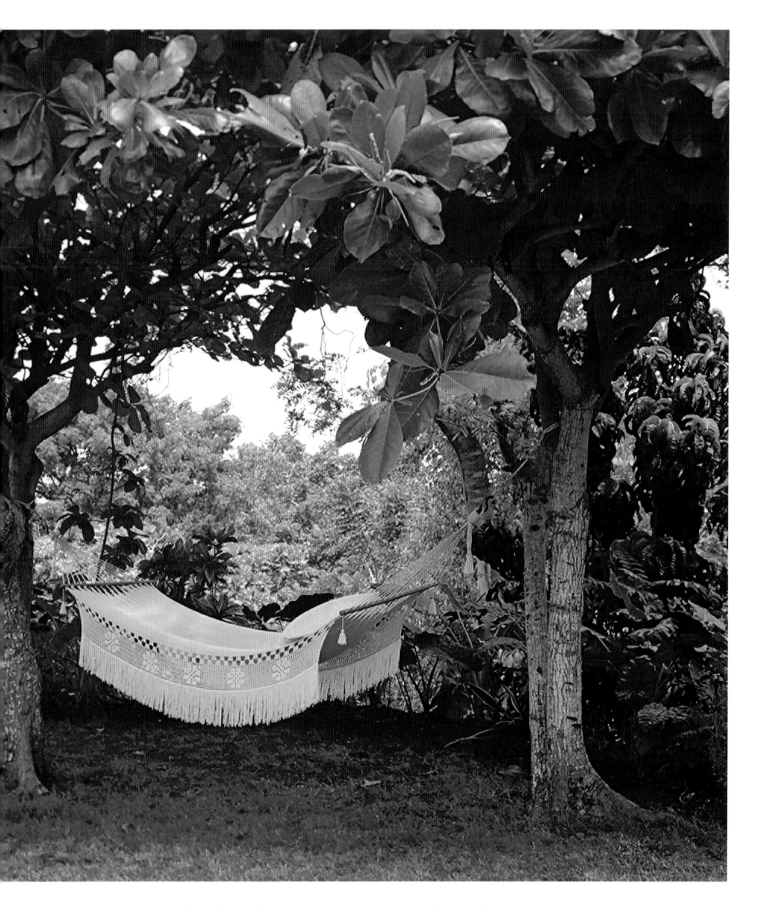

While Colorado is for enjoying the land, sun-shot Jamaica is for relaxing, for lying on the land. Outside in the jungle of trees that are Ralph's pride, a white hammock is strung between two sea-almond trees. "I live a very hectic life," says Ralph, "and I'm busy all the time. In Jamaica I have no obligations. It's very serene, a different world, far from everything."

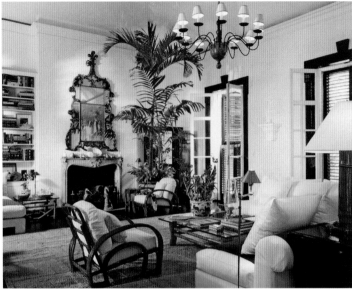

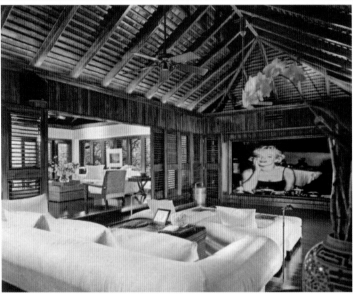

Above: High Point had initially not presented itself well; it had become dark, dreary, and closed up. The Laurens asked New York designer Angelo Donghia to help them restore it and give it the light, airy feel that it lost under the previous owner. As Ricky Lauren says of her residence, "Now it's more like a plantation house."

Below: Movies have long played an outsize influence on the designer's rich fantasy life and dream world. All the Lauren residences feature screening rooms—more times than not the couple and their guests can be found topping off the evening with a movie. High Rock is no exception.

where the Laurens' first house sits, set on the estate's highest point and appropriately named High Rock. Its seclusion even from the exclusive world of Round Hill makes the property almost remote. According to Ralph, "It's possible to be there for a long time without casting an eye on anyone else."

The house is approached by a long driveway with banks that are ablaze in bougainvillea. At the end of the drive you arrive at a structure with a British colonial feel to it surrounded by cascading tropical foliage. Built for Clarence Dillon, the head of one of Wall Street's most important investment banks (Dillon, Reed & Co.) and his wife, Anne, the property reflects that elevated style of the forties and fifties: restrained luxury, expanses of soft-spoken mahogany, and an appreciation for what has preceded it. Designed in 1954 by architect Burrall Hoffman, the designer of Miami's famous Italianate mansion Villa Vizcaya, Hoffman was responsible for what Ralph calls "its beautiful bones."

But upon first seeing it, High Rock did not present itself well; it was veiled and off-putting. It had become dreary and musty, with black railings and heavy draperies; its mahogany shutters had been painted battleship gray. Neither sunny nor joyous, the pool was the size of a bathtub.

The Laurens asked Angelo Donghia to help them restore it and return the house to the light, airy feel that it lost under the previous owner. Donghia gave it a clean, simple look reminiscent of the twenties and thirties, with white walls, dark stained floors with sisal rugs, and mahogany crown moldings framing all the doors. Decorated with a mix of European antiques and contemporary seating areas, there's a homey mixture of oversized rattan and mahogany furniture loosely slipcovered in white duck accented by blue-and-white Chinese jardinières and green palms. With an indoor-outdoor colonnaded terrace for eating and sitting, it's the kind of holiday dream home that one fantasizes about.

From *Architectural Digest*: "But High Rock also reflects the Laurens' love for Jamaica, which, as Ricky Lauren writes in her own book, *My Island*, 'has color, more vibrant and impressive than I have ever seen.' She filled her book with her own photographs of lush pink, red and orange flowers and golden sunsets, and she brings those vibrant hues to her dining table. 'In the big house I have napkins and linens in bright colors, like the Jamaican flowers. I like to make the table fun and exciting.'"

The original property, High Rock, was purchased by Ralph and Ricky Lauren in 1982. "With their children growing up, the Laurens decided they needed more space, and in 1997 they bought a second house, this one right on the water, a short walk down the hill. Cottage 26, as it was called, was built for another formidable figure in the New

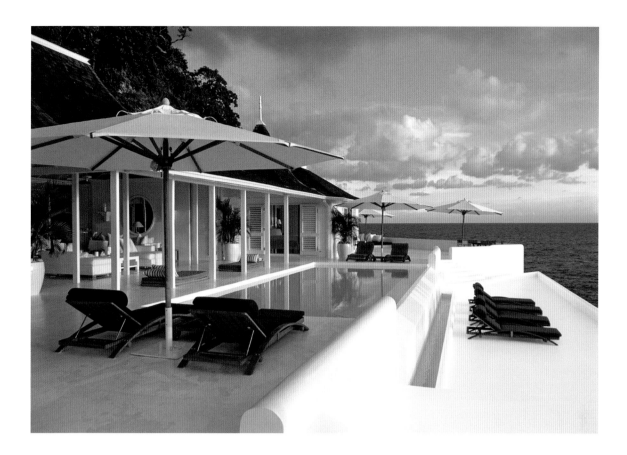

York business world—William S. Paley, the founder of CBS. Paley blasted away rocks to create a site perched on the ocean, then constructed a pagoda surrounded by four bedrooms."

Named White Orchid, the smaller ocean-house sends out a different message than High Rock. "'It's white and pure,' says Ricky Lauren, 'and you feel as if you're floating on the sea—and you are.'

"'The great house has a classic feel,' says Ralph. 'The White Orchid is clean, barefoot, and seagoing luxurious.' He expanded the terraces, and he made the house appear more spacious by lifting the doors and windows by two feet and the roofline by three feet. Its pool deck was likewise expanded. As he observed, 'It's now very dramatic and it relates better to the ocean and the rocks.'"

Interior-wise, the color scheme is decidedly nautical with contrasting white and royal blue. Keeping with the watery setting, blue-and-white pottery is all the color allowed against the predominately stark-white backdrop. Accents of teak, brass, and glass give the house its sophisticated, oceangoing feel.

The years here have deepened the family's relationship with Jamaicans and Jamaica itself. Their affection for Jamaica is not just something the Laurens talk about. When Hurricane Gilbert battered half the island in 1988, Ralph quickly sent food and clothing to the people he finds "so quiet, soft and loving." Not only have they given money to various local causes, everything from The University of the West Indies to the emergency unit of a nearby hospital, but

the designer has also used the island as a source of fashion inspiration, promoting Jamaica as an idyllic retreat.

"'He has put his stamp of approval on Destination Jamaica,' says [Josef] Forstmayr [Round Hill's managing director]. In appreciation, the Jamaican government has bestowed on Lauren its Order of Distinction, with the rank of commander, and put his smiling face on a stamp, an honor previously given to only Winston Churchill and Princess Diana."

Ralph Lauren says, "In a way, it's like the Garden of Eden—the smell and fragrance, look, color and light; the peacefulness and quiet. My life here is about rejuvenating; a sense of quiet, a sense of privacy. There are so many more places to go than there were in the fifties. There's always the new 'hot' island," he continues. "Jamaica isn't it. Why is it we never leave? I ask the same thing every time. I never have an answer."

BEDFORD

Admiring the Past Without Reliving It

In the 1980s the Laurens began thinking about establishing a residence outside the city where they could raise their three children, sons Andrew and David, and daughter Dylan. As Ralph explains it, "We had built and furnished houses all over the world, but, finally, we wanted something closer to home, a base, a stone manor house."

Touring the metropolitan's byways over the years in one of his vintage roadsters, Ralph searched for a suitable home and eventually took his family to Bedford, New York, a Westchester suburb. "We would take drives through Bedford and saw it was one of the most beautiful places in America," said Ralph. "I like the feeling of being in the open air, driving with the trees and the country surrounding me," states motoring enthusiast and car collector Ralph. "All my cars," he mused, "feel at home on Bedford roads."

Whether by limousine, Jeep Defender, or Bugatti, Bedford was no more than an hour's drive from Manhattan central. As Ralph operated his international fashion empire from his Madison Avenue headquarters, Bedford offered an easy shuttle back to a habitat that pretty much personified the stately but genteel style that has long informed his larger design vision.

However, to think of Bedford as simply an elitist retreat would be to misconstrue its appeal back in the Gilded Age when prominent families like the Phippses, Vanderbilts, and Whitneys were the country's reigning aristocrats. Bedford's lushly forested and rolling landscape, evocative of the English countryside, had long been a place of quiet wealth. Since the early 1900s, members of New York society seeking to avoid the social spotlight of places like Newport, Rhode Island, or Southampton, New York, would gather there. Ralph, speaking about Bedford, remarked, "It has a combination of oldness—there are dirt roads with horses on them—and refinement, in terms of

Talk about divining picture-perfect worlds, here's a dreamscape that even Hollywood would find hard to improve upon. The spacious lawn and ivy-covered walls of the seventeen-thousand-square-foot house evoke an estate in the English countryside. Built in 1919 and French Norman in style, the combination hunting lodge and stately home boasts the *purr*-fect circular driveway to accommodate stand-ins from the owner's automotive inventory, of which sixty or more stock-keeping-units reside nearby; the owner can pick up the telephone and in twenty minutes, a Ferrari of his choice can be idling at his doorstep.

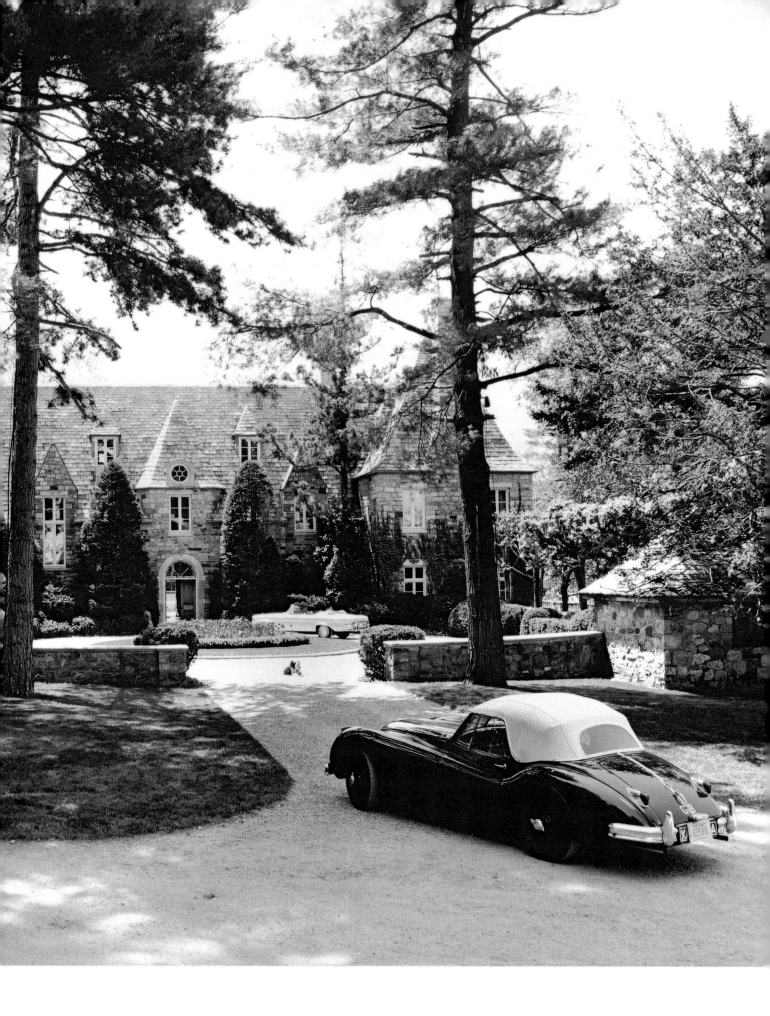

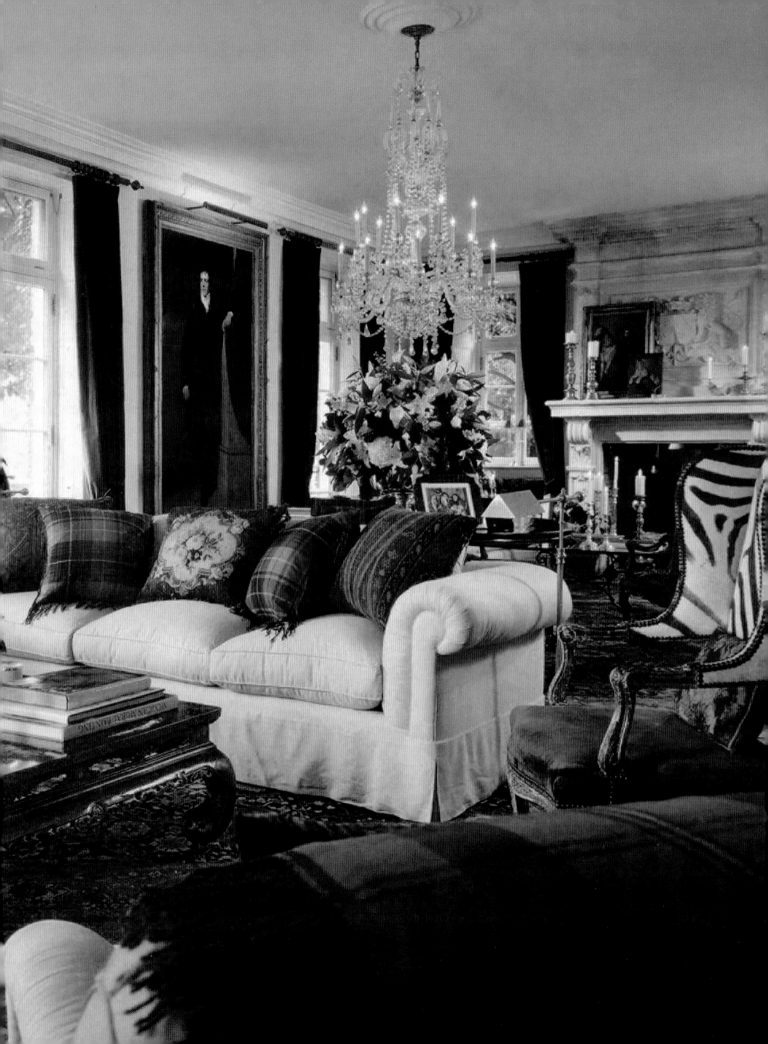

architecture. It's rural yet sophisticated. You would think it would be far away from New York City, yet it's so close. It's Old World, but it doesn't look like it's trying to be Europe. It has a style of its own."

As an estate with generations of built-in grandeur, the Bedford property was a bit different in spirit from the family's other residences. The property was originally named Oatlands by its first owner, landscape designer Robert Ludlow Fowler Jr., who in the early 1920s enlisted the help of Delano & Aldrich, one of the day's most esteemed architectural firms, to design and build the house. The firm's works include the Knickerbocker and Union Clubs in New York City and the American Embassy in Paris. They created a restrained French Norman–style manor house, placed in a landscape designed by Fowler, a personal work that continued to evolve until his death in 1973.

Unfortunately, by the time the Laurens purchased the property in 1987, the grounds had fallen into serious disrepair. Included was a mishmash of entities: a long-neglected farm overrun with vines and arid tulip trees, a caretaker's cottage, a separate Robert Venturi–designed wood-and-glass building, and the property's seat, the seventeen-thousand-square-foot main house.

Practically everything on the estate was then Laurenized, which is to say, reimagined, redesigned, and then repositioned into perfection to become the family's adopted country seat. To get the job done, husband and wife divided the labor. "I was concerned with the look, the feeling, the mood," says Ralph. "Ricky focused on the flow, the orderliness, and the details underlying how the house would be run." "In twenty-eight years of marriage, we pretty much share the same taste," notes Ricky. "But I love to organize things. Closets, in particular. The lighting, the mirrors, everything has to be just right. It should be an elegant space—a showcase for the beautiful things Ralph makes."

A pool house and tennis court were added and the glass-and-wood building transformed into a studio for Ricky. "We conceptualized the site while walking through it with the Laurens," says landscape architect Randolph Marshall, a nearby Katonah neighbor. Having landscaped all of Ralph's other properties, Marshall was familiar with his client's predilections; however, the Bedford project went beyond anything either had ever done. The main house was eventually surrounded by carpeted acres of green lawn. Hills were reshaped, terrain remolded, views opened, and new spaces like woodland paths, gardens, and drives were created. At the very least hundreds of white pine, Norway spruce, hemlock, and cypress trees were trucked in. "After you locate the trees," the landscaper explains, "they have to be root-pruned a year in advance

and balled in burlap. It was a massive undertaking. I don't know anyone else who would have had the strength and the courage to do this much," says Marshall.

Bedford harks back to the roots of the designer's vision, to his oldest and most venerable images, that of the well-born and stylishly outfitted gentleman. More Purple Label than his other residences, Bedford is the rural counterpart to the brand's urban redoubt for men, the Rhinelander Mansion on Madison Avenue. Tweed hacking

Opposite: Civilized insouciance— as if it had been thrown together over generations. "I don't love one thing," the designer stresses. "I love contemporary. I love American Country, the Southwest, the Bauhaus. . . . I don't follow architectural rules. I just took every period and all the things I loved and put them together: cowboy paintings, seventeenth-century pieces, photographs."

Below: From Stephen Drucker's article in a 2004 issue of *Architectural Digest*: "As in English 'stately,' the entrance hall is not overly decorated. A generously proportioned George II mahogany side table and the first of many oil paintings greet you, as does the scent of lilies. . . . Much of the furniture and art came from the Laurens' own buying excursions to England and France. The foyer is lined with a limestone and cabochon floor bought from France. While the décor is undoubtedly the most formal of Ralph's residences, it's also both playful and eclectic in a way that is uniquely the designer."

289

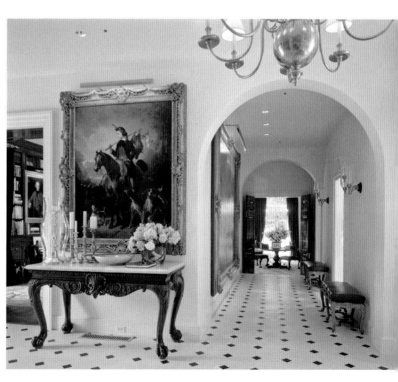

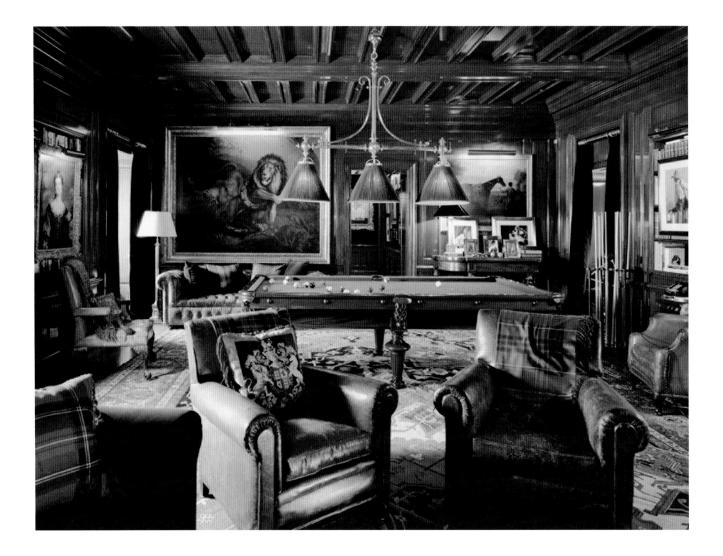

jackets, hand-knit Fair Isle sweaters, and tartan trousers would best exemplify the estate's dress code, if it had one.

Although the décor is undoubtedly the most formal of his residences, it's also both playful and eclectic in a uniquely Ralph Lauren way, which is to say, haute clutter is curated together and then thrown about with seeming abandon. The inside space contains massive limestone mantelpieces, mahogany paneling, stone-and-polished-wood beam floors, all framed with rich coverings on the walls, seating, and floors. Much of the furniture and art came from personal buying excursions to England and France.

The interior design walks a precarious tightrope between theatrical and homey. The public quarters such as the plaid-lined library, the kilt-fringed-drapery-swathed dining room, or the zebra-tartan-paisley-tousled living room exude a kind of civilized energy from the play of pattern, color, and texture that cavort atop, next to, and around each other. Zebra skin—covered poufs rest atop verging-on-threadbare Persian runners; sitting groups featuring oversized couches and brawny

leather chairs decked out with all manner of stuffed-pillow poise beckon guests to, please, make yourself comfortable. Surfaces abound with objects and family photos along with carefully arranged collections of antique-plaid metal boxes and other such bibelots. Says the designer, "It's very easy to do a formula. It's harder to do a mix, get a balance. Very few houses have that easiness. Most look decorated."

The kitchen, with its mahogany cupboards and brass rails, and the breakfast room, with its antler-horn chandeliers recall the upper-crust, old-moneyed setting of the fictionalized Long Island Larrabees from the classic Humphrey Bogart and Audrey Hepburn film *Sabrina*. Although not that far removed from the days of hot and cold–running maids, Ralph's old-world incarnations are usually spiffier, if not more emphatic, than the originals.

Upstairs in the Laurens' private quarters, a round mahogany-paneled hall leads through their five-room master suite. The bedroom, with walls of deep-blue baize, hosts somewhat dressier furniture than elsewhere. A

Opposite: Bedford is a microcosm of the world Ralph offers through his finely drawn approach to display, and his billiard room captures all of that: masculine, rich, and welcoming. An antique three-light fixture hangs above the Victorian-style billiard table. There may be other man caves where guests can gather to share stories, shoot pool, sip port, smoke cigars, and watch Fred Astaire frolic across the screen; however, it's unlikely they can do so on such unremittingly stylish terms. As in Edwardian England, where the titled gentry after dinner would escape the ladies to don their smoking jackets and engage in man talk, the designer has added yet another rung to the proverbial ladder of male fantasized home preserves.

Right: Each of the couple's residences represents a particular slice of what Ralph describes as "the whole atmosphere of the good life." Bedford symbolizes what he terms as "forever values." For millions of people around the world, Ralph Lauren proposes a lifestyle that may be better than the average person's, but not beyond imagining.

mahogany-and-walnut Georgian bureau-cabinet and an eighteenth-century Georges Jacob chair share the limelight with a Regency bed, bookended by bedside tables filled with the bric-a-brac of gracious living—porcelain lamps, silver-framed photos, crystal tumblers, cut-glass stem holders, et cetera. The adjoining white-marble bathroom, with a floating white fireplace and an eighteenth-century mantelpiece at its center, overlooks the expansive back gardens.

The dressing room and closet may be the closest one could describe as the house's nerve center. And why not? We are talking about the head of the manor's habiliments, as well as his lifetime muse's, which in large part got them there in the first place. With walls covered in a pool-table-green felt and embellished with polished mahogany millwork, the hush of so much beautiful clothing perfectly hung and carefully arranged by color comes through loud and clear. Like a storied and preserved tack room where everything has its place and provenance, a pew of bone-polished leather boots sits in

weathered repose, patina-fresh from repeated buffings. Travel-worn pieces of fine tanned-leather luggage line the room. As with all the home's niches and nooks, it's difficult to cast a wayward eye without stopping at a random composition that doesn't look like a Ralph Lauren advertisement come to life.

At opposite ends of the decorating spectrum from their modern Manhattan duplex, Bedford is an amalgam of deep-dish-upholstered, swag-cascading English country style as championed by America's former decorating deities, Sister Parish, Dorothy Draper, and Billy Baldwin, filtered through Ralph's eye and playful sensibility. With artfully layered spaces heaped with beautiful rarities, a dialogue between the elements needs to be struck, a balance between compliment and contrast. Much like the successful dinner party, the mixing of guests who are not the same but all get along would make for the perfect evening. It's safe to say that anyone fortunate enough to find themselves bivouacking at Bedford will undoubtedly leave with pupils dilated and spirits buoyed.

RALPH LAUREN HOME

Investment Decorating

In 1983, as if he did not have enough on his already elaborately laid place setting, Ralph Lauren was about to pioneer another design frontier, this time making the leap from apparel to home furnishings. Word was that the designer was planning to unveil a collection that would sweep the entire "Home" fashion scene.

Upon previewing it, *House & Garden* magazine described the collection, which numbered more than 2,000 items and included everything from sheets to furniture to flatware, as "the most complete of its kind ever conceived by a fashion designer. Add Ralph's keen marketing acumen, his avowed disregard for conventionality, and his insistence on being the best, and it's easy to see why so much anticipation attended its opening."

Development of the home-goods business was being done in partnership with J. P. Stevens & Co., a textile giant with corporate offices in Manhattan and mills across the South, which had set up a Ralph Lauren Home Furnishings subsidiary to produce and market everything. Conceived by J. P. Stevens' vice-chairman David Tracy as a game-changing marketing move, it was described by *Business Week* as "Stevens' quantum leap to shed its image as the grande dame of the textile industry and become the major supplier of decorative home furnishings to department stores." As

Mr. Tracy was quoted, "there is a crying need in this industry to relate directly to the consumer, to give her exactly what she wants. And we want to be that company."

For years fashion designers had lent their design talents and names to various home-furnishing items. Bill Blass's signature had long been on bed linens, Diane von Fürstenberg and Halston, among others, licensed the cachet of their names to leading retail-catalog chains. According to Ralph, "When you thought of designers who have entered the home furnishings business, you think of a flowered print or a new design with a guy's name on it. If you wanted quality, you went to Pratesi. The American industry was a rip-off; they priced things up so they could mark them down. There was no reality, I hated that, I wanted to change the business."

Ralph told the *Washington Post* that he was not going to just lend his name to products, he was bent on creating a complete environment for the home, as his Polo Fashions was doing for men and women. Although not all the merchandise would carry the Polo label, such as china, most did, with all products paying royalties for the privilege. Stated Ralph, "I did it for the same reason I've gotten involved with everything else I've done—because I'm the consumer." Legend has it that shopping for sheets with his wife, not only could he not find cotton sheets, if he had wanted a patterned sheet, there was basically one choice, one motif, floral—which ranged in design from less feminine to more. For

"FOR ME TO PUT MY NAME ON ANYTHING I HAVE TO WANT TO OWN IT. I HAVE TO WANT TO WEAR IT OR WANT MY WIFE TO WEAR IT. I HAVE TO WANT IT IN MY HOME. THAT'S HOW I WORK."
—RALPH LAUREN

Ralph Lauren, a self-professed romantic. "I have always been inspired by the dream of America—families in the country, weathered trucks and farmhouses; sailing off the coast of Maine; following dirt roads in an old wood-paneled station wagon; a convertible filled with young college kids sporting crew cuts and sweatshirts and frayed sneakers."

Ralph, home was a merchandise category that had hardly been touched by high-quality design.

One of the major distinctions of the Stevens program was the presence of Ralph himself. "I am not of the home furnishings business," he told Mary Connors, editor of Fairchild's *Home Furnishings News*. In a refreshingly candid interview, Ralph stated that, "the Ralph Lauren name will not sell it. The consumer will never say, that's a Ralph Lauren, I'll buy it. The product will make it sell, I design for the way people live, or would like to live." Although an honest and forthright sentiment, the growth of the Ralph Lauren Home business would ultimately prove the designer both right and wrong. Right, because many of the products would go on to become their own classification's gold standard. Wrong, because by the end of the eighties, Ralph Lauren products and looks conjured up almost instant brand identity, which national style chroniclers had begun to refer to as the Laurenization of America.

In a venture labeled as one of the boldest, riskiest, and most novel in the history of the home furnishings business, Ralph was about to kick off a revolutionary merchandising concept. There had never been such a thing in home goods as a coordinated fashion collection, let alone the crafting of products around different lifestyle themes. "I came at everything with a sense of how I would want to live," says the designer. Nobody had foreseen the potential for breaking out sets of categories such as bedding, wall coverings, linens, and bath fashions and marketing them together as a themed approach. Ralph segmented consumer fantasies into different lifestyles, giving each group a name that conveyed the concept. He approached home furnishings as if he were designing a collection of clothes, with many of the fabrics taken from his own fashion archives.

Surprisingly, the more than 2,000-item line, which ran the gamut from sterling silver flatware to hand-painted wallpaper borders, was to appear without the famous Polo pony insignia that had been synonymous with the brand. Although it was to be used for advertising and on a few correlating items such as bathrobes and barware, for the most part Ralph's home furnishings were expected to stand on their own. When word first leaked out about his home furnishings' launch, some expected

only labels and logos. "Oh yeah, they expected Polo players all over the place, they thought I'd take the easy route. I was very proud of the fact that detractors who foretold a flood of polo player sheets were found wrong."

As the eighties biographer Jeffrey Trachtenberg explained, "What was the most interesting about the home furnishings, however, is not whether it made Ralph Lauren more money, but how the collection was introduced. Ralph didn't set out to peddle sheets and towels, the customers already had sheets and towels. Instead of selling cottons and flannels and terry cloth, Ralph sold the fantasy of how enjoyable it would be to share the same high-quality sheets and towels used in the best American and English homes."

Ralph was the first to admit that he was not an interior designer. But he can, as he puts it, "visualize how you'd live in a particular environment." In the same way he might picture what people might wear at a seaside villa in Round Hill, Jamaica, he could also envision the rattan chair in which they'd relax with a good book, the blue-and-cream china they'd use for lunch on the terrace, and the hand-blown tumbler from which they'd sip their afternoon rum cocktail.

Ralph explains, "The consumer lives in many ways, different ways, and just as they have different lifestyles, they want that for their home. People just don't want things, they want to know what the 'look' is. These lifestyles must be presented in an environment that you can walk into."

And the designer made sure customers got a chance to see the whole look, extracting some remarkable concessions from J. P. Stevens and retailers alike. First he insisted on enough space for a total environment. His ideal was 4,000 square feet, but he knew that was a lot to ask for an untried idea. He made do at Bloomingdale's, where he was its most-favored designer, with 2,500 square feet.

As for display, Ralph wanted his furniture, lamps, linens, and such all shown together in the in-store boutiques, not split up among the different departments or spread around the store. And he refused to let any store, citing space limitations, place orders for just sheets and towels. "If you believe in it, do it, if not, you don't." Furthermore, there would be no "white sales" of his merchandise, an almost heretical notion given the historically promotional culture of the home business up to that point.

> "WHEN I BUY SOMETHING, IT HAS TO PERFORM, AND IT HAS TO LAST. AND IT ALSO HAS TO LOOK BETTER FOR HAVING BEEN USED. THAT'S HOW MOST PEOPLE WOULD DEFINE SOMETHING OF VALUE. QUALITY IMPROVES WITH AGE AND USE."
> —RALPH LAUREN

It took seven separate licensees to carry out Lauren's wide-ranging master plan. The project was developed over eighteen months, costing J. P. Stevens about five million dollars. With four soup-to-spoon home packages, incorporated within each theme were hundreds of individual items that had to pass Ralph's standards of perfectionism, from seventy-two-inch tablecloths (most mills made only sixty-inch) to ninety-five-dollar paisley sheets to one-thousand-dollar linen sheets trimmed with embroidered lace from Switzerland.

Sitting squarely at the center of his apparel business, sharing every design decision from lowering buttons to enlarging labels, Ralph's involvement with Home's creation was no different. The designer was present at every step, choosing the colors, fabrications, and materials. Ralph Lauren is a man committed to perfection. For him perfection can be a victory over limited thinking, a victory over the "it can't be done" frame of mind. As he is given to saying, "doing something well doesn't always come easily." "Let's stop dreaming and begin doing" was his credo.

And he was not kidding. It took almost two years to develop the linen sheet he was looking for. Declares the designer, "A perfect towel, who cares? I do." Getting the right towel required more than nine months of development. Nancy Vignola, the vice president and director of Ralph's design staff, was interviewed at the time. "Ralph is the ultimate consumer; when he can't find something, he makes it. In the case of the towels, we all agreed on what we wanted to achieve, then we showed Ralph the best sellers and the best towels. One towel might have great loft, but if it was too lofty, it might not dry well. How many twists were there in the yarn? Our towel mill became like a scientific laboratory." Testing innumerable samples finally produced a towel whose material was a plush, twistless yarn that came in twenty-six colors.

In a 1989 edition of *Manhattan Inc.*, Ralph noted: "I felt like just creating clothes wasn't enough. . . . It's all an extension of something I wanted in my life—or my dream life. My sense of what was happening was that there was so much clothing out there, so much fashion, that I was bored. I felt that the home became interesting. That your life was not only wearing the clothes, it was also being at home."

Considering Ralph's own lifestyle encompassed his many homes, it was not hard to see where much of his inspiration came from. Ricky Lauren talks about the connection between her husband's personal and professional lives. "'The places we live are sort of dreams of Ralph's that have come true,' she says. 'But once there, he sets about making things perfect. He designs for the place. If we didn't have the house

Never before had so massive an undertaking been attempted; it was the biggest gamble the home furnishings industry had ever seen. Before Ralph Lauren, there was no such thing as a coordinated fashion collection, let alone something that suggested "lifestyle." Going from a bare room to a total signature look would carry the concept of a designer environment to new horizons.

in Jamaica, perhaps he might still have designed a Jamaica look. But having it gave him the stimulation.'"

Stated Vignola, "The products in the collection were inspired by the taste and lifestyle of the designer himself. We decide what we're going to do based on what we want to own. We don't think about price." Ralph says, "When I buy something, it has to perform, and it has to last. And it also has to look better for having been used. That's how most people would define something of value. Quality improves with age and use."

Having made his mark by creating an incredibly successful merchandising approach to fashion based on lifestyle, the designer followed the same lead with Home. As the company's brochures explained, each product was keyed to one of four lifestyle themes: New England, Log Cabin, Jamaica, and Thoroughbred. Ralph reaffirmed, "Within

Above: Getting the right towel required more than nine months of development. Testing innumerable samples finally produced a towel whose material was a plush, twistless yarn that came in twenty-six colors. Home's towels were big and heavy by industry standards and came in an unusual array of unique colors.

Opposite: "In on every button." From the drawing board to store display, Ralph Lauren keeps a close rein on every aspect of his business. Here he inspects the first transparencies from his new Home collection shoot in his West Fifty-Fifth Street office. As famed photographer Bruce Weber points out, "Lauren's eye doesn't just notice things, it connects them."

each style group, every item, 2,500 over eight lines, will work together, like blazers and shirts. I'm selling a point of view, just the way I sell my clothes. I don't design a single blouse or skirt, I put all the pieces together the way (I hope) the consumer understands."

For the first time shoppers could find everything in one place to create an image in their own home. Those who wanted the look most typically associated with Polo Ralph Lauren could key into the New England and Thoroughbred collections. New England meant solid and striped oxford sheets, button-down pillowcases, cashmere throws, and hand-loomed rugs. The Thoroughbred collection, conveyed Ralph's horsey, English heritage. This meant Scottish wool throws and blankets, paisley sheets, and wall coverings in plaids, tattersalls, tartans, and checks.

A third collection, Log Cabin, suggested a rugged outdoorsy image. All-wool blankets were offered in lumberjack-red-and-black checks and plaids, cotton flannel ticking-striped sheets came in bold colors to be accessorized with white-eyelet dust ruffles peeking out under stone-washed denim comforters. And at the upper end was the Jamaica collection, inspired by the light, airy feel of the tropics: bedclothes, table linens, and towels made in 100 percent Italian linen, some ornamented with Swiss embroidery, or hand-painted floral sheets with fagoted hems.

But even the best-laid plans can go awry as serious problems emerged throwing the rollout off its stride. Stevens experienced difficulties getting the products to retail outlets on time as well as maintaining quality control, having itself licensed parts of the line to other companies. As the Stevens executive in charge of the business reflected, "When you build anything, it takes a lot of time, effort, and sheer guts to fight through all the untraditional principles we were going up against."

By untraditional principles, he meant the pricing of the line, which was steep by industry standards, the breadth of the collection, and the fact that the line required a certain sophistication on the part of the sales staff to romance and sell it. One day the Stevens sales force was pushing mass-market, commodity products and the next day they were expected to romance a Jamaica-inspired collection with hand-painted linen sheets.

As a vice president of Bloomingdale's was quoted, "If it doesn't sell, it will be for only one reason—price. The design and quality cannot be faulted. We believe the public will respond, but it's definitely a risk." But in Vignola's mind, the Lauren Home collection couldn't realistically be prejudged, because there was nothing to measure it against. "Some people were saying that the line was very expensive but there is really nothing to compare

it to. There's not another yarn-dye oxford cloth sheet out there. What it prices out to be is because of what it is."

As for the upfront investment, clearly the Ralph Lauren Home line required a high degree of commitment on the part of the retailer, both financially and otherwise. The demand that those stores had to construct (with blueprints provided) a $250,000, freestanding, wood-paneled boutique to display the items was a problem. According to reports at the time, the total commitment could run as high as one million dollars per store for inventory and real estate. Stores balked at the price tag.

Experienced buyers understood the challenge, as an in-store concept shop has to be kept new and fresh all the time. A specialty store might be able to sustain such an effort over a couple of years, but for a department store to execute it properly and keep it updated required a total departure from business as usual. With the start-up's hiccups and the business not meeting the initial projections at the manufacturer or retailer level, a number of leading department stores decided to put their plans for new Ralph Lauren Home shops on hold. Deliveries had been poor and more often than not, the shelves in the Home stand-alone concept shops were wanting. With concern that the business was starting to stall, Polo Ralph Lauren and J. P. Stevens announced a reorganization with the appointment of one of Polo's top young executives, Cheryl Sterling, to the new position as president of the Lauren Home

> "SOME PEOPLE WERE
> SAYING THAT THE LINE WAS
> VERY EXPENSIVE BUT
> THERE IS REALLY NOTHING
> TO COMPARE IT TO.
> THERE'S NOT ANOTHER
> YARN-DYE OXFORD CLOTH
> SHEET OUT THERE.
> WHAT IT PRICES OUT TO
> BE IS BECAUSE OF
> WHAT IT IS."
> — NANCY VIGNOLA

Furnishings division. She was to report not to a Stevens executive but to Polo Ralph Lauren's vice-chairman, Peter Strom.

"The interest was phenomenal because no one had ever put together a collection like the one Ralph put together," stated Strom. "However, pulling sublicensees together was really not J. P. Stevens' expertise." Not sugar-coating it, Strom told *Time* magazine that the introduction was "a disaster!"

Polo executives rushed in to assume more control over their new home business. The decision was made on the

297

Lauren side that they had the expertise to best coordinate the delivery of all the diverse products in the various collections. "This is the kind of thing we do in apparel every day; we sell knit shirts, sweaters, pants, and sport coats, and we have one sales force that sells all these products so the stores don't have to deal with eight different divisions and eight different salespeople," stated Peter Strom.

Whatever the problems Polo Ralph Lauren had in getting its first home collection off the ground, the organization believed its redoubled efforts would repair the cracks in the foundation and put the division back on course. As Strom reasoned, "In my whole career at Polo, I cannot think of any launch that didn't have problems, so you can never delay it long enough. It's just streamlining, it's better control, and it will be easier for the stores to work with just one person."

Another important step that was taken allowed the department stores currently housing the Lauren Home shops to also sell the product outside them, in their classification areas. Until now all the towels, sheets, flatware, and other components were confined to sales within the individual 2,500-square-foot shops. To further broaden their reach, they decided to expand the specialty store business as well. Strom was not concerned that the specialty shops would dilute the department stores' businesses. On the contrary, he believed the smaller, owner-operated shops would make better presentations and thus incentivize and strengthen the Ralph Lauren Home sales in the bigger stores; at least that was what had happened in apparel.

Despite the successful sell-through of the collection at the thirty-four stores premiering the Home merchandise and the surprisingly large reorders and satisfied customers, Ralph found the late deliveries, delayed openings, and disgruntled licensees very upsetting. He complimented the J. P. Stevens group for being "willing to define a new level of quality and open up new doors in home furnishings without backing down on the quality, no one else would do that."

From 1984 article in *HFN Magazine* by Janet Morgan: "The towels, big, thirsty, and heavy, were something special in the designer's eyes. He had expected them to be the fastest-moving items in the collection yet he admitted they were a bit of a disappointment. Ralph said, 'The customer found so many other things in the collection, like the paisley bedding and the oxford sheets, that at a glance the towels didn't seem that special. I see them becoming a major business as customers replace their towels, not unlike the knit shirt in my ready-to-wear.'"

For the follow-up spring collection in 1984, the home design team introduced the lifestyle themes of Cricket, Mariner, and Cottage. That Ralph's almost 2,000-unit entry into a seemingly foreign industry was proving to be a winner surprised no one. Like his offerings in men's and women's apparel, his home furnishings collections were virtual grab bags of items that paid homage to classic American designs in new, alluring colorings and fresh pattern combinations.

According to a J. W. Robinson's buyer, "What sold best were the unique colorations and textures that couldn't be found in competing brands. The Ralph Lauren Home collection provided a giant, upmarket fashion umbrella for everything in our domestics area. The first deliveries were horrible, but spring deliveries were better than last year's fall."

In the final analysis and perhaps, the ultimate irony, it was the Lauren goods' higher pricing and better quality that helped to set them apart from the myriad of other home merchandise on the market. Commented one Lauren licensee, "He does things differently; Ralph is not constricted by convention," adding, "It may well be because the home furnishings industry has always done it one way, that is why it's so sick. We may fail, I don't know," the manufacturing executive concluded, "but it's a worthwhile effort, and heaven knows, the industry needs it."

It took several years for the Polo executive team to get the home business back on track. Gradually, Sterling and Strom turned the company around by reorganizing the sublicensees and canceling some lines altogether. According to *The Man Behind the Mystique,* in August 1986 the Lauren home furnishing business quietly became a wholly owned subsidiary of Polo Ralph Lauren. A year later it was doing nearly fifty million dollars annually in wholesale sales.

States Ralph Lauren, "All the businesses I have started had the same starts and fits in the beginning. I put everything together in a collection rather than making one item, and then I put that collection in the right environment. You go through growing pains, just as I did, then it starts to click. I couldn't deliver on time, prices were high, those were the growing pains of trying to get people to understand. Now it's moving right."

As with anything Ralph put his hand to, along came the knockoffs. At first, the home furnishings industry as well as the big textile mills were skeptical. Then all the manufacturers started to copy Ralph. Companies began to produce natural fiber, Polo-looking bedding and towels with department stores styling their ads with equestrian themes and vintage typewriters. Noted a *Newsday* reporter at the October 1987 Southern furniture market in High Point, North Carolina, "The Ralph Lauren influence was so widespread that many exhibitors propped their

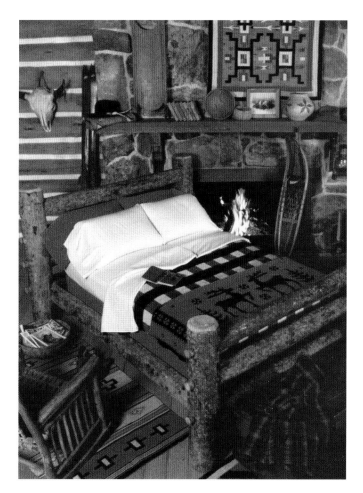

Right: The Log Cabin series suggested the rugged outdoor life. All-wool blankets were offered in plaids and checks. Cotton-flannel ticking-striped sheets came in bold colors such as emerald, grape, and scarlet that were accessorized with white-eyelet dust ruffles peeking out under stone-washed denim comforters. Reindeer-patterned rugs were laid on top of larger cotton dhurrie plaid rugs. Red-and-black lumberjack plaid plates and mugs finished the look.

Below: The Thoroughbred line conveyed Polo's horsey, English heritage. This meant Scottish wool blankets, Shetland tweeds, and wall coverings in tartan checks, tattersalls, and foulards, with sheets in solids and stripes, paisley and dark foulard prints. Tartans, tweeds, tattersalls, and hunt or pheasant motifs were the predominant patterns, woven in the natural fabrics of wool, cotton, and cashmere. Matching dinnerware in English bone china came with Polo scenes in a range of colors.

Log Cabin collection

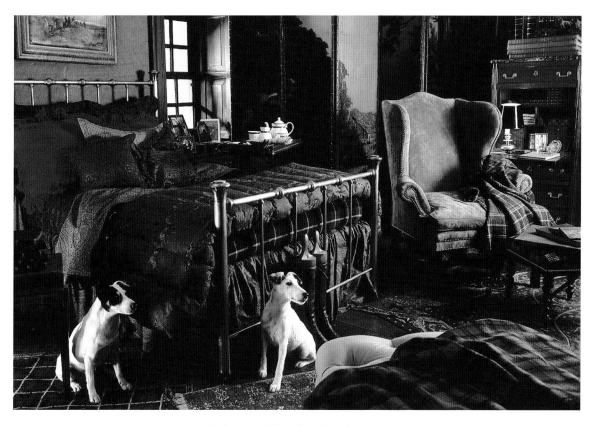

Thoroughbred collection

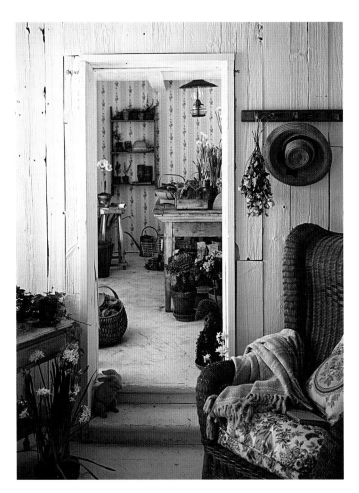

Left: Cottage embodied the country freshness and romantic charm of a New England summer home. Bold eyelet-trimmed florals, watermelon-hued glen plaids, and tattersall and pastel oxford striped sheeting draped with Indian hand-knit throws created a ready-to-wear feel of casual, throwaway sophistication.

Below: The Cricket collection was intended to convey an idealized preppy dorm or country house bedroom. Cricket was inspired by the elegant English game of the same name where "whites" or cream flannels were considered "good form." A color scheme of blazer navy blue accented by a lighter chambray blue was teamed up with a cream ground and navy window-pane bedding, striped navy wallpapers with matching navy and white cricket-scene borders, Italian lambswool and cashmere throws woven in varsity-colored cable designs and towels trimmed with jacquard cricket-motif borders.

Cottage collection

Cricket collection

showrooms with enough riding crops, dog portraits, and silver decanters to outfit all the hunt clubs in the state of North Carolina." Other interior designers, like Mario Buatta and Mark Hampton, introduced their own home collections, while 1988 witnessed the opening of five home-furnishings stores by Laura Ashley.

It was the biggest growth spurt the domestic linens' industry had experienced in decades. The interest in home furnishings was so great that by 1986, three years after Ralph's entrance, makers of sheets and towels had doubled their advertising expenditures to ten million dollars. Observed *Adweek*, "It represents a giant leap in an industry that traditionally spends little on consumer advertising."

In 2013, Ralph Lauren's Home collection, a business whose reach and impact cannot be overstated, marked its thirtieth anniversary. It's hard to think of anyone, anywhere, who would have had the vision, or the fearlessness, to launch a start-up the way Ralph did in 1983, at full gallop with over two thousand stock-keeping units. The idea that you could apply fashion to the home effectively crowned Ralph as the "Lifestyle King." Now he could roll out his gorgeous interior melodramas in lavish multipage narratives capturing what the designer calls "the whole atmosphere of the good life."

In making decorating a little more like getting dressed, Ralph helped demystify interior design for a generation searching for a language of décor to call their own. Balancing his own narrative instincts with those of the marketplace, Ralph focused on his idealized versions of the familiar, reinterpreting them to make them better and more accessible. He transformed his company into a lifestyle-driven fashion-and-home powerhouse built on the diverse dreams many people share.

Alfredo Paredes joined the company in 1986, and eventually took over the reins from the talented late Jeff Walker as the man responsible for creating the company's famously evocative environments, which translates into everything from store design to product presentation. He carefully evolved the designer's pioneering vision, fusing fashion, furnishings, and the worlds in which these elements most photogenically connect.

Working alongside Ralph was the equivalent of earning his MBA in design. States Paredes, "Like a painter, Ralph sees things, colors, and combinations that most people at the table simply do not see. His bank is so deep, and yet he's pretty chill about it, never using it to intimidate or lord it over anyone. As he will occasionally remind me, 'If it makes your heart race, it's good. From excitement comes creativity.'"

Above: Dressing the bed. Bed décor once meant several pillows, two sheets, a blanket, and a quilted bedspread that was draped to the floor. Today, due largely to Ralph Lauren Home, a bed is now dressed in two standard pillow shams, two regular pillowcases, three decorative pillows, a cashmere throw, a comforter, and a fitted sheet with a bed skirt that hangs from the frame to the floor.

301

Paredes says, "I can't think of any designer who has such a broad appreciation of different approaches to living. It's about taste." Paredes believes Ralph's success is quietly a function of the fact that even when he is at his most contemporary, there's always the seed of a future classic.

Retail customers can now buy Ralph Lauren Home online as well. Not limited by space, the Internet provides the company with the opportunity to go deeper, to create an even richer sensual and visual experience, almost like going to see a flagship presentation but online. The designer says, "It's this whole other dimension, so we're able to do storytelling in a way that we've never been able to do before." Home covers a lot of aesthetic ground. From stately country mansions to panoramic city penthouses, the range of offerings reflects Ralph's unwillingness to be pinned down by a single style. "I'm never just one person," he notes. Nevertheless, everything carries the unmistakable imprint of the designer and his brand.

Penthouse Suite collection

Downtown Modern collection

Counterclockwise from opposite left:
Fall 2015 Penthouse Suite Collection. Chocolate cashmere-covered walls and rich furnishings in mahogany and rosewood convey the collection's feel of masculine luxury and glamour. Chocolate-leather accents combine with art deco–minded furniture to affect a bold yet confident interior, while silver-plated accessories and crocodile-embossed leather items add further shebang to the proceedings.

Downtown Modern Collection. Cloistered in the sleek urban refinement of a glass-encased penthouse, Downtown Modern emerges in a mix of smooth leather, wood, and steel. A minimal palette of graphic black charcoal and white along with ebonized oak and cypress wood furnishings accented by Navajo-inspired designs add a touch of gusto and spice to its metropolitan moxy.

Fall 2013 Apartment No. One Collection. Inspired by England's legendary royal tastemaker, the famous Duke of Windsor, Apartment No. One was named for today's Duke and Duchess of Cambridge's residence in Kensington Palace. Accenting a grand mahogany, art deco dining table and French 1920s-inspired sleek black-leather dining chairs with polished nickel strikes a graceful balance between masculine and feminine tastes.

Spring 2014 Point Dume Collection. The Point Dume Collection is inspired by Ralph Lauren's Montauk home and his love of seaside living. Conceived to commune with a coastal backdrop, the look's clean architectural lines and crisp white palette combine with tonal textiles and textures to produce a waterside harmony and rapport.

Point Dume collection

303

Apartment No. One collection

PUBLIC PORTALS

Stores, Headquarters & Eateries

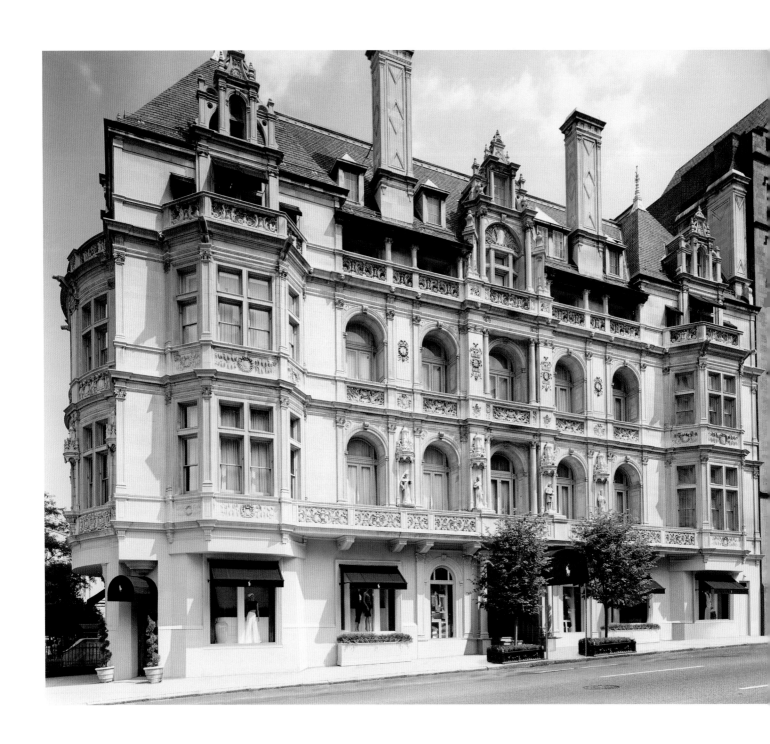

867 MADISON AVENUE: THE MANSION

FOR RALPH LAUREN, the pinnacle of his business and personal accomplishments was the 1986 unveiling of his American flagship store in Manhattan's former Rhinelander Mansion. Finally Ralph's taste, love of quality, and sense of timeless style would be available for all to see and experience . . . right down to the last detail, exactly as he wanted it, smack in the middle of New York City's most elegant neighborhood. Upon its opening, the *New York Times* architecture critic Paul Goldberger called it "the most successful conversion of a New York house into a luxury emporium since Cartier took over the former Morton Plant residence on Fifth Avenue."

The Rhinelander was to be the culmination of the designer's pioneering concept of lifestyle retailing. It would stand as its public testament and an open invitation for everyone to come in and partake of it. While old-world, upper-class, Anglo-American taste would continue as the backbone of the designer's creative vision, assembling all his timeless style references and upscale visual signifiers within this elegant public setting basically closed the twenty-year circle of the who, what, and where of the Polo Ralph Lauren story line.

Ralph instructed the project's architect, Naomi Leff, to return to prewar times when New York City was home to many stately family dwellings. He wanted to create a destination as well as a window into the prevailing lifestyle of the upper classes in America and England during the 1920s and 1930s. Whereas Ralph wanted to preserve and restore the mansion's beauty and historical birthright, he was not interested in re-creating an old-fashioned carriage-trade store for the privileged to parade around in. He felt that people from all backgrounds are fascinated by the style and elegance of past generations and that in giving people something aspirational to consider, the experience would both inform and entertain.

Built in 1898 for socialite and heiress Gertrude Rhinelander Waldo, who dreamed of living in a Loire Valley–inspired chateau, the Renaissance revival mansion on Madison Avenue at Seventy-Second Street was an exquisite building; however, it had fallen into serious disrepair. Bringing it back to its hundred-year-old glory days was a bold and risky venture. The investment in both money and

prestige represented a huge leap of faith. In those days, an upper Madison Avenue location would have precluded it from serious consideration as an important retail destination. Everyone advised against it. Some people said it was too big . . . it was in the wrong location . . . it was too small . . . it would take business away from his existing outlets.

In a profile penned a few months after the store opened in April 1986, *Forbes* magazine characterized Ralph's decision to operate his own store as "business heresy and bad taste to compete with your own customers." Imagine sitting down with your two Manhattan retail anchors, Bloomingdale's and Saks Fifth Avenue, and explaining to them that you planned to open your own consumer colossus right in their backyards, and oh yes, it would end up increasing their Ralph Lauren businesses. The decision was Ralph's alone.

A huge gamble in every sense. Naomi Leff's firm was only five years old when she was offered the Rhinelander commission. More than a handful of people tried to convince Ralph that she didn't have the track record for such a mammoth task. But he had made his decision. Polo Ralph Lauren obtained the lease in 1983 and set about creating its first flagship store.

The undertaking is a chronicle of painstaking dedication and patience, on the part of not only Naomi Leff and her staff but also the Lauren creative team, vital collaborators in the venture along with a throng of fine craftsmen without whose skills the building's artistic standards would have never been upheld. Although the structure had pedigree and great bones, over the years it had been subdivided into apartments and offices. The ground-floor windows had been replaced with a plateglass storefront, and the interior was a dilapidated wreck with drop ceilings and ductwork that obscured the neoclassical details, leaving scant physical evidence on which to base a restoration. Nevertheless, pulling from the remaining architectural elements and using what historical documents were available, the renovation remained as faithful as possible to the spirit and intent of the chateau's original owner.

In 1986 when Ralph Lauren opened the doors to his fantasy emporium, published figures projected costs at around fifteen million dollars; however, it took three years and thirty million dollars before the building was

305

"Ralph Lauren never really thought of himself as a designer, but as someone who tells stories through his clothes," states son David Lauren. "And he never thought of the mansion on Seventy-Second Street as a store. It was an environment, a club, and an atmosphere that created context around his brand, allowing him to tell his story in a clearer and more powerful way." At the time, Ralph described the mansion similarly, if more succinctly, saying: "It is, quite simply, my dream come true."

Designed by Naomi Leff & Associates, the rundown neo-Renaissance mansion underwent a revival befitting its fairy-tale facade. The herculean two-year renovation included a complete restoration of the façade and rebuilding of the interior. Skilled artisans, gathered mostly by word of mouth, were assembled to restore the building to its former grandeur . . . and beyond.

306

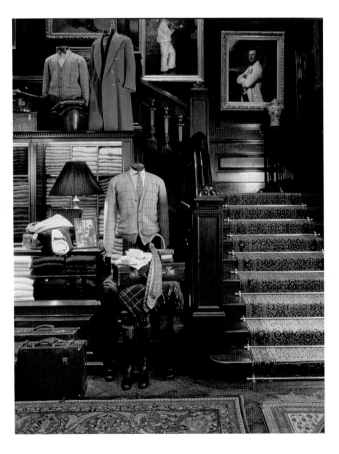

finally returned to its former stature. In the age of fashionable-today, dated-tomorrow architecture, the Bronx native was to swim against the current and deliver a beautiful addition to the city's storied retail pantheons. Architectural preservationists lavished Ralph with praise for bringing life and architectural dignity back to one of New York City's most historic buildings.

To enter the Rhinelander is to be immersed in a deluge of sensory overload. Highlighted by the warm mahogany wall paneling, baronial staircase, and hand-carved balustrades lined with gilt-framed ancestral photographs—the tones, the textures, the collective luster evoke a castle-in-the-air kind of reverie. Fragrant with the scent of fine sachet, the airwaves stream the résumés of Berlin, Porter, and Gershwin.

Build it and they will come . . . and they did. People flocked to see the designer's clothing and lifestyle-decorated rooms. A year after the store opened, sales topped thirty million dollars with an average of 1,000 to 1,500 customers walking through the doors each day. John Fairchild, *Women's Wear Daily*'s legendary publisher, speaking on the subject: "There are a lot of people for whom just going in there bestows a kind of cachet. In one hundred years' time, the Rhinelander will stand as the ultimate testimony of what we liked doing best—shopping. He is a merchandiser of his ideas par excellence."

That year Ralph Lauren made the cover of *Time* magazine. In 1987 *Women's Wear Daily* anointed the Rhinelander as one of the city's top tourist attractions. Ralph's gambit had dramatically altered the face of luxury retailing, becoming a blueprint for designer flagships that then began to rise along major shopping avenues around the world. The Rhinelander was to forever change the way customers would shop in the nineties and into the new millennium.

The difference between Ralph's universe and that of his modern, hard-edged European rivals was never more apparent than when one entered one of his retail installations. Whether a stand-alone or a shop within a larger store, passing through its portals made customers feel like they were coming home. "I don't usually feel comfortable walking into designers' stores. At Ralph, everybody makes you feel at home," states Italian couturier Valentino.

Not only did sales increase at Ralph Lauren venues around Manhattan, the Polo businesses at Bloomingdale's and Saks Fifth Avenue also grew precipitously in the Rhinelander's wake.

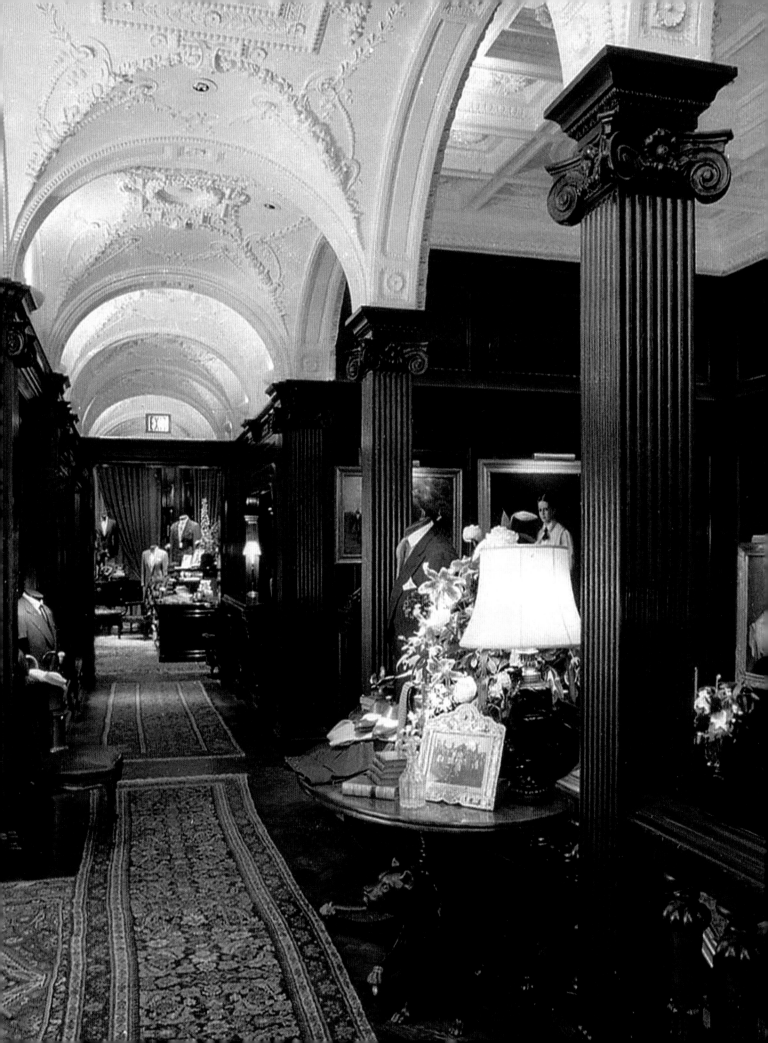

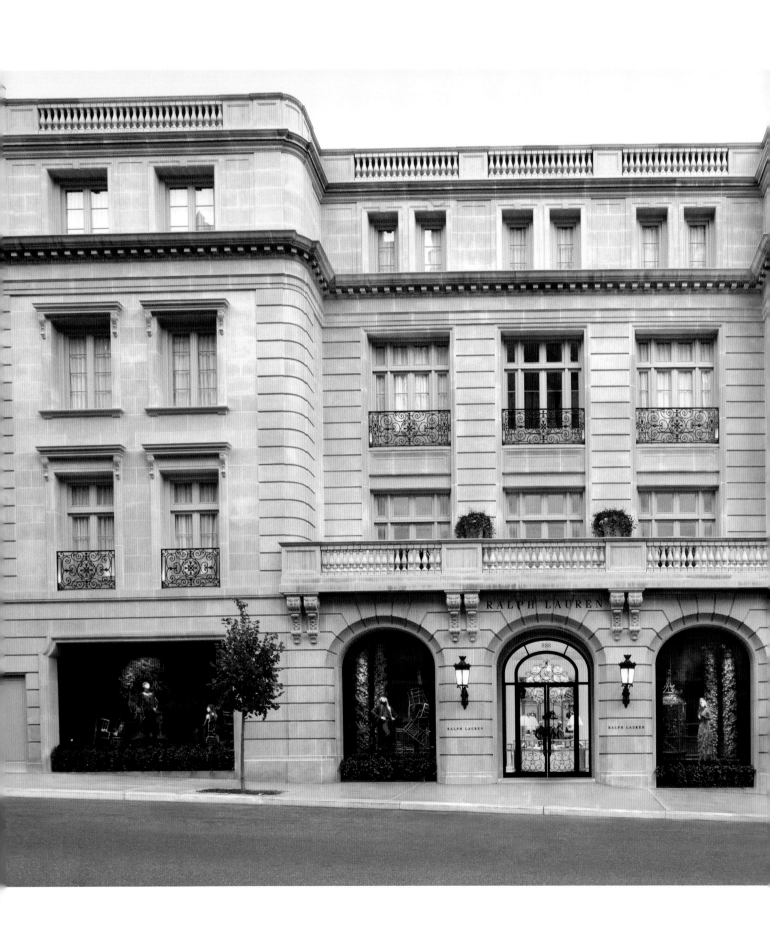

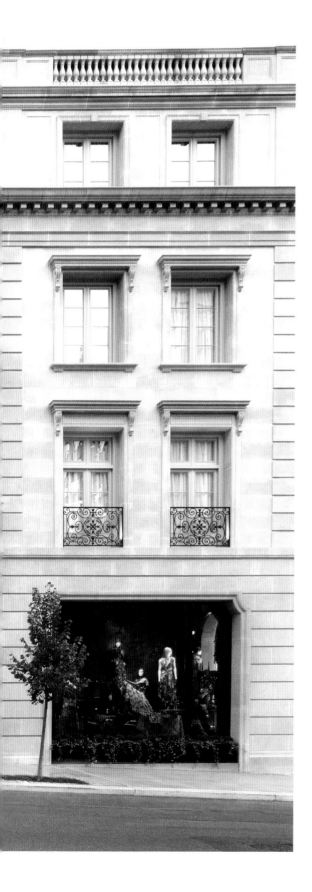

888 MADISON AVENUE
The Women's Store

"IT'S GREAT TO BE IN A SMALL BUILDING
that was built on a budget," laughed Mayor Bloomberg
addressing a crowd of New Yorkers attending the opening
of Ralph Lauren's new women's and home store at 888
Madison Avenue, across from the Rhinelander. Paul
Gunther, president of the Institute of Classical Architecture
& Art, noted, "I believe it's a noble structure that ulti-
mately will surrender itself to the context of the neighbor-
hood as time goes by."

In place of the unprepossessing two-story building
that previously housed his sportswear shop, Ralph Lauren
decided to create a proper counterpart to the Gilded Age
mansion across the street. For his latest retail palace, the
designer chose the Beaux-Arts style, a boldly classical
architectural movement last popular in the 1920s that first
came into prominence around the turn of that century.
Though some local skeptics challenged the idea of

The women's store at 888 Madison Avenue is a study in balance
and light: beautifully symmetrical with arched entryways, a
balustraded second-story terrace, and wrapped in perfectly mortared
blocks of rusticated Indiana limestone. Built from the ground
up by the architect Thomas Hut and the design team at Weddle
Gilmore (who had just completed the designer's Paris shop on
Boulevard Saint-Germain), the new mansion on Madison is an
understated yet perfect counterpoint to the steep roofs and Gothic
tracery of the fanciful Rhinelander chateau across the street.

constructing something that took its justification from being from the past as opposed to the future, the designer took comfort in communing with other iconic Beaux-Arts buildings such as the neighboring landmarked Duke and Frick mansions. Strangers have been known to come up to him in the street and thank him for his architecturally sympathetic additions to the neighborhood.

With its large cantilevered cornices, arched glass door entrances, and flawless mortared blocks of Indiana limestone, many believe Ralph's newest testament to high-class taste is the most ambitious shopping statement made in Manhattan since Bergdorf Goodman opened its doors in 1928. Working for more than two years, American and European craftsmen carved parts of the façade by hand, while the lacy black ironwork for the door, window railings, and interior staircase was fittingly forged in artisan-pure tradition, with fire, hammers, and tongs. The façade's arched windows were specifically requested by Lauren to resemble those gracing turn-of-the-century Paris. Much of the interior plaster paneling was custom designed and crafted by hand.

Conceived from the ground up as the definitive showcase for the Ralph Lauren lady, the twenty-two-thousand-square-foot store is currently the brand's largest women's store. Splendor reigns within these walls. Paved in Turkish limestone with a special honed finish, the entrance hall exudes glamour from the refracted glow of the illuminated display cases and special fabricated vitrines trimmed in custom antique-silver finishes. The ground floor is dedicated to specialty accessories like the Ricky bag, which can be made to order in twenty-one shades of crocodile.

The four-story mothership pulsates with the prospect of unremitting prosperity; every wall opening offers a seemingly unending treasure hunt. Luxury sleepwear is rolled out in a Hollywood-boudoir stage setting while another nook leads to a made-to-measure department for individually tailored pieces. One elegant cul-de-sac introduces the first Ralph Lauren fine jewelry boutique along with the company's first watch and jewelry salon in the States. Ralph's collection jewels are shown alongside vintage costume jewelry and a stockpile of fine antique jewels.

A sweeping four-story staircase of cream limestone embellished with black cabochons escorts shoppers from one floor to another. Each floor's stairwell is highlighted with beveled mirrors and dressed with original photography, sketches, and lithographs. Although its grand staircase is said to have been inspired by those of the Astor and Duke residences, some posit whether Chanel's famous stairway in her Paris salon might not have insinuated itself into the conversation. Many grand town houses feature expansive marble staircases with ornate wrought-iron banisters; however, this one evokes an understated splendor as its wider, more gracious scaled steps are unpolished and thus, like everything else, exudes a well-mannered, discreet luxury.

Upstairs, elaborately paneled rooms are lit with coruscating crystal chandeliers that cast a sequined light across the ceilings, bathing the passerby in a flattering glow. Dressing rooms are sheathed in exotic wall coverings. The top floor houses the designer's Home collections featuring two seasonal lifestyle rooms as well as assorted tabletop items and fine bed and bath linens. Furniture from the Ralph Lauren Home collections is beautifully choreographed throughout the floors' displays and mannequins.

This high-flying but feminine neoclassical structure is a perfect complement to the handsome French mansion across the street. Ascend to its second floor and walk toward its Madison Avenue windows. Floor-to-ceiling French doors open onto the looming French Renaissance–inspired Rhinelander, momentarily transporting you to Paris's Hotel Ritz where gazing out, another French architectural horizon envelops you, the famous Place Vendôme with its circle of Jules Hardouin-Mansart decorated façades.

There would be yet another first before the night was to draw to a close. Mayor Bloomberg presented Ralph with the key to New York City, making him the first fashion designer to receive the honor. Later that evening, kicking back to take in the ceremony's full import, the designer turned to the mayor and jokingly asked, "What does this key open?" His Honor's reply, "Absolutely nothing."

For anyone stopping to take in Manhattan's most elegant intersection, that answer may not be entirely on point. It's hard to remember what the *ville*'s most elegant intersection looked like before Ralph Lauren.

The new store's layout with its sweeping stairwell creates a mirror image to the men's store. While both staircases inspire a sense of history, the women's store manages to seamlessly blend a Busby Berkeley, old-Hollywood theatricality with a modern, cutting-edge glamour. Its wide stairs and expansive use of mirrors connects the four floors of generously scaled chambers that showcase the full breadth of the designer's luxe women's apparel and home furnishings.

CORPORATE HEADQUARTERS

FROM 1967 TO 1991, Polo Fashions corporate offices operated out of a warren of tiny rooms scattered throughout a narrow ten-story former apartment building on Manhattan's West Fifty-Fifth Street. Employees buzzed around in cramped quarters, the elevators so slow staffers took the emergency stairs, meeting and interacting in and around the connective stairways. There was a great family atmosphere to it. Everyone from the president on down enjoyed the creative chaos that resulted from such close-knit quarters, creating an informality and camaraderie that everyone hoped would always define Polo's corporate culture.

Today the company's nerve center is situated in a reflective glass skyscraper on Madison Avenue in Midtown Manhattan. The visitor enters through sets of swinging glass doors to a vast, high-ceilinged, sleek lobby appointed in gray marble. The elevator whisks you up to the sixth floor, where, stepping out, you enter an altogether different universe.

The new offices were designed by Shelton, Mindel & Associates. Back in the 1990s, there were few plum architectural projects to be had in recession-troubled New York. The new 170,000-square-foot Polo Ralph Lauren international headquarters that was to house three hundred people was clearly one of them. As to why a small design firm staffed in a twelve-person downtown atelier beat out more than two dozen large design firms with tons of experience, Nancy Vignola, senior vice president of Polo's Home Collection design and creative services says, "Other design firms came to us showing us what they thought we wanted—it looked like the style of a conservative law office. In fact, it was exactly what we didn't want. They just didn't understand us. We are used to judging people in terms of creativity and we liked the way SheltonMindel hit the right chord."

The other reason for the ostensibly random choice was that designer Ralph Lauren prefers to roll the dice on smaller, more flexible, and more creative firms for jobs that call for a high level of originality. Says Ralph of his decision, "From the start of my career, I went for mavericks in the world, people who dream." "Ralph always takes chances," Peter Shelton observes. "He was very courageous to have the faith to pursue this approach. It was a sort of unraveling of the Polo image to a more modern look, as if layers came off the Polo pin-striped suit and white shirt analogy."

The designer's vision of his world is as strictly contextualized behind the scenes as it is in front of them. Commencing with a six-floor elevator ride, you step off into the mahoganized universe of Polo Ralph Lauren. So quiet you could hear a pin drop, welcome to the reading room of Ralph's imagination, a more irresistibly rendered English library from a stately home in Gloucestershire than likely exists anywhere in the physical world.

The principle Peter Shelton and Lee Mindel seemed to have grasped up front was the real-life counterpoint to the business's public image of luxury and upscale grandeur, that of an easygoing, somewhat informal interpersonal fraternity. In fact, the project's true test was being able to reconcile the need to fashion a warm residential feel within a cavernously stark commercial cube. SheltonMindel's interiors were to bear little resemblance to its sleek-tower host.

Upon arriving at the sixth floor, the elevator opens onto a dark paneled area, where you are greeted by an enormous bronze of the Ralph Lauren polo player. Moving through to the reception area, the seduction of the space's expanding aesthetic begins to unfold. Before you is a cavernous two-story atrium called the Reading Room with walls paneled in mahogany and covered with Black Watch plaid, complete with a major stairway and balustered balcony. It wouldn't look out of place in a stately country home in Gloucestershire. States the designer, "This place is special, but it was never meant to be too special. It's about our design, image, quality. It makes our statement clear; we do quality things, things that endure."

The impression is like everything Ralph touches, a looking glass into times gone by, except here, done up more consummately than the real past ever was. Its leathery sofas and clubby chairs are deep and inviting, the tables piled high with magazines and coffee table–size, illustrated books. There is a graciousness to its tranquility and hush, with the only voucher of daily life being the large ceramic bowl stockpiled with multicolored M&M's, the company's signature snack, from which everyone who passes manages to spoon up one or more mouthfuls.

Ralph has long believed that the most favorable environment to conduct business in is where both employees and customers feel relaxed and highly regarded. Toward that end, SheltonMindel created a series of quadrangles within the work space's four floors for people gathering, where both customers and employees are invited to lounge, to use a cell phone, read a magazine, and even stop to gab. With an open floor plan, the light-filled vertical campus combines traditional wood-paneled walls and columns linked by a grand mahogany staircase that sweeps from bottom to top of four of the eight floors. Like the Rhinelander, the stairway was inspired by London's Connaught Hotel's renowned central concourse.

From the close-quartered honeycomb setting of its former offices, Ralph understood the stairway's inherent virtues, allowing people to run into each other while getting to know each other better. Personal interactions en route from floor to floor serve to keep the in-house design teams better connected and encourage a more organic exchange of ideas. In facilitating such movement, the architects stacked all the work spaces and studios vertically rather than horizontally.

To create a working environment that exists both apart and alongside the reception's soaring mahogany chamber, the architects laid out four floors of gleaming white design space that enclosed the lobby. Each floor is virtually identical, with the same long hallways, ash

Opposite: The back offices are designed with a home-office, residential feeling. Blond maple wood and special workstations adaptable to various conditions provide individuality and flexibility within the white spaces. The corporate library and resource center provide professional cover for the creative teams whose need for design reference and authenticity requires the company's vast archives be properly organized and easily accessible.

Above: The designer's chock-filled sanctum is a tidal wave of mementos and gifts from family and friends accumulated over a lifetime. The office's noncorporate demeanor reveals a lot about the designer's personal tastes and interests, as well as the creative forces driving his vision, being both traditional and modern at the same time. Like the great storyteller that he is, Ralph's office reflects an individual of great imagination and originality.

cabinets, open work spaces, conference rooms, and galley kitchens. The white walls, sisal carpeting, trowel-plastered ceilings, and custom lighting combine to create a light, modern feeling. Enhanced with residential furnishings and accessories from the Ralph Lauren Home collection, the custom-designed workstations reflect the desired homelike atmosphere found in the executive offices. Remarked Mindel, "Both worlds need each other, the mahogany needs the white spaces. The sum of the parts is more interesting than the pieces. The tension between the two is celebrated."

The carefully curated informality reflects that of the entire executive offices, particularly the dress code, which is more understood than spoken. As to what the boss might be wearing is anyone's guess. Ralph dresses to express that day's particular mood. He can appear in anything from a double-breasted pinstripe to his usual work uniform of frayed denim work shirt and jeans to a black T-shirt, beat-up cargo pants, combat boots, and Navajo beads at his neck. More family-like than in other fashion headquarters, no one calls him Mr. Lauren. Many of his staff have been with him for decades.

Anchoring all this style-setting is the inner sanctum, the designer's own office, undoubtedly one of the most eclectic work spaces ever divined by the central figure of a multibillion-dollar international company. Eschewing the typically voluminous and often-spare corporate backdrops favored by other Masters of the Universe, Ralph has taken the size of a large living room and basically created his own private fishbowl. Much like his homes, every surface is crowded with mementos of his life, black-and-white portraits of his wife and three children, model cars and airplanes, miniature cowboys and horses, and innumerable stacks of coffee-table books on topics ranging from architecture to watches.

Some might find the setting too busy to live with; however, it does kind of set the house style, as many of his longer-term staffers conduct business in their own personality-strewn offices. No design work is actually done there, only small meetings. Ralph prefers to go to an individual design team's backyard where, flanked by season-specific idea boards and theme-in-progress visuals, it's easier to work on each collection's development together.

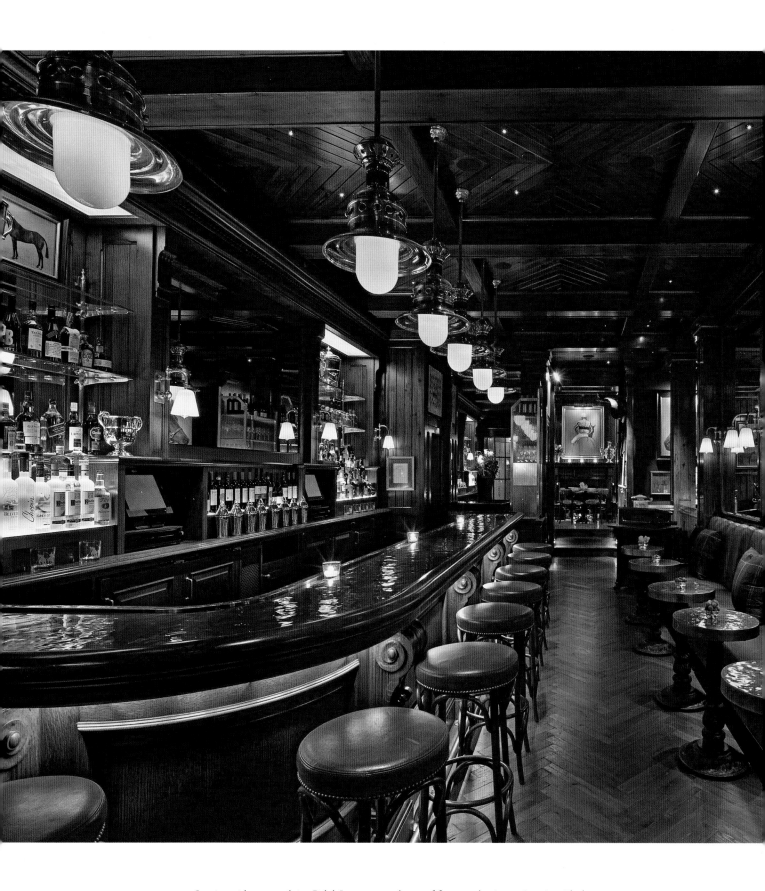

Starting with some neckties, Ralph Lauren spent the next fifty years shaping an American ideal
of the good life. Now New Yorkers can dine in it. Upon entering there is a clubby sense of
occasion. States the designer, "When you walk through the door, I want you to feel immediately
at home, and when you leave, I want you to look forward to returning soon."

THE POLO BAR
Running on All Hooves

FOR ALMOST HALF A CENTURY, New York society gathered at La Cote Basque—Gotham's grand bastion of old-world French cuisine and couture-donning ladies who lunch. Today its newest proprietor attracts a similar cross section of blue-chip patrons while serving classical American fare amid clubby wood paneling and a profusion of equestrian-themed art. Welcome to Ralph Lauren's Polo Bar.

"The celebrity chef Bobby Flay expressed awe at Lauren's ability to take what amounts to an oversized crypt and turn it into a warmly inviting destination restaurant. 'If a broker had shown me that space, with the bar upstairs and the restaurant downstairs, I would have walked out in twelve seconds,' Flay said. 'I don't think I'm that good.'"

With his talent for made-to order history, Ralph must be "that good" because his bi-level space opened for invitation-only previews during the bitter days of winter to quickly become the "hot place" where even knowing the secret email was no guarantee of booking a table anytime soon. At first the quickly expanded reservation department was trying to dispatch 1,200 calls a day. Today the door is manned by a gauntlet of smiling iPad-clad gatekeepers waving reservation lists. To merely step inside, a booking is required. Five years later, if you call for a table, expect a one-month wait.

The Polo Bar reprises a winning formula Ralph has used, with some variation, at his two other restaurants, the RL in Chicago, adjacent to the designer's large flagship store, and Ralph's in Paris. A fashion eatery in the windy city, RL first debuted in 1999 as an Italian-inspired restaurant, changing to a more traditional American menu sometime afterwards.

Ralph's, the designer's first restaurant in Europe, opened in Paris in April 2010. Tucked inside what was the stable in this structure, a seventeenth-century limestone *hôtel particulier* on the famous Boulevard Saint-Germain, the restaurant enjoys rapturous acceptance with stylish locals for its American standards such as Cobb salad, crab cakes, and its towering Ralph Burger. Full nearly every night, many of its devotees are foreigners with American-in-Paris food cravings as well as Parisians who've become obsessed with elements of the hipster foodie culture, like artisanal cocktails and brunch in Brooklyn. "I'm a novelty in Paris," the designer reprises.

For his first hometown eatery, the designer turned to New York City establishments like the famed 21 Club and Keens Steakhouse to inspire some of the restaurant's midcentury club aesthetic. Upon entering you are ushered into a handsome railroad-car-size barroom with herringbone floors made from reclaimed oak and walls paneled in pine boards salvaged from an 1860s Alabama textile mill. A massive oak bar with a hammered-brass top flanks a long banquette upholstered in aged saddle leather servicing a row of bistro tables with beaten-brass tops. Equestrian-themed regalia abound.

"'It's the 21 Club meets the Carlyle Hotel,' said Aerin Lauder, the Estée Lauder heiress and eponymous founder of a lifestyle luxury brand. 'The second you walk in, you're greeted at this beautiful bar with the silver buckets of wine and waiters looking perfect and bowls of fried olives.'"

Cooling your heels while waiting for reception to give you the dining go-ahead, the bar offers a selection of artfully crafted cocktails, many of them served in glasses as heavy as fishbowls. Just past the bar at the head of a stairway, you pivot right and take the lacquered-wood stairway down to the subterranean dining room.

Cocooned within its honey-hued coffered ceiling with nooks and alcoves covered in deep-green billiard cloth, its sumptuous saddle-leather banquettes are upholstered in a deep caramel shade similar to that of the ceiling. Appointed with plush, plumped tartan pillows, the room exudes a glamorous yet casual elegance. Indeed the richly layered and nuanced interior devised by the Ralph Lauren creative services team achieves the familiar hallmark of a fully actualized Lauren environment—that of entering time immemorial.

Custom-made brass lamps cast an attractive glow. When Ralph decided to create what, in an interview, he termed, "the restaurant I wanted to go to," he was unwavering about a few of the requisites. And one of them was that the lighting had to be pretty enough to flatter diners not necessarily in the first blush of youth. The room's glow seems to flow with conscious pleasure about every object of the room. Le Bernardin's Eric Ripert was quoted as having stated that the dining room is "the best-lighted restaurant in New York."

Whereas Ralph wanted a hometown haunt, he also wanted the kind of food that attracted customers rather than Michelin stars, simple fare like getting an old-fashioned veal chop served the right way. If the city's elite were first drawn to The Polo Bar to rub shoulders with those of similar stripe, they returned to the cozy in-crowd clubhouse for an unexpected reason—they liked the food.

Instead of the usual breadbasket foreplay, waiters serve richly flavored popovers. But unlike the sometimes dry and re-warmed upper-class staple, the Polo Bar's are fresh-baked chewy numbers crusted with Gruyère cheese, graced by a nearby *tranche* of real butter, should one want to parlay the wheat high any further. In preparation for the main course, you can snack on a bar menu that includes a fine gourmet version of pigs in a blanket with a pot of whole-grain mustard on the side.

Ralph decreed that his restaurant would serve the simple foods that he favors, so the menu offers classic American fare like roast chicken and Dover sole along with grass-fed beefsteaks from his Double RL ranch, as well as the thinly pounded chicken so beloved by fashion's weight-watching crowd.

Also included was a fatty holdover from his Bronx boyhood that he never quite lost a craving for. The Polo Bar's twenty-two-dollar corned beef sandwich is an updated Reuben served with a great twirl of fries basking in a silver cup. Layered with house-brined sauerkraut and melted Swiss cheese on marble rye, the sandwich is garnished with a pickle and a side of coleslaw. No deli Reuben here; this mouthwatering treat is memorable enough to galvanize any self-respecting foodie's taste buds for a return round.

Some toss off The Polo Bar's extreme success to the owner's alleged Midas touch, as if Ralph waved a wand and *poof*, it all just happened. As anyone who has ever worked alongside the control-or-die designer will attest, he was involved in each step of the restaurant's birthing and bidding, from the color of the ceiling (inspired by the interior shade of his vintage woodie station wagon) right down to the menu's typeface and color of the polo mallet–shaped swizzle sticks. From Raul Barreneche's 2015 article in *Architectural Digest*: "The designer's all-encompassing aesthetic extends to the barware and table settings: The etched-crystal glassware and the silver cocktail shakers and corkscrews are all from the Ralph Lauren Home collection, while the dinnerware is made in England exclusively for The Polo Bar."

The restaurant conducted months of invitation-only previews to those from inside and outside the company to help fine-tune the diner's experience. As the designer opined, "My other two restaurants are successful; however, opening in New York City is a whole other thing. This is a tough crowd with high expectations and little tolerance for mediocrity."

Now entering its fifth year, The Polo Bar appears to be running on all hooves. "'Where else can you go that's buzzy and cozy that has great comfort food and is truly chic?' [literary power agent] Lynn Nesbit asked one evening."

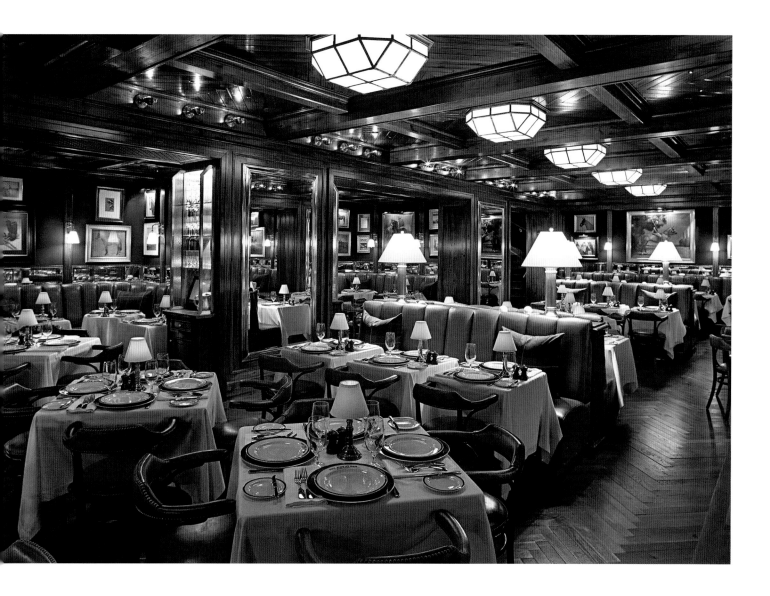

Above: "Brooke Astor would have loved it," declared a regular patron, referring to a lighting scheme that deployed virtually every theatrical sleight-of-hand known to interior design. Ralph's design team had to do whatever was needed to distract diners from what is clearly the restaurant's most glaring deficit. "It was only later that I realized there were no windows," Barbara Walters said of a recent dinner eaten in what, as she pointed out, is in fact a basement.

Right: This blue-blooded Reuben is exceptional enough to entice any foodie back for another round.

HOODS UP

Ralph's Bachs, Beethovens & Brahms of Horsepower

In early 2005, sixteen vintage European sports cars sped toward Boston's Museum of Fine Arts for the institution's first exhibition devoted to car design. On March 5th the museum unveiled *Speed, Style, and Beauty*, a show dedicated to Ralph Lauren's personal collection of vintage automobiles. The cars, fifteen of which were displayed in the museum's second-floor Gund Gallery, had never been shown together and a few had never been publicly viewed. Additionally, a spectacular 1958 Ferrari 250 Testa Rossa was positioned in the museum's west-wing lobby. In commemoration of the event, the museum produced a lavish and authoritative book including photographs of twenty-nine of Ralph's automotive wonders with commentary by the designer along with the exhibition's curators and automotive historians.

"These cars—with their exquisite lines and innovative designs—are works of art, and their designers are artists," stated Malcolm Rogers, the Ann and Graham Gund Director of the Museum of Fine Art. "This is a unique opportunity to celebrate examples of the finest automotive design of the past century," says Darcy Kuronen, curator for the exhibition. "The automobiles in this exhibition were carefully crafted by skilled coachbuilders, and the wealth of detail found in not only the shape of the bodies but also in the wheels, grills, and even the gas caps is extraordinary."

Unfortunately, not everybody was up to speed when it came to displaying automobiles in Boston's Museum of Fine Arts. "Ralph Lauren's cars caused a stir in the art world . . . naysayers found dubious the very idea of the car as an art form. Critics questioned whether automobiles, even ones as prized as Lauren's, belonged among the museum's collections of sculptures, antiquities, Monets, and old masters."

Objects used for transportation had for a long time not been seen as art, although there can be no denying that with the growth in the field of industrial design, vehicles of every sort have been a source of inspiration for some of the most original stylists of the twentieth century. In the 1920s and 1930s, Italy and France first held outdoor events to celebrate automotive design called Concours d'Elegance.

The decades straddling World War II were an especially fertile time as craftsmen created elegant and innovative cars with exquisite lines and proportions. As a result, automobiles became increasingly admired as works of art as collectors and museums began to recognize the sculptural quality of particular designs and models. With its landmark presentation of *8 Automobiles* in 1951, New York's Museum of Modern Art (MoMA) became the first American art museum to collect and exhibit automobiles as examples of functional design. Arthur Drexler, MoMA's curator of architecture, boldly characterized cars as "hollow rolling sculptures." The 1946 Cisitalia (the name derives from Campagnia Industriale Sportiva Italia) 202 GT was the first car to enter MoMA's permanent collection, the forerunner to Ralph's own 1960 Ferrari 250 GT Berlinetta.

From the book *Speed, Style, and Beauty*: "Perhaps more than any other technological artifact of modern times, it is the automobile that has dramatically changed the way we live. For decades the world's major car manufacturers hoped to realize one of the most intricate relationships of form and function, of man and machine. A container that has the ability to transport us both physically and psychologically, it is a room on wheels that has become an overt and potent emblem of contemporary living. Like any art form, car design has always reflected ongoing changes in fashion, technology, and societal attitudes."

The vast majority of assembly-built cars produced since the early 1900s could have never been considered some form of higher art. Alternatively, there were a handful of small European firms that, under the stewardship of a visionary designer like Jean Bugatti, Enzo Ferrari, or Ferdinand Porsche, managed to turn out inspired models in limited production runs of fifty or fewer cars. Back in those days when an exotic, handcrafted, one-off car was still a

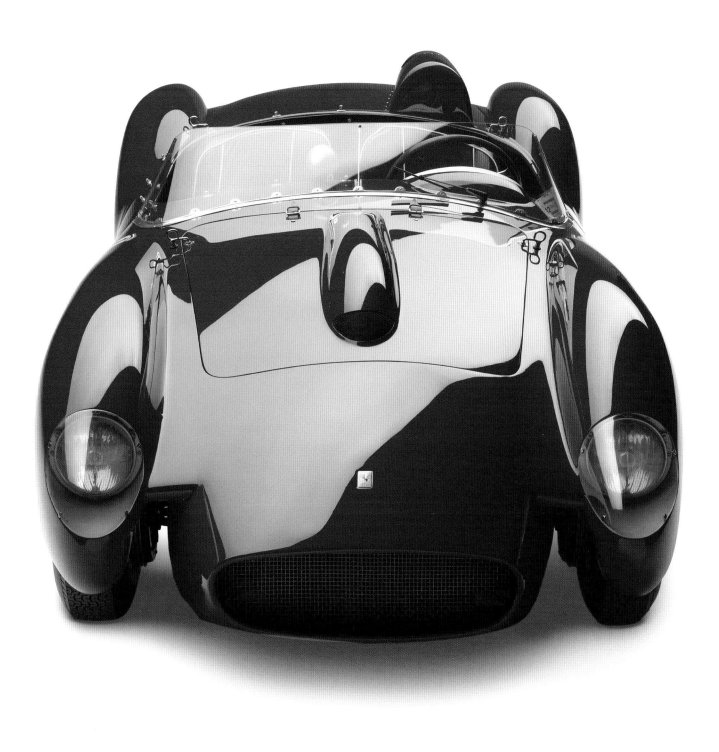

FERRARI 250 TESTA ROSSA

The Ferrari 250 Testa Rossa is a race-car model whose body was built by the Carrozzeria Scaglietti for Ferrari in the 1950s and 1960s. Unlike virtually every other coachbuilder, Scaglietti never put a pen to paper to sketch a design. He did everything "by the eyes alone," stating "good taste, aerodynamics, style, and function were the main elements of his designs." Characterized by a long hood, torpedo or pontoon-shaped fenders to cool the brakes, and streamlined headrest, the ageless design of the eye-catching 250 Testa Rossa is the ultimate 1950s Ferrari race car. In Italian, Testa Rossa means "red head," referring to the V12's valve covers on the cylinder heads of its engine that were painted in crinkle-finish red paint. In all, thirty-four 250 Testa Rossas were built from 1956 through 1961, with this car being the fourteenth of thirty-four. It was created for endurance and sports-car races the world over, most specifically the 24 Hours of Le Mans. The Testa Rossas won Le Mans in 1958, 1960, and 1961.

1938 BUGATTI TYPE 57 SC ATLANTIC COUPE

Ettore Bugatti once said, "A technical creation can only be perfect if it is perfect from the point of view of aesthetics."
Ralph Lauren's wonderfully rare and curvaceous Bugatti Atlantic Coupe is one of those rare cars that resides somewhere between
engineering marvel and fine art. Bugatti was at its best in the 1930s, and the Atlantic could be the most beautiful car the company
ever made. Early on, Ettore Bugatti gave himself the sobriquet Le Patrono (the boss). Wearing his imperiousness like a badge, he dressed
the part, bowler hat and jodhpurs, handsome boots and riding crop, artfully tailored sport jacket (which he probably designed).
"Bugatti was not willing to sell to just anyone with money. He had refused to sell one of his Royales to King Carol II of Romania because
he didn't like the man's table manners. A complaint about brakes from another customer brought the rejoinder, "I build my cars to go,
not stop." To the fellow who lamented his Type 55 would not start in cold weather, Ettore replied, "If you can afford a Bugatti, surely you
can afford a heated garage."Alarmingly sleek with aerodynamic designed fenders and cabin suggests cutting-edge aviation as much
as art deco–era automotive design. The avant-garde aluminum-bodied coupe featured a supercharged dual overhead-cam straight-eight

engine and had a top speed of over one hundred twenty miles per hour—an astonishing feat for its day. One of only four ever built and only two fully authentic models remain in existence, the Atlantic is derived from the 1935 Aerolithe show car. Designed by Ettore's son, Jean, the beauty of the Atlantic is that it's outrageous. This fantastic car is almost sinister looking with its exposed seams and button-head rivets running down its spine and around the fenders of its body. After Ralph acquired the Bugatti in the late eighties, there was only one firm he would entrust with such a precious treasure: Paul Russell and Company of Essex, Massachusetts, restorer extraordinaire to the automotive world. Over a two-year span, the Russell team spent in excess of ninety-six hundred hours working on it. From its dashboard to its tooling to its engine, every detail on the Bugatti Atlantic is like fine art or like a very fine watch. It's refined, it's elegant, it's fast, and it's also very beautiful. In May 2013 Ralph's one of two existing Atlantics was awarded the prestigious Coppa d'Oro at the annual Concorso d'Eleganza Villa d'Este car show in Italy. If the Atlantic were to come up for sale, experts predict it would be the most expensive car ever.

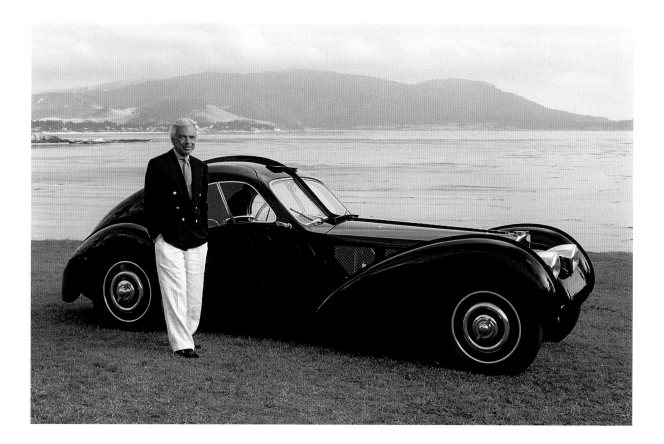

325

possibility, an owner bought a chassis and commissioned a coachbuilder to "clothe" it to his liking. Not unlike the fine art world where affluent patrons still sponsored much of the art-for-hire business, wealthy car-racing enthusiasts were responsible for bringing many unique designs to the marketplace that might have initially been rejected as too impractical for industrial purposes.

Although the exterior of a great car typically attracts our attention first, the wheels, grilles, bumpers, headlights, and even gas caps can be minor marvels of machine art in their own right. The engine and drive train, whose function is to move the car fast and methodically, can also be objets d'art of engineering genius. Likewise the interiors are frequently mini cockpits of princely privilege featuring etched window glass and rare wood steering wheels, exotic leather seats and dashboards composed of unique polished metal and wood knobs, gauges, and dials from which to operate the car.

In the 1950s and 1960s, the colors on racing cars represented specific countries, with both the car and the color being emblematic of the country from which it came. Jaguars were British racing green, Ferraris were *rosso corsa* (competition red), while French entries were typically French blue. The war may have ended but nationalistic pride still ran high. As a Jaguar Company advertisement proudly put it, their mobile steeds were intended to be unparalleled combinations of "Grace, space, pace."

Above: Awarded Best of Show at the 1990 Pebble Beach Concours d'Elegance, the designer stands next to his 1938 Bugatti Type 57SC Atlantic coupe. Ralph Lauren says, "I love discovering new worlds. Like race-car driving: I didn't know anything except I liked race cars. So I did research. I went to the raceway, I went to racing school, I bought cars. Little by little, I learned."

Below: Boston's Museum of Fine Arts showcased the evolution of car design from the 1930s to the 1990s with the Ralph Lauren Collection bringing together some of the rarest and most important automobiles from that time period. In commemoration of the event, the museum produced a lavish and authoritative book titled *Speed, Style, and Beauty*.

SPEED, STYLE, AND BEAUTY
CARS FROM THE RALPH LAUREN COLLECTION

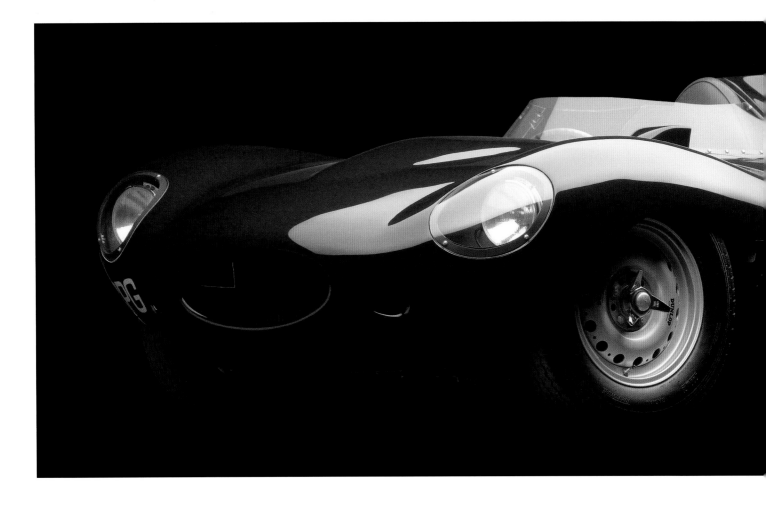

1960 FERRARI 250 GT BERLINETA SWB

If one automobile silhouette came to represent Italian style after World War I, it was the Berlinetta (Italian for "little sedan"), a shape most Americans term a fastback. The postwar maestro of the Berlinetta was the Industrie Pininfarina S.p.A., which began experimenting with the shape in the 1930s. "My father was instinctively an aerodynamist," said Sergio Pininfarina. "He believed aerodynamics were very, very important for speed, performance, and safety."

After World War II, Pinin worked with Turin-based company Cisitalia to create the landmark Berlinetta design for its 202 model. In 1951 a Cisitalia 202 was placed on permanent exhibition in New York's Museum of Modern Art, the star of the museum's groundbreaking exhibition. "The Cisitalia's body is slipped over its chassis like a dust jacket over a book" was how the show's catalog summed up Pininfarina's masterwork.

The 250 SWB was equally at home on the street or on the track. You could hop in your car in Milan, drive to Le Mans, win your class, and drive home. It was available with a steel body and luxury interior or aluminum body, like this one, stripped for racing, with disc brakes and no bumpers. The alloy-bodied competition SWB was the precursor to the GTO but much more user-friendly. Ralph's car is the thirty-first of one hundred sixty-five built.

This was a design that came out of Italy's unique cultural heritage, because the men who designed cars were never trained in styling. They were endowed with a natural instinct and taste for what was right in the delicate balance between line and mass. One story goes that the great designer Pinin was reviewing a full-scale plaster mock-up of the car and told his men to take five millimeters off it to make the car's appearance tauter. But rather than do as instructed, the group decided simply to paint the model, knowing it would appear smaller when seen in a color other than white. Upon viewing the model a few days later, Pinin nodded but then said, "I hate to tell you this, but the design still isn't quite right. We'll need to take off another five millimeters." That's the kind of intuitive eye responsible for the 250 SWB.

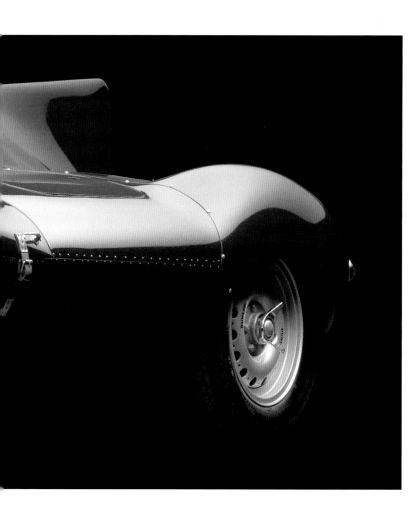

1955 JAGUAR XKD LONGNOSE

A sign on the wall in the Jaguar design studios in Whitley, England, succinctly states, "A Jaguar is a copy of nothing." The first Jaguars were stunning and offered tremendous presence and performance at a cost that was substantially less than one would pay for a corresponding Bentley and, later, Ferrari or Maserati.

With the introduction of the XK120 roadster in 1948, Jaguar Cars Limited took a decided detour away from the usual British designs of austere and formal-looking motorcars to create a shape that was flamboyant, distinctive, rounded, and flowing. There was no unnecessary adornment, just a look of pure, efficient power. It looked more like a fighter plane than automobile.

Fittingly, heartthrob and leading man Clark Cable took the delivery of the first XK120 in the states. Actor Humphrey Bogart would follow, and Jaguar's slinky roadster became an integral part of Hollywood life. Out of the XK120 came the next generation of Jaguar race cars, specifically the 1955 XKD. Perhaps no car from the fifties represents speed better than this racing Jaguar; its design looks like it came straight from a jet fighter. The front is rounded and smooth, a blunt instrument to cut the air. The windshield is cut down lower than one would expect and the wheels are tucked inside the car's clean fuselage of a body. The long-nosed XKD's undulating body terminates with an air-cheating tail fin behind the driver's head, making the car look like something from outer space, yet it was built in 1955.

Jaguar XKDs won Le Mans in 1955, 1956, and 1957. This is one of only ten longnose cars, which raised the D-Type's top speed to one hundred ninety miles per hour. This car was owned and raced by Duncan Hamilton, a prominent race car driver.

GEARING UP
Ralph's Car Infatuation

GROWING UP IN 1950s AMERICA, according to the book *Speed, Style, and Beauty,* cars were a part of every boy's life. Recalls the designer, "You weren't aware of being an enthusiast, you were just tuned in. I remember sitting with my friends and we'd count the cars, we'd say how many Chevrolets had gone by, how many Oldsmobiles, how many Pontiacs. You could recognize every car. For me a car was always something special. It brought you somewhere else, the car was a way of entering another environment. Eating in the car, driving to the country, stopping at a restaurant, being on your way to somewhere—the car was a part of my culture growing up, I never saw it as status symbol so much as an escape, or an entry into wonderful worlds.

"I learned to drive in my father's navy blue 1949 Pontiac fastback sedan. It had torpedo fins and boasted an Indian head ornament on the front hood that was a golden color—I loved that car. However, I was the youngest of four children so between battling my two older brothers to take a date out in it and by that time, the car was pretty old and shabby, it whetted my appetite to own something special someday. Like most guys, my dream was always, 'Boy, wouldn't it be cool to pick up a date in a great car!'"

Ralph bought his first car in 1963 when he was twenty-three and a traveling tie salesman for Rivetz & Co. His first dream machine was a British-made white 1961 Morgan convertible with red-leather seats and strap on the hood that he bought from Fergus Motors in New York City. "I drove it home and thought, I can't believe this is my car. That's a thrill that all people who love cars will get to feel in their lives."

Often asked about which of his cars is his favorite, Ralph will answer that cars are like children, it's very hard to say which one he prefers. "There are little things about each car that you come to love, whether it's the look, the steering wheel, the way it drives, or even the way it drives differently when you put the top up." Having different identities and spirits, as time went on each car came to represent a different period in his life. For example, after he started his company, he bought a 1971 Mercedes 3.5 280SE convertible. It was the last hand-built convertible Mercedes ever made. "I walked into Mercedes on Park Avenue and said I wanted that car, but with a tan top, tan leather seats, and a silver body. . . . They told me that they didn't make it that way. But then, they did it."

Picking it up for thirteen thousand dollars, it was an extravagance given how far from profitability his new namesake company was in those days. Nonetheless, Ralph was beginning to live as if he were already the successful person he was destined to become. And as his

fortunes increased, so did his appetite for automobiles. By the time Ralph Lauren and Polo became household names, he was one of the country's most discriminating car collectors.

Ralph's first real performance car was a black 1979 Porsche Turbo. He had all the wheels darkened so that no gleam of steel or chrome would break its sleek lines. Ralph loved it; it was new, it was rare, it was his own car with a unique Darth Vader look. Driving about in it he became very excited about cars and test-driving others. One day he was out in the Hamptons and his neighbor said, "Do you want to try my Ferrari? I'll try your Porsche." Ralph's knee jerk response was that he didn't really like red cars and therefore he didn't really like Ferraris. However, after taking the Ferrari out on Montauk Highway, the sound was so great and it felt so different that he fell hard. With his newly stoked Ferrari fervor, from that moment forward, it was pretty much off to the races.

"After that I was in London, coming out of the Connaught Hotel and there was this black 1971 Ferrari Daytona Spyder convertible. I said, 'What is that?' It was the Sultan of Brunei's car. I had a little fever for that car. I said, 'Where do you get them?' I wasn't collecting cars as such, I was just enjoying them. I could afford it and I figured if I had to get out, I could sell it."

As Ralph explains, "As I started to buy cars, I didn't know that I was building a collection. I just wanted the cars I was dreaming about. Once you drive a good one, it is like having a fever." But it was also about the famous car owners and the men who built the cars. He was fascinated reading about what made Enzo Ferrari tick, or Ferdinand Porsche's commitment to excellence, or how Ettore Bugatti seemed to live bigger than life—getting a sense of why these men built these cars and what their lives were like.

Although Ralph's collection is not the largest by any measure, it is highly regarded for the exceptional rarity and caliber of its makeup. Rather than creating a car collection in any systematic way, Ralph took a more idiosyncratic approach, acquiring particular cars that appealed to his personal aesthetic, much like a collector of fine art. He avoided the baroque period cars and the chrome-dripped Americana of many collectors, focusing instead on those automotive thoroughbreds that bridged the gap between art and engineering. As a result the shape and contents of his collection are very much a function of his own keen perception of style and beauty. Over the years autophiles have compiled numerous lists of what they consider to be the most collectible, no less the coolest cars of all time. It's no surprise that many from Ralph's stable have ended up in close proximity to the starting line.

Despite the seemingly random character of the Ralph Lauren collection, there is a kind of harmony to its makeup. With the exception of certain utilitarian vehicles such as the vintage Jeeps, pickups, and a nostalgic Ford woody station wagon, all of his cars are European, and all were created for racing or touring. Preeminently, it's their purposeful beauty that appeals to him. Not attracted to cars that sizzle because of artifice or cosmetics, the designer is drawn to those four-wheelers whose artistic components serve a particular function, like speed. Which may be why most of Ralph's thoroughbreds have racing provenances.

Opposite: This is no mothballed set of trophies intended to be turtle-waxed and untouched; you can pull them out and take them for a ride. Ralph Lauren, "Sports cars are the most exciting pieces of art I know and I think of them as athletes: they need a workout every so often or they'll get sick. And driving them is a workout for me too."

Below: One seat, no luggage, one purpose: the 1930 Mercedes-Benz SSK "Count Trossi" is one of the most coveted automobiles in the world. Lauren's SSK is a one-of-a-kind gem. It was built for Italian industrialist and gentleman racer Count Carlo Trossi, who, as legend has it, sketched this body on a cocktail napkin and a custom coachbuilder skinned it to his liking.

With a thundering, seven-liter supercharged six-cylinder engine and outside pipes, the Trossi SSK was the most copied car of its generation. Hollow formed with crested pontoon fenders, its long hood enveloped more than half its body. With an exhaust roar that was music to its owner or terrifying to the uninitiated, it must have seemed like a spaceship in 1930s Milan, where there were still donkey carts.

Ralph says of the car, "A one-off sports car designed by a man who was very influential in the racing world and had a wonderful taste level. It looks like an amazing 1930s car, but also, especially from the back, it could be the Batmobile from today's movies."

329

CHANGING LANES

"When I think about cars, I think about clothes."

RALPH DESCRIBES how cars have influenced his designs: "Cars have always been a rich source for my designs. I look at a car and love its highly stylized air vents, its gas cap, its richly polished burl-wood dashboard or the beauty of a leather strap over the hood. I take those details and integrate them into everything I design, from a watch to a sneaker to a bed to a woman's evening dress. . . ."

For the designer, automobiles are more than a conveyance to get from point A to point B, and like clothes, they are an expression of the individual who drives them. Cars are not only fundamental to Ralph's being, they are an essential component in his creative mindset and connecting story line. Ralph says, "Just the way I 'write' stories through my clothes, I think of my collections as movies with glamorous heroes and heroines, and how they dress and what car they drive as extensions of that dream."

Ralph always knew what he liked carwise, and he still owns almost every classic car he ever bought. One of his criteria for beautiful design is that it can never look dated. That's how he designs, for the long term, and that's been his guiding principle for buying automobiles. The cars he's collected throughout the years look as good today as they did when they were made—and sometimes better.

"Good design is about staying power as well as about being current. As a fashion designer, I'm always searching for ideas. And my ideas come from my dream world, they come from my work, and they come from everyday living," states Ralph. "There was one car that excited me when I was designing running shoes. I've been inspired by various cars to design many different things—luggage, for example. When I wanted to put luggage in the back of my first Porsche, I thought to myself, I can't put saddle-tan leather in this black Darth Vader car. I needed something dark and sleek with utility that represented what this car was about. So I designed luggage with a techie exterior and a glove leather interior, black, utilitarian pieces to put inside a black utilitarian car."

For example, both watches and cars are working machines that are fun, and the designer is well-versed in both. "I'm a collector, and I'm always looking for great design, especially in watches." Today evidence of that crossover philosophy can be seen in the way his array of impeccably restored vehicles has sparked many of his designs for fashion and home.

"If you love cars, the purposefulness with which they were created, in every detail, the engine, their upholstery, the outside ornamentation, the design of the wheels, the whole spirit is very exciting. You can't help being stimulated. Cars are a release for me."

"When I think about cars, I think about clothes," says Ralph. For his Fall 2017 fashion presentation, the designer staged a high-octane racing-themed runway show in his Westchester garage-museum using his iconic car collection as the backdrop. The soundtrack began with the *vroom, vroom* of engines starting.

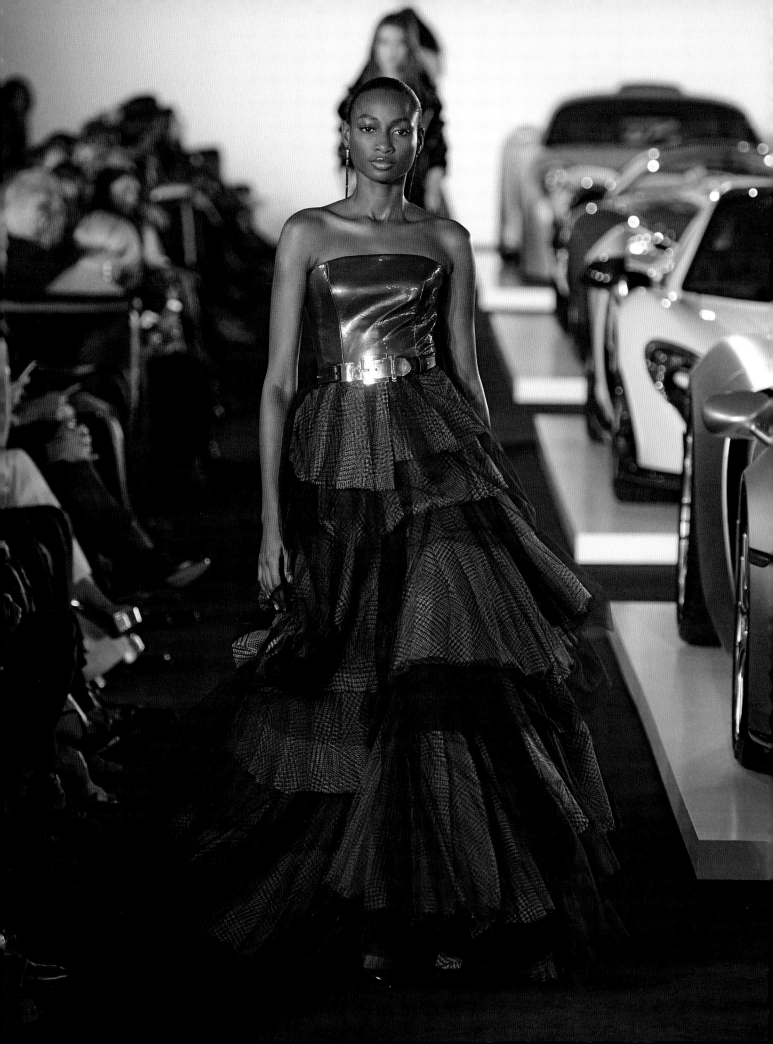

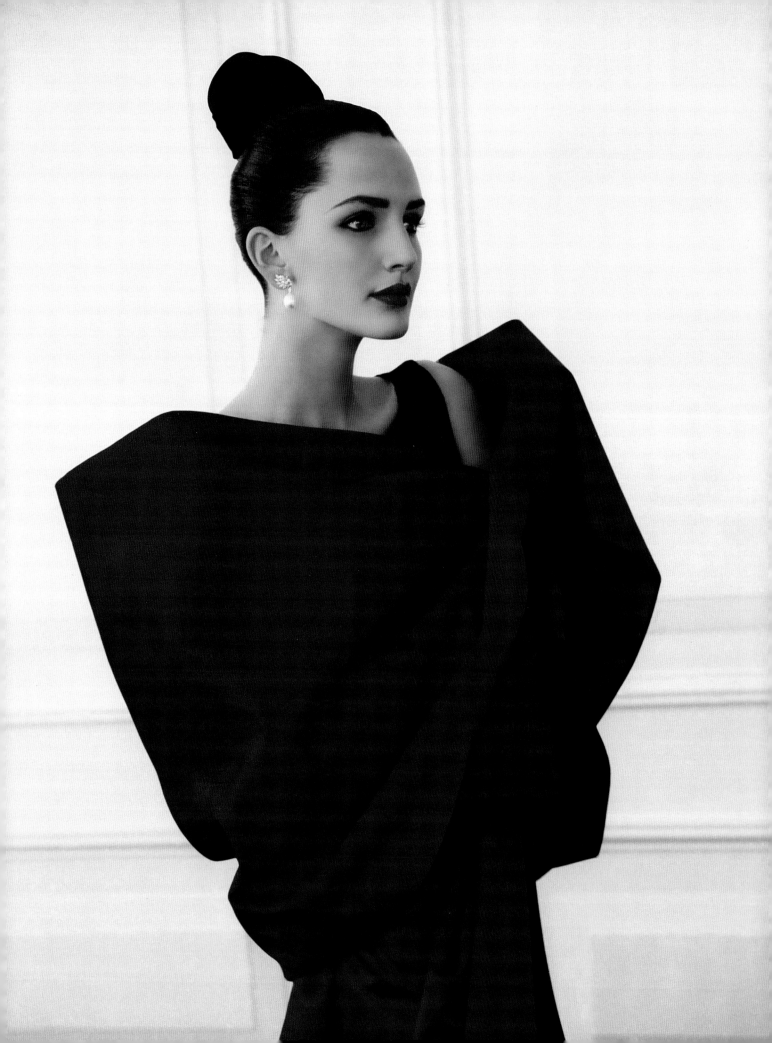

334

There's a shared design language between traditional timekeeping and the instrument panels of classic cars. The RL Automotive Skeleton watch is a tribute to the otherworldliness of his most prized car, the Bugatti Atlantic coupe. "Looking at the open workings of the Skeleton is like looking under the hood of a race car," he said. "There is an artfulness at the core of its every movement and a new boldness to the way time is measured."

Right: In 1998 the Ralph Lauren Home Collection introduced a lifestyle vignette called the Southport Collection inspired by the wood-sided station wagon of the fifties and sixties. Elements from the car are seen especially in the oak-and-mahogany veneer of the collection's Garrison bed.

Far right: Introduced in 1923, the first wooden-bodied station wagons were four-wheeled workhorses. Featuring handcrafted stripes of birch and mahogany on both interior and exterior panels, they were priced higher than other models. After the Second World War, the affectionately named "Woody" went on to become the automotive Norman Rockwell. "As American as apple pie. It's about my sense of my own life, how I live, what I love. I love the spirit of living in the country. I think the Woody captures this spirit. It is not a ritzy car, it was a car that the family could afford. It represented part of the dream of my life that had to do with the culture I grew up in."

Far left: In 1952, Mercedes-Benz advertised its 300SL Gullwing as "the best performing production model ever to be offered to the public." "Aerodynamics dictated the production of the 300SL's body, the car is round all over, as if a straight line would be a sin—no protrusions, no door handles, no outside rearview mirror, no appurtenances to impede the flow of air." The coupe's frame required very high sills, so it's most singular feature was its airplane-type doors, which were developed to open vertically, like wings. With both doors open, a seagull was suggested, and the evocative description "Gullwing" stuck.

The 300SL was very successful, winning the 1952 24 Hours of Le Mans and the 1952 La Carrera Panamericana road race. It also boasts a celebrity fashionability. Sophia Loren sported hers around her native Naples; Porfirio Rubiroso gifted one to Zsa Zsa Gabor; movie stars Glenn Ford and Elvis Presley were both proud owners.

Left: Crossover design: The channeled tan-leather seats of Ralph's Gullwing Coupe inspired the Bond Street Bed for the designer's Modern Metropolis Collection 1998.

337

D.A.D.
A Vroom of His Own

FOR MANY YEARS, the designer's car collection was dispersed between his New York estate in Westchester, his beach house in Montauk, and his ranch in Colorado. His most highly prized steeds like the Bugatti Atlantic and the Count Trossi Mercedes had been fully restored by Paul Russell and Company in Essex, Massachusetts, and then kept in storage there. With the exception of loaning them out for a particular museum tour or Concours event, Ralph had not seen many of them for years.

When the number of cars started to approach sixty, he decided that he had to do something to gather them under one roof, as many of them needed to be housed in climate-controlled conditions, away from the sea's salt air and danger from hurricanes, not to speak of the insurance company's concerns about damage and theft. Upon seeing the cars represented as art and presented for the first time by Boston's Museum of Fine Arts, Ralph felt that he really could, and should, do something important with them. His first thought was to build an underground garage on his two-hundred-fifty-acre Westchester property, but he soon discovered that even Masters of the Universe are not exempt from the intrigues of a recalcitrant local zoning board. There was also the consideration about how anyone who might want to visit the collection would have to be let onto the property and thus the logistical and security issues that might ensue.

Nevertheless, fortune smiled as Ralph's Bedford estate-keeper Mike Farina recommended to Mark Reinwald, the manager and curator of Ralph's car collection, that he take a look at a local Mercedes-Benz dealership's former storage facility not far from the Bedford property. Passing muster, Ralph bought the building and then asked Alfredo Paredes to collaborate with Reinwald to make the forty-eight-thousand-square-foot building into something more interactive and museum-ready.

A corporate name was needed under which the garage could do business so the acronym D.A.D. was devised from the first initials of Ralph's three children, David, Andrew, and Dylan. From the outside, the structure housing hundreds of millions of dollars' worth of motorcars is virtually anonymous, without a visible cue or sign that you've arrived at your destination. But once inside, it's anything but nondescript. You are buzzed into a glass-enclosed lobby leading to a glass-lined corridor housing a workshop on one side and a library-cum-archives on the other. A black-lacquer conference table anchoring Herman Miller Aeron chairs centers the room. A flat-screen television and models of some of Ralph's cars along with various trophies, certificates, and souvenirs out of their past decorate the walls. Specially designed black file cabinets set under stainless-steel counters hold expansive black binders on each car. The archives would happily consume weeks of any car aficionado's passions.

Across the hall, whitewashed walls, high-tech lights, and a floor clean enough to eat off confirm the workshop is not any oil-stained mechanic's lair. Other than a few selected posters from some of the car's races, there is nothing to distract the viewer's attention from the style-in-steel patients being treated to routine service and repairs.

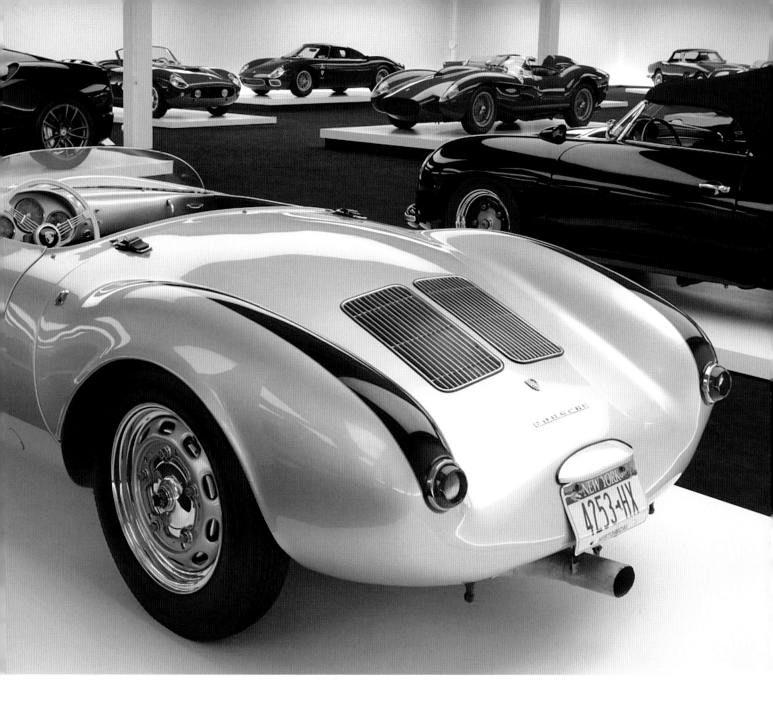

Stopping in the library to view a brief video of Ralph talking about his garage's four-wheeled cargo, you are then presented with a set of headphones. Each car has been assigned a number that corresponds to that car's exhibition signage inside. During the tour, should you want a more in-depth explanation of a particular car's ownership history or racing provenance, you can just dial up its number and press Play. Listening to American racing great Phil Hill's anecdote of how the Ferrari "scream" signaled who was behind him or how thrilled legendary race driver Roger Penske was to compete back in the early sixties in the Ferrari sitting before you, you enter an insider's world of racing lore and legend that animates the illustrious pasts of these torque-wrenching beauties.

Paredes and Reinwald designed the garage so that from the lobby you can see only as far as the workshop or library. As to where the cars are kept, that has yet to be revealed. However, at the appropriate moment, much like a Broadway theater's grand curtain being swept away, wall panels slide open to reveal SHOCK AND AWE . . . AUTOMOTIVE NIRVANA! Part Zen garden, part Rothko-like art gallery, forty-five of the world's most spectacular four-wheelers sit majestically in stone silence. Resting atop raised white platforms set on black carpeting stretching across a pristine-painted white arena, each four-wheel object is lit as if it has just emerged from the shadows below. Like an excited child suddenly being released by his mother, you feel sucked in, forced to run toward the light. A ramp—not stairs—connects the two-floored space so that the cars can easily be moved in and out. "You can just pull them out and take them for a ride," says Reinwald.

THE MUSEUM TREATMENT IN PARIS

The Art of the Automobile:
Masterpieces of the Ralph Lauren Collection

THE YEAR 2010 marked a series of Polo in Paris celebrations, the bestowal of the *Légion d'honneur* by President Sarkozy, and the openings of Ralph Lauren's flagship store and the designer's first European restaurant, Ralph's. However the designer was to treat the French to one more reason to celebrate. He dispatched the crème de la crème of his car collection, roughly a third of his cars, to Paris's Musée des Arts Décoratifs (located in the Palais du Louvre's western wing) for an exhibition titled *The Art of the Automobile: Masterpieces From the Ralph Lauren Collection.*

"It is undoubtedly one of the most important car collections in the world," stated Rodolphe Rapetti, chief curator of heritage at the Directorate of Museums in France who handpicked the vehicles for the show that opened in April and ran through August 2011. In deciding upon the cars for the exhibition, Rapetti favored those offering the most impressive provenances while demonstrating the same iconic artistry as found in the museum's own acquisitions like the Fabergé egg or the Ashbee bowl collections.

Showcased were seventeen exotic steeds of European provenance dating from 1929 to 1996. As with museum quality sculpture, the cars were displayed on white plinths. *The Art of the Automobile* was a chance for the Louvre to introduce one of the most important sources of inspiration for a designer who has influenced the taste of the world, offering a glimpse into what excites him on a personal level. It also aimed to portray the automobile as a work of art and not just a method of transportation. "By staging this exhibit within the Musée des Arts Décoratifs we show there is no difference between a superbly crafted automobile and other forms of fine art," says Rapetti. "They are all works that people can relate to on a profound, emotional level."

The droves of car enthusiasts queuing up along the Rue de Rivoli entrance were hoping to find a dazzling display of breathtaking bodywork. As advertised, enough sensuously shaped metal was in the gallery to make even a casual speedster's heart quicken. While each car was rare and steeped in racing lore, their collective beauty transcended the genre. That's why even the fanatics, the gear heads—who usually don't like cars consigned to such rarefied venues where it is forbidden to sit in them or even touch them—had to admit that the masterpieces from Ralph Lauren's private collection had every reason to be housed in such august surroundings as the assembly hall of the Musée des Arts Décoratifs on Paris's chic Rue de Rivoli.

Entry to the museum's makeshift automotive Valhalla was through an imposing wrought-iron gate. The king of the collection, Ralph's mysterious and stunning 1938 Bugatti Atlantic coupe welcomed the attendees. One of four ever created, with now only two remaining, the 1938 Bugatti Type 57 SC Atlantic Coupe, Chassis number 57591, is the last of the four originally produced models. Named in 1997 "the most beautiful car in the world" by a panel of automotive writers, designers, and historians—clearly Ralph's Bugatti Atlantic was an extraordinary work of art.

Visitors then ascended a massive marble staircase to three cavernous halls where the other cars were on display beneath vintage films of their racing heydays. Dating back seven decades, they encapsulated an era of adventurous owners, intense customization, and rich racing histories. Included was a brace of Bugattis, Mercedes and Ferraris, a couple of Alfas, and rarely seen stunners from Bentley, McLaren, Jaguar, and Porsche. With several of the entries making their first public appearance, this was a rare chance to savor one of the world's best-kept and most secretly curated car collections.

If the Bugatti Atlantic was the exhibition's king, then Ralph's 1962 Ferrari 250 GTO would have to be crowned the queen. Not just because its estimated price was in the same stratosphere, but because the 250 GTO was considered the quintessential racing Ferrari model: only thirty-nine were ever built with this model winning the GT World Sportscar Championship three times (1962, 1963, and 1964).

While there are a lot of celebrity car collections, few would qualify as the centerpiece of a world-class international exhibition glorifying the automobile as a museum-quality art form. Patiently assembled over multiple decades, they are some of the most extraordinary dream machines to ever grace the world's highways—all jewels from Europe's automotive crown, courtesy of America's own motoring royalty, sportsman Ralph Lauren.

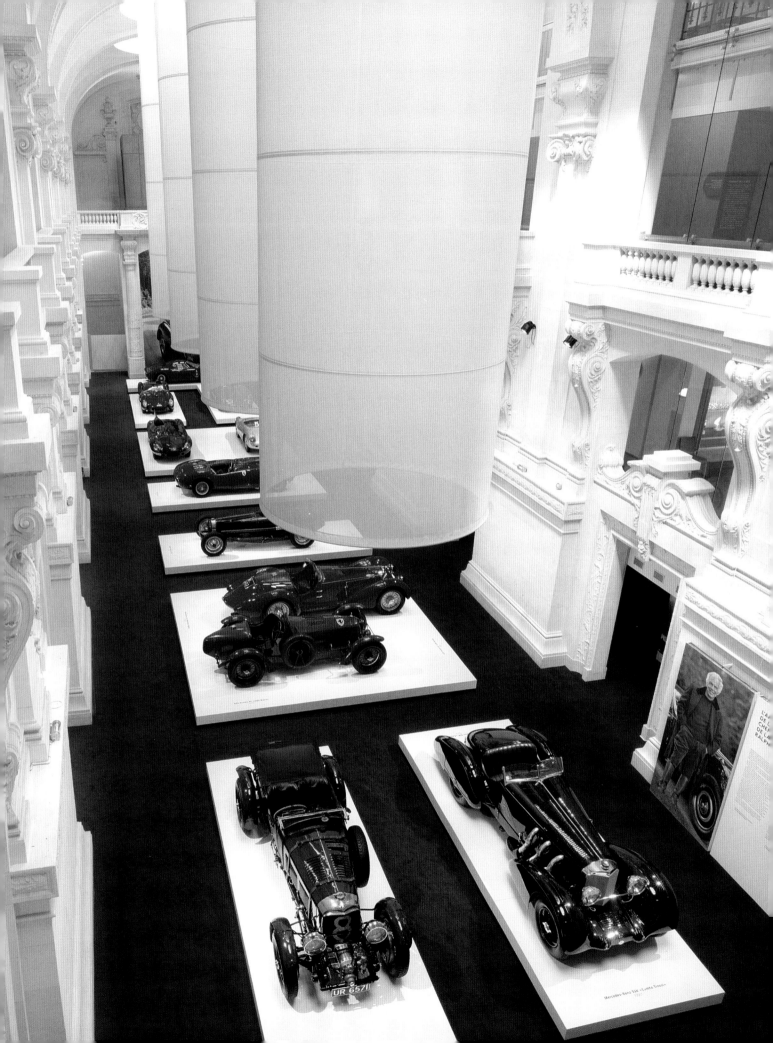

UR 6571

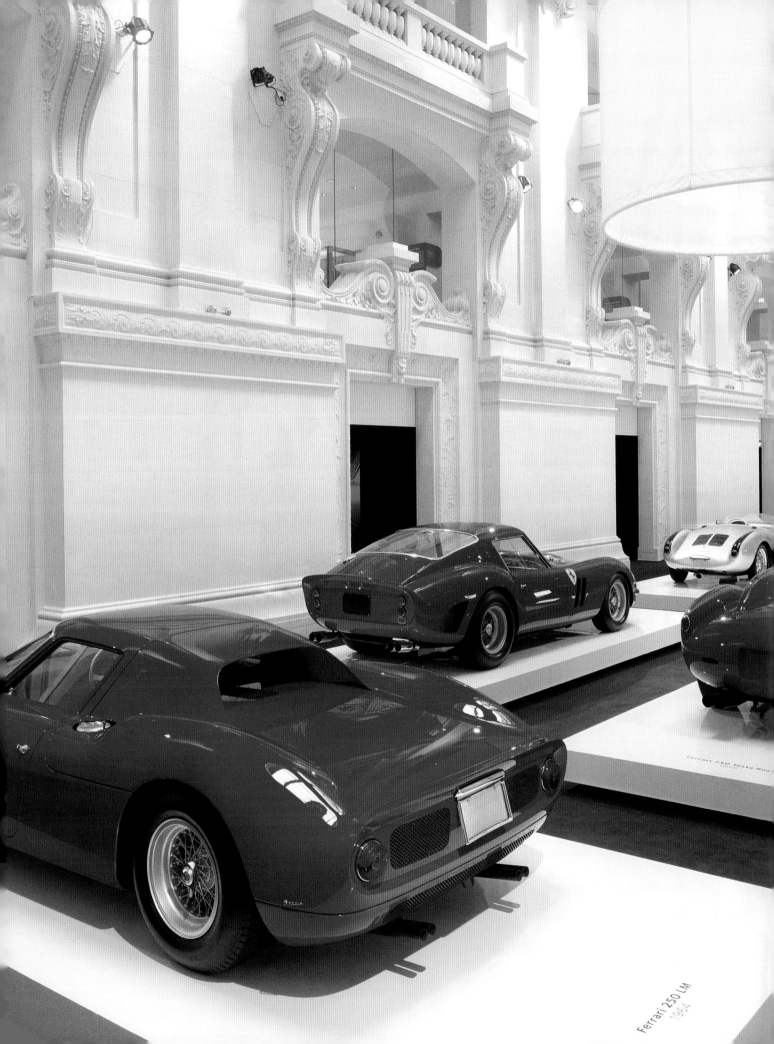

Ferrari 250 LM
1964

But Ferrari wasn't the only brand able to hoist prestigious triumphs on the racing circuit. Visitors were treated to the Jaguar XKD (three consecutive victories between 1955 and 1957), Alfa Romeo's dependable speedster, the 8C 2900 Mille Miglia, and McLaren's F1 LM, one of only six commemorative cars built. There was also the Birken Bentley Blower, whose massive bodywork set it apart from the other road warriors. In between was a bounty of celebrated midcentury models that could make even non–car folk swoon, such as Alfa Romeo's Monza, Porsche's 1955 Spyder, and the Mercedes 1930 SSK "Count Trossi." This car was put together on a design spontaneously drawn on a napkin by its aristocratic Italian owner, Count Carlo Felice Trossi—one more reminder of the exhibition's champagne pedigree and the opportunity to view that rare combination of towering wealth and taste in the service of man's perfection of automotive function and form.

In between soaking up all the automotive candy, enthusiasts could put on headphones and listen to the sounds of each car being started up and then accelerated at high speed. "Like chamber music," said Rapetti. However, capturing the McLaren's pitch-bending loudness or the Ferrari's legendary "scream" became one of the exhibition's more eventful behind-the-scenes *histoires*.

The Louvre had made a last-minute request to film the cars as well as record them in top gear . . . seemingly a capital idea. What the most esteemed art museum in the world didn't count on was exactly what such a grand idea might actually entail. With the April 28 date of the Paris show opening fast approaching, the film segments needed to be readied by the end of March, which meant producing quality sound recordings of the cars at top speed during America's coldest winter months. What would have realistically been available only at a proper racetrack in warm weather with a top driver, the challenge now became to simply capture representative sound and speed samplings. But it had also been one of the toughest winters in America's Northeast, with two feet of ice and snow on the tracks. The decision was finally made to try and capture the sounds on the public roads in Westchester County, one of the busiest places in all of New York State.

As the master motorhead charged with pulling off this minor miracle, Chris Szwedo recalls, "The idea of taking

343

Acting as a visual timeline in the evolution of twentieth-century European automobile design, the models on display from Bugatti, Alfa Romeo, Bentley, Mercedes-Benz, Jaguar, Aston Martin, Porsche, and Ferrari rank among the most exceptional in the world, and in some cases are making their maiden sighting, having never been seen by the public before. Restored to perfection, each one stands as a masterpiece of technological innovation and impeccable design.

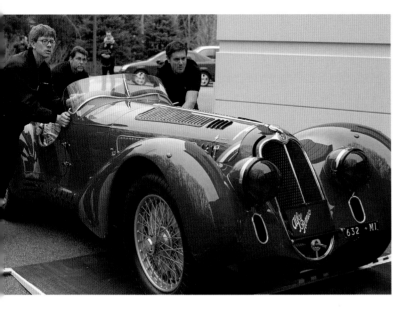

1938 ALFA ROMEO 8C 2900 MILLE MIGLIA

Left: Considered to be one of the most prestigious prewar Grand Touring Alfa Romeos, every part of the 8C 2900 is a work of art; you could admire its engine components all by themselves. If money were no object, any serious racing devotee would aspire to own one of these.

1996 McLAREN F1 LM

Opposite: "Once you drive the McLaren, it's over," Ralph says. "The McLaren is like Star Wars—a hovercraft." So fast, its central-seat-driving position makes you feel like you're piloting a spaceship. One of only six F-1s specially built, at just over two thousand pounds and seven hundred horsepower it can accelerate from zero to one hundred miles per hour in five-and nine-tenth seconds. The McLaren has beauty, it has art, it has racing magic, and it fulfills all the criteria you could ever dream for in a car. Plus, you can drive it to go get groceries.

multimillion dollar works of art out on busy public roads in search of less-trammeled stretches on which to press the pedal to the metal bordered on the crazy, no less the courageous. As many were race cars with tiny doors the size of a pizza box, most of the cars could be considered relatively dangerous. After all, the F1 McLaren, the safest car from a design standpoint, hit one hundred miles per hour in second gear. With no permits, what if the police came? To participate meant being willing to get arrested, not to mention the risk to the priceless automobiles."

For weeks the team roared through the back roads near the Cross River Reservoir sometimes exceeding posted speed limits. Freezing in open cars, they persevered, finding new places to put these racing steeds through their paces. On one occasion they were stopped by a state trooper on State Route 100 who inquired as to what they were up to. When he heard what the mission was, the policeman firmly explained that he was going off duty in twenty minutes and would they please finish up their business. In the end, cobbled together with patience, persistence, and luck, the team was finally able to record all the requisite audio sound-clips so as to add yet another sensory exclamation to the spectacle of these rare masterpieces from the mechanical age.

If the pressure from such a high-stress deadline and performance was not enough of a distraction, imagine the prepping, handling, shipping, and transatlantic delivery of seventeen priceless beauties from a high-security garage in Westchester County, New York, to a seventeenth-century Parisian exhibition hall accessible only via a grand staircase.

Assuming full responsibility from the moment the cars exited their Westchester garage, the Louvre's conservators spent three days inspecting and thoroughly documenting every component of each car. To prevent an irreplaceable loss and thus a whopping insurance tab should one of the cars fall out of the sky, the collection was split into four groups with an assigned courier to travel with each. Shipping only one group per week, the cars were transported to Kennedy Airport on a special enclosed truck and then flown to England on a Lufthansa cargo jet.

Arriving in Manchester, England, they were then separated into two groups and loaded onto two specialized trucks that would make two runs via the Chunnel to the center of Paris.

After pulling up in front of the Musée des Arts Décoratifs at four in the morning the real fun began . . . moving the cars up the central staircase. The Louvre installers had constructed a special wooden ramp to cover the stairway, as the bodywork on the cars was so lightweight and fragile that they could not simply be pushed up the grade. Each auto was secured to a large dolly that was then winched up into the gallery. Imagine the nerves of the forklift operator and the men handling the cars—one false move and disaster lurks right around the corner.

Naturally, at the close of the exhibition, the entire delivery process labyrinth had to be reversed, concluding with a final inspection by their waiting owner back in Westchester, New York.

"There's nothing like waking up on a nice sunny morning, putting on a hat and goggles, rolling down the top of a convertible, and putting it through a few paces on a country road. The pleasure is not about trying to go fast; it's the feeling of handling a thoroughbred: the way it comes around a corner; the way the mechanism feels when you shift. The engine is roaring and your heart is pounding. It's one of life's true pleasures."

AFTERWORD

I n April of 2010 at the Élysée Palace in Paris, French President Nicolas Sarkozy awarded Ralph Lauren his country's highest decoration of merit—its Legion d'honneur as established by Napoleon Bonaparte in 1802. Pinning the medal on the designer, the president stated, "You represent an America we like very much—you and Barack Obama are the American dream." Recognizing the designer for his philanthropic activities, especially his international commitment to the fight against breast cancer, he added, "You represent beauty, democracy, and quality of life."

Much like the Voice of America that was conceived in 1942 to help promote international goodwill through a better understanding of the US culture, Ralph Lauren has been spreading the message of America as a force for good for more than half a century. Today, you can experience the world of Ralph Lauren stores from Boulevard Saint Germain in Paris to Tokyo, Dubai, and Moscow—not to mention Antwerp and Hong Kong. They may be the best advertisements for America that you could ask for. The designer, through his Polo brand and the power of his style, personified the country where dreams of a better life and anything is possible were more often realized than anywhere else in the world.

Back in the middle of the last century, America's role as a moral standard-bearer and protector of freedom was celebrated on screen by Hollywood's legendary directors like Frank Capra and Stanley Kramer: Women looked to Barbara Stanwyck and Katharine Hepburn, men to Jimmy Stewart and Gary Cooper as role models both in love and in life. These days, it's harder to find those films, forums, or public airwaves dedicated to such high-minded, hope-filled purposes. With his overt optimism and uplifting imagery, Ralph Lauren filled that emerging vacuum by creating fantasy lifestyles so transcendent and convincing that customers of both sexes felt they were buying into his vision of real life made better when they purchased his clothes. In doing so, the designer became the most important shaper of an American ideal that could be.

Andrea Robinson, an executive who worked with Ralph on his cosmetic business, tells the story of trying to launch the Polo Bleu Fragrance overseas in 2003 as America was invading Iraq. Europe was unhappy with the United States as were many other Middle Eastern countries, and Robinson's efforts were meeting with increasing resistance. The new fragrance's packaging had a picture of a model in a boat with an American flag. In a moment of reckless abandon, Robinson asked the designer if he would consider taking the flag off the box. He looked at her dumbstruck and said, "How can you ask me such a question, you know me, I would never take our flag off that boat to promote sales."

Frustrated, Robinson went back to Europe where the first thing company officials asked her was whether they could take the flag off the boat. That year Polo Bleu attracted less financial commitment than it should have. Ralph didn't care—he wasn't removing that flag for any amount of money.

Whether or not one buys into Ralph's world, the combination of fashion, flair, and business acumen has made him indisputably the most successful designer in American fashion history. And somewhere along the way, the Ralph Lauren name became a litmus test for good taste. From the very beginning, Ralph tried to represent the highest of America's ideals. In an industry that has always catered to sexual insecurities, there has never been the slightest hint of vulgarity in the designer's imagery as he has long disdained sexually suggestive advertising. Too preoccupied with a vision of high-class taste, Ralph was more interested in depicting a woman's individuality in clothing as a statement rather than an invitation.

In 1998, the designer had an opportunity to pay tribute to the country that helped him to realize his dreams. Hillary Clinton, whose First Lady initiatives included the Save America's Treasures campaign, asked Ralph for help in preserving the deteriorated American flag. Measuring 30-feet-by-42-feet, the original Star-Spangled Banner flew over Baltimore's Fort McHenry in 1814, where it inspired Francis Scott Key's national anthem. On near-continuous display for over ninety years, Old Glory had fallen into extreme disrepair.

The goal was not to just restore the flag but to preserve it for generations to come. The designer gave thirteen million dollars, which in turn inspired other donors. It was the largest corporate donation ever made to the Smithsonian Institution. "Ralph responded to the call. He didn't have to," Clinton said. "But he understood because it was deep within him that part of being an American is giving back."

Ralph, whose earliest memories of the Star-Spangled Banner were those of the flag that flew from the flagpole in his schoolyard, said after the ceremony, "It got the ball rolling. I've had a good life, a wonderful life, and I've tried to do my best to give back. What I've done, I've done from the heart, because it's the right thing," he says. "And I've been successful doing that."

Sixteen years later in 2014, Ralph was back on stage alongside Clinton at the National Museum of American History—surrounded by his siblings, his three children, his wife Ricky, and a battalion of his company's executives—to receive the James Smithson Bicentennial Medal. It read: "For supporting artistry, creativity, innovation and entrepreneurship for more than five decades, and for redefining for national and international audiences a style that embodies the American spirit."

In finding his lifelong podium and using it to raise his country's flag as a rallying call for American morale and leadership, Ralph Lauren, designer and patriot, became Ralph Lauren–American treasure. In spring 2019, his life already a long list of firsts, the ambassador of American style and can-do spirit was made an Honorary Knight Commander of the British Empire, the first American designer to be recognized with an honorary knighthood.

From the designer: "My life has been a dream. If someone had to write a story about it, it would seem a little unreal. It's the kind of story I would read and say, 'Nah, that's not possible.'"

347

ALAN FLUSSER

ACKNOWLEDGMENTS

My heartfelt thanks to the following people:

Hope Cantor: To the love of my life who cocooned me in the most uplifting and warm-hearted force field. No one has sacrificed more in the cause of this book. Driving me in silence to and from Southampton so I could work, spending weekends on your own, making sure I left home with watch and wallet, Hopie, you have been my rock. I could never have done this without you and I now turn to you and what I can do to make it up to you for the rest of our years together.

Jon Sigmon: To my colleague, partner, and sartorial Boswell. To know you are on the job making the custom shop sing is to have my favorite music playing reassuringly in my ear. Without you, I could have never sustained both—our custom business and this book are the better because of you. Thank you so much for not only maturing into my closest and most capable disciple, but for helping me to continue what I love to do so much.

Ralph Lauren: My sincerest gratitude for opening up your life and company in support of my twelve-year marathon. Thanks for always giving it to me straight while teaching me that patience is a necessary preamble to perfection.

Paul Lucas: Agent extraordinaire, who had to earn his keep not once, but twice, and did so with the grace and unflappedness of someone much his senior. We set out on a mission that needed to change course at the last minute, which, as a result of his efforts, landed us in much higher cotton.

Rebecca Kaplan: With special thanks to my cheerfully steadfast editor who graciously kept us all on track as she maintained the book's vision while meeting its tight deadlines. Your droll forbearance of my endless requests helped make the task at hand as joyful as any deadline-driven collaboration could ever be.

Emily Wardwell: My heartfelt gratitude to our designer extraordinaire for bringing my text and visuals so elegantly to life. Your impeccable taste, creativity, and exquisite feel for line and scale produced a work beyond expectation.

David Lauren: My sincerest appreciation for keeping tabs on my progress, inquiring after each show as to whether I needed anything more. In our chats about Dad, you always managed to peel back another layer of his public persona for me to get a better feel for his reality. Of my interviews, yours were among the most thought-provoking and memorable.

Buffy Birrittella: Thank you so much for sharing your lifelong experience of helping Ralph to fulfill his spectacular vision. As the conscience and first-hand shaper of all things Polo and Ralph Lauren, your candor and insight not only enriched the story but helped authenticate it.

Mary Randolph Carter: A very special tribute to the book's Godmother and in-house angel at Polo Central. As one of Ralph's most trusted eyes and ears, no less an accomplished author and editor in her own right, Carter's creative feedback was inestimable. Always making time for me, she ran point on my investigatory activities facilitating access and insight along the way. I am forever in her personal-style-to-burn and nurturing debt.

Cybil Powers: My good photo fairy. Cybil was a pivotal, invaluable presence who came to my rescue so often and for so long that no thanks could ever be enough. Organized, indefatigable, and undeterred by the laborious job of vetting hundreds of random images from the vast Ralph Lauren archives, she made certain each of our sit-downs was organized and productive. As one of the special stars in the Polo galaxy, Cybil's light burns so brightly that others bask in its glow.

348

Jane Harnick: My permissions sleuth—like a dog with a bone, in this case a bloodhound, Jane tracked down each and every photo to clear it for inclusion in the book. Thank you so much for your single-mindedness of purpose—it was as personally encouraging as it was professional.

BJ Berti: A special mention to a devoted collaborator whose kindness and shared passion helped me to walk the book forward until it collected its final wings.

Woody Hochswender: To my departed but not forgotten dear friend, literary co-conspirator, and fellow Buddhist. Had he lived longer, he would have made as much of an editorial contribution to this book as anyone else. I chant for you every day.

Dr. Charles Siegal: My heartfelt appreciation for helping keep Himself pointed in the self-reflective direction. Your compassion and wisdom were a lifeboat throughout.

I embrace dear friends Tom and Sheila Wolfe for their early cheerleading and on-demand editorial guidance.

It's a pleasure to salute the many friends and professional associates who in facilitating my research ransacked their memories to lend accuracy, insight, and illumination to my Ralph Lauren story. My fond and continuing gratitude goes out to the following people:

Ricky Lauren	Lee Norwood	Richard Press
Andrew Lauren	John Wrazej	Joel Avirom
Dylan Lauren	Bobbi Renales	Robin Blakely
Jerry Lauren	Spencer Birch	Jason Synder
Lenny Lauren	Michel Botbol	John Vancheri
Greg Lauren	Janet Scholder	Dennis Cahlo
Charles Fagan	Joe Barrato	Andrew Yamato
Nancy Vignola	Gil Truedsson	Al Zuckerman
Amy Jaffe	Jeffrey Banks	Charlie Davidson
Nicole Truscinski	Robert Stock	Tom O'Toole
Allison Johnson	Sal Cesarani	Henry Ferris
Kristen Altuntop	John Vizzone	Bob Adler
Audrey Yoon	Basha Hargurjit Singt	Saul Katz
Marvin Traub	John Calgagno	Jay Stein
Peter Strom	Andrea Quinn Robinson	Peggy LeGrand
Roger Farah	Pat Christman	Michael Salzburg
Wayne Michener	Graydon Carter	Suzy Slesin
Jerry Magnin	Bill Cunningham	Bruce Boyer
Mark Reinwald	Ami Fine Collins	Joseph Montebello
Rebecca Evans	Nora Ephrom	Nian Fish
Cheryl Sterling	Cliff Grodd	Paul Cavaco
Stuart Kreisler	Paul Goldberger	Tom Fallon
Neal Fox	Mickey Drexler	Allen Berk
Henry Grethel	Glenn O'Brien	Dennis Cahlo
Alfredo Paredes	Mario Buatta	Piper Flusser
Valérie Hermann	Phil Miller	Skye Flusser

BIBLIOGRAPHY

Baird-Murray, Kathleen. *Vogue on Ralph Lauren.* New York: Abrams Books, 2015.

Barreneche, Raul. "Ralph Lauren's Polo Bar Debuts in Manhattan," *Architectural Digest,* February 1, 2015. https://www.architecturaldigest.com/story/polo-bar-ralph-lauren-restaurant-manhattan-article.

Bershad, Lynn. "Learning Some Lessons in the Second Year," *HFD Magazine,* August 20, 1984.

Bowles, Hamish. "Grand Opening: A Look Inside Ralph Lauren's New Store," *Vogue,* October 14, 2010. https://www.vogue.com/article/ralph-lauren-madison-avenue-store.

Boyes, Kathleen. "Telling Stories," *Women's Wear Daily,* October 24, 1988.

Bryant, Thomas L. "Track," *Road & Track,* April 2005.

Buck, Joan Juliet. "Everybody's All-American," *Vogue,* February 1992.

Chensvold, Christian. "The Rise and Fall of the Ivy League Look," *Ivy Style,* January 7, 2013. http://www.ivy-style.com/the-rise-and-fall-of-the-ivy-league-look.html.

Clarke, Gerald. "Take a Look Inside Ralph Lauren's House in Jamaica" *Architectural Digest,* November 2007. https://www.architecturaldigest.com/galleryralph-lauren-jamaica-home-slideshow.

"Classic Cars From Ralph Lauren's Personal Collection," Artdaily, Accessed June 5, 2019. http://artdaily.com/news/13829/Classic-Cars-From-Ralph-Lauren-s-Personal-Collection#.XGGsdC2ZPYI.

Cloud, Barbara. "Meet Ralph Lauren," *Pittsburgh Press,* May 3, 1981.

"Designer's Concept by Ralph Lauren," *Arizona Tribune.* July 23, 1978.

DiGennaro, Ron. "The Fashion Specialists," *Menswear,* June 6, 1969.

Drucker, Stephen. "Ralph Lauren's Bedford Beauty," *Architectural Digest,* November 2004. https://archive.architecturaldigest.com/article/2004/11/ralph-laurens-bedford-beauty.

Dyer, Ezra. "From Horses to Horsepower," *Delta Sky,* July 2011.

Edmonde, Charles-Roux. *Chanel and Her World.* New York: Vendome Press, 2005.

Fairchild, John. *Chic Savages.* New York: Simon and Schuster, 1989.

Ferretti, Fred. "The Business of Being Ralph Lauren," *New York Times,* September 18, 1983.

Fiori, Pamela. "Life is But a Dream," *Town & Country,* December 1996.

Fitzgerald, F. Scott. "Winter Dreams," *Metropolitan,* December 1922.

Foley, Bridget. "The Importance of Being Ralph," *Women's Wear Daily,* May 14, 2002.

Foley, Bridget. "Ralph at 25," *Women's Wear Daily,* January 20, 1992.

Gale, Bill. "The Thirties are Alive and Well in Ralph Lauren," *Gentleman's Quarterly,* February 1971.

Goldberger, Paul. "A Vroom of His Own," *Vanity Fair,* December 17, 2010. https://www.vanityfair.com/news/2011/01/ralph-lauren-garage-201101.

Goldberger, Paul. "American Dreamer," *Vanity Fair,* August 22, 2007. https://www.vanityfair.com/news/2007/09/lauren200709.

Goldfarb, Brad. "In His Element," *Architectural Digest,* September 2013. https://archive.architecturaldigest.com/article/2013/9/1/in-his-element.

Goodfellow, Winston, Beverly Rae Kimes, and Darcy Kuronen. *Speed, Style, and Beauty: Cars From the Ralph Lauren Collection.* Boston: MFA Publications, 2005.

Greene, Richard. "Unconstructed Clothing: The New Image," *Daily News Record,* August 8, 1972.

Gross, Michael. *Genuine Authentic: The Real Life of Ralph Lauren.* New York: Harper Perennial, 2004.

"His Bazaar," *Harper's Bazaar,* February 1969.

Kaplan, James. "From Ralph's House to our House," *Manhattan Inc.,* July 1989.

Kornbluth, Jesse. "America's Dream Merchant," *Metropolitan Home,* June 1984.

Kosover, Toni. "Ralph Lauren," *L'Officiel,* Summer 1978.

Lacombe, Brigitte. "Penthouse and Pavement," *Observer Magazine,* May 9, 1999.

Lauren, Ralph. "Art on Wheels," *Art & Antiques,* March 1991.

Lauren, Ralph. *Ralph Lauren.* New York: Rizzoli, 2007.

Lauren, Ralph. *Ralph Lauren.* New York: Rizzoli International Publications, 2011.

Lauren, Ralph. *Ralph Lauren: Revised and Expanded Anniversary Edition.* New York: Rizzoli, 2017.

Lauren, Ricky. *My Island.* New York: Random House, 1994.

Lifshey, Earl. "If You Ask Me," *Retailing Home Furnishings,* September 13, 1983.

Lipke, David. "The Color Purple," *Daily News Record,* February 11, 2002.

Markoutsas, Elaine, "Ralph Lauren, "Seeking his next conquest, has decided there is nothing like Home," *Chicago Tribune,* October 2, 1983.

McDowell, Colin. *Ralph Lauren: The Man, the Vision, the Style.* New York: Rizzoli International Publications, 2003.

McKeough, Tim. "The Great Migration," *Town & Country,* June 2011.

Morgan, Janet R. "Lauren on Lauren," *HFD Magazine,* January 9, 1984.

Morris, Bernadine. "Lauren Scores for American Sportswear," *New York Times,* November 9, 1984.

Newman, Jill. "The House that Ralph Built," Robb Report, September 1, 2010. https://robbreport.com/style/fashion/the-house-that-ralph-built-235138/.

"New York Fall Eye View," *Women's Wear Daily,* May 5, 1975.

Owens, Mitchell. "A Grand Gesture," *Architectural Digest,* February 1, 2011. https://www.architecturaldigest.com/story/ralph-lauren-grand-gesture-article.

Patch, Catherine. "Lauren's well-bred Close to Flawless," *Toronto Star,* November 12, 1987.

Pennington, Audrey. "Putting on a a Show," *Austin American-Statesman,* November 20, 1984.

"Polo—The Easy Suit," *Daily News Record,* April 6, 1970.

Ralph Lauren: Celebrating 40 Years. New York, Ralph Lauren Corporation, 2008.

Ralph Lauren Corporation, *Polo Magalog,* Fall 2015.

Reed, Julia. "Ralph Lauren's Chic Retreat," *ELLE Décor,* October 4, 2010. https://www.elledecor.com/celebrity-style/celebrity-homes/news/a4018/ralph-lauren-interiors/.

Reginato, James. "Duke of Bedford," *WH magazine,* March 1993.

Reynolds, William C. "Ralph Lauren," *Cowboys & Indians,* September 30, 2015. https://www.cowboysindians.com/2015/09/ralph-lauren/.

Ibid. "Ralph Lauren: A Western Original," *Cowboys & Indians,* January 2005.

Russell, Beverly. "In the Club," *Interiors,* July 1992.

Shaw, Dan. "Black, Male, and Yes, a Supermodel," *New York Times,* November 1994.

Sheppard, Eugenia. "Inside Fashion," *New York Post,* June 29, 1970.

Smith, Jack. "Autos: Moving Masterpieces," *Robb Report,* May 1, 2011.

Spindler, Amy M. "Lauren Moves Polo Into Its Own Quarters," *New York Times,* September 17, 1993.

Stanfill, Francesca. "Decoding the Styles of the 70's," *New York Times Magazine,* December 30, 1979.

Stevens, William K. "The Urban Cowboy, 1978 Style," *New York Times,* June 20, 1978.

Szwedo, Chris. "The Private Automobile Museum of Ralph Lauren," Filmed 2015. Vimeo Video, 4:22. http://www.szwedo.com/main/ralphlauren.html.

Tornabene, Lyn. "The World According to Ralph Lauren," *Cosmopolitan,* February 1987.

Trachtenberg, Jeffrey. "You are what you Wear," *Forbes,* April 21, 1996.

Ibid. *Ralph Lauren: The Man Behind the Mystique.* Boston: Little Brown and Company, 1988.

Traub, Marvin. *Like No Other Store.* New York: Three Rivers Press, 1994.

Trebay, Guy. "Dinner at Ralph's," *New York Times,* March 12, 2015. https://www.nytimes.com/2015/03/12/style/dinner-at-ralph-lauren-polo-bar.html.

Walker, Maureen. "In their Own Fashion," *Times London,* June 17, 1984.

Women's Wear Daily. WWD Fifty Years of Ralph Lauren. New York, Rizzoli, 2018.

CREDITS

Photography of Babe Paley by Slim Aarons / Getty Images: 157; Photography by William Abranowicz / Art + Commerce: 264, 267, 268; Photography by William Abranowicz / ELLE DÉCOR: 270; Jade Albert: 37, 68; Arnaldo Anaya, 2014: 120; Arnaldo Anaya: 43, 111, 216; Courtesy of Apparel Arts Magazine / Author: 56; Courtesy of Apparel Arts Magazine: 89; Courtesy of Apparel Arts Magazine, Sept. 1939: 87; Don Ashby: 239; Paraphernalia with Twiggy modeling / Associated Press, March 1967 / Howard Conant: 143; Prince of Wales / Author: 22; Gary Cooper / Author: 29; Author: 65; English team Polo coats / Author: 112; Backgrid: 254; Chris Barham: 171; Carter Berg: 41, 222, 227, 235, 241, 242, 247, 248, 251, 252, 255, 257, 258, 259, 324; Carter Berg, 2011: 116; Getty Images / Photography by Bettman: 136; Villager Blouse, Skirt, Peter Pan Collar / Getty Images / Bettman: 138; Katharine Hepburn / Getty Images / Bettman: 154; Paris Fashion 20s / Branger / Getty images: 130; John Bright, 1978: 174; Courtesy of Brooks Brothers, 346 Madison Ave., 1962: 54; Dennis Cahlo: 102; RRL Western shirts – Author / Photography by Dennis Cahlo: 102; Mary Randolph Carter: 293; Courtesy of the Chicago Tribune / PARS: 295; Paul Christensen, 1980: 94; Nathan Cooper: 205, 344; Richard Corman: 55, 345; Erik Dalzen 2018: 129; Gilles De Chabaneix: 8, 285; Patrick Demarchelier, 1980: 188; Patrick Demarchelier: 262; Pierre-Olivier Deschamps / VU' for Ralph Lauren: 341, 342; Noe Dewitt: 225; Dior New Look 1947 / Gamma Keystone / Keystone France: 132; Jacques Dirand: 299; Tony Edgeworth: 104, 177; Pate Eng: 309, 316, 319; Slim Keith Red Jacket / Photography by John Engstead: 52; Slim Keith Tunic / Condé Nast / Photography by John Engstead: 158; Photography by Pieter Estersohn / Contour by Getty Images: 273, 274; Doug Fairbanks / Author: 29; Fashion Models Andre Courreges 1960s / Universal History Archives: 133; Zackary Freyman: 5, 59; David Friedman: 304; Michael Furman: 321, 322, 324, 325, 326, 327, 337; Jen Galatioto: 308, 311; Island Lookout / Getty Image / Slim Aarons: 208; Oberto Gili: 224, 299; Les Goldberg: 16, 20, 67; Ralph Photo / Photography by Les Goldberg: 83; Tim Graham / Camera Press / Redux: 19; Fred Astaire 1938 / Granger: 53; Grace Kelly's departure from Hollywood / Life Images Collection / Getty Images / Photography by Allan Grant: 155; Joel Griffith, 2015: 112; Joel Griffith: 245; Cliff Grodd / Paul Stuart Archive: 57; Fancois Halard: 302, 303; Laziz Hamani: 335; C.Z. Guest and American designer Oscar de la Renta / Photography by Mary Hilliard: 159; Lauren Hutton / Cheap Chic / Peter Hujar: 160; YSL / Courtesy of Hutton Archive / Photography by Wesley: 139; Thomas Iannaccone / Penske Media Corporation / Shutterstock: 170; Mark Jenkenson: 166; Steve Kapovitch and James Barnes / Courtesy of Men's Wear, 1969: 44; Lynn Karlin / Penske Media Corporation / Shutterstock: 48; Photography by Ke.Mazur / WireImage: 230; Dan Kornish: 312, 313, 314; Paul Lange: 115; Jerry Magnin's Polo Shop / Courtesy of Lauren family archives: 80; Dan Lecca: 41, 243; Claire McCardell / Getty Images / Photography by Wynn Richards Bettman: 145; Photography by Roland Meledandri / Courtesy of Meledandri family archives: 58; Sheila Metzner: 40, 119, 121, 124, 242, 262, 302, 337; Michael Mundy: 289, 290, 291; Jimmy Nelson: 260; Bendels Street of Shops / Courtesy of the New York Times / Redux: 140; Courtesy of the New York Times / Redux: 151, 297; Jackie Kennedy, Sept 15, 1965 / Shutterstock / Photograph by Tony Palmieri: 135; Tony Palmieri / Penske Media Corporation / Shutterstock: 161; Photography © Penske Media Corporation: 34, 70, 73, 75, 98, 99, 101, 175; David Phelps: 306, 307; Richard Phibbs: 91; Greta Garbo, Two-Faced, 1941 / Photofest: 150; Mary Quant, March 24, 1969 / Getty Images / Photofest: 137; Karen Radkai: 190; Courtesy of Rake Magazine, May 2018 / photographer unknown: 63; Maria Robledo: 219, 262; Durston Saylor: 284, 288; Steve Schapiro / Getty Images: 100; Audrey Hepburn / Shutterstock / Kobal Collection: 156; Skrebneski Photographs: 69, 271; Marcelo Soubhia: 331; Vogue Ad, 1946 / Courtesy of Stewart & Co. / By Vionnet Paquin: 132; Peter Tenzer: 336; Martyn Thompson: 14, 42, 107, 126, 261; Chanel Suit, 1959 / The Image Works / Courtesy of Topfoto: 231; Biba, London / Courtesy of V&A Magazine / Redux: 141; Photography © Björn Wallander / OTTO: 280, 315; Photography by Barbra Walz: 25; Bruce Weber: 2, 7, 13, 40, 41, 42, 66, 90, 127, 181, 183, 192, 193, 194, 195, 198, 199, 200, 201, 202, 206, 217, 226, 227, 228, 229, 240, 258, 263, 300, 324, 328, 329, 332, 333; Bruce Weber, 1980: 91; Bruce Weber, 1981: 184, 185; Bruce Weber, 1982: 191; Bruce Weber, 1983: 162, 163; Bruce Weber, 1986: 149; Bruce Weber, 1987: 123; Bruce Weber, 1988: 77; Bruce Weber, 1995: 110; Bruce Weber, 1996: 94, 212, 215; Bruce Weber, 1998: 92; Bruce Weber, 2004: 186; Bruce Weber, 2007: 125; Bruce Weber, 2010: 113; Bruce Weber, 2014: 108, 109; Courtesy of Tom Wolfe archives: 64; Susan Wood: 168, 169; Patrick H. Zack: 38; Ricky Zehavi: 18, 221;

THE AUTHOR CONDUCTED INTERVIEWS FOR THIS BOOK
WITH THE FOLLOWING PEOPLE:

Jeffrey Banks	Charlie Davidson	David Lauren	Bobbi Renales
Joe Barrato	Mickey Drexler	Jerry Lauren	Andrea Quinn Robinson
Spencer Birch	Nora Ephron	Ralph Lauren	Janet Scholder
Buffy Birrittella	Charles Fagan	Ricky Lauren	Cheryl Sterling
Michel Botbol	Tom Fallon	Jerry Magnin	Robert Stock
Mario Buatta	Roger Farah	Wayne Michener	Peter Strom
John Calgagno	Neal Fox	Lee Norwood	Marvin Traub
Graydon Carter	Paul Goldberger	Glenn O'Brien	Gil Truedsson
Mary Randolph Carter	Cliff Grodd	Tom O'Toole	Nancy Vignola
Sal Cesarani	Valérie Hermann	Alfredo Paredes	John Vizzone
Ami Fine Collins	Stuart Kreisler	Richard Press	John Wrazej
Bill Cunningham	Andrew Lauren	Mark Reinwald	

Editor: Rebecca Kaplan
Designer: Emily Wardwell
Production Manager: Alison Gervais

ISBN: 978-1-4197-4146-3

Text copyright © 2019 Alan Flusser

Jacket © 2019 Abrams

Printed and bound in China
10 9 8 7

Abrams books are available at special discounts when purchased in quantity for premiums
and promotions as well as fundraising or educational use. Special editions can also be created
to specification. For details, contact specialsales@abramsbooks.com or the address below.

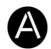

ABRAMS The Art of Books
195 Broadway, New York, NY 10007
abramsbooks.com